Green Building – Guidebook for Sustainable Architecture

Prof. Dr. Michael Bauer
Peter Mösle
Dr. Michael Schwarz

Drees & Sommer Advanced Building Technologies GmbH
Obere Waldplätze 11
70569 Stuttgart
Germany

info.green-building@dreso.com

ISBN 978-3-642-00634-0 e-ISBN 978-3-642-00635-7
DOI 10.1007/978-3-642-00635-7
Springer Heidelberg Dordrecht London New York

Library of Congress Control Number: 2009938435

Original German edition published by Callwey Verlag, Munich, 2007
© Springer-Verlag Berlin Heidelberg 2010
This work is subject to copyright. All rights are reserved, whether the whole or part of the material is concerned, specifically the rights of translation, reprinting, reuse of illustrations, recitation, broadcasting, reproduction on microfilm or in any other way, and storage in data banks. Duplication of this publication or parts thereof is permitted only under the provisions of the German Copyright Law of September 9, 1965, in its current version, and permission for use must always be obtained from Springer. Violations are liable to prosecution under the German Copyright Law.
The use of general descriptive names, registered names, trademarks, etc. in this publication does not imply, even in the absence of a specific statement, that such names are exempt from the relevant protective laws and regulations and therefore free for general use.

Cover design: wmxDesign GmbH, Heidelberg,
 according to the design of independent Medien-Design

Printed on acid-free paper

Springer is part of Springer Science+Business Media (www.springer.com)

By Michael Bauer, Peter Mösle and Michael Schwarz

Green Building – Guidebook for Sustainable Architecture

Table of Contents

A

The Motivation behind the Green Building Idea

Increased Public Focus on Sustainability and Energy Efficiency 10
Supportive Framework and General Conditions 12
 CO_2 Emission Trade 13
 Rating Systems for Sustainable Buildings 15
An integrated View of Green Buildings –
 Life Cycle Engineering 20

B

Green Building Requirements

B1 Sustainable Design 24
Perceived Use defines the Concept 25
Relationship between Level of Well-Being
 and healthy Indoor Climate 26
 Relationship between Comfort Level and
 Performance Ability 27
 Operative Indoor Temperature in Occupied Rooms 28
 Operative Temperature in Atria 30
 Indoor Humidity 32
 Air Velocity and Draught Risk 34
 Clothing and Activity Level 35
 Visual Comfort 36
 Acoustics 40
 Air Quality 42
 Electromagnetic Compatibility 45
Individualized Indoor Climate Control 47

B2 Conscientious Handling of Resources 50
 Energy Benchmarks as Target Values for Design 51
 Fossils and Regenerative Energy Resources 52
Today's Energy Benchmark – Primary Energy
 Demand for Indoor Climate Conditioning 53
 Heating Energy Demand 54
 Energy Demand for Water Heating 55
 Cooling Energy Demand 56
 Electricity Demand for Air Transport 57
 Electricity Demand for Artificial Lighting 58
Future Energy Benchmark – Primary Energy Demand
 over the Life Cycle of a Building 59
 Cumulative Primary Energy Demand
 of Building Materials 60
 Primary Energy Demand – Use-related 61
Water Requirements 62

C

Design, Construction, Commissioning and Monitoring for Green Buildings

C1 Buildings 66
Climate 67
Urban Development and Infrastructure 69
Building Shape and Orientation 71
Building Envelope 74
 Heat Insulation and Building Density 74
 Solar Protection 80
 Glare Protection 85
 Daylight Utilization 86
 Noise Protection 88
 Façade Construction Quality Management 90
Building Materials and Furnishings 92
 Indoor Acoustics 94
 Smart Materials 97
Natural Resources 100
Innovative Tools 105

C2 Building Services Engineering 108
Benefits Delivery 109
 Concepti and Evaluation of Indoor
 Climate Control Systems 110
 Heating 112
 Cooling 113
 Ventilation 114
Energy Generation 120
 Trigeneration or Trigen Systems (CCHP) 121
 Solar Energy 124
 Wind Energy 126
 Geothermics 127
 Biomass 128

C3 Commissioning 130
 Sustainable Building Procedure Requirements 131
 Blower Door Test – Proof of Air-Tightness 132
 Thermography – Proof of Thermal Insulation and Evidence of Active Systems 133
 Proof of Indoor Comfort 134
 Air Quality 135
 Noise Protection 136
 Daylight Performance and Nonglaring 137
 Emulation 138

C4 Monitoring and Energy Management 140

D

A closer Look – Green Buildings in Detail

D1 Dockland Building in Hamburg 146
Interview with the Architect Hadi Teherani of BRT Architects, Hamburg 147
Interview with Christian Fleck, Client, Robert Vogel GmbH & Co. KG 149
Highly transparent and yet sustainable 150

D2 SOKA Building in Wiesbaden 154
Excerpts from the Book titled »SOKA Building« by Prof. Thomas Herzog
 and Hanns Jörg Schrade of Herzog und Partner, Munich 155
Interview with Peter Kippenberg, Board Member of SOKA Construction 156
Robust and Energy-Efficient 158
Optimizing Operations – Total Energy Balance for 2005:
 Heat, Cooling, Electricity 159

D3 KSK Tuebingen 160
Interview with Prof. Fritz Auer of Auer+Weber+Associates, Architects 161
Transparently Ecological 163

D4 LBBW Stuttgart 166
Interview with the Architect Wolfram Wöhr of W. Wöhr – Jörg Mieslinger
 Architects, Munich, Stuttgart 167
Interview with the Client Fred Gaugler, BWImmobilien GmbH 168
High and Efficient 169

D5 The Art Museum in Stuttgart 172
Interview with the Architects Prof. Rainer Hascher and Prof. Sebastian Jehle 173
Crystal Clear 175

D6 New Building: European Investment Bank (EIB) in Luxembourg 178
Interview with Christoph Ingenhoven of Ingenhoven Architects 179
Sustainably Comfortable 181

D7 Nycomed, Constance 184
Interview with the Architect Th. Pink of Petzinka Pink Technol.
 Architecture, Duesseldorf 185
Interview with the Client Prof. Franz Maier of Nycomed 185
Efficient Integration 187

D8 DR Byen, Copenhagen 190
Interview with the Clients Kai Toft & Marianne Fox of DR Byen 191
Interview with the Architect Stig Mikkelsen, Project Leader
 and Partner of Dissing+Weitling 192
Adjusted Climate Considerations 194

D9 D&S Advanced Building Technologies Building, Stuttgart 196
Low-Energy Building Prototype 197
Basic Evaluation and Course of Action 198
Indoor Climate and Façade Concept 199
Usage of Geothermal Energy for Heat and Cooling Generation 200

Appendix 202

Preface by the Authors

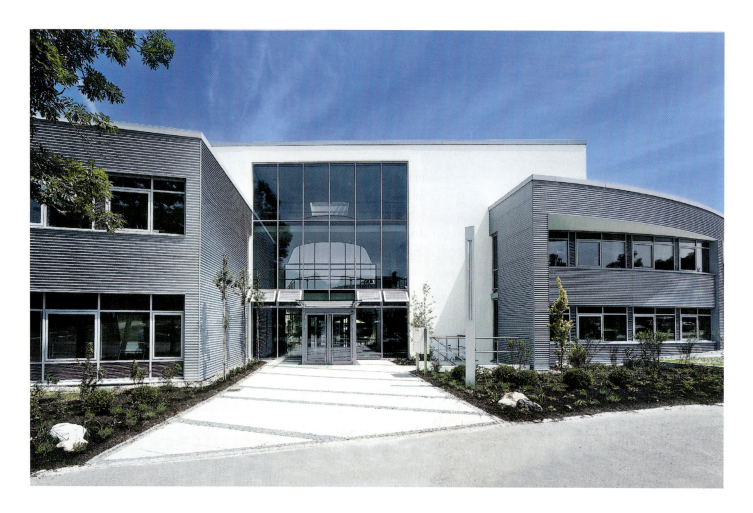

There are essential challenges for the future, such as taking a responsible approach towards nature. Also, there is the search for an environmentally-friendly energy supply that is easy on resources and climate. A further challenge is the search for clean sources of drinking water. Aside from novel and more efficient technologies than are currently in place, additional emphasis will thus need to be placed on reducing energy and water requirements without decreasing either comfort level or living standard. The building sector worldwide uses up to 40% of primary energy requirements and also a considerable amount of overall water requirements. Meanwhile, the service life of both new and renovated buildings reaches far into the future. Hence, these buildings considerably influence envisioned energy and water needs for the next 50 to 80 years. This means that, even today, they must be planned, constructed and run according to the principles of energy efficiency, climatic aspects, and water conservation. This applies even when global outlines to counteract climate change seem to lie too far in the future to grasp. Buildings that show these attributes of sustainability are called Green Buildings. They unite a high comfort level with optimum user quality, minimal energy and water expenditure, and a means of energy generation that is as easy as pos-

sible on both climate and resources, all this under economic aspects with a pay-back span of 5 to 15 years. Green Buildings are also capable of meeting even the most stringent demands for aesthetics and architecture, which is something that the examples given in this book clearly show. Planning these buildings, according to an integrated process, requires the willingness of all those involved: to regard the numerous interfaces as seams of individual assembly sections, the synergies of which are far from being exhausted yet. An holistic and specific knowledge is needed, regarding essential climatic, thermal, energy-related, aero-physical and structural-physical elements and product merits, which does not end at the boundaries of the individual trades. Further, innovative evaluation and simulation tools are being used, which show in detail the effects throughout the building's life cycle. The examples in this book show that a building can indeed be run according to the principles of energy and resource conservation when – from the base of an integrated energy concept – usage within a given establishment is being consistently tracked and optimized. The resulting new fields of consulting and planning are called energy design, energy management and Life Cycle Engineering. In this particular field, Drees & Sommer now has over 30 years of experience, as one of the leading engineering and consulting firms for the planning and operation of Green Buildings. Our cross-trade, integrated knowledge stems from Drees & Sommer's performance sectors of Engineering, Property Consulting and Project Management.

The contents of this book are based on the extensive experience of the authors and their colleagues – during their time at Drees & Sommer Advanced Building Technologies GmbH – in planning, construction and operation of such buildings. It documents, through examples, innovative architectural and technical solutions and also the target-oriented use of specialist tools for both planning and operation. This book is directed primarily at investors, architects, construction planners and building operators, looking for an energy approach that is easy on resources. It is meant as a guideline for planning, building and operation of sustainable and energy-efficient buildings.

At this stage, we would also like to thank all the renowned builders and architects together with whom, over the last years, we had the honour of planning, executing and operating these attractive and innovative buildings. The level of trust they put in us is also shown by the statements they gave us for this book and the provided documentation for many prominent buildings. For their kind assistance in putting together this book, a special thanks is due.

We would be pleased if, by means of this book, we succeeded in raising the level of motivation for erecting Green Buildings anywhere in the world, whether from scratch or as renovation projects. Engineering solutions to make this happen are both available and economically viable. Our sustainability approach goes even further, incidentally. The CO_2 burden resulting from the production and distribution of this book, for instance, we have decided to compensate for by obtaining CO_2 certificates for CO_2 reducing measures. Hence, you are free to put all your energy into reading this book!

We would now like to invite you to join us on a journey into the world of Green Buildings, to have fun while reading about it, and above all, to also discover new aspects that you can then use for your own buildings in future.

Heubach, Gerlingen, Nuertingen

Michael Bauer
Peter Mösle
Michael Schwarz

A
B

The Motivation behind the Green Building Idea

Fig. A3 State Office Building in Berlin. Architects: Petzinka Pink Technologische Architektur®, Duesseldorf

Increased Public Focus on Sustainability and Energy Efficiency

Man's strive for increased comfort and financial independence, the densification of congested urban areas, a strong increase in traffic levels and the growing electric smog problem due to new communication technologies all cause ever rising stress levels in the immediate vicinity of the individual. Quality of life is being hampered and there are negative health effects. All this, coupled with frequent news about the global climate change, gradually leads to a change of thought throughout society.

In the end, it is society that must bear the effects of economic damage caused by climatic change. Due to the rising number of environmental catastrophes, there was in increase of 40% between the years of 1990 to 2000 alone, when compared to economic damage sustained between 1950 and 1990. Without the implementation of effective measurements, further damage, which must therefore still be expected, cannot be contained. Companies across different industries have meanwhile come to realize that only a responsible handling of resources will lead to long-term success. Sustainable buildings that are both environmentally and resource-friendly enjoy an increasingly higher standing when compared to primarily economically oriented solutions.

Aside from social and economic factors, steadily rising energy costs over recent years facilitate the trend towards sustainability. Over the past 10 years alone, oil prices have more than doubled, with an annual increase of 25% between 2004 and 2008. Taking into account both contemporary energy prices and price increases, energy saving measures have become essential in this day and age. A further reason for the conscientious handling of resources is a heavy dependency on energy import. The European Union currently imports more than 60% of its primary energy, with the tendency rising. This constitutes a state of dependency that is unsettling to consumers and causes them to ask questions about the energy policy approach of the different nations. Since energy is essential, many investors and operators place their trust in new technologies and resources in order to become independent of global developments.

Real Estate, too, is starting to think along new lines. End-users look for sustainable building concepts, with low energy and operating costs, which offer open, socially acceptable and communication-friendly structures made from building materials that are acceptable from a building ecology point of view and have been left in as natural a state as possible. They analyze expected operating costs, down to building renaturation, and they run things in a sustainable manner. Aside from looking at energy and operating costs, they also take an increasing interest in work performance levels, since these are on the

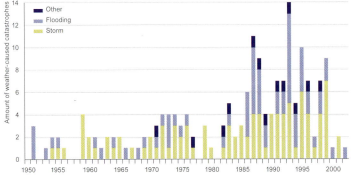

Fig. A1 Major weather-caused catastrophes from 1950 to 2000

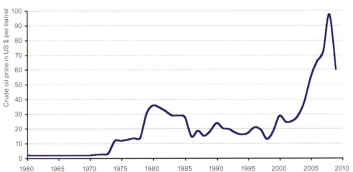

Fig. A2 Nominal Development of Crude Oil Prices from 1960 onward

rise for workers in Europe. Only when people feel good and are healthy they can work at their optimum performance level. By necessity, this means providing both a comfortable and healthy environment. Investors also know they should use sustainable aspects as arguments for rental and sale, since nowadays tenants base their decisions in part on energy and operating costs and are looking for materials that are in accordance with building ecology considerations. Green Buildings always offer a high comfort level and healthy indoor climate while banking on regenerative energies and resources that allow for energy and operating costs to be kept as low as possible. They are developed according to economically viable considerations, whereby the entire building life cycle – from concept to planning stage, from construction to operation and then back to renaturation – is taken into account. Green Buildings, therefore, are based on an integrated and future-oriented approach.

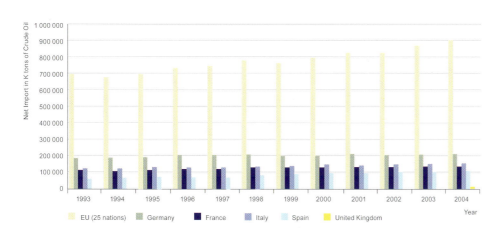

Fig. A4 European Union Dependency on Energy Imports

Supportive Framework and General Conditions

Owing to rising public interest in sustainable and ecological solutions, the last few years have resulted in the establishment of numerous framework conditions that facilitate the use of energy-saving technologies, energy sources that are easy on resources and sustainable products for the property sector.

The base of a sustainable energy policy can be found in various national, European and International laws, standards, norms and stipulations that specify measurable standards of energy efficiency for buildings and facilities. Further, the norms define the minimum standard for energy efficiency of buildings and facilities. The norms also set minimum standards for thermal comfort, air quality and visual comfort.

Across Europe, there is currently a drive to unify these standards. On an international level, however, the different nations are setting their own guidelines and these cannot necessarily be directly compared to each other. The standards are being supported by a variety of available and targeted grants for promising technologies that are currently not yet economical on a regenerative level. Examples for this in Germany would be the field of photovoltaics, for instance, or of near-surface geothermics, solar thermics, biogas plants or energy-conserving measures for the renovation of old buildings.

In the currently available laws, standards and stipulations, however, not all the essential building and facility areas are being considered. This means that many of these areas are unable to fulfil their true potential when it comes to the possibility of optimisation on an energy level. Further, legally defined critical values for energy consumption are generally below those required for Green Buildings. These critical values are usually set in a manner that allows for marketable products to be used. Laws and stipulations will, therefore, always be backward when compared to the actual market possibilities for obtaining maximum energy efficiency.

This gap can be bridged by the use of Green Building labels, guidelines and quality certificates, since these can at least recommend adherence to more stringent guidelines. The higher demands placed on true energy efficiency can also be justified by the fact that the technology in buildings and facility has a great lifespan. This means that a CO_2 emission limit specified today will have long-ranging effects into the future. Today's decisions, therefore, are essential aspects in determining future emission levels.

CO_2 Emission Trade

From February 2005, the Kyoto protocol applies. It is meant to reduce the levels of global greenhouse gas emissions. The origin of this protocol can be traced back to 1997. It stands for an international environmental treaty where the 39 participating industrial nations agreed, by 2012, to reduce their collective emission of environmentally harmful gases, like, for instance, carbon dioxide (CO_2) by a total of 5% when compared to 1990 levels. Within the European Community, the target reduction level is 8%, in Germany even 21%. As *Figure A6* shows, most industrial nations fall far short of meeting their targets at this time.

By means of CO_2 trade, a long-term corrective measure is supposed to be achieved for the human-caused greenhouse effect. The environment is hereby considered as goods, the conservation of which can be achieved through providing financial incentives.

Politicians have now recognized that environmental destruction, resulting from climatic change, firstly cannot only be counteracted by purely economic means and secondly must be regarded as a serious global problem. For the first time, the idea behind the CO_2 trade clearly unites both economical and environmental aspects. How precisely does CO_2 emissions trading work, then? For each nation that has ratified the Kyoto protocol, a maximum amount of climate-damaging greenhouse gases is assigned. The assigned amount corresponds to maximum permitted usage. The Greenhouse Gas Budget, which goes back to 1990, takes into account future development for each participating nation. Economies that are just starting to rise as, for instance, can be found in Eastern Europe, are permitted a higher degree of CO_2 emissions. Industrial nations, however, must make do every year with a reduced greenhouse budget.

For each nation, a certain number of emissions credits are assigned on the basis of the national caps on the emissions in that nation. These credits are assigned to the participating enterprises, according to their CO_2 emissions level. If the emissions of a given enterprise remain below the amount of emission credits that it has been assigned (Assigned Allocation Units or AAUs), for instance as a result of CO_2 emission reduction due to energy-savings measures applied there, then the unused credits can be sold on the open market. Alternatively, an enterprise may purchase credits on the open market if its own emission-reducing measures would be more costly than the acquisition of those credits. Further, emission credits can be obtained if a given enterprise were to invest, in other developing or industrial nations, into sustainable energy supply facilities. This means that climate protection takes place precisely where it can also be realized at the smallest expense.

In Germany, during the initial stage that runs up to 2012, participation in the emissions trade process is only compulsory for the following: operators of large-size power plants with a

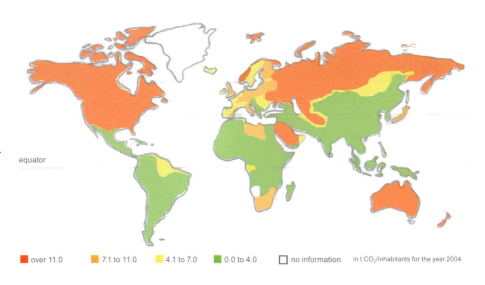

Fig. A5 CO_2 Emissions Distribution levels per Capita, World Population, for the year 2004

14 The Motivation behind the Green Building Idea

thermal furnace capacity in excess of 20 MW and also operators of power-intensive industrial plants. With this, ca. 55% of the CO_2 emissions potential directly participates in the trade. Currently, neither the traffic nor the building sectors are part of the trade in either a private or commercial manner. However, in Europe, efforts are already underway to extend emissions trading to all sectors in the long run. In other, smaller European nations like, for instance, Latvia and Slovenia, plants with a lower thermal output are already participating in the emissions trade. This is explicitly permitted in the Emissions Trade Bill as an opt-in rule. The evaluation and financing of buildings based on their CO_2 market value is something that, in the not-too-distant future, will reach the property sector as well. A possible platform for building-related emissions trade already exists with the EU directive on overall energy efficiency and with the mandatory energy passport. Our planet earth only has limited biocapacity in order to regenerate from harmful substances and consumption of its resources. Since the Nineties, global consumption levels exceed available biocapacity. In order to reinstate the ecological balance of the earth, the CO_2 footprint needs to be decreased. Target values that are suitable for sustainable development have been outlined in *Figure A7*.

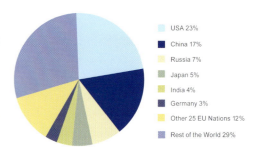

Fig. A8 Distribution of CO_2 Emissions by World Nations for the Year 2004

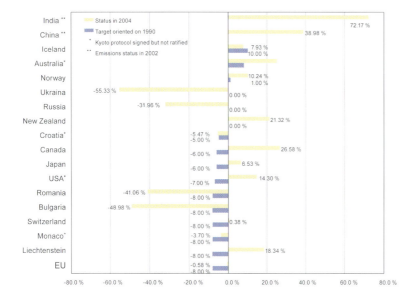

Fig. A6 Reduction Targets, as agreed in the Kyoto Protocol, and current Standing of CO_2 Emission Levels for the worldwide highest global Consumers

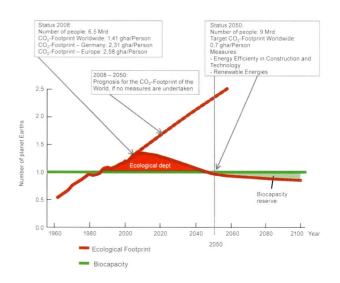

Fig. A7 Sustainability wedges and an end to overshoot

Rating Systems for Sustainable Buildings

Rating systems have been developed to measure the sustainability level of Green Buildings and provide best-practice experience in their highest certification level. With the given benchmarks, the design, construction and operation of sustainable buildings will be certified. Using several criteria compiled in guidelines and checklists, building owners and operators are given a comprehensive measurable impact on their buildings' performance. The criteria either only cover aspects of the building approach to sustainability, like energy efficiency, or they cover the

System (Country of origin)	DGNB (Germany)	BREEAM (Great Britain)	LEED (USA)	Green Star (Australia)	CASBEE (Japan)	Minergie (Switzerland)
Initiation	2007	1990	1998	2003	2001	1998
Key Aspects of Assessment & Versions	- Ecological Quality - Economical Quality - Social Quality - Technical Quality - Process Quality - Site Quality Purpose of the DGNB Certificate: Application for buildings of any kind (Office high-rises, detached residential homes, infrastructure buildings etc.) DGNB for: - Offices - Existing Buildings - Retail - Industrial - Portfolios - Schools	- Management - Health & Well-being - Energy - Water - Material - Site Ecology - Pollution - Transport - Land consumption BREEAM for: Courts, EcoHomes, Education, Industrial, Healthcare, Multi-Residential, Offices, Prisons, Retail	- Sustainable Sites - Water Efficiency - Energy & Atmosphere - Material & Resources - Indoor Air Quality - Innovation & Design LEED for: New Construction, Existing Buildings, Commercial Interiors, Core and Shell, Homes, Neighborhood Development, School, Retail	- Management - Indoor Comfort - Energy - Transport - Water - Material - Land Consumption & Ecology - Emissions - Innovations Green Star for: - Office – Existing Buildings - Office – Interior Design - Office – Design	Certification on the basis of "building-environment efficiency factor" BEE=Q/L Q ... Quality (Ecological Quality of buildings) Q1 - Interior space Q2 - Operation Q3 - Environment L ... Loadings (Ecological effects on buildings) L1 - Energy L2 - Resources L3 - Material Main Criteria: (1) Energy Efficiency (2) Resource Consumption Efficiency (3) Building Environment (4) Building Interior	4 Building standards are available: (1) Minergie - Dense building envelope - Efficient heating system - Comfort ventilation (2) Minergie-P additional criteria to (1): - Airtightness of building envelope - Efficiency of household appliances (3) Minergie-Eco additional criteria to (1): - Healthy ecological manner of construction (optimized daylight conditions, low emissions of noise and pollutants) (4) Minergie-P-Eco Adherence to criteria of Minergie-P and Minergie-Eco
Level of Certification	Bronze Silver Gold	Pass Good Very good Excellent Outstanding	LEED Certified LEED Silver LEED Gold LEED Platinum	4 Stars: 'Best Practice' 5 Stars: 'Australien Excellence' 6 Stars: 'World Leadership'	C (poor) B B+ A S (excellent)	Minergie Minergie-P Minergie-Eco Minergie-P-Eco

Fig. A9 Comparison of different Rating Systems for Sustainable Buildings

16 The Motivation behind the Green Building Idea

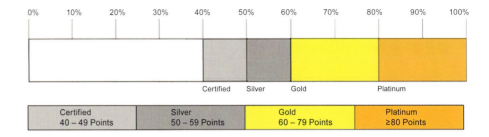

Fig. A12 LEED® Certification

whole building approach by identifying performance in key areas like sustainable site development, human and environmental health, water savings, materials selection, indoor environmental quality, social aspects and economical quality.

Furthermore, the purpose of rating systems is to certify the different aspects of sustainable development during the planning and construction stages. The certification process means quality assurance for building owners and users. Important criteria for successful assessments are convenience, usability and adequate effort during the different stages of the design process. The result of the assessment should be easy to communicate and should be showing transparent derivation and reliability.

Structure of Rating Systems

The different aspects are sorted in overall categories, like ›energy‹ or quality groups ›ecology‹, ›economy‹ and ›social‹ demands (triple bottom line). For each aspect, one or more benchmarks exist, which need to be verified in order to meet requirements or obtain points. Depending on the method used, individual points are either added up or initially weighted and then summed up to obtain the final result. The number of points is ranked in the rating scale, which is divided into different levels: The higher the number of points, the better the certification.

LEED® – Leadership in Energy and Environmental Design

The LEED® Green Building Rating System is a voluntary, consensus-based standard to support and certify successful Green Building design, construction and operations. It guides architects, engineers, building owners, designers and real estate professionals to transform the construction environment into one of sustainability. Green Building practices can substantially reduce or eliminate negative environmental impact and improve existing unsustainable design. As an added benefit, green design measures reduce operating costs, enhance building marketability, increase staff productivity and reduce potential liability resulting from indoor air quality problems.

The rating systems were developed for the different uses of buildings. The rating is always based on the same method, but the measures differentiate between the uses. Actually, new construction as well as modernization of homes and non-residential buildings are assessed. Beyond single and complete buildings, there are assessments for neighborhoods, commercial interiors and core and shell. The rating system is organized into five different environmental categories: Sustainable Sites, Water Efficiency, Energy and Atmosphere, Material and Resources and Innovation.

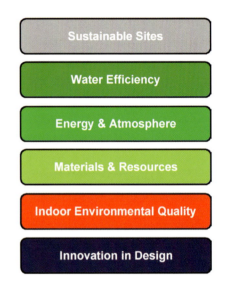

Fig. A10 LEED® Structure

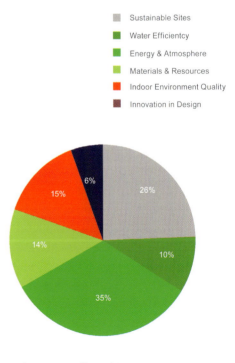

Fig. A11 LEED® Weighting

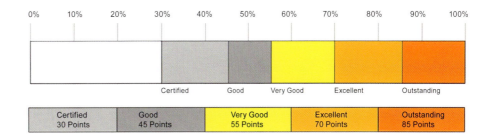

Fig. A15 BREEAM Certification

BREEAM – BRE Environmental Assessment Method

The assessment process BREEAM was created by BRE (Building Research Establishment) in 1990. BRE is the certification and quality assurance body for BREEAM ratings. The assessment methods and tools are all designed to help construction professionals understand and mitigate the environmental impacts of the developments they design and build. As BREEAM is predominately a design-stage assessment, it is important to incorporate details into the design as early as possible. By doing this, it will be easier to obtain a higher rating and a more cost-effective result. The methods and tools cover different scales of construction activity. BREEAM Development is useful at the master planning stage for large development sites like new settlements and communities.

Different building versions have been created since its launch, to assess the various building types. Currently, the evaluation program is available for offices, industry, schools, courts, prisons, multiple purpose dwellings, hospitals, private homes and neighborhoods. The versions of assessment essentially look at the same broad range of environmental impacts: Management, Health and Well-being, Energy, Transport, Water, Material and Waste, Land Use and Ecology and Pollution. Credits are awarded in each of the above, based on performance. A set of environmental weightings then enables the credits to be added together to produce a single overall score. The building is then rated on a scale of certified, good, very good, excellent or outstanding and a certificate awarded to the design or construction.

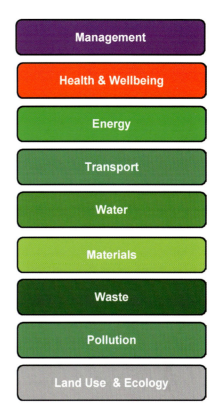

Fig. A13 BREEAM Structure

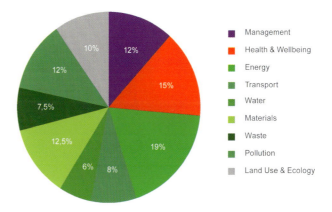

Fig. A14 BREEAM Weighting

18 The Motivation behind the Green Building Idea

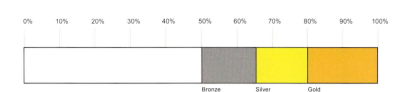

Fig. A18 DGNB Certification

Fig. A19 Certification medals with DGNB Gold, Silver, Bronze

DGNB – German Sustainable Building Certificate (GeSBC)

In contrast to comparable systems, the GeSBC label takes all three sustainability dimensions in account in its assessment structure, examining ecological, economic and socio-cultural aspects.

As the result of legislation, the German real estate industry already has a high standard of sustainability. In addition to the Energy Passport, the GeSBC addresses all items defining sustainability to meet the demands.

The German Sustainable Building Council (DGNB) was founded in June 2007 and created the German Sustainable Building Certificate together with the German Federal Ministry of Transport, Construction and Urban Development. The goal is »to create living environments that are environmentally compatible, resource-friendly and economical and that safeguard the health, comfort and performance of their users«.

The certification was introduced to the real estate market in January 2009. It is now possible to certify at three different levels, »Bronze«, »Silver« and »Gold«. As shown in Fig. A16, site quality will be addressed, but a separate mark will be given for this, since the boundary for the overall assessment is defined as the building itself.

MINERGIE ECO®

Minergie® is a sustainability brand for new and refurbished buildings. It is supported jointly by the Swiss Confederation and the Swiss Cantons along with Trade and Industry. Suppliers include architects and engineers as well as manufacturers of materials, components and systems.

The comfort of occupants living or working in the building is the heart of Minergie®. A comprehensive level of comfort is made possible by high-grade building envelopes and the continuous renewal of air.

The evaluation program is available for homes, multiple dwellings, offices, schools, retail buildings, restaurants, meeting halls, hospitals, industry and depots. Specific energy consumption is used as the main indicator of Minergie®, to quantify the required building quality. The aim of the Standard »Minergie-P®« is to qualify buildings that achieve lower energy consumption than the Minergie® standard. The Minergie and the Minergie-P® Standard are prerequisites for the Minergie ECO® assessment. The ECO® Standard complements Minergie with the categories of health and ecology. The criteria are assessed by addressing questions on different aspects of lighting, noise, ventilation, material, fabrication and deconstruction. The affirmation of the

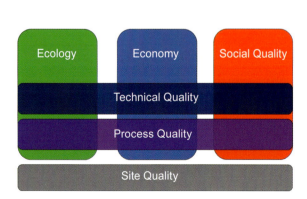

Fig. A16 DGNB Structure

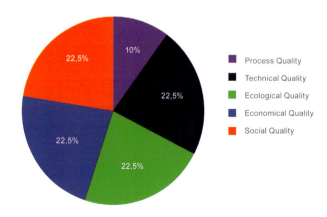

Fig. A17 DGNB Weighting

question must comprise at least 67% of all relevant questions. The assessment includes two different stages: the pre-assessment during the design stage (Fig. A20) and the assessement during the construction stage to verifiy the success of previously planned measures (Fig. A21).

Energy Performance Directive
An important building certification, incorporated by the EU, is the Energy Performance Certificate. They developed the prototype of the federally uniform Energy Performance Certificate. The certificate has been legally compulsory since 2007 as a result of the energy saving regulation, which is a part of the EU building laws. For Germany, Energy Saving Regulation defines maximum values for primary energy demand and the heat loss by transmission for residential and non-residential buildings. The maximum value depends on the type and use of the building. The maximum value for modernization in general lies 40% below the values of new construction. Energy balancing comprises beyond heat loss of transmission heat input of solar radiation, internal heat input, heat loss of distribution, storage and transfer inside the building as well as the energy loss by the energy source through primary production, transformation and transport. »Green Building« is an European program setting target values 25% or 50% below compulsory primary energy demands. Its focus is especially on buildings with non-residential use, like office buildings, schools, swimming pools and industrial buildings.

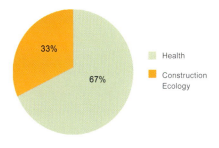

Fig. A20 Minergie ECO® Weighting Pre-Assessment

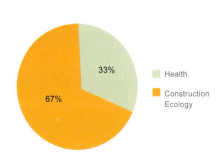

Fig. A21 Minergie ECO® Weighting Construction Stage

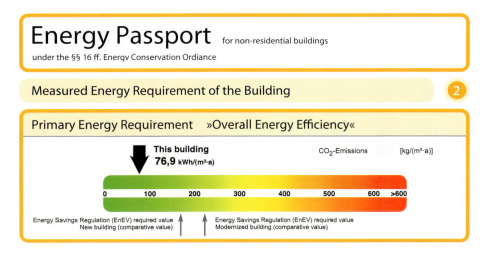

Fig. A22 Energy Passport

An integrated View of Green Buildings – Life Cycle Engineering

Green Buildings are buildings of any usage category that subscribe to the principle of a conscientious handling of natural resources. This means causing as little environmental interference as possible, the use of environmentally-friendly materials that do not constitute a health hazard, indoor solutions that facilitate communication, low energy requirements, renewable energy use, high-quality and longevity as a guideline for construction, and, last but not least, an economical operation. In order to achieve this, an integrated, cross-trade approach is required to allow for an interface-free, or as interface-free as possible, handling of the trades of architecture, support structure, façade, building physics, building technology and energy while taking into account both usage considerations and climatic conditions. To this end, innovative planning and simulation tools are employed, according to standards, during the design and planning stages for Green Buildings. They allow for new concepts since – by means of simulation of thermal, flow and energy behaviour – detailed calculations can be achieved already during the design stage. Attainable comfort levels and energy efficiency can thus be calculated in advance and this means that, already during the design stage, it is possible to achieve best possible security in regards to costs and cost efficiency. Equipped with these kinds of tools, Green Building designers and planners can safely tread new paths where they may develop novel concepts or products.

Aside from an integrated design and work approach, and the development and further development of products and tools, sustainability must be expanded so that the planners are able to gather valuable experience even during the operation of the buildings. This is the only way that a constructive back-flow of information into the building design process can be achieved, something that, until now, does not apply for contemporary building construction. This approach is to be expanded to encompass renaturation, in order to make allowances for the recycling capability of materials used even during the planning stage. In other industrial sectors, this is already required by law but, in the building sector, we are clearly lagging behind in this aspect. On account of consistent and rising environmental stress, however, it is to be expected that sustainability will also be demanded of buildings in the medium-term and thus not-too-distant future.

The path from sequential to integral planning, hence, needs to be developed on the basis of an integral approach to buildings and is to be extended in the direction of a **Life Cycle Engineering** approach. This term stands for integral design and consultation knowledge, which always evaluates a given concept or planning decision under the aspects of its effects on the entire life-cycle of a given building. This long-term evaluation, then, obliges a sustainable handling of all resources.

The authors consider Life Cycle Engineering to be an integral approach, which results in highest possible sustainability levels during construction. It unites positive factors from integral planning and/or design, the manifold possibilities of modern planning and calculation tools, ongoing optimisation processes during operation, and conscientious handling during renaturation of materials. All this results in a Green Building that, despite hampering nature as little as possible, can provide a comfortable living environment to meet the expectations of its inhabitants.

Fig. A23 Life expectancy of contemporary components when seen inside the timeframe of possible rises of global temperature levels

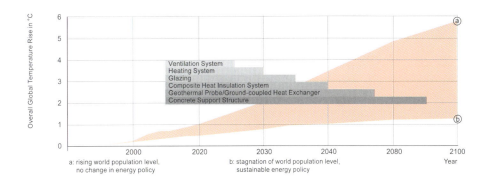

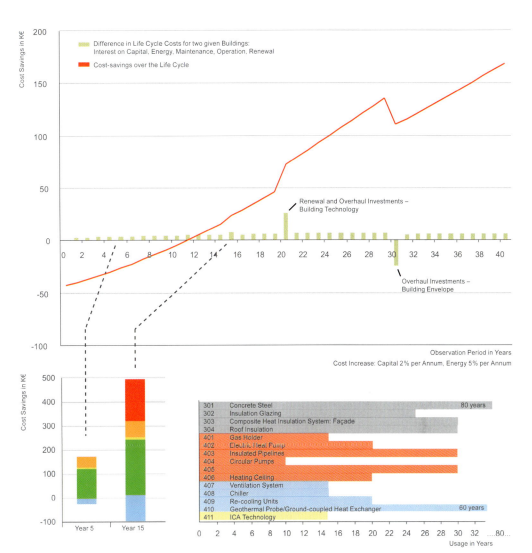

Fig. A24 Cost-savings Green Buildings vs. Standard Buildings – detailed observation over the entire Life Cycle

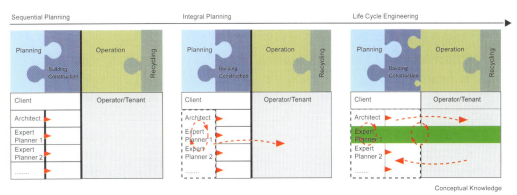

Fig. A25 Development of Planning Methods, from sequential Methodology to Life Cycle Engineering

A

B

Green Building Requirements

B 1

Sustainable Design

Perceived Use defines the Concept

Whether it is an office building, school, recreational facility or industrial building – aside from climatic considerations, the intended use of a given building plays an important role in the design of energy-efficient buildings.

Usage demands are usually related to the desired comfort level and can be expressed in terms of minimum and maximum indoor temperatures, indoor humidity levels or illuminance. Further, there are time-related stipulations for adhering to the desired indoor conditions. Just think of decrease of room temperature at night. In office buildings, this requirement as a rule only exists for reasons of energy conservation, since no energy consumers are present at night. In residential buildings, however, this requirement can be for comfort reasons also. For instance, the kids' room, especially when it is also being used as a playroom, should be warm enough during the day while, at night, it is rather the cooler temperatures that are desirable for sleeping. The building and facility design ought to make this possible without unnecessary energy expense.

Application	Usage Means and Merit	Requirements	Need	Building and Facility Function
Living	Few people, Playing, Eating, Living, Cleaning, Watching Television, Hobbies, Parties	High level of thermal comfort, partially also sufficient if achieved per section (reading corner), different room temperatures (day/night), good air quality	Even thermal balance for radiation and convection, flexible system	Heating surfaces, demand-oriented addition of outdoor air, need-based lighting
Office	Normal amount of people, concentrating on their work	High thermal comfort level, room temperature and humidity kept as comfortable as possible, temperature reduction at night for energy conservation reasons, fast heating-up at the start of operation, very good air quality	Even thermal balance for radiation and convection, flexible system, sufficient outdoor air supply, without draught	Heating and cooling surfaces, sufficient supply of outdoor air, efficient heat recovery, on account of longer operation times: sufficient illumination
School	Many people studying intensely, break, school operation	Very good air quality, high thermal comfort level covering all areas, short-term turn-off during break	High volume of outdoor air flow, short turn-off times, high level of performance reserves for heating-up process	Efficient ventilation concept, optimal heat supply covering all areas, adequate lighting, energy-saving outflow of heat sources
Trade Fairs	High people density, high heat source density, short operation times, flexible use	Good air quality, no draught, good thermal comfort level, high cooling loads that are surface-oriented, fast heating-up process	High and surface-related air flow volume, high and surface related cooling performance levels	Locally arranged layered ventilation so that only the user zone is coordinated, quick heating-up process
Industry	Different density levels for heat and source areas, different activity levels	Good air quality at the work place, high level of thermal comfort depending on degree of activity, locally adaptable	Sufficient outdoor air flow - if possible: without draught, locally adjustable, thermal balance adjustment	Locally arranged layered ventilation for sufficient work place ventilation, layered ventilation also used to efficiently transport source areas out of the populated zones, possibly also localized suctioning of the source areas, heating and cooling surfaces for thermal balance

Tab. B1.1 Details different user applications, according to their merits and requirements

Relationship between Level of Well-Being and healthy Indoor Climate

Buildings, as a kind of third skin, are an important factor for our health and quality of life. A high performance level at work can only be obtained when a high level of well-being exists also. This gives rise to creative processes and ideas and also allows our body to regenerate and heal. The related high performance capacity of man is reflected in both work life and inter-human relationships. Naturally, there are many different influences and sizes of those influences on man's well-being and biorhythm. Some can be physically measured, such as air temperature or indoor noise level. Other factors are of a biological nature, like age and state of health, or ethically different education levels. For thermal comfort levels, it is also important what type of clothing is worn during which activities. Intermediate well-being criteria are also, for instance, whether a colleague in a two-person office is liked or not. There are also other influences that only become noticeable when one is subjected to them over longer periods of time. Among these, for instance, are high-emission materials (for instance, adhesives) and electromagnetic rays that continue to gain ever-increasing influence *(see table B1.2)*.

Subjective thermal comfort sensation of a human being is determined by the heat flows running through his or her body. Heat generated inside the body must be completely emitted to the surrounding environment in order to maintain thermal balance. The human organism is equipped with the ability to maintain a relatively constant inner core temperature level, minor fluctuations included, independent of environmental conditions and during different physical activities. Under harsh climatic conditions, the human regulating mechanism can become overloaded when trying to adapt body temperature to its surrounding environment, resulting in it either sinking or falling. The infrared images, *B1.1* and *B1.2*, show a person during light and then elevated levels of physical activity

Factors	Conditions	
Internal surface temperature	Clothing	Nutrition
Air temperature	Degree of activity	Ethnic influences
Relative humidity	Individual control possibility	Age
Air movement	Adaptation and acclimatization	Sex
Air pressure	Day and annual rhythm	Bodily condition
Air quality	Room occupancy	Building design
Electromagnetic compatibility	Psycho-social factors	
Acoustic influences		
Visual influences		

Tab. B1.2 Influence factors for comfort level sensation indoors

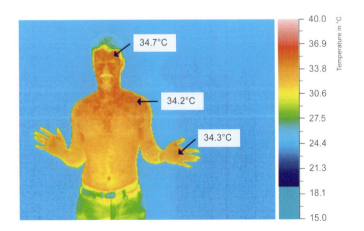

Fig. B1.1 Skin surface temperature of a person during low activity levels and with a surrounding environmental temperature of 26 °C

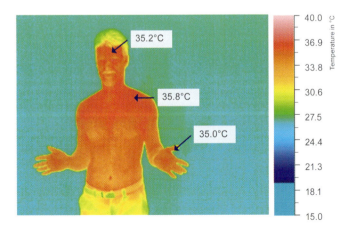

Fig. B1.2 Skin surface temperature of a person during high activity levels and with a surrounding environmental temperature of 26 °C

Relationship between Comfort Level and Performance Ability

and also the corresponding temperature distribution on the skin surface. These differences show that, in both cases, thermal comfort can only be achieved when either the temperature of the surrounding environment or the clothing worn has been chosen according to the situation. Uncomfortable sweating (high level of evaporation) can be largely avoided, for instance, when a skin surface temperature of about 34 °C is not exceeded and the surrounding environmental temperatures range somewhere just below the 26 °C level.

As the infrared images also clearly show, the highest surface temperatures for people are around the head region, the lowest at the point farthest from the heart, the feet region. This allows for the conclusion that thermal comfort can only be obtained whenever surface temperatures of room envelope surfaces are adjusted to human need. A ceiling that is too warm inside a heated room, for instance, prevents heat emission in the head region and quickly leads to headaches. Likewise, cold floors elevate heat loss levels via the feet and increase surface temperature differences of the human body *(Figure B1.3)*.

The work performance level of a person and the required work efficiency level have risen in recent years, especially in industrial nations, on account of global competition. Building owners and tenants have recognized by now that comfortable indoor climate levels are a decisive factor when it comes to upholding productivity levels. If, for instance, a company suffers from an unacceptable indoor climate for 10 % of work time, this leads to a more or less noticeable decrease in work performance levels, spread over 200 hours or 25 days per annum per staff member. For service enterprises with daily rates of 500 to 2000 Euro per day, this means a financial loss of between 12 500 to 50 000 Euro per annum per employee. When this is now applied to the gross floor area (GFA) of a typical office building, an annual loss of 500 to 2000 Euros per square meter GFA results. Compare this to the required costs for the installation and operation of a cooling system, which are, on average, only 15 to 25 Euros per square meter GFA per annum. You will see that this is a relatively small amount by comparison. *Figure B1.4* shows physical and mental performance capacity as it relates to room temperature and was determined by past research. It shows that, from room temperatures of about 25 °C to 26 °C upwards, performance capacity noticeably decreases. From 28 to 29 °C onwards, work efficiency clearly decreases.

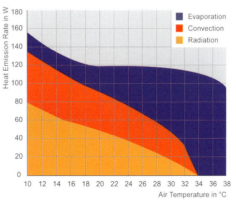

Fig. B1.3 Heat emission rates for a person as it relates to surrounding environmental temperature. From a temperature of 34 °C, the body can exclusively emit heat via evaporation (sweating), since the surface temperature of the human skin is also 34 °C.

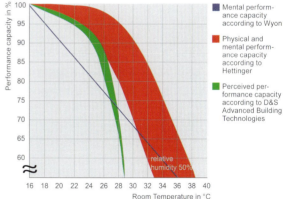

Fig. B1.4 Performance capacity of a person as it relates to room temperature.

Operative Indoor Temperature in Occupied Rooms

Prof. P. O. Fanger of the University of Denmark at Copenhagen, undertook some research into how precisely the level of well-being of people indoors is perceived under different thermal conditions. The basis for the research was the essential influential factors of man on thermal body balance: activity level and type, clothing, air and radiation temperature, air velocity and air humidity levels. Research results were interpreted in such a manner as to allow calculation of prospective and subjective heat sensation, so long as the above-mentioned factors can be determined. They also show that it is impossible to please everyone, on account of the individuality of man. A study with more than 1300 human subjects has shown that at least 5% of the subjects will perceive the indoor climate as being of an uncomfortable level. For heat sensation, according to valid and current international and European standards, three different categories of thermal comfort have been defined: Category A, the highest (very good) has a probability of 6% dissatisfied, the medium category B (good) has 10% dissatisfied and in category C (acceptable) there is a high probability of the presence of about 15% dissatisfied people.

Temperature is the decisive factor for subjective thermal comfort. Depending on mood, duration of stay and locale, the same situation is being perceived differently by the same person. Direct solar radiation on the body, for instance, can be perceived as pleasant when it happens during relaxation in one's own living room. In stress situations, however, the same heat supply source is perceived as uncomfortable. A person perceives temperature as it results from the adjacent air temperatures, individual temperatures of surrounding surfaces and, possibly, direct solar radiation. This temperature is known as operative temperature.

For rooms with a longer duration of stay, the criteria used are the mean operative temperature without direct solar radiation. To simplify matters, this becomes the mean value, resulting from the present surface temperatures of interior surface areas and indoor temperature in general. Surface temperatures are also known as radiation temperatures. The relation between radiation and air temperatures can be changed by means of heat insulating merits of the façade system, building mass present or through the technical facilities that are in use. In *Figures B1.5* and *B1.6*, comfort criteria for winter and summer respectively are shown. The highest degree of satisfaction is achieved at an operative indoor temperature of 22 °C in winter and 25 °C in summer. Depending on outdoor climate, physical material properties of components and the type of technological systems in use, different surfaces inside a room may present different temperatures. Care should be taken that these temperatures do not differ too much from room temperature. Further, they should be as closely matched

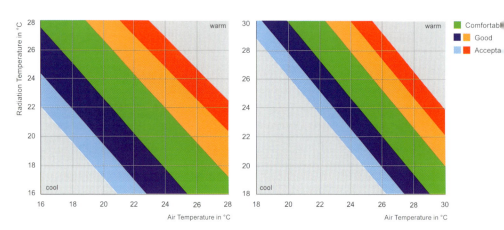

Fig. B1.5 Comfortable room temperature range in winter, with matching clothing (light sweater). High surface temperatures balance cooler outside temperatures.

Fig. B1.6 Comfortable room temperature range in summer, with matching clothing (short-sleeved shirt). Low surface temperatures balance warmer outside temperatures.

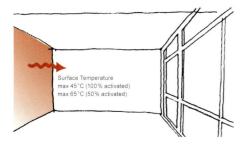

Fig. B1.7 Comfortable temperature range for warm wall surfaces

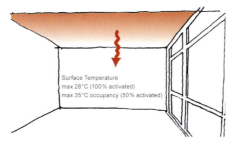

Fig. B1.8 Comfortable temperature range for warm ceiling surfaces. In order to maintain head region temperature at a constant 34 °C, ceiling temperature should be maintained below 35 °C

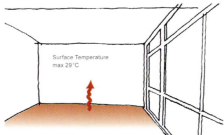

Fig. B1.9 Comfortable temperature range for warm floor surfaces with shoes worn

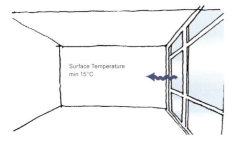

Fig. B1.10 Comfortable temperature range for cool window areas. Uncomfortable radiation asymmetries result when inner surface temperature of the façade is less than 15 °C. This means cold air drop can be avoided

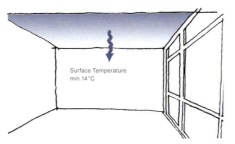

Fig. B1.11 Comfortable temperature range for cool ceilings. High levels of uncomfortable indoor radiation asymmetries can be avoided in summer when surface temperatures of cool ceilings do not exceed 14 °C

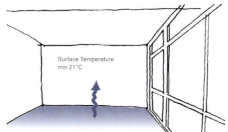

Fig. B1.12 Comfortable temperature range for cool floor surfaces with shoes worn

as possible since thermal comfort levels are influenced especially by local surface temperatures. If this is not the case, we speak of so-called radiation asymmetry. *Figures B1.7 to B1.11* show recommended maximum discrepancies for winter and summer settings, as they were determined by empirical research. During the planning stages, however, these critical values ought not be exploited to the limits. It is much better to keep surface temperature discrepancies small, already from the concept-stage onward, for this saves the later need for having discussions about the validity of empirically defined comfort limits.

The floor is a component with direct human contact. For this reason, it makes sense to define maximum and minimum temperatures within the range of the human comfort level for this particular building component. The values, however, are dependent on such factors as the thermal effusivity of the floor surface and heat insulation characteristics of shoes as well as duration of floor contact *(Figures B1.9 and B1.12)*. For shorter contact duration, like, for instance, at circulation areas, the acceptable temperature range is much larger (ca. 12 to 32 °C) than in steadily populated areas with longer contact duration (ca. 21 to 29 °C).

Aside from the differences in surface temperature, it is also important for local comfort levels that the difference between air temperature in the head region and that in the foot region is kept to a minimum. A cool head and warm feet are no problem in this; however, when there is a higher temperature in the head than foot region, it is perceived as uncomfortable. For sophisticated populated areas, the maximum temperature difference between head and foot region should remain within the 2 K range.

Operative Temperature in Atria

Evaluation criteria for common rooms cannot be applied to atria and halls in anything but a limited manner since these areas are, as a whole, used as circulation areas and only at times also serve as settings for functions. As a guideline for design, in this case, we need rather to look at operative outdoor temperatures in comparison. This depends largely on temperature differences between winter and summer, wind velocity and sunlight influence. In *Figure B1.14*, the magnitude of influence on physically operative temperature (PET) is depicted: aside from the known magnitudes of influence like air temperature, surface temperature and air velocity, in this case there is also a relationship to be taken into account between direct solar radiation and the resulting operative temperature. When designing halls and atria for Green Buildings, hence, it is important to obtain an indoor climate – by the exclusive use of construction means and natural resources – that for most of the year will be experienced as being nicer

Fig. B1.13 Deichtor Center in Hamburg. Architects: BRT Architects Bothe Richter Teherani, Hamburg

than outdoor climate. In winter, operative temperature in the outdoor area – depending on wind speed and sunlight influence – can lie well below the 5 to 10 K range. In *Figure B1.15* the range of possible operative temperatures in the outdoor area is depicted for an outdoor temperature of -5 °C. In comparison, there is the operative temperature for an atrium with different outside climate. Without heating, and in case of a airtight and heat insulating building envelope, an operative temperature of 5 °C is reached. In case of a high level of direct solar radiation, operative temperature inside the atrium can quickly rise to 15 to 20 °C. This is very comfortable for the atrium stay.

For users of adjacent common rooms, however, this can also have a negative effect since direct weather contact and the related temperature fluctuations are only possible in a limited manner.

In summer, for most atria, there is thermal stratification with temperatures rising toward the roof area. In order to maintain inside conditions for the atrium at a level that is still perceived as comfortable, the operative temperature inside the atrium needs to be noticeably below operative temperature in the outdoor area, so that, when entering the atrium, the difference will be consciously felt.

In *Figure B1.16*, operative temperatures for the outside area and the atrium are depicted for different settings and for an outdoor air temperature of 30 °C. Operative temperature under the influence of direct sunlight, and with no wind, is at 45 °C. In the bottom region of the atrium, it reduces by 10 K. If additional means are implemented also, like, for instance, plants or awnings, then operative temperature is reduced by a further 5 K. This approach clarifies that atria are also acceptable to users if they boast higher temperatures than the adjacent common rooms. During the design stage, however, it also needs to be kept in mind that the specified operative temperature levels are really achieved through application of constructional undertakings. If the louvers are too small, or there is awkward glazing quality, this can easily lead to operative temperatures inside the atrium for summer not being too far below those for winter conditions or even exceeding

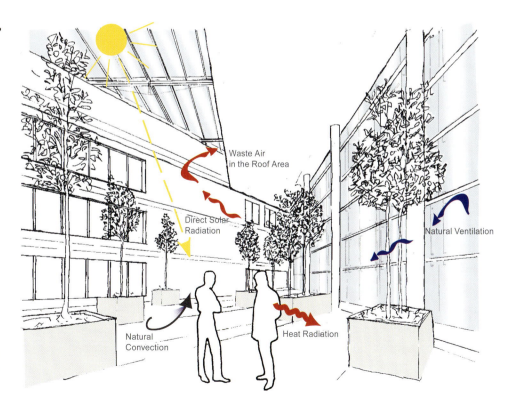

Fig. B1.14 Measurable magnitude of influence of thermal comfort inside atria. Aside from heat exchange through convection and long-wave infrared radiation, we often also need to consider the influence of direct solar radiation on a person and as it relates to operative temperature.

Sustainable Design

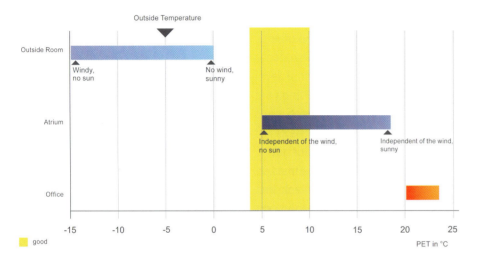

Fig. B1.15 Comfortable winter climate in atria, at outside air temperature of -5°C, in comparison to outside area and heated populated areas (e.g. office)

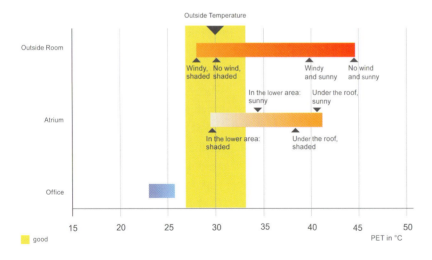

Fig. B1.16 Comfortable summer climate in atria, at outside air temperature of 30°C, in comparison to outside area and cooled populated areas (e.g. office)

them. If this is the case, then the atrium cannot be used properly. Of importance when designing atria is also that work stations located inside the atrium are equipped with a so-called microclimate adhering to thermal requirements for work stations. In order to achieve this, most rooms will need to be designed with a sectioned box equipped with the relevant indoor climate technology.

Indoor Humidity

Humidity levels only have a negligent influence on temperature perception and thermal comfort indoors as long as air temperature is within the usual range, activity levels of the persons inside are fairly low and indoor humidity range lies between 30 and 70%. Therefore, a room with a relative humidity level that is higher by around 10% is perceived as being as warm as temperatures that are 0.3 K higher. For higher indoor temperature and activity levels, humidity influence is larger because people then emit heat primarily through evaporation (sweating). High levels of humidity, however, make this process more difficult or even impossible, meaning that operative temperature rises and discomfort results.

Even at regular indoor temperature levels, a lasting, very low or very high humidity level can negatively influence well-being. Humidity levels below 30% lead to drying out and to mucous irritations of the eyes and airways while humidity levels above 70% can cause mould through condensation. The latter, aside from being hazardous to health, can also damage the building. Whether additional technological measures need to be undertaken, in order to control indoor humidity levels, depends on the frequency of occurrence of indoor humidity levels that are either too high or too low.

Figures B1.17 and B1.18 show the amount of utilization hours that are

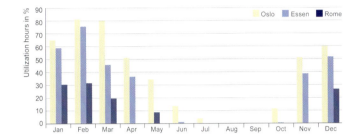

Fig. B1.17 Amount of required utilization hours (Monday to Friday, 8 am to 6 pm) for the humidification of added outside air in order to obtain a relative room humidity level of 35 %

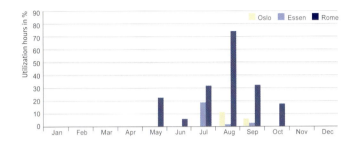

Fig. B1.18 Amount of required utilization hours (Monday to Friday, 8 am to 6 pm) for the dehumidification of added outside air in order to obtain a relative room humidity level of 60 %

required to humidify and dehumidify the air, for different climatic regions across Europe. If requirements for humidity balance are not very high, e.g. relative minimum indoor humidity of more than 35% then, at least for middle European regions, active humidification is not required. In these regions, on average, very dry outside air only occurs for less than 15% of utilization time. However, in very airtight buildings, where air exchange only works through ventilation units, care should be taken to provide for sufficient sources of humidity. This means that passive measures, like humidity recovery through rotation wheels in automatic ventilation units, should be undertaken. In Northern Europe, on the other hand, cold and dry outdoor air occurs much more frequently, so that it could constitute an advantage to humidify indoor air.

In middle and southern Europe, the air is often muggy in summer. If this does not happen often, then there is no need for mechanical dehumidification of rooms. It may be possible, under some circumstances, to store room humidity inside the materials. However, if muggy outside air conditions prevail over a longer period of time, then at least partial dehumidification of the outside air that was added mechanically is to be recommended.

On account of the latent amount, dehumidification requires a large amount of energy. Hence, for Green Buildings, processes are recommended that do not dehumidify through energy-intensive cooling of the outside air but that dry out the air through, for instance, the use of absorptive materials. These processes are being developed jointly with those of solar cooling and, especially for regions with high outside air humidity levels, they offer significant energy and CO_2 saving potential.

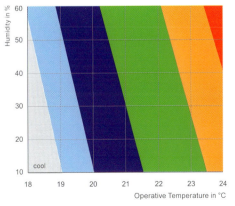

Fig. B1.19 Relative humidity influence on operative indoor temperature in winter

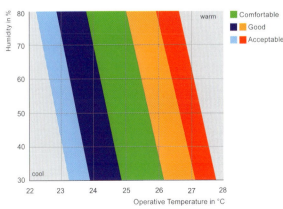

Fig. B1.20 Relative humidity influence on operative indoor temperature in summer

Air Velocity and Draught Risk

Local thermal discomfort is especially perceived when the body's energy turnover is very low. This happens mainly with sitting work. For a higher degree of activity, for instance when walking or undertaking other physical tasks, local heat sensation is not as prominent. In that case, there is much less danger for local discomfort. When judging the influence of draught occurrence on thermal comfort levels, these circumstances always need to be checked out first, before technological or constructional systems are applied.

For sitting people in office, residential, school and conference settings, draught is the most frequent cause for local discomfort. Excessive heat emission and draught can be caused, on one hand, passively through the cold air temperature drop from cool surfaces (e.g. badly insulated walls or tall glass façades). On the other hand, they can be actively caused through mechanical and natural ventilation systems. The effect is the same in both cases, however: a localized cooling of the human body occurs, caused by higher air velocity and the resulting higher amount of heat transfer. Depending on air velocity, fluctuation (turbulence) and air temperature, air movement is being more or less accepted. This means that air movement in winter, with a cold air stream, can become uncomfortable very quickly, while slightly warmer outside air in summer, via vents, can feel very good, indeed, since it actively supports heat emission by the body. Air movements are accepted much better, incidentally, when brought about by the user through manual processes (e.g. opening of windows) or when the user places no demands on a high level of comfort (e.g. atrium).

Figures B1.21 and B1.22 show critical values for three different comfort level categories in order to obtain even and turbulent ventilation. In common rooms, values for the highest category should be adhered to while, in entrance or circulation areas, the lowest category provides a sufficient level of comfort on account of the temporary utilization.

However, constantly populated rooms and the reception area need to be regarded apart, especially since, there, frequent complaints about discomfort ensue. If this happens, then a separate local microclimate needs to be created for these areas.

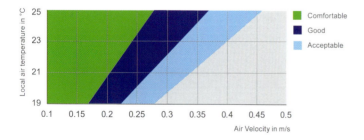

Fig. B1.21 Comfortable air velocities at an even flow level (turbulence degree: 10%), dependent on air temperature

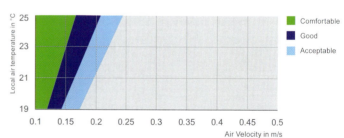

Fig. B1.22 Comfortable air velocities with turbulent flow (turbulence degree: 50%), dependent on air temperature

Clothing and Activity Level

The type of clothing a person wears has a significant influence on his or her thermal well-being. Having said that, a common definition of comfort cannot be achieved without taking into account the situation or mood at the time. If direct solar radiation is perceived as comfortable while at home wearing a warm sweater or when it happens on a nice winter's day, the same operative temperature is perceived as disturbing in a stress situation. The same applies to different degrees of activity: sitting people react much more sensitively to air movement and temperature fluctuations than people who move about a lot. The influence of clothing and activity level on local comfort, therefore, must be taken into account during building design. Requirements differ depending on utilization.

Figure B1.23 shows the influence of clothing on operative indoor temperature in summer. In regular common rooms, for building arrangement, it is assumed that the user will wear long trousers and sleeves in winter. This means that indoor temperature perceived as optimal will be at 22 °C. In summer, an indoor temperature of between 25 °C to 26 °C will only be perceived as optimal when short-sleeved shirts can be worn. For those utilizations where the occupants wear suit and tie year round, indoor temperature needs to be set at 2.5 °C lower, in order to achieve the same comfort level.

For building areas like gyms or atria, where activity level of the occupants is significantly higher than in populated areas with sitting activity, comfort temperatures are significantly lower. Depending on clothing, indoor temperatures for standing activities or light exercise will be perceived as being quite comfortable from 15 to 18 °C *(Figures B1.24 and B1.25)*.

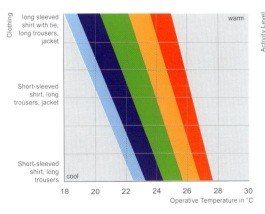

Fig. B1.23 Influence of clothing on thermal comfort during summer

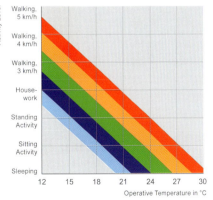

Fig. B1.24 Influence of activity level on thermal comfort when wearing a suit

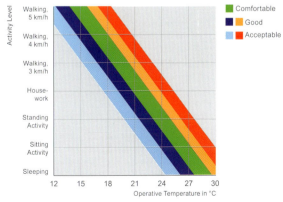

Fig. B1.25 Influence of activity level on thermal comfort when wearing summer sportive clothing (short-sleeved shirt and short pants)

Visual Comfort

The degree of visual comfort is decided by both daylight and artificial lighting levels. Generally, these two lighting means can be evaluated separately, since artificial lighting is provided for those situations when there is no or insufficient daylight present. In Green Buildings, however, there is frequently an interaction between these two light sources and/or their control and regulation. This leads to a soft transition between daytime and evening illumination.

The evaluation of visual comfort in an **artificial lighting** setting is based, in essence, on these factors:
- Degree of illuminance, both horizontally and vertically,
- Evenness of illuminance distribution through the room,
- Freedom from glare for both direct and reflex glare settings
- Direction of light, shading and colour
- Reproduction and light colour

Illuminance course is defined especially through direction of beam and capacity of beam of the lamps used. The advantages of indirect illumination are a high degree of evenness and a low potential for glare effects. Advantages of direct illumination include low electricity consumption, better contrasts and demand-oriented regulation. *Figures B1.26* and *B1.27* show room impression for direct and indirect illumination. For indirect illumination, the only way the same illuminance level of 500 Lux can be achieved, on the work plane, as for direct lighting is by using twice the amount of electricity. While evenness of room illumination is still achieved, it is monotonous, however, on account of missing shades. With exclusively direct illumination of the room, vertical illuminance is so low that is restricts perception of the room. This does not allow for comfortable communication among the occupants and, further, there is uneven illuminance also at the working plane level. It is by the combination of these two lighting means that, most often, both the visual and economic optimum is achieved. Each task requires a different illuminance level. The minimum limit for tasks requiring a certain amount of concentration is 300 Lux. In *Figure B1.28*, minimum illuminance requirements as outlined in the European directives, are summarized. Office readings show that, with daylight illumination,

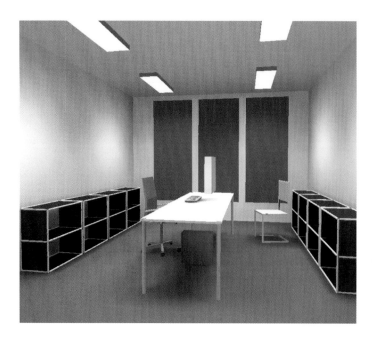

Fig. B1.26 Room presentation with exclusively direct illumination

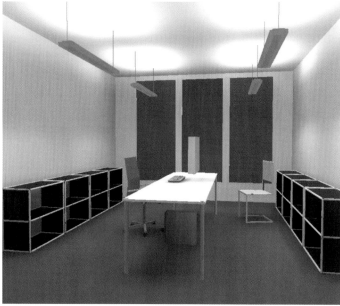

Fig. B1.27 Room presentation with exclusively indirect illumination

illuminance of 300 Lux is perceived as comfortable. Unfortunately, these settings are not included in the standards for artificial lighting, although they have been demonstrated to apply in practice.

The prevailing lighting atmosphere inside the room is determined by the reflection characteristics of surface areas, light colour and colour reproduction of the illuminants used. Contemporary, quality illuminants are capable of setting light moods for the room that are similar to those in daylight. Available illuminant colours are off-white, neutral white and daylight white. Usually it is off-white and neutral white light that is perceived as comfortable by office occupants. Daylight white light, at 500 Lux, is rather perceived as being cold and uncomfortable. Only at much higher illuminance levels does this particular light colour start to be accepted. Colour reproduction merits of a lamp, on the other hand, stand for its ability to reproduce the colours of people and objects as close to life as possible. For a good level of colour reproduction, the illuminants used should have, at the very least, a colour rendering index of $R_a = 80$ or, better still, of $R_a = 90$ and higher.

Evaluation of visual comfort in a daylight setting, independent of artificial lighting used, is much more complex since it is not only the stationary situation that needs to be taken into account but also changes in brightness levels over the course of an entire year. Room shape, immediate vicinity obstruction, and chosen lighting-technological merits of the façade are all decisive factors for determining daylight quality inside a room. All three factors, however, are linked to architectural and thermal requirements, so that an optimum illumination can be achieved only through an integrated approach. Good daylight quality levels are given when:
• Indoor brightness, as opposed to outdoor brightness in winter and summer, reaches certain critical values (Daylight Factor and Sunlight Factor)
• Natural lighting inside the room is evenly distributed
• Indoor brightness changes according to outdoor brightness so that a day-night rhythm can be felt (this especially applies for rooms not oriented to the North, since they receive sunlight for parts of the year)
• An outside relationship can be established with concurrent sufficient solar protection
• Glare, especially as it occurs with work place monitors, can be avoided (near and far field contrasts)
• A large proportion of lighting, during usage hours, stems exclusively from daylight, without the use of electric power or artificial lighting (daylight autonomy).

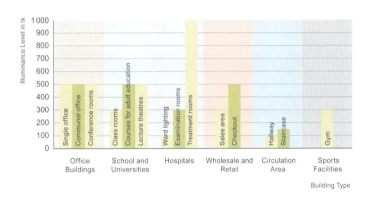

Fig. B1.28 Illuminance levels for different user applications

Correct façade design for maximum use of natural daylight potential present, while also adhering to solar protection considerations and limitation of glare, is one of the most difficult tasks of building design. The reason for this is the high variability factor of sun and sky conditions over the course of the day *(Figure B1.32)*. Horizontal illuminance encompasses readings from 0 to 120 000 Lux, while solar luminance is up to one billion cd/m^2. For rooms with monitor work stations, an illuminance of 300 Lux suffices, window surface luminance should not exceed 1500 cd/m^2. This means that sufficient natural light-

ing is achieved if a mere 0.3% of daylight in summer and 6% in winter can be transported onto the work planes. The degree of difficulty is mainly due to the fact that sky luminance simultaneously needs to be reduced to between 3 and 13%, and solar luminance to 0.0002%.

Daylight and solar factors define daylight quality inside a room. Both values define the relationship of illuminance on the working plane to outdoor brightness. The daylight factor is calculated for an overcast sky, in order to evaluate a given room independent of any solar protective devices or systems. The solar factor, on the other hand, is calculated for a sunny room with solar protection in order to allow evaluation of daylight conditions with solar protection active. This distinction is of importance in order to compare façades, with and without daylighting systems, across the board for any sky condition.

The measurement variable called luminance can be imagined as the level of light perception for the eye. Different luminance levels lead to contrast formation. Contrasts are important so that the eye can even identify objects. Yet, if contrasts are too high, they lead to glare effects that are hard on the human organism. In order to attain a comfortable and sufficient visual level at the monitor, contrasts between working field and near field should not exceed 3:1 and between working field and far field should not be greater than 10:1. The near field runs concentric around the main viewing direction, with a beam angle of 30°C. The far field has twice that opening angle. Research shows that higher contrast levels for both near and far field are acceptable to the user. This can be traced back to the fact that, through the psychologically positive effect of daylight on people, higher luminance levels outside the window are not perceived as bothersome. Contemporary monitors are mainly non-reflecting and boast own luminance levels of between 100 and 400 cd/m^2. *Figures B1.33* and *B1.34* show an evaluation of luminance distribution on that basis, as well as of contrasts for the near and far field.

Contrary to artificial lighting, a high level of evenness for one-sided daylight illumination is much harder to achieve. Illumination equability is defined as the ratio of minimum illuminance level and medium illuminance level of a given area of the room. For artificial lighting, the ratio should be larger than 0.6. For daylight illumination, however, this value can scarcely be achieved, or only

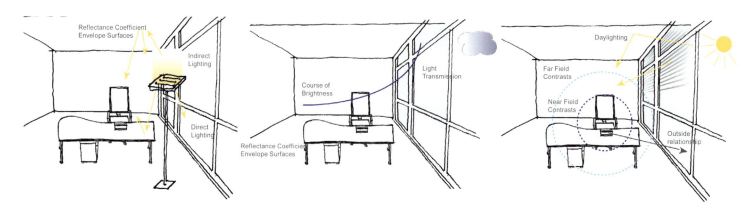

Fig. B1.29 Magnitude of Influence when designing artificial lighting

Fig. B1.30 Magnitude of Influence for daylight design (winter)

Fig. B1.31 Magnitude of Influence for daylight design (summer)

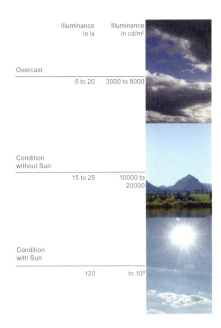

Abb B1.32 Sky illuminance rates and luminance in various settings

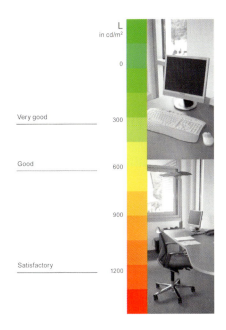

Fig. B1.33 Near field contrasts as luminance distribution for direct work place vicinity (desk)

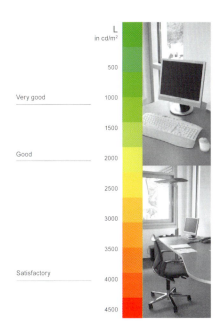

Fig. B1.34 Far field contrasts as luminance distribution for expanded work place environment (windows, inside walls)

by decrease of the overall illuminance level. For this reason, equability evaluations for daylight illumination cannot be based on the same criteria as those for artificial lighting. Rather, practically attainable values need to be consulted. The aim here is to achieve a reading of more than 0.125 for equability. Essential factors of influence in this are downfall size and reflection grades of the materials used indoors.

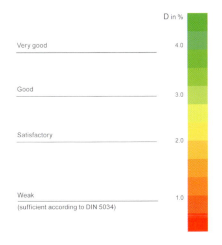

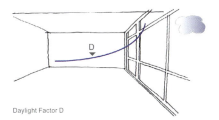

Fig. B1.35 Evaluation of a given room according to daylight factor D. The daylight factor is the ratio of illuminance at 85 cm height to outdoor brightness in overcast sky conditions. Most frequently, the parameter used is the reading at half room depth, maximum of 3m distance from the façade.

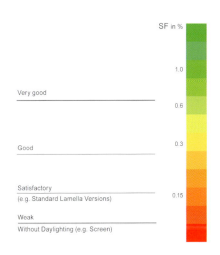

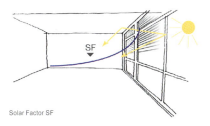

Fig. B1.36 Evaluation of a given room according to solar factor SF. The daylight factor is the ratio of illuminance at 85 cm height to outdoor brightness with sunny façade. The façade is being shaded by the planned solar protective device in order to calculate remaining natural brightness inside the room. Most frequently, the parameter used is the reading at half room depth, maximum of 3m distance from the façade.

Acoustics

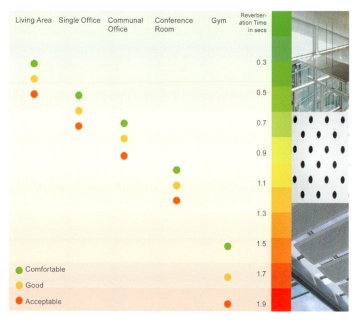

Fig. B1.38 Measuring Values for typical reverberation times for different utilization

We usually only perceive acoustic influences subconsciously. However, physical and mental well-being can sometimes significantly depend on both the amount and type of sound that we are subjected to. Since it is not possible to close one's ears to sound influence, at the very least it is our subconscious that gets strained by noise. It does not necessarily have to be a permanently high noise level to, literally, get on our nerves. Even heavily fluctuating or impulse-oriented sounds can be very damaging. Inside a building, this frequently includes sound-containing information, fragments of conversation from phone calls or staff discussions, neighbours arguing etc. In the design stage, we distinguish between hampering and harming of our health. The limit which defines from when onward there is real danger to our health depends, aside from the loudness of outside noise, also on the amount of time a person is subjected to the noise. As a general rule, noise levels running somewhere around 85 dB(A) are only reached in industrial and recreational settings.

Outside noise sources that influence levels of concentration and work performance, and also hinder our communication or interrupt required rest phases, are primarily traffic-caused. In this, we distinguish between a permanent noise level (road) and a short-term noise level (airplane, train, cars waiting at a traffic light). In case of even sources, constructional countermeasures can be enacted, like, for instance, double façades or noise protection shields. The amount of stress caused by short noise level caps depends on their frequency and, as a rule, is much harder to evaluate. Since, when moderate outdoor temperatures prevail, most people enjoy ventilating their rooms via the windows, one needs to look at outdoor noise influence for two different settings: closed and open windows. For energy considerations also, natural ventilation is to be preferred during those times of the year that allow for it without hampering thermal comfort in any significant manner. This reduces running times of technical systems and thus also energy demand. Depending on window arrangement, different levels of indoor noise are being reached. Decisive is, however, how high the disturbance factor really is and whether it is being accepted inside the room on an ongoing basis. Practice shows that, for the sake of natural ventilation through the windows, occupants are frequently willing to accept higher levels of noise interference from the outside. In contrast, smaller noise levels from ventilation units are not accepted as well. *Figure B1.39* shows an evaluation of indoor noise levels for different applications.

Interior noise sources result from other people, technological systems or other devices. In this, we need to distinguish between the need for total noise elimination or whether there is merely the need to render conversation fragments incomprehensible. For settings with only temporary stay rates (restaurants, department stores), for instance, higher noise levels are accepted than would be the case in bedrooms or meeting rooms. For sectioned rental areas, be it for residential or office applications, a high degree of insulation is required. Within the flat or the entire rent-

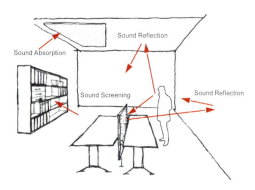

Fig. B1.37 Factors of influence on reverberation time and acoustic comfort

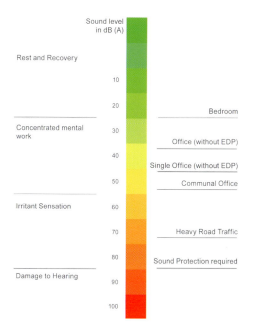
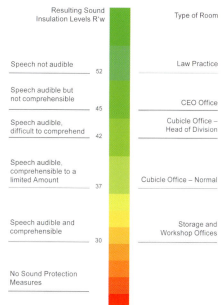
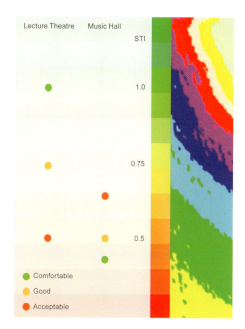

Fig. B1.39 Classification of indoor noise levels, dependent on activity and utilization

Fig. B1.40 Sound insulation classification for dividing walls in office areas according to utilization

Fig. B1.41 Measuring values for speech comprehension for different utilization

al area, there are highly differing quality levels for sound insulation, which depend to a large extent on their area of application *(Figure B1.40)*.

A high level of acoustic comfort is obtained when noise interference for the individual utilization sector is minimized while speech comprehension levels are increased. Demands placed on the materials used for this, however, are of differing natures. For materials like glass, metal and visible concrete, it is becoming increasingly more essential to reduce echo inside rooms through acoustically effective facing framework, like suspended ceilings. This allows for pleasant acoustic indoor conditions but it renders ineffective to a large extent the concrete steel ceiling for thermal storage. Individual optimisation shows clear disadvantages in this for achieving the overall target of a comfortable and energy-efficient building.

Echo time, also called reverberation time, is a measuring value that provides readings for the type of sound inside a room. It is significantly influenced by the sound absorbing or reflecting characteristics of room surface areas and by room volume. Aside from equability of sound distribution, it is the most influential measuring value for evaluating the acoustic merits of a room. For sectors with a high demand for communication, a minimum reverberation time is required in order to allow for concentrated work. On the other hand, when enjoying music, a longer reverberation time is actually of advantage *(Figures B1.37 and B1.38)*. Calculations for small to medium sized rooms usually span a frequency range of 125 to 400 Hz for the respective medium third frequencies.

Complementary to reverberation time calculation it is essential, for complex room geometry or high acoustic demand, also to calculate detailed measuring values for indoor acoustics. These are, as a rule:
• Speech Transmission Index (STI)
• Articulation Loss of Consonants (ALC)
• Equability of noise levels in communal rooms

STI and ALC are measuring values that determine the degree of speech comprehension but also the acoustic completeness of musical performances *(Figure B1.41)*. In order to achieve the same comfort level for all the people inside a concert hall or auditorium, sound level distribution needs to be as even as possible. This can be achieved primarily through the correct choice of room shape and the material characteristics of inner surfaces. With the assistance of modern simulation techniques, tracing sound ray path and thus calculating sound distribution, these criteria can already be evaluated in the early design stages. In this, it is important that – during the design phase – there is a simultaneous optimisation of indoor acoustics and thermal and visual comfort, in order to achieve overall utilization optimisation.

Air Quality

Air is vital to life for human beings. Air quality not only determines our level of well being while at home, at school or at work, in hospital or during recreational activities. It also affects our health. Hence, assuring optimal air quality is an important consideration in building design. Requirements will generally depend on utilization and duration of stay. For very airtight buildings like green buildings or passive houses, on account of lower requirements for heating and cooling, there must be very careful design that cannot fall back on »experience shows« kind of values.

The required air exchange rate is no longer merely dependent on density of occupancy but also on outdoor air quality, the kind of ventilation system used and the type of emitting materials used in the building.

»Bad Air Quality« is often given as a reason by people suffering from a wide array of ailments and complaints, such as eye-nose-airway or occasionally also skin irritations, headaches, tiredness, general feelings of being unwell, vertigo and concentration problems. Among experts, these types of complaints are referred to as Sick-Building-Syndrome.

The causes, however, are manifold and can be found either in psychological factors (stress, work overload) or in physically measurable values. Aside from lack of hygiene for ventilation systems, or insufficient ventilation in general, there are other factors responsible also: high emission levels of health-damaging and stench-intensive materials from the components, uncomfortable indoor climate (temperature too high, humidity level either too low or too high, bothersome and constant noise interference, glare from monitors at work).

Pollutants outside the Rooms

Outdoor air in the vicinity of the building can have a negative effect on indoor air quality, by means of pollutant influx from traffic, heaters, industrial and corporate operations. The most significant pollutants are:

- Suspended matter like dust or particulate matter/fine dust (PM10, diesel soot)
- Gaseous pollutants (carbon monoxide CO, carbon dioxide CO_2, sulphur dioxide SO_2 (E-220), nitrogen oxide Nox and other volatile organic compounds (VOC), e.g. solvents and benzene) and also
- Mould fungi and pollen.

Outdoor air ozone content, as a rule, is not relevant for interior rooms since ozone is a very reactive substance and therefore, its concentration levels drop rapidly once in the room. Natural

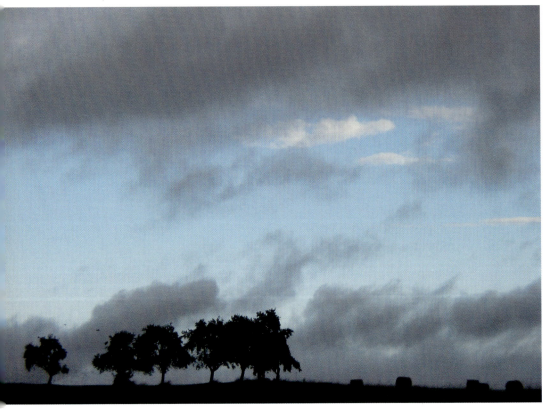

Location Description	Concentration Levels					
	CO_2 ppm	CO mg/m^3	NO_2 µg/m^3	SO_2 µg/m^3	Overall-PM mg/m^3	PM_{10} µg/m^3
Rural Areas, no significant Sources of Emission	350	< 1	5 to 35	< 5	< 0.1	< 20
Small towns	375	1 to 3	15 to 40	5 to 15	0.1 to 0.3	10 to 30
Polluted Downtown Areas	400	2 to 6	30 to 80	10 to 50	0.2 to 1.0	20 to 50

Tab. B1.3 Examples for mean annual concentration levels of outdoor air pollution

or mechanical ventilation decisions, therefore, are primarily based on building location and the prevailing levels of air pollution. Depending on outdoor air quality levels, all the possibilities and limits of air supply in respect to natural ventilation via the windows, filtering and cleaning of outdoor air, must be taken into account during the planning phase (Table B1.3).

Indoor Air Quality

The required amount of air exchange primarily depends on the number of people in the room, what kind of activities they engage in (e.g. cooking) and the kind of emissions present from materials or appliances. Human emissions, also, place a strain on indoor air quality, depending on degree of motion of the persons concerned. Pollution levels can be fairly easily determined by looking at carbon dioxide concentration levels in the air (Figure B1.42). CO_2 concentration has proven to be an excellent indicator, provided that no significant dust-containing air pollutants are present. Oxygen transport rates in the body decrease with rising CO_2 load and this leads from headaches and decline of performance levels all the way to dizziness.

Emissions from Building Components and Furniture

Aside from humans, materials can also contribute to changes in indoor air quality – by means of their own emissions.

This especially applies to building materials used for interior extensions. Building material emissions contribute to raising pollutant levels for indoor air. To secure indoor air quality, therefore, careful choice of ventilation system is important and thus a concept for air pollutant avoidance must be designed prior to deciding on the system to be used. Materials that have a negative application effect on air quality should not even be used in the first place.

In addition to using low-emission or emission-free extension materials and furniture, a well-adjusted and verified cleaning concept needs to be present also. All too often, building cleaning companies make their own decisions as to which cleaning agents are to be used. In this, air quality and ecological aspects usually are not taken into consideration. However, it should be standard to use biodegradable materials only (according to OECD recommendations). High solvent and acid ratios of more than 5% can be avoided also, provided that the products are carefully selected. Likewise, for regular applications, it is possible to completely do without biocides, phosphates and visual brighteners in cleaning agents. Ingredients of cleaning agents proposed by the cleaning companies should be tested, prior to initial use, by a construction biologist. The absence of health-hazardous components needs to be determined and precise dosage instructions defined. This must

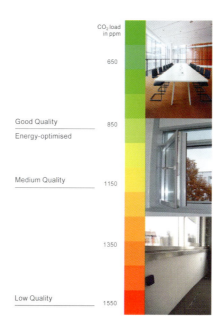

Fig. B1.42 Values for indoor CO_2 concentration

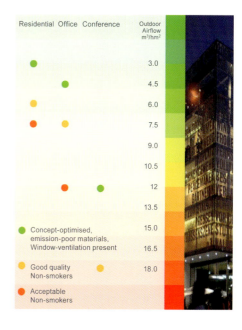

Fig. B1.43 Hygienically required surface-related outdoor airflow rates for different ulilizations

be done so as not to endanger a low-emission environment, on the construction side, through unnecessary influx of harmful substances from the outside.

Legal guidelines and stipulations for indoor emission levels are only few and far between. Only for those work stations dealing with hazardous substances is adherence to maximum allowable concentration (MAC) levels compulsory. This is why a task force consisting of members of the Interior Air Quality Commission of the Federal Environmental Agency, and another task force made up of members of the superior health authority of two nations, worked together for defining two standard values. Standard Value II (RW II) is the critical value of concentration levels leading to health hazards for sensitive persons when they stay inside a room for extended periods of time. Immediate action is essential. RW I is the standard value for concentration levels of those materials that, provably and according to current findings, do not damage health even during life-long exposure. This value, in redevelopment, serves as the target value and readings should stay below it, if possible (Table B1.4).

Since there are a number of organic compounds present in indoor air, and since people also tend to complain of adverse health effects when critical values for the individual compounds have not been exceeded, there are further some guidelines for concentration levels of volatile organic compounds (VOC). In indoor settings with a VOC concentration between 10 and 25 mg/m^3, duration of stay should be brief. For longer-term stays, concentration levels should lie between 1 and 3 mg/m^3 and ought to not be exceeded. Target values for good air quality readings lie below a VOC concentration of 0.3 mg/m^3.

Hygienic Requirement for Air Exchange
In order to keep pollutant load in a room to a minimum, the room needs to be supplied with outside air that is as clean as possible. This can happen through natural ventilation, via the windows, or mechanical means like ventilation systems. If pollution is measured solely on CO_2 concentration levels, a person needs at least 20 m^3 of outdoor air for adherence to the hygienically acceptable critical value of 1500 ppm for CO_2 concentration levels in the room. If harmful substance emissions from building components are taken into account also then, with this level of CO_2 concentration, the air is no longer perceived as being fresh and hygienic. *Figure B1.43* lists surface-related outdoor airflow rates as they are to be recommended if the following criteria apply: sufficient ventilation of the room, low-emission extension materials, and energy-efficient sensible consideration.

Compound	(Maximum Value) RW II (mg/m^3) 1)	(Target Value) RW I (mg/m^3) 2)
Toluol	3	0.3
Nitrogen Oxide	0.35 (1/2 h) 0.06 (1 Week)	–
Carbon Monoxide	60 (1/2 h) 15 (8 h)	6 (1/2 h) 1.5 (8 h)
Pentachlorphenol	1 µg/m^3	0.1 µg/m^3
Methylene Chlorid	2 (24 h)	0.2
Styrene	0.3	0.03
Mercury (metallic Hg-Steam)	0.35 µg/m^3	0.035 µg/m^3

1) Immediate action required when exceeded
2) Redevelopment target value

Tab. B1.4 Reference Values for Pollutant Concentration Levels for Indoor Air

Electromagnetic Compatibility

Ever since his origins, man has been subjected to natural electromagnetic radiation from space: light and heat are forms of very high frequency electromagnetic radiation. Aside from direct sunlight however, naturally occurring radiation levels are rather low. However, through technological advance, additional radiation sources ensued and these impact us humans. *Figure B1.44* shows frequently occurring radiation sources, arranged according to their frequency ranges and their effect on humans. High-frequency radiation, like UV light and X-rays, has an ionising effect and has been proven to harm body cells. Other frequency ranges have proven heat and irritation effects on humans: electromagnetic fields, as they are caused by, for instance, communication media, can be absorbed by the human body. This leads to tissue warming and, depending on intensity and duration, also to health damage like high blood pressure. Further, short- and long-term impact biological effects are as yet not known. There are occasional experiments and studies, however, which show that high levels of electromagnetic radiation in the frequency range of communication media can certainly have a negative impact on sleeping patterns, brain performance capacity, the immune system and also the nervous and cellular systems. For certain, with the rapid rise in communication media presence, electromagnetic load

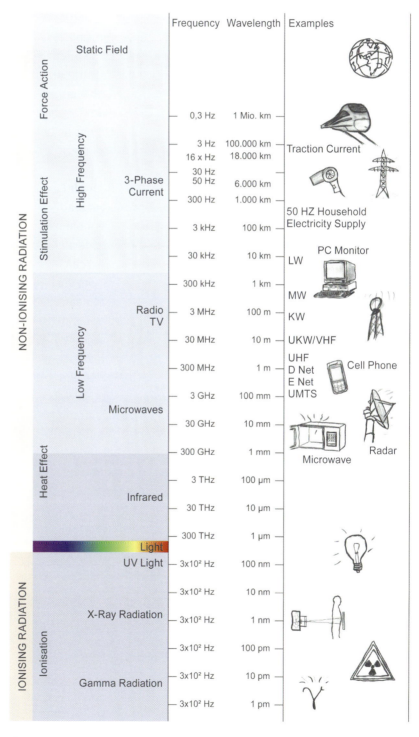

Fig. B1.44 Overview of different radiation sources with their corresponding frequency ranges

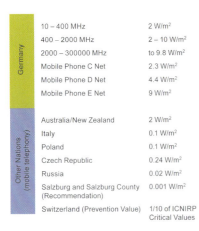

Tab. B1.5 Critical Values for Electromagnetic Radiation in various Nations

on humans has increased also. Until current long-range and short-term studies have been scientifically interpreted, both communal rooms and the buildings themselves should be designed with preventative aspects in mind: existing critical values and recommendations of international expert panels ought to be adhered to, and there should also be a detailed analysis of particularly critical areas with high radiation load.

Essential decisive factors for human tissue warming through electromagnetic radiation are: frequency range, field intensity, distance to emitter and length of exposure. Radiation intensity can be measured with the unit Watt per square meter (W/m^2) whereby output decreases about squarely with distance. This means that an emitter with higher capacity (cell phone antennae) may be less harmful at larger distance than a small emitter in direct body vicinity (cell phone). Radiation load from a cell phone at the ear is 100 times more than at 1 meter distance from the body. International guidelines for mobile telephony critical values have been incorporated in the German Electric Smog Ordinance *(Table B1.5)*. International recommendations, however, when compared to applications in some other nations, are at times between 10 and 100 times higher. The large variability range for critical values only goes to show how widely spread the lack of knowledge about the biological effects of harmful radiation really is.

For Green Buildings, in the interest of prevention, there needs to be a concept – right from the start of the project – for lessening electromagnetic radiation loads. In this, occupant work tools like telephone systems and cell phones ought to be taken into account also. Radiation emission characteristics of a mobile end device are being defined through the Specific Absorption Rate (SAR), the unit of which is Watt per kg of body weight. Operation of a device with a SAR reading of 2W/kg, for instance, and with direct radiation influence on the human body, leads to an elevation of body temperature by about 0.5°C. Currently, scientists are working with research models to investigate penetration depth and SAR distribution levels inside the human body for different age groups. State-of-the-art cell phones are required to remain below a cap SAR value of 2W/kg. However, for prevention agreements, the critical value proposed by the BMU, of 0.6W/kg, can safely be recommended.

Individualized Indoor Climate Control

Humans are individuals who, depending on character, sex, mental and physical condition, have different needs and wants. Buildings serve humans, on one hand as a protective shell against harmful outside weather influence, on the other as a platform to use for running their lives. For Green Buildings, there has to be the right balance between control of the occupant for indoor climate and automatic regulation. Occupants are supposed to feel comfortable but the required comfort level can fluctuate individually with better energy efficiency application.

One option for **indoor temperature** control ought to be present already through heating and cooling, or both – dependent on climate zone. Temperature control is dependent on outside temperature also because it is significant how often it needs to be implemented. This is also a decisive factor for overall economical considerations as they apply to the building.

For Green Buildings, operative indoor temperature will be similar to air temperature, on account of the large amount of winter and summer heat insulation. Further, the difference between day maximum and night maximum indoor temperatures, as a rule, will be no more than 6K – whether it is in winter or summer. Therefore, it suffices completely to arrange zone temperature control for 2 to 3 °C in order to meet individual requirements.

In climate zones with mean annual outdoor temperatures between 0 and 20 °C, with simultaneous moderate outdoor humidity levels, **window ventilation** serves to save electricity, usually required for mechanical ventilation and cooling generation, and to raise thermal comfort levels. Further, there are psychological factors for availing a window to the occupant. Behind closed façades, people tend to feel locked in and restricted in their free actions. A connection to the outside is established not merely through transparency but

through the actual action of opening a window, and then hearing the sounds outside and the feeling the outside air on the skin. Survey among tenants have shown that windows that can be opened are among the most significant criteria when it comes to making a decision on renting a building or parts thereof. This even applies for the King Fahad National Library Project in Riad, Saudi-Arabia. The occupant placed immense emphasis on windows that can be opened, even though outdoor temperatures there only drop below 20°C from December to January during the day.

Transparency, then, and establishing a connection to the outside are both important characteristics for building where the occupants feel comfortable. Daylight, also, has a very positive effect on human well-being. An individually controllable **anti-glare device** is then inevitable, depending on utilization. The **solar protection device** ought to be individually controllable whenever the room becomes very shaded and thus connection to the outside is restricted. However, an additional automatic control is also essential in order to operate the building in an energy-efficient manner, independent of occupant behaviour.

Lighting should be individually controllable, similar to temperature regulation, owing to different human requirements. It needs to be ascertained, however, that artificial lighting automatically goes off when sufficient daylight illumination is present. This is done in order to operate on an energy-efficient level. It needs to be kept in mind that the addition of artificial light, in that case, does not contribute significantly to the elevation of illuminance.

Variable **indoor noise levels** can still be created nowadays through opening and closing of windows. Further, there are concepts that elevate overall quality of indoor noise levels and thus serve to counteract sound propagation even in large rooms. Unfortunately, this is no solution for an individually controllable interior noise level and the resulting speech comprehension. For office buildings, the future path would lead toward controllable high-tech absorbers in order to fully exploit the advantages of open space areas while at the same time matching them to individual demand. There are already absorbers for multi-purpose halls that function either as sound reflecting or sound absorbing, depending on rotational angle, and therefore can adapt to conditions at hand.

Indoor Air Quality (IAQ) ought to be able to be influenced through opening the windows, depending on outdoor temperature and outdoor climate. Only when low-emission extension materials are used and the design has provided for a good level of airflow, can mechanical ventilation rates be reduced to a minimum. Even so, intermittent airing for special situations is important. Effective window ventilation depends on window size and type. Whether window ventilation suffices for air exchange should be evaluated also in case of complex façades, since in most cases it constitutes an important component of the overall concept.

Occupant/User Acceptance
Most buildings serve humans for purposes of working, living, relaxing and recovery. The average person living in an industrial nation spends about 85% of lifetime indoors. Buildings, thus, can be considered as a kind of third skin for humans. They can and may be designed differently according to mentality and origin of the users, yet they should have something in common: adherence to indoor comfort levels within a certain tolerance range and the use of non health-hazardous material. The tolerance range is determined primarily by ethnic and national-geographic differences. Higher summer indoor temperatures are being accepted better in Northern nations than in nations with a warm climate year round, since maximum indoor temperatures occur there simultaneously with the few hot days of the year. On the reverse, this also applies for minimum temperatures: in Northern Europe, temperatures of 20°C are frequently perceived as being too cool in winter while, in Southern nations, indoor temperatures of 18°C – on account of their rare occurrence – are accepted by a large part of

the population. These examples show that any type of comfort, as defined by the planner, can only be regarded as a probable comfort that is acceptable to the majority. There will always be exceptions, based on individual preferences and ethnic considerations.

In Europe, needs placed on indoor comfort levels keep rising and so does energy requirement. This applies especially when the buildings are equipped with high quality climate control systems. Surveys show that buildings that have been optimised from a constructional point of view, and are equipped with less technology, are generally well accepted by their occupants if indoor temperatures do not stray too far from optimum levels. Often, such types of buildings are very economical. Purposely, adherence to optimal indoor conditions is foregone for between 3 to 5% of occupancy time but without disregarding comfort consideration. At the same time, these kinds of buildings allow for better incorporation of regenerative energy resources, which means that energy costs are significantly lower than in buildings that are equipped to a sophisticated level. Via modern simulation techniques, winter and summer indoor conditions can be very accurately predicted in their absoluteness and frequency of occurrence. This means that, nowadays, overall economical solutions can already be defined during the early design stages, so long as a certain tolerance level pre-

Ventilation

In order to assure constant multizone air supply, the ventilation unit is permanently in operation here. Through the air passages, fresh outdoor air flows into the multi-zone nd waste air is suctioned.

Atrium Ventilation

Control of roof and façade flaps is automatic and adapted to climate conditions. Through the flaps, there is fresh air inflow into the atrium. Doors leading to offices and into the cafeteria ought to always remain closed.

Roof and façade flaps can also be operated manually via the control board

Supportive mechanical ventilation for offices

All offices are connected to a central ventilation system. In the interim period, with outdoor temperature ranges of between 5 and 20°C, ventilation in offices that are located in façade vicinity is turned off. During that period, ventilation is via the windows.

Window Ventilation

Each office is equipped with rotating windows and hopper windows that can be opened. During the interim period, windows ought to regularly be opened for ventilation purposes (min. for 10 minutes every 2 hours). During winter and summer, the ventilation system is responsible.

Solar Protection

Solar protection (outside shutter) is controlled automatically. It can, however, also be adjusted manually via a switch located beneath the window.

From April through October, solar protection automatically drops down during periods of direct solar radiation

From November through March, solar protection does not drop down automatically once outdoor temperature falls below 15°C. This allows for heat loss avoidance inside the building

In winter, during daytime, the solar protection device should only be brought down if there is a glare sensation because, during those months, every single sunray can be used to conserve energy otherwise expended for heating.

Thermal Comfort

Heating and Cooling Ceiling
Meeting rooms or being heated and/or cooled via a heating and/or cooling ceiling. Settings for heating and cooling can be regulated via a control located in the respective rooms. When leaving the meeting rooms, the regulators should be set to 0 and windows ought to be closed.

Marginal Strip Activation (MSA)

Offices always have a temperate ceiling and a temperate floor as well as marginal strip activation for individual control

With a specially installed switch, marginal strip activation can be individually set. Cooling should only be activated when window ventilation fails to provide sufficient cooling. When MSA is active, there should only be interim ventilation of about 5 to 10 minutes every 2 hours. MSA should be off when there is no occupancy for more than three hours and the regulator ought to be set to 0.

Fig. B1.45 Occupants' brochure for the D&S Advanced Building Technologies building in Stuttgart

vails for indoor temperature frequency of occurrence. Our experience shows that the following requirements need to be met, however:
- The rooms have the aforementioned control options and window ventilation
- Slightly higher indoor temperatures only occur in case of very high outdoor temperatures
- Clothing can be adapted to climatic conditions. This means, for instance, that it is possible for the occupants to wear summer clothing with short-sleeved shirts.

If these prerequisites are met, then, additionally, a maximum 28°C indoor temperature needs to be adhered to, at all times, for occupied rooms. Otherwise, performance capacity tends to drop too low. Within this framework, it is quite possible to achieve a higher degree of occupant satisfaction than in buildings that have consistently lower indoor temperatures in summer.

B 2

Conscientious Handling of Resources

Energy Benchmarks as Target Values for Design

Among the essential requirements for Green Buildings is a conscientious handling of available resources. While there is careful handling of the humans that occupy the building – through creating a high indoor comfort level and through using non health-hazardous materials – care also needs to be taken that energy and water requirements are minimised. At first glance, it seems to be a contradiction to expect elevated levels of indoor comfort while at the same time wishing to decrease energy requirements. However, through the concept of Green Buildings, this can actually be achieved.

Man needs targets in order to get somewhere. Energy Benchmarks can be used as target values during the design stage, as long as they are both realistic and sophisticated at the same time. The energy benchmark is defined on the basis of mean climate for a given location, mean typical utilization and the expected operation manner of the technological units. It is most often expressed as net surface related energy requirement value. With the implementation of the new energy saving ordinance in Germany and Europe, for the first time, energy passes are allocated to each building. The energy pass lists energy requirements for individual buildings, allowing even laypersons to compare them to each other. This process, of energy-based evaluation of buildings, is identical to that used by the automotive industry. There, mean fuel requirements are listed for specific referential conditions of route and driver behaviour. When comparing buildings to each other, care must be taken to only consider buildings of the same utilization sector and then, within that sector, the same indoor comfort levels. These two factors should also be considered when defining target values, since – if we are to stay with the automotive industry for a while longer – a middle-class vehicle with less driving power and without air conditioning will require less fuel than a premium class car.

Requirement Minimisation, Energy Efficiency and Regenerative Energy Supply

Three essential criteria for creating energy-friendly buildings with a high comfort level: 1) minimising building energy requirements through constructional measures 2) increasing energy efficiency for technical systems 3) use of regenerative energy sources for the generation of heat, cooling and electricity for the buildings. Ever since the Freiburg Zero Energy House was presented in the nineties (Zero energy, because no fossil energy like gas or electricity is provided from the outside), it has become clear that, even in Germany, it is possible to equip residential buildings with a high degree of comfort through efficient use of available environmental energy resources. Since property is very often used as an investment, it makes sense for Green Buildings to be evaluated over their entire life cycle. Minimising building energy requirements means, in essence, to adapt to utilization and climate both the building shape and the building envelope. Energy requirement, here, is determined by orientation and shape, by the quality of building materials and also by the amount and type of transparent building components and shading systems used. Energy efficiency not only encompasses the need to optimise every single system or installation inside the building but also the need to shape the overall system so the building becomes one efficient unit.

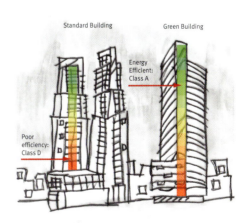

Fig. B2.1 Classification of non-residential buildings according to the energy pass

Fossils and Regenerative Energy Resources

Coal, oil and gas are our most important raw materials – they are the so-called primary energy sources. The turbulences experienced by the energy market over the last few years have shown that, even for economical reasons, a certain independence from traditional energy sources needs to be achieved for today's new buildings and redevelopment projects.

Regenerative, or renewable, energy sources are divided up into two sectors: natural energy sources and regenerative raw materials. Natural energy sources can be found anywhere and they differ in their performance capacity and available amounts, according to the region where they occur: sun, wind, earth heat, water, and outdoor air. Regenerative raw materials, on the other hand, are from fauna and flora (biomass) and, during growth, draw the same amount of greenhouse-endangering carbon dioxide out of the atmosphere as they later emit during incineration and energy generation. The atmosphere is not loaded with further carbon dioxide during this form of energy generation and, therefore, no increase of greenhouse effect results. Only that energy which is used for manufacture and transport of the materials to the incineration facility is not yet considered to be regenerative primary energy. Renewable resources are most often locally available materials like wood (pellets, wood shavings), energetic plants (grains and feed plants) and biogas. This means that energy-intensive transportation routes are kept to a minimum and dependency on imported raw materials, like oil or gas, decreases.

The advantages of renewable energy resources are almost no environmental stress and low energy costs. However, there are disadvantages also: small or fluctuating output levels mean that large areas are required for energy generation and storage and this leads to higher initial investment costs. *Figures B2.2* to *B2.4* show output density, energy yield and heating values for different energy sources. Only very few renewable energy sources can match output levels of the fossil ones. In order still to be able to use renewable energy sources in an efficient and economical manner, the following needs to be adhered to:

• Energy requirements must be minimised
• Operating temperatures for heating and cooling must not differ too greatly from indoor temperatures in order to incorporate natural energy resources more efficiently. This means flow temperatures of 16 to 35 °C for heating and cooling.
• The ratio of overall property size to building volume must be balanced in order to ascertain efficient use of both solar power and earth geothermal heat. A skyscraper, for instance, does not offer good conditions for natural ventilation, geothermal usage or solar energy usage through photovoltaic panels on the roof.

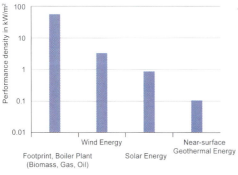

Fig. B2.2 Power Density of various Energy sources

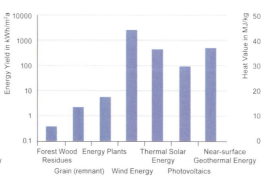

Fig. B2.3 Energy Yield of various Energy sources

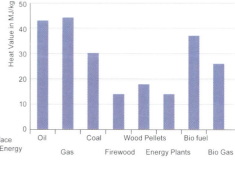

Fig. B2.4 Heat Values of various Energy sources

Today's Energy Benchmark – Primary Energy Demand for Indoor Climate Conditioning

When evaluating buildings and the systems used therein from an energy point of view, energy flow rates are taken into account for heating, cooling, illumination and heating of drinking water. Herein, we distinguish between **energy requirement and energy demand**. Energy requirement is the amount of energy needed in order to meet requirements for indoor temperature, indoor humidity, illuminance etc. Energy demand is the amount of energy the systems present must use in order to meet energy requirements. The type of energy demand required for benefits delivery, distribution and energy generation is known as energy demand for generation or final energy demand. Energy demand defines the amount of energy that is used from energy supply companies (oil, gas, wood, electricity etc.) Related to final energy demand, we also have primary energy demand, the so-called pre-chain for primary energy sources used: exploration, extraction, harvesting, transport and conversion – basically, the entire path to the generating system inside the building. Each primary energy source is allocated a so-called primary energy factor that tracks all energy-relevant demand from initial harvesting to the building limits. It is different for each nation since, for instance, efforts for gas transport in Russia are much less than, let's say, Germany where all gas needs to be imported. Further, the primary energy factor takes into account those emissions that are primarily responsible for the greenhouse effect. A non-renewable energy source like gas, for instance, receives a less favourable rating than, let's say, renewable resources like energy plants or wood. However, here in Germany, wood requires the application of differential energy factors since we distinguish between wood that is delivered, for instance, as relatively untreated wood shavings or as pressed pellets.

The primary energy factor for electricity is also dependent on the type of energy generation in each nation. In France, for instance, nuclear power plants dominate the scene whereas in Sweden, for instance, it is hydropower stations. Therefore, primary energy factor is lower for these nations since CO_2 emission for this type of energy generation is fairly low.

In Germany, there are pure power plants for energy generation where 30 to 35% of electricity is generated from primary energy sources like coal, oil or gas. Since an ever-increasing number of large power plants are being changed over to trigeneration, the primary energy factor in Germany for electricity can be expected to decrease. In order to achieve a unified evaluation system for buildings in Europe, the same primary energy factors are used throughout: for heat 1.1 and for electricity 2.7.

Primary energy demand consists of the individual demand for heating, heated drinking water, cooling, ventilation and illumination. The target value for primary energy demand of Green Buildings in Central Europe is 65 kWh/m² for residential buildings and 100 kWh/m² for office buildings. On account of their higher occupancy density and utilization time, hotels and department stores have higher target values, of up to 180 kWh/m². All of these values are approximately half of what is legally required for not fully temperature-controlled new buildings in Central Europe. Inside other climatic regions in Europe, fluctuations from these values can be up to 30% *(see also: Figure B2.5)*.

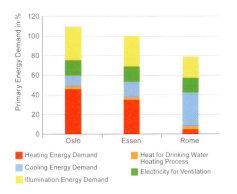

Fig. B2.5 Comparison: Primary Energy Demand for temperature control units for different locations across Europe

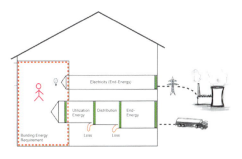

Fig. B2.6 Energy Supply Chain for calculating Primary Energy Factor

Heating Energy Demand

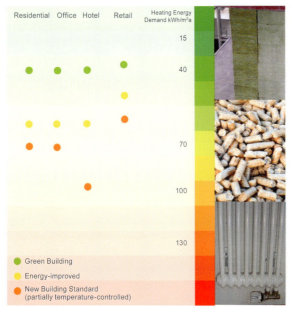

Fig. B2.7 Parameters for Heating Energy Demand in Central Europe, for different utilizations

Until the Nineties of last century, heating energy demand was the decisive factor for building energy in Northern and Central Europe, whether in residential or non-residential buildings. With the respective heat insulation ordinances for new buildings and redevelopment projects, requirements could be decreased significantly through elevated levels of heat insulation, higher building density and better heat recovery through ventilation systems *(see Figure B2.8)*. Today's low energy buildings only present with about 20 to 30% of heating energy requirements when compared to existing buildings from the 70ties *(Figure B2.9)*.

Aside from the original function of the heat-insulated envelope, which is to reduce heat emission to the outside, an elevated insulation level also leads to increased thermal comfort. Through low inlet heat movement in winter, and in summer the reverse, indoor surface area temperatures and indoor air temperatures draw increasingly closer together. This results in a comfortable, homogenous distribution of indoor temperature. With the original, passive house idea, the approach was taken so far as to completely forego the use of heaters and, instead, to apply mechanical ventilation systems to supply the rooms with the required amount of residual heat. This means that there is no heat radiation, although heat radiation is being perceived as very comfortable. A combination of optimum heat insulation, as can be found in a passive house, complemented by heat-radiation emitting components, and all of this with overall comparable energy efficiency to a passive house: and you would have an ideal solution!

For regions with a lastingly cold and dry climate, it is essential to humidify outside air so that it meets health criteria. During the humidification process, the air cools down, making night heating necessary. For prevailing climatic conditions in Central Europe, however,

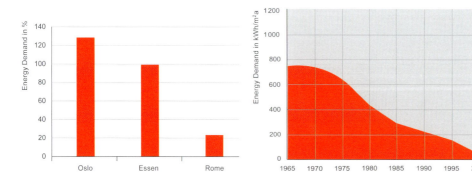

Fig. B2.8 Comparison readings for Heating Energy Demand at different locations in Europe

Fig. B2.9 History of Heating Energy Demand for offices in Germany

Energy Demand for Water Heating

a general humidification of inlet outdoor air is not required. Nonetheless, from a minimum indoor humidity level of 35%, active humidification is to be recommended. Heat energy demand for air humidification, with Northern and Central European climatic conditions, constitutes some 10 to 30% of overall heat demand. On account of the high energy demand for humidification, currently new materials are being tested that would adjust indoor humidity levels on a natural basis.

Figure B2.7 shows the heating energy demand coefficient for different utilizations. For energy-efficient buildings located in Central Europe, it is assumed that at least a part of heat generation can be achieved through the use of renewable energy sources. If indoor temperature rises by 1 Kelvin, then heating energy requirement rises, dependent on heat insulation and ventilation systems, by anything from 5 to 15%. For the different climate zones in Central Europe, there are differences of plus or minus 10%. Southern Europe, for instance, especially when good insulation protection is available, only shows low heating energy requirement, which is for air-conditioning. In contrast, heating energy requirement in Northern Europe is about 50% higher than in Middle Europe.

The greatest proportion of heat energy in existing residential and non-residential buildings is being used for indoor heating. While heating energy requirement declines in new buildings and redevelopment projects on account of improved construction-related heat insulation and energy-efficient system technology, energy requirement for the heating of drinking water remains unaffected. For a building insulated according to current standard, energy demand for heating of drinking water is only about 20% of total heating energy demand. In this, circulation loss accounts for a high proportion of about 30 to 40%. In office buildings, requirement for heated drinking water is comparably low, so that the proportion is much less at only 5% *(Figure B2.10)*.

For residential or hotel buildings with highly insulated building envelopes, energy demand for heated drinking water can be the dominating factor. For such utilizations, energy demand ought not be neglected, especially since the required temperature level of 60°C is often significantly higher than operating temperatures for the heating system, on account of the required legionella safeguard (for instance: floor heating at 35 to 40°C). Measurements to decrease demand are, hence, to be recommended for implementation. For office buildings, many of the essential sections can do completely without heated drinking water as a general rule. For residential and hotel buildings, there are various options on offer, such as solar-thermal systems, water-saving fittings, waste heat use from cooling processes and water circulation with time and temperature control.

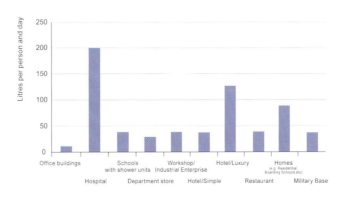

Fig. B2.10 Requirements for Heating of Drinking Water per utilization sector

Cooling Energy Demand

Over the past 10 to 20 years, cooling energy demand in Germany, and in Europe as a whole, has risen. There are primarily four reasons responsible for this development. Firstly, technical equipment, especially in office and administration buildings, tends to give off heat through the connected EDP devices and that heat needs to then be dissipated with the assistance of active or passive cooling measures. Secondly, there have been great improvements in glazing regarding heat protection and daylight influx, something which grants the architect greater scope for using glass in his design. There is, therefore, a trend toward glass architecture, which comes with numerous advantages regarding transparency and daylight utilization but at the same time, unfortunately, due to higher heat gain from solar radiation, also comes with a greater cooling load requirement. Thirdly, then, we have already advanced as a whole toward the construction of buildings that are much better insulated and increasingly more airtight. The building envelope, therefore, behaves like a thermos flask: inside, it stays warm, regardless of outdoor temperatures. For buildings located in Germany and Central Europe, this means that natural cooling processes during summer may be hampered but, in return, there is less energy demand for heating in winter. Fourth but not least, our expectations regarding thermal comfort have risen considerably. It

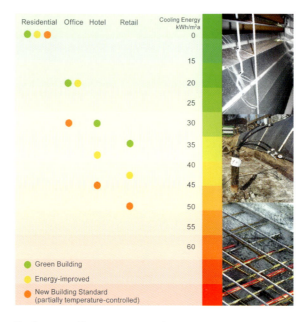

Fig. B2.11 Cooling Energy Demand coefficient for different utilizations, Central Europe

is very difficult when, coming out of an air-conditioned car, train or airplane, one is then expected to enter a building for shopping, work or relaxation and stay there for a longer period of time if this building is not air-conditioned. Finally, we have now come to recognize that performance output increases when comfortable climatic conditions prevail indoors.

Despite of the obvious disadvantages associated with increased insulation for Central European climate zones, these are outweighed by the advantages. Through the airtight and higher insulated building envelope, there is a better chance for improved indoor comfort and also for less primary energy utilization. As we all know, a thermos flask is also capable of keeping fluids cool, over long periods of time, during hot summer days. If we apply this concept to our buildings, then it means that a highly insulated building envelope causes heat to remain outdoors during hot summer periods, so long as we keep the windows closed. For Cen-

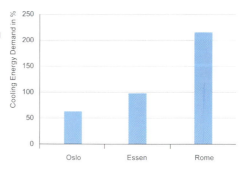

Fig. B2.12 Comparative study of Cooling Energy Demand for different locations in Europe

Electricity Demand for Air Transport

tral Europe, cooling requirements can easily be met via natural energy resources so that there does not need to be any significant primary energy demand.

Figure B2.11 shows cooling energy demand coefficients for different utilizations. For the living area, we do not presume significant cooling energy requirement since, for one, through active night cooling, building mass can be activated. Further, if indoor temperatures are higher for only a brief amount of time, this can easily be tolerated. For non-residential buildings, it is unfortunately often not even possible to undertake manual night ventilation merely through opening the windows on account of the climate and security protection device that is no longer present. For Central Europe, we assume for energy-efficient buildings that cooling energy requirement can be reduced to a minimum through accessing natural energy sources. If room temperature drops by 1°C, then cooling energy requirement rises by ca. 10%. Within the different Central European climate zones, there are differences ranging between plus-minus 15%. While Northern Europe, so long as good solar protection devices are available, only shows significant cooling energy requirement when there are huge inside heat sources, cooling energy requirement for Southern Europe is about thrice as high as for Central Europe when there is a mean temperature of above 15°C.

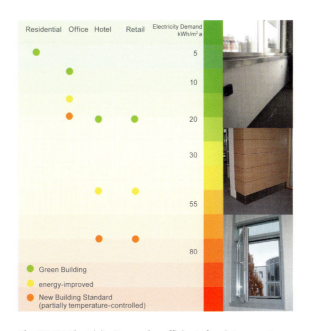

Fig. B2.13 Electricity Demand coefficients for air transport for different utilizations

Air Quality inside buildings is secured via ventilation. The simplest means of ventilation is through opening a window. Natural forces, such as wind, pressure and temperature differences, cause different volume air streams dependent on window size. Natural ventilation always takes precedence, as long as outdoor air temperature and quality, as well as outdoor noise level and utilization, allow for it. Otherwise, mechanical ventilation needs to be used that is capable of filtering and conditioning the outside air when it hits the building (air-conditioning). Further, suitable systems should then be used for heat recovery from the return air. This results in a decrease of both heating and cooling energy requirements.

In order to allow for the desired amounts of air to enter the room in a conditioned manner, electric power is needed for the air transport. The amount is dependent on:
• Outside air exchange rate
• Utilization, and the related air conditioning settings of the AHU
• Size and length of duct system (high air velocities cause greater pressure loss)
• Outdoor climate (partial turn-off in favour of natural ventilation)
• Type of ventilation system used (central, semi-centralized or de-centralized ventilation)

The exclusive use of air for heating and

Electricity Demand for Artificial Lighting

cooling purposes constitutes some decisive disadvantages in comparison to water-based systems since water, with equal transport energy, can transport a much larger heat volume. For this reason, energy-efficient buildings generally restrict air transport exclusively to the amount of outside air required for hygiene reasons, which depends on air quality, occupant density and building materials emissions.

If local outside noise conditions allow, in Central Europe, for the greatest time of the year, there is no need for mechanical ventilation for rooms with normal occupancy rates without a negative influence on thermal indoor comfort. A large proportion of electricity can thus be saved, provided that both building structure and building volume allow for sufficient ventilation control, as needs to be the case also for ventilation arrangement. Since window ventilation is quite simple, it ought to become a given for Green Buildings in Europe.

Figure B2.13 shows electricity demand coefficients for air transport for different utilizations.

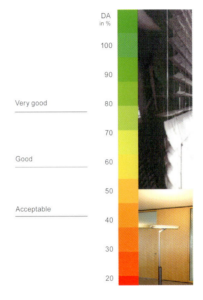

Fig. B2.14 Parameters for daylight autonomy (DA) for a typical office in Central Europe

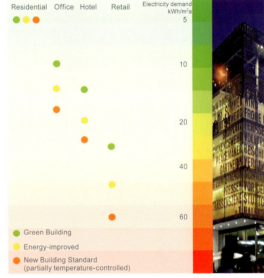

Fig. B2.15 Parameters for Electricity Demand for artificial lighting in Central Europe for different utilizations

Electricity demand for artificial lighting is dependent on the artificial lighting concept and on daylight conditions. When calculating expected artificial lighting requirement, the following needs to be taken into account: shading of the room through adjacent buildings, control design for the solar protective device and daylight conditions inside the room.

Illumination in flats is occupant-dependent and, these days, only play a minor role for overall electricity consumption. In office settings, however, artificial lighting constitutes a significant part of primary energy demand. If two significant criteria are kept in mind, then it is possible to achieve artificial illumination for office buildings with minimal electricity demand. The first of these criteria: short operation times for artificial lighting result in less electricity demand. Daylight autonomy stands for that proportion of operation time during which the room can be illuminated exclusively by daylight. Depending on illumination degree, the time under consideration and climatic conditions, different readings are obtained. Very small electricity demand results for office buildings in Central Europe when artificial lighting is not required for at least 60% of operation times (Monday through Friday, 8 am to 6 pm, nominal lighting strength of 500 lx). Favourable readings for elec-

Future Energy Benchmark – Primary Energy Demand over the Life Cycle of a Building

tricity demand are obtained when the daylight and sunlight factors outlined in *Figure B1.35 (see chapter B1)* can be achieved at the »very good« level.

The second of the essential criteria for a more efficient approach to artificial lighting operation is a low electricity connected load for the lighting. This can be achieved through the utilization of highly effective illuminants and when a direct-indirect lighting concept applies. If these two criteria are being met, it is possible to achieve low electricity demand readings for office lighting. Further reduction can be achieved with a demand-oriented controls system: artificial lighting is not handled manually in a layered manner but, rather, artificial lighting is automatically dimmed to the required illumination level via regulating devices and then lowered or increased via presence-sensing devices. *Figure B2.15* shows guide values for electricity demand for artificial lighting in office buildings.

For new buildings and redevelopment projects, primary energy demand for any systems used for conditioning a room must, depending on utilization, stay below certain critical values. Implementation of these Europe-wide requirements was a big step in the right direction, for once, but it does not suffice. Energy-based evaluation of energy-efficient and sustainable buildings must take into account all energy flows including, for instance, energy demand for the manufacture, renewal and maintenance of building materials as well as electricity demand for furnishings supplied by the occupant. Only if there are additional stipulations, for restricting total energy flow, can all who are part of the construction process be forced into treading new paths and therefore having to provide innovative solutions. Today's business plans for big companies frequently include life cycle costs as a management instrument. Shortsighted action can be avoided if all expected expenses are being considered from the start. The same should apply for primary energy demand in the building industry. Here, too, the entire life cycle needs to be looked at. What good is it to have the best insulation materials if, for their manufacture, we need many times over the energy that they eventually save? Energy sector developments over recent years have shown that energy-efficient products can also be supplied within an economical frame. All that is needed is for the market to demand them.

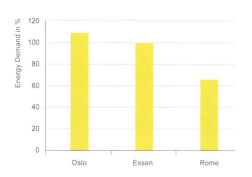

Fig. B2.16 Comparison of Electricity Demand for artificial lighting for different locations in Europe

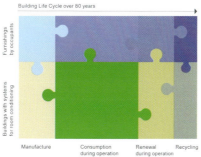

Fig. B2.17 Spread of primary energy demand over the life cycle of a building. In future, Europe will only regulate energy demand for systems needed for room conditioning

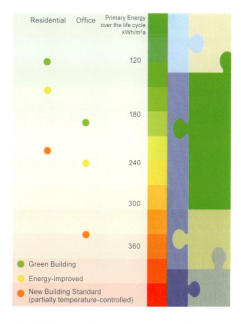

Fig. B2.18 Approximate parameters for Primary Energy Demand over the life cycle of a building in Central Europe for different utilizations

Cumulative Primary Energy Demand of Building Materials

Building materials, from the time they are supplied all the way through their operation, have an influence on total energy demand of a building. During operation, the building materials emit substances, something that, for instance, can lead to increased ventilation demand. Further, they need to be cleaned on a regular basis and also require service-maintenance and overhaul measures, which also place strain on energy demand. At the stage of manufacture and transport of building materials, already, energy is expended, meaning that the energy demand of a building can be significantly influenced by its construction and the types of materials used. Once the building has arrived at the end of its life cycle, there are further expenditures for demolition and disposal. How high these values will be in the end is determined largely by the recycling ability of the materials originally used. Considered over the entire life cycle of a building, we speak of the primary energy demand of building materials *(Figure B2.17)*.

As a rule, the proportion taken up by cumulative energy demand is less than 10% for contemporary standard buildings and, therefore, does not constitute the highest priority for energy conservation. It is obvious, however, that for those buildings where primary energy demand actually decreases on an annual basis, the proportion of energy amount set aside for building materials will subsequently rise. This, in turn, means that it will become an increasingly important factor in evaluating total energy demand in future. *Figure B2.19* shows the spread of total primary energy consumption for an office building. On account of low-energy construction and the use of earth heat, the proportion of cumulative energy demand, as related to total primary energy demand (without furnishings by the occupant), is around 25%. This is a significantly higher proportion than applies to standard buildings. It shows that it is imperative also to place higher expectations on energy efficiency for this particular area of a building and focus on the development of new products. Further, it also means that products assisting in the active use of renewable energy resources – like wind, solar energy and earth heat – are increasingly facing scrutiny. Amortisation time, hence, as it relates to energy demand, thus becomes a decisive factor in making the choice for a particular product. Photovoltaic systems, depending on the producer, have amortisation times of between 2 and 8 years, at optimum southern orientation here in Central Europe. This particular characteristic is not yet taken into account at the time of purchase of a system, although it should be.

Optimising cumulative energy demand can either be done by selecting building materials with a large life span or by using building materials made of regenerative natural resources. *Figure B2.20* shows primary energy demand over the life cycle of a building for different insulation materials with equal insulation performance.

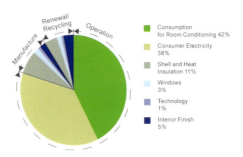

Fig. B2.19 Spread of Primary Energy Requirement over an office building

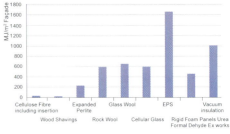

Fig. B2.20 Cumulative Primary Energy Demand for various heat insulation materials over building life cycle

Primary Energy Demand – Use-related

In today's office buildings, primary use-related energy demand for EDP devices and servers is about 25 to 40% of total primary energy demand (without building materials). For energy-efficient buildings, the relative proportion increases up to 60%, so that here, especially, there is a considerable savings potential. When designing a building, waste heat from EDP devices is already taken into account. Critical value requirements for maximum electricity demand for typical usage applications, however, do not exist. The high influence of waste heat on cooling system arrangement, and also on energy costs, show that – when it comes to Green Buildings – efficient devices must be allowed for also. In *figures B2.21* and *B2.22*, variation range of electricity connection and consumption values for different appliances is shown. We can see that energy-efficient appliances show only about half the energy consumption of standard appliances. For buildings with big servers there are heating and cooling concepts, nowadays, which use waste heat for energy-efficient cooling. The dividing line between building technology and user equipment therefore begins to fade more and more.

The energetic parameter of the future is primary energy demand over the entire life cycle of a building, including consumption values for building materials and user-side equipment. For these parameters, we can only fall back on limited experience. However, an integral view of Green Building energy demand is essential in the opinion of the authors. *Figure B2.18* shows some recommended figures for residential and office buildings that can be used as target values for design and construction of Green Buildings in Central Europe.

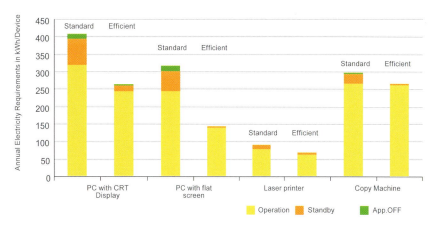

Fig. B2.22 Electricity Demand for work aids. Through the use of energy-efficient appliances, electricity demand can be decreased by up to 50% when compared with standard appliances.

Fig. B2.21 Parameters of Electricity Demand for work aids in the office

Water Requirements

The main consumers of drinking water are private households, small commercial operations and industry. Daily drinking water consumption in Germany is currently at around 125 litres a person, a day, which means that it has dropped by 20% when compared to 1975. For one, this is due to rising water prices (by 50% between 1971 and 1991). Secondly, it is due to people increasingly developing an environmental conscience. Since non-polluted drinking water is already becoming scarce, further conservation measures urgently need to be undertaken at this time, for all areas but especially also for households.

Water Requirement for Drinking Water

In the average household, 68% of drinking water is used for washing and toilet flushing. Laundry and dishwashing actions account for another 19%. The remaining water volume is used for drinking and cooking and also for garden watering and cleaning *(Figure B2.24)*.

Drinking water consumption for non-residential buildings is heavily dependent on use. Hotels, hospitals and senior care homes have a proportionally higher requirement that can be accounted for, primarily, through washing and catering needs. In office buildings, on the other hand, the requirements can be explained primarily by cleaning (façade and general cleaning). High levels of drinking water consumption also lead to high levels of energy consumption for heating, while also placing additional load on wastewater systems and sewage facilities. However, water consumption can be reduced by up to 50% through the following measures: adjustment of habits, installation of water-conserving devices and use of natural and renewable resources (rainwater and grey water).

Habits

Water consumption for washing can be reduced by up to 35% if, let's say, one would shower instead of taking a bath.

Over 75% of water consumption used for tooth brushing could be saved if the tap were only opened during those stages of tooth brushing when water is actually required (rinsing etc.). When washing, the pre-wash cycle should only be used for heavily soiled laundry. A normal cycle suffices completely to get the washing clean and it uses 20% less water.

Water-conserving Appliances and Technologies

The installation and use of water-conserving appliances leads to a noticeable reduction in water consumption. The most important measures are:
- Lavatory flush with economy switch
- Water-conserving taps (single lever handle faucet) and shower fittings
- Public sector: fittings with infrared sensors
- Hot water in administrative buildings only to be supplied in kitchens and sleeping areas
- Vacuum urinals

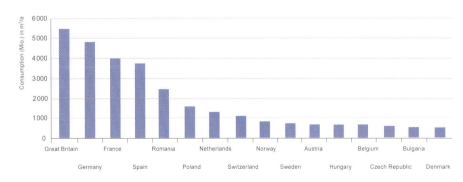

Fig. B2.23 Comparison: Water Consumption in different European Nations

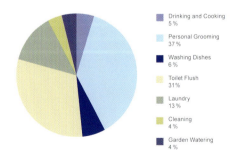

Fig. B2.24 Water Consumption spread for the average household

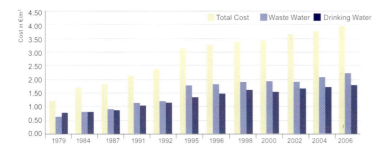

Fig. B2.25 Drinking and waste water costs in Germany over the past few years

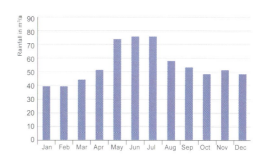

Fig. B2.26 Typical rainfall amounts in Central Europe

Water conservation can also be applied to existing buildings if dripping taps and faulty toilet flushes can be avoided and if existing water pipes are repaired *(Figure B2.25)*.

Rain Water Use

Systematic rainwater utilization can reduce drinking water consumption by about half. Rainwater can be used for flushing, washing and cleaning, as well as for watering the garden. This requires a rainwater cistern and a second piping system. Since rainwater is soft, less washing powder is needed for the laundry. For watering the garden, rainwater is especially useful due to its high mineral content, which means that the plants like it better than regular drinking water. Another advantage of rainwater use is that it takes load off the wastewater systems. Further, the cistern serves as a buffer for rainfall volume peak caps. For this reason alone, many new buildings now require rainwater collection.

Grey Water Use

Grey water is waste water from households, stemming from shower, bathtub, bathroom sink and the washing machine and which, hence, is not contaminated with faeces or highly polluted kitchen waste water. It only contains a moderate amount of soap residue and skin oil. The average household produces about 60 litres of grey water per day, per person. This type of water can be processed into usable water, which is safe from a hygienic point of view but does not have the same quality as drinking water. It can be used for toilet flushing, watering and cleaning purposes. This means, in effect, that drinking water is then being used twice. Grey water processing usually takes place through a biological and a mechanical process. Fine particles are filtered out. Afterward, the water is cleaned in the aerobe-biological stage and disinfected through UV radiation. These kinds of installations are already available on the market *(Figure B2.28)*. For Green Buildings, the application of water-conserving means such as this one is to be expected.

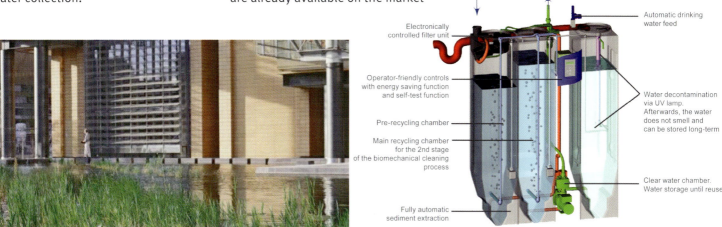

Fig. B2.27 Rainwater collection in Berlin, Potsdamer Platz

Fig. B2.28 Principles of Grey Water Use

Design, Construction

ommissioning and Monitoring for Green Buildings

C　　　D

C1 Buildings

Buildings 67

Climate

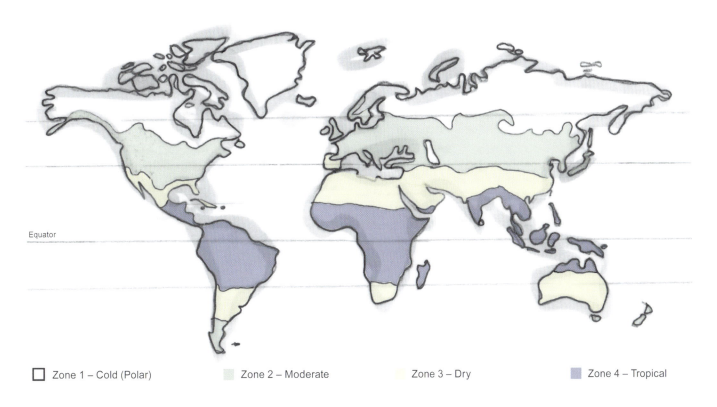

☐ Zone 1 – Cold (Polar) ☐ Zone 2 – Moderate ☐ Zone 3 – Dry ☐ Zone 4 – Tropical

Fig. C1.1 Worldwide Climate Classifications

An important consideration for the development, design and construction of buildings with low energy requirements, aside from their usage, are the local, prevailing climatic conditions. Throughout the centuries, and adapted to climatic conditions on location, man has been developing sensible buildings from a climatic point of view, which offer the possibility of an economical energy and resource use while, at the same time, also presenting with sufficient levels of occupant comfort. The resulting building shapes and designs have been tailor-made over a long period of time, adapted to local climatic conditions and utilization.

Aside from the four global climate zones, »Cold/Polar«, »Moderate«, »Hot and Dry«, »Hot and Humid«, one also needs to consider regional and local climatic conditions. The essential influential factors are outside temperature and humidity, solar radiation, wind speed and fluctuation levels between the seasons and day/night. The amount of rainfall, especially, influences roof shape. Rainwater, however, can also be used for adiabatic cooling.

Examples for climate-adapted Construction
Houses located in the Black Forest in Germany constitute an excellent example for how local climatic conditions can influence construction in a given region. Black Forest climate is characterised by great fluctuations between the seasons. Winters are cold, with plenty of snow and often also with a lot of wind. Therefore, the buildings are equipped with highly heat-insulated walls and their window surface is only very moderate. Single glazing, which barely has any heat-insulating merits,

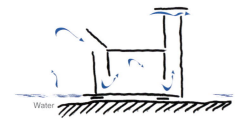
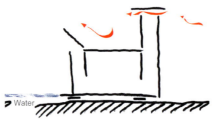

Fig. C1.2 Wind tower function for cool air currents: through the openings, the wind is guided into the building. Before, it is being cooled via a water surface

Wind tower function for hot air currents: the wind is guided over and away from the building and therefore does not heat up the interior

can be upgraded to becoming double-skin box windows that can resist cold outside temperatures. At the same time, the double-skin design increases wind insulation during cold winters *(Figure C1.3)*. Long, steep pointed roofs prevent excess snow load during periods of huge snowfall and, at the same time, offer plenty of room for dry storage of provisions during the long winter months.

Summers in the Black Forest region can be very warm, with the sun high in the sky. The double-skin box window construction is no longer required then and the outer window can be removed. The building can be naturally ventilated while the moderate amount of window surface, combined with the storage-oriented construction, protects against excess heat. Overhanging roofs and balconies have very good self-shading characteristics and offer a pleasant and cool environment for working outside.

Another, well-known example for climate-adapted construction can be found in the wind towers of Arab and Persian regions, which are also knows as »Badgir«. These wind towers are designed in a manner that allows for cold air influx into the building for cooling purposes, depending on wind direction, and for letting warmer air streams pass over the building *(Figure C1.2)*. These wind towers are open at the top, either on all four or two sides, and are equipped with diagonal partitions. Their outline is ca 3x3 meters and they stand some 7 meters high. Through the upper openings, a »Badgir« is capable of using wind flow from all directions and conduct them into the buildings lying below in form of a cool draught. The tower also serves as a chimney, since warm air currents from the rooms below stream off the lee/downwind side on account of the pressure difference.

Through this kind of chimney effect, the tower contributes toward natural ventilation even when wind velocity is low. Due to the unique temperature fluctuations that can be found in the Arab regions, the towers are unique to them.

There, summer temperatures range between 32 and 49 °C during the day and drop down to 20 °C at night. In winter, outside temperatures during the day are between 20 and 35 °C while, at night, they drop to 9 °C. The wind towers, however, are only effective during certain times of the day. They work better during the interim periods. Due to the extreme temperature differences for the seasons, residential buildings are being used in a variety of different ways. They are usually divided into two layers. The bottom layer is primarily inhabited during the winter, the upper one in summer. Further, the flat roof is used for sleeping on hot summer nights. Therefore, one building can present up to three wind towers, one each for ventilation of the respective bedrooms.

Fig. C1.3 Double-skin window arrangement for a typical Black Forest Building

Urban Development and Infrastructure

Encroachment on rural land: Nowadays, new developments are generally subject to studies about direct environmental impact and rural encroachment. This encompasses micro and macro climatic impact (temperature, wind, air pollution) and also impact on surrounding fauna and flora. By use of long-range land development plans, efforts are undertaken to curtail rural encroachment. They stipulate that any countryside invasion must be compensated through ecologically balancing measures. It is considered very positive, for instance, when contaminated plots are made available for construction. Through recontamination of the plot during construction, a positive environmental impact is made. These kinds of compensation regulations make a lot of sense, yet they are neither compulsory for new developments nor even broadly accessible in Germany.

Traffic infrastructure has an enormous impact on the additional energy requirement resulting from traffic. This requirement is not yet included in primary energy equilibration for buildings. Aside from energy requirements, it also includes pollutant load from the vehicles. In view of these comprehensive, ecological aspects it would be advantageous to situate the plot as near as possible to existing traffic infrastructure (bus routes, cycle paths, railways). Therefore, urban concentration is not a bad thing under sustainable considerations. It is even to be recommended, for one because of ecological aspects and, secondly, to decrease the problem of rural encroachment.

From this viewpoint, a sufficient supply of bicycle holders and shower and changing facilities should also be looked at equally as favourably when it comes to office and commercial properties. And, if solar-generated electricity were on offer, then the enterprises could even motivate their staff to use electric vehicles for their journey to work. If this type of offer is available, then staff can be encouraged to use energy-conserving means of transport for their route to work. The LEED® energy label provides a good start, here!

Independent of the building shape or concept used, **location and size of plot** are also an important consideration for achieving a low level of primary energy requirement.

Naturally, a plot is defined primarily by such characteristics as location, access opportunities, market value, required plot and gross floor area and capital cost. Many construction projects do not come with any alternatives regarding location, on account of urban stipulations.

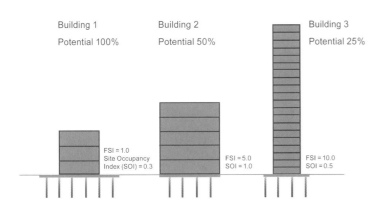

Fig. C1.4 Potentials for the use of geothermics for different ratios of plot area to building cubic content. Depicted here is possible proportion of terrestrial heat usage for heating and cooling purposes in residential and office buildings.

However, when plot location is not defined from the outset and there are several different options, then factors like primary energy requirement and environmental stress should become part of the decision process.

The floor space index describes the relationship between floor area and plot area and thus constitutes a measuring value for densification as well as available roof and office areas. These values allow us to recognize to what extent energy demand can be met from natural resources like sun or soil. The following rules of thumb apply:

• Integration of near-surface geothermal facilities up to a depth of 200 m only makes sense when sufficient plot area is available for positioning different types of soil heat exchangers. Floor space index for residential construction should be somewhere between 3 to max 5 for this. For office buildings, values between 3 to max 6 are desirable. If this can be achieved, then a large proportion of heating and cooling energy for energy-efficient buildings in Northern and Central Europe can be supplied from the soil (Figure C1.4).

• If solar power is to be used for heat generation, then there must be sufficient roof space available for positioning the collectors. The façade is only suitable in a limited manner for this since, for most rooms, daylight is required and yet the amount of sunshine on façade area only constitutes a maximum of 70% of optimum yield. In order to cover a large proportion of drinking water heating requirements through solar energy, there should be no more than 10 to maximum 20 floors to the building (Figures C1.5 and C1.6).

• When using solar power for electricity generation there should be a maximum of 3 to 5 floors for residential, and 2 to 4 floors for office buildings. That is, if a large proportion of electricity requirements for room conditioning systems and for household and EDP appliances is to be met via photovoltaic systems. This rule of thumb applies for buildings located in Northern and Central Europe where no opportunities whatsoever exist for installing photovoltaic facilities on the property. In Southern Europe, the amount of solar radiation may be higher but so is requirement for solar electricity generation or solar-powered cooling. Since, in Southern Europe, geothermics can only be used in a very limited manner for cooling, the same rule of thumb applies for electricity supply from photovoltaic systems as it does for Central Europe.

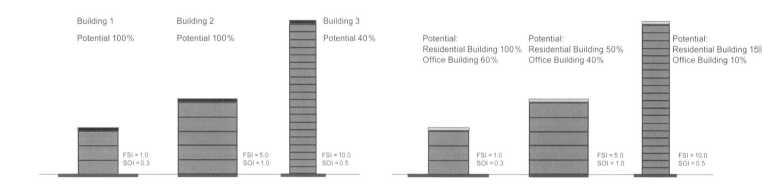

Fig. C1.5 Potentials for the use of thermal solar power for different ratios of roof area to building cubic content. Depicted here is possible proportion of solar energy usage for the purpose of drinking water heating in residential buildings.

Fig. C1.6 Potentials for photovoltaic solar energy usage for different ratios of roof area to building cubic content. Depicted here is possible proportion of solar energy usage for meeting electricity requirements in residential and office buildings.

Building Shape and Orientation

The orientation of a given building – especially of its transparent surfaces – influences its energy budget due to the different heights from which solar radiation hits. Windows are elements of the envelope area of a building, which offer both heat insulation and passive heat gain. Correct orientation and dimensioning of windows is dependent on outdoor climate and utilization. For office rooms, solar gains can be exploited less than in residential settings. This is due to the requirements by monitor-equipped workstations (a solar protective device, or a glare protector, is usually present). Further, in residential settings, higher indoor temperature is much better accepted by the occupants, on account of different clothing worn and different types of activities when compared to an office situation. Another difference can be found in the fact that, for office settings, sufficient daylight is of great significance for most rooms while, in residential settings, the rooms can be arranged according to utilization. Bedrooms, for instance, should be facing North if possible, and be located as far removed from noise stress as possible. Living rooms, on the other hand, are better arranged toward the South, so that solar gains can be exploited in the best possible manner.

An energetically correct positioning of utilization applications within an urban planning concept can be seen in *figure C1.7*. Shopping malls and recreational buildings, which require more sophisticated ventilation on account of dense occupancy, are usually placed close to heavily frequented roads. Residential and office buildings, in contrast, are generally placed in a more quiet area, in order to fully exploit natural ventilation potential. *Figure C1.8* shows what block shapes are the most favourable ones with equal use area. Closed structures constitute the least favourable solution, since passive solar energy exploitation potential is lowest on account of heavy shading of the façades. One consequence of heavy shading is elevated electricity requirement for artificial lighting. Increased use of artificial lighting, on the other hand, not only leads to raised electricity costs and therefore to higher energy requirement, but also results in a decreased level of psychological well-being. Aside from the disadvantages that a solar energy supply of the rooms brings in its tow, one also needs

Fig. C1.7 Example for an urban development energy analysis. Outdoor noise sections are divided into zones with limited or no window ventilation possible. Utilizations like shopping malls should be situated in the nose-intensive areas, so as to leave ample room for placing residential and office buildings in those areas that allow for maximum use of natural energy potential.

Façade closed
100 %

Façade open toward the East
108 %

Façade open toward the South
111 %

Fig. C1.8 Example of an energy analysis for basic construction forms in the framework of urban development. Depending on construction form, different energy gains result from solar radiation on the façade at equal area of use.

Fig. C1.9 Energy analysis for urban project development in Stuttgart/Germany

to consider that air exchange rates are worse in the inner courtyard because they depend on yard height. This leads to a longer running period for mechanical ventilation. Independent of building concept, an optimum arrangement of structures results in a saving of between 10 and 20 % for energy requirements, in regard to systems used for room conditioning.

The more compact a given structure is, the more energy can be saved. This statement applies only in part to non-residential settings: where heat insulation is stipulated at minimum quality only. One effect of improved heat insulation, as it is becoming a requirement for Green Buildings, is an ever increasing independence from envelope area to room volume ratio. If one looks at heating energy requirement alone, then it is, of course, absolutely correct to minimize a building in respect to heat loss area while aiming to keep utilization area as is. However, this approach presents energetic disadvantages for highly insulated buildings, when taking into account cooling energy and electricity requirements for ventilation and lighting. By merely aiming to minimize heating energy requirements, no overall optimisation can be achieved. This revelation is all the more important since, in Germany for instance, all former and current energy conservation and heat insulation stipulations are based on measuring heating energy requirements according to its proportion of total energy requirements. Green Building architecture, hence, in future will no longer orient itself solely on building compactness, even for colder regions like Northern and Central Europe. Rather, allowances will need to be made for optimising all energy flows that are of importance to building operation. Less compact buildings, with more daylight and a higher potential for (at least part of the time) areas that are capable of being naturally ventilated, can quite possibly be at an advantage here.

Buildings

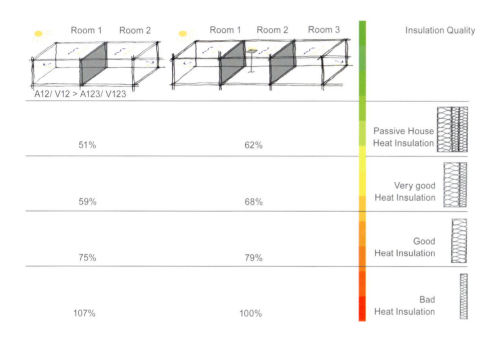

Fig. C1.10 Influence of envelope area (A)/room volume (V) ratio on primary energy requirements for room conditioning systems at different insulation characteristics of envelope area

Building Envelope

Heat Insulation and Building Density

The façade of a building constitutes the interface between outside and indoor climatic conditions. While indoor climate in rooms that are occupied year-round tends to fluctuate only within a narrow corridor of 4 to 8 K, outdoor climate can present temperature differences of up to 80 K, depending on location. For instance, in Chicago/USA, minimum outdoor temperatures in winter of -40 °C are no rarity. In summer, they may rise to +40 °C.

For Northern and Central Europe, heat insulation is desired primarily because of the long winter duration. Minimum insulation strength values, in the 8oties, were primarily used to prevent physics of buildings damage to outer components. The aim here was to move a component's dew point as much to the outside as possible in order to avoid inner surface condensation. Moist walls on the inside inevitably lead to mould formation and place a heavy load on indoor air quality and human health. With the now prevailing insulation strengths for Central and Northern Europe, there is no more danger of condensation at the interior of the room, so long as correctly constructed external components are present. Nowadays, insulation strength is oriented on the following criteria: heating energy requirements, thermal comfort through high interior surface temperatures, and a sustainable economical approach for the building envelope and technology system.

Good heat insulation, however, not only makes sense for countries subjected to long-lasting, cold outdoor climate. This becomes clear once we take a closer look. In Southern Europe, many buildings are not equipped with any kind of heating installation. An acceptable indoor comfort level, hence, can only be achieved by improved insulation. For countries with a hot outdoor climate of up to 50 °C, as are found in the Middle East, there is nearly the same temperature gradient (outdoor/indoor climate, 25 to 30 K) as in Germany, only in reverse. The building does not lose heat to the outside but, rather, gains it from there. In order to uphold thermal comfort levels, one does not need to heat but cool. Of course, there are climate zones that do not require high levels of heat insulation on account of their continental, even outdoor climate. In Central Africa, for instance, outdoor temperature presents evenly, day and night, winter and summer, somewhere between 10 and 30 °C. Yet, these regions should still be provided with some kind of heat insulation, especially in view of damage sustained through humidity (very high outdoor humidity), and also with sound protection (if lots of outdoor noise is the case).

Adjustable Heat Insulation Designing heat insulation in an adjustable manner remains a target for energy-efficient construction. In the 90ties, double-skin façades were partially equipped with motorized flaps, which allowed shutting off the air inlets for the building and thus creating a »winter garden effect« by preventing heat loss from the building during periods of, for instance, solar radiation. The flaps can be opened when outdoor temperatures are high, something which avoids overheating of the rooms. Another manner of adjusting summer or winter heat insulation is by arranging transparent membranes, in form of foils, on the inside ceiling region by placing them one behind the other at different proximity. This results in different air cushions between the foils. Added up, they provide good heat insulation. *Figures C1.12* and *C1.13* show an example for this, from a study object for a transparent customer centre: in winter, the bot-

Buildings

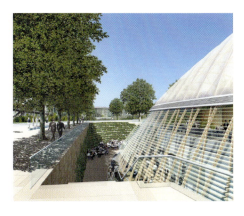
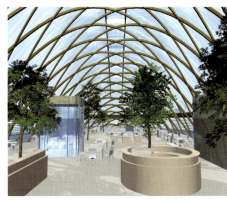

Fig. C1.11 Outer and interior view, competition design for a customer centre. Architects: Petzinka Pink Technologische Architektur®, Duesseldorf

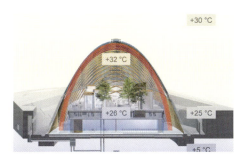

Fig. C1.12 Operative indoor temperature in summer. Through expanded room volume, thermal stratification can result that presents comfortable temperatures at the bottom.

Fig. C1.13 Operative indoor temperature in winter. The decreased room volume of the heated customer centre decreases heating energy demand and creates energetically intelligent buffer zones in the roof area.

tom movable foils shut off the usable area at a certain height and so form a buffer between building envelope area and usable area. The naturally elevated temperature in the buffer zone now lowers temperatures in the useful area.

Transparency, however, remains. The air volume of the usable area that is to be heated decreases, which results in further energy savings. In summer, all the foils adapt to building shape. This means that, for one, the sun is kept out to a great extent on account of the differently imprinted foils. Further, useful space is expanded back to its original size, which results in thermal stratification toward the top. Then, it suffices to guide the cool inlet air into the lower region of the room while the warm air flows toward the top and then, via controllable ventilation flaps, out through the roof. Full building height is exploited through thermal stratification: cool at the bottom, warm at the top. With this, required cooling load can be kept low.

Demand-oriented Heat Insulation

Aside from outdoor climate, the manner in which a given building is being used constitutes a decisive factor for choosing the right heat insulation in regard to energy-efficiency. As a rule, it is a good idea to decrease heat dissipation to the outside through improved heat insulation and/or to prevent heat inflow from the outside in the same manner (when indoor cooling is desired). For buildings types and utilizations with large indoor heat sources and great room depth like, for instance, department stores, lower level heat insulation can be advantageous for the climate zones of Central Europe. This is because, due to the large indoor heat sources and the low ratio of envelope area to room volume, the building needs to be cooled almost constantly. This means that too much heat insulation could be counterproductive, actually, for the greatest part of the year. An exceptional stipulation

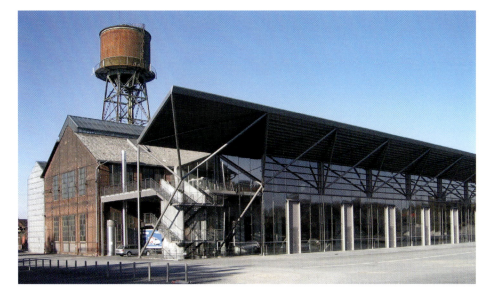

Fig. C1.14 Century Hall (Jahrhunderthalle) at Bochum/Germany. Architects: Petzinka Pink Technologische Architektur®, Duesseldorf

clause for those cases is specifically included in building regulations for Germany. Minimum heat insulation values for the avoidance of damage through humidity, however, ought to be adhered to in all cases.

An excellent example for demand-oriented heat insulation is the renovation of the Bochum Century Hall in Germany *(Figure C1.14* and *C1.15)*. At the beginning of the 20th century, the three individual halls were the location of a gas power plant and served also as exhibition halls for industry and commerce. Later, they became storage and workshop facilities. Due to the huge volume of available space, and on account of the halls coming under the local historical building protection act, the only insulation measures undertaken were those required for the avoidance of any constructional damage. Through simulation calculations, it was determined up to what outdoor climate conditions a level of acceptable indoor comfort could be maintained for the envisioned 2000 spectators *(Figures C1.17* and *C1.18)*. The halls are ventilated exclusively on a natural basis, something that constitutes a novelty for assembly halls of this magnitude. The only available heating system is floor heating, the heat for which is harvested, to a large extent, from a neighbouring industrial plant. Since 2003, the century hall has been hosting the »RuhrTriennale« between May and October each year.

Fig. C1.15 Bochum Century Hall after revitalisation. Architects: Petzinka Pink Technologische Architektur®, Duesseldorf

Buildings

Measuring values for frame structure optimisation/façade

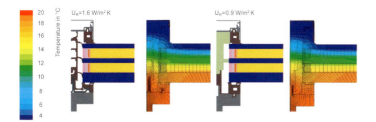

Fig. C1.16 Optimisation of frame construction. Overall Heat Loss Coefficient for the frame structure was decreased from 1.6 to 0.9 W/m² K through the implementation of optimisation measures

Façades with Extreme Temperature Insulation Window systems and unitised façades are held together by frame profiles. Triple glazing or an extreme-temperature insulated panel, when held together by standard framing, does not provide the energy characteristics that are required by a Green Building. Pillars and frame construction must also be extreme-temperature insulated since otherwise, the desired effect of high inner surface temperature with simultaneous, construction-based avoidance of cool air drop at the façade cannot be obtained. Aside from the optimisation of individual components, thermal bridges should be largely avoided during the planning and execution phases. Not only do they hamper indoor comfort but they also result in increased energy demand.

For a building envelope, we distinguish three different forms of thermal bridges: first, there is the geometrical thermal bridge. On account of the larger envelope area as related to room volume, this bridge causes a higher level of heat loss *(Figure C1.24)*. The easiest form of a geometrical thermal bridge is a corner of the building that keeps presenting a mould potential in insufficiently insulated and ventilated rooms. For new buildings, the negative impact of geometrical thermal bridges can usually be avoided with sufficient outer insulation. For existing buildings, outer insulation is usually an effective means for counteracting condensation-based humidity problems on the inner wall surfaces.

The second form of thermal bridges is materials-related and can be found in all junction components of the building shell area *(Figure C1.25)*. With ever improving insulation, the effects of poorly planned or executed junctions on heating energy requirements are enormous. This can be seen, for instance, in the case of vacuum insulation: the elements of the vacuum insulation panels usually nowadays measure a maximum of 1.20 by 1 meter. The area ratio of the highly heat conductive plate junctions can, depending on plate format, constitute between 5% and 10% of total area. Without the implementation of additional measures at the joins, the effective U value of the outer wall will be 0.2 instead of 0.1 W/m²K of the vacuum insulation panel, which is a reduction of 100%. As for conventional insulation substances, it is also to be recommended for extreme-temperature insulated constructions to strive to stay as free from thermal bridges as possible. Every single plate anchor and support rail that is not thermally decoupled causes elevated heat loss levels.

The third form of thermal bridges can be traced back to construction *(Figure C1.26)*. For the most part, this happens in the planning stages and, if caught early enough, can be counteracted through changes of materials or construction. Classical examples would be overhanging balcony panels or steel ceiling supports that break through the façade. These kinds of thermal bridges

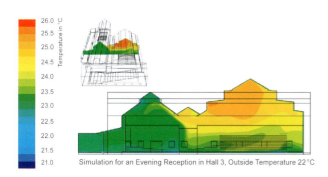

Fig. C1.17 Flow simulation results. Arrangement of operative indoor temperatures for an evening reception in Hall 3. Hall 1 is not occupied and is used as a fresh air reservoir during the intervals.

Fig. C1.18 Three-dimensional Simulation Model of the Century Hall

conduct a large proportion of heating energy to the outside, through the sometimes quite considerable proportion of inner component areas that lead on to the outside and possess very good heat conductivity. Frequently, this only happens in conjunction with surface cooling of these components in the façade vicinity. Hence, aside from heat loss, we must also prepare ourselves for condensation damage. For the areas of steel construction and concrete steel construction, building materials technology offers a variety of solutions for thermal decoupling or heat insulation of such thermal bridges. Precisely which one of these technological measures would be the most economical one can be determined by means of a thermal bridge analysis *(Figure C1.19)*. For the thermal bridge calculation, various alternatives are looked at for adhering to thermal requirements. Then, the most economical alternative is defined.

As for improvement of **building airtightness**, this is an important factor for all Green Buildings in all climate zones. While, for Northern and Central Europe, badly insulated buildings increase total heating demand, for Southern nations excess heat needs to be »cooled away« again. This usually happens because the air conditioning unit on the inside generates a higher amount of pressure there than is present on the outside, which means that no airflow from outside can get indoors. But what happens when the system is not in operation? The problem gets even larger when the region concerned is hot and humid since, in case of lack of airtightness, air conditioning units need to run continuously in order to keep the building cool and dry.

The advantage of an airtight building also comes with a disadvantage: the less natural infiltration there is, the greater the risk for condensation in critical areas (geometric thermal bridges) on cold days. To avoid this, we strive for mechanical ventilation with heat recovery function for highly insulated, airtight buildings. This saves a lot of energy when compared to leaking buildings. *Figures C1.20* to *C1.23* show target values for heat insulation (overall heat transfer coefficient U_w) and building density (joint permeability as a measuring value for air tightness) for the various structural components of the envelope area. Aside from the aforementioned exceptions for special constructions, these values should be adhered to in order to achieve the target values set for heating energy demand.

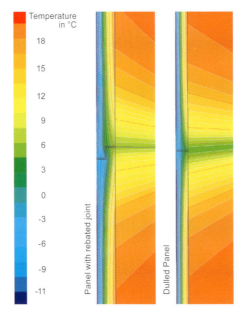

Fig. C1.19 Thermal Bridge calculation for vacuum insulation panels with and without rebated joint

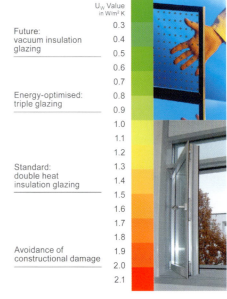

Fig. C1.20 Parameters of Overall Heat Transfer Coefficient U_w for different glass and window types

Buildings

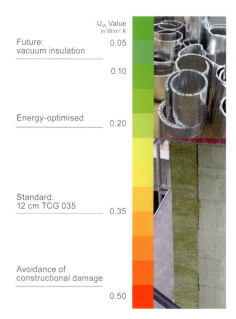

Fig. C1.21 Overall Heat Transfer Coefficient U parameters for outside walls

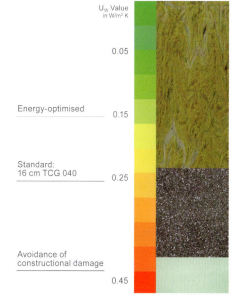

Fig. C1.22 Overall Heat Transfer Coefficient U parameters for rooftops

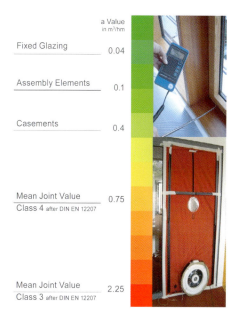

Fig. C1.23 Permeability parameters for different façade joints

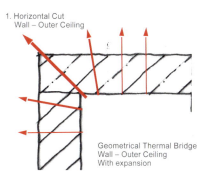

Fig. C1.24 Examples of a Geometrical Thermal Bridge

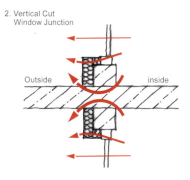

Fig. C1.25 Examples of a Material Thermal Bridge

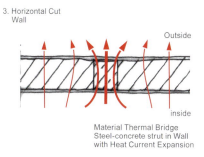

Fig. C1.26 Examples of a Structural Thermal Bridge

Solar Protection

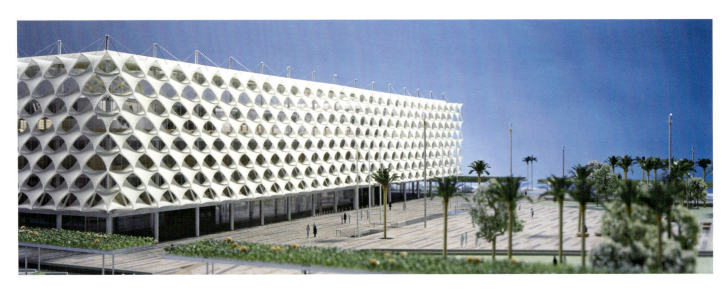

Fig. C1.27 King Fahad National Library in Riad, Saudi Arabia. Architects: Gerber Architekten, Dortmund

A good level of solar protection is essential to Green Buildings. The aim here is to afford the building sufficient solar protection so as to keep both cooling energy requirements and expected cooling load as low as possible. Solar protection arrangement is according to manner and type of glazing and it can be regulated via an additional element in either rigid or movable version. Aside from the course of the sun for the specific location, for mobile solar protection devices that are located on the outside, we also need to take into account during the conception stage how stable the wind is. Since glazing and solar protection influence the amount of daylight in a given room, there is a direct proportional effect between energy requirements for room cooling and artificial lighting.

Solar protection shading demands are largely independent of both location and type of use. Naturally, for different climatic regions and design desires, there are different solution approaches also. However, they all need to meet the same requirements for effective shading. *Figure C1.28* shows target values for solar protection as an effective total energy permeability grade of the façade. The effective total energy permeability grade consists of window area proportion of the façade (interior view) and total energy permeability grade of glazing when combined with solar protection device. For smaller window areas, less effective solar protection can be used, for instance something like transparent screens. Larger window areas require a highly effective outside solar protection device. Inside solar

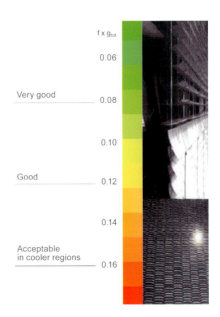

Fig. C1.28 Parameters of total energy permeability grade g_{tot} in relation to window area proportion f of the façade for occupied rooms. The effective total energy permeability grade consists of the combined characteristics of glazing and solar protection device. When multiplied by window area proportion, a parameter for occupied rooms results. It defines to a great proportion both cooling energy requirements and indoor comfort in summer.

Buildings

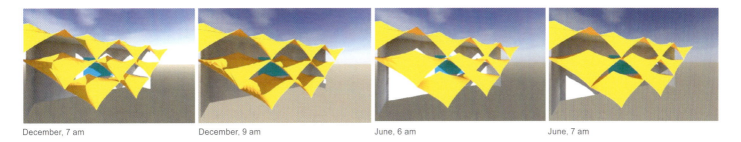

December, 7 am December, 9 am June, 6 am June, 7 am

Fig. C1.29 Visualization of shading grade generated by solar sails, depending on seasonal and daytime considerations.

protection devices usually heat up to a high degree, something that has a negative effect on cooling energy requirement and on local operative temperature in façade vicinity. When choosing a suitable solar protection system, especially when an inside arrangement applies, it is absolutely essential to calculate total energy permeability only in combination with the type of glazing used. To this day, the values provided by many manufacturers only go for outside systems.

Very warm regions occur at latitudes where the sun is rises very rapidly high into the sky. For these regions, a rigid solar protection device is to be recommended, since this can be used year-round in most cases. *Figure C1.27* shows the solar sail arrangement for the Riad National Library in Saudi Arabia. Through 3-dimensional simulation calculations, sail geometry is optimised in for view of solar energy yield while still presenting vista *(Figure C1.30)*. Aside from direct radiation, diffuse sunlight, which gets reflected into the room either from the façade or the sails, needs to be taken into account.

In **wind-intensive regions** there are three basic varieties for sufficient summer heat insulation: the first is a rigid outside solar protection device, often executed in form of a roof protrusion. This form of solar protection, however, only provides adequate protection for southern nations where the sun is high in the sky and then only for cases of direct solar radiation. In Central Europe, with Southern orientation, additional solar protective measures need to be undertaken. The second variation consists of installing an overhanging glass construction as a wind-protected solar screen. This is typically done for double skin façades. Third is the use of a wind-resistant, movable kind of construction. It may consist of a variety of materials, be they wood, aluminium or even imprinted glass. If an interior sunscreen is desired behind sun protection glazing then, in Central Europe, this frequently leads to exceeding maximum effective total energy permeability grade unless, that is, the window surface areas of the façade present a very low ratio of 30 to 40 %. This, however, would greatly reduce daylight entry rates and, aside from an adverse psychological effect, also result in greater energy demand for artificial lighting. Only for some Northern European regions, where warm and sunny days are a rarity, solutions can be implemented in an energy-efficient manner to include larger window areas and inside solar protection systems.

When revitalizing or renovating **protected** façades, there is often a conflict during conception already between design and efficiency. Because of the buildings being protected, it is often not possible to equip them with an outside solar protective device. Yet, the new indoor climate must still present good thermal comfort. Unlike new buildings, existing buildings used for offices often have low thermal storage ability (e.g. rib ceilings that are less than 15 cm thick), so that cooling requirements very quickly increase. *Figure C1.31* shows the Kaiserhof office tower in Hamburg: the building's protected façade was recreated almost completely, with only one add-on at the

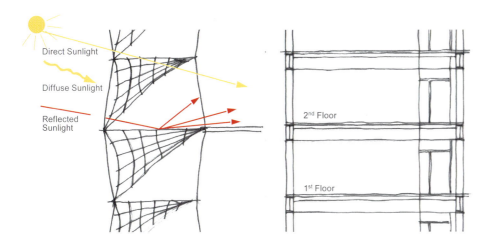

Fig. C1.30 Simulation model for calculating solar influx, dependent on sail geometry and the position of the sun

Fig. C1.31 Kaiserhof Office Towers in Hamburg. Architects: Prof. Winking Architekten, Hamburg

bottom having been added. Behind the trap windows, a movable solar protection device was installed, which is also suitable as glare protection. At a specifically set spacing, directly behind, slidable glass windows were put in. The occupant can operate them whenever desired. In winter, the opening of the upper trap suffices for natural ventilation. In summer, both trap wings are open. The inside slidable windows, however, are still manually opened or closed by the occupant, depending on outside climate (wind, sun, temperature). Natural back ventilation for the solar protective device is always assured in summer through the open traps. This means that cooling load inside the room remains low. At night, the traps also offer an excellent means of night ventilation.

Naturally, solar protection also always constitutes a **design element** of the façade and therefore also of the building. In Central Europe, solar protection needs to be active during most of the summer but, in Southern nations, this applies year round. For this reason, solar protection is a decisive factor in defining overall building presentation. A Green Building, however, cannot merely be justified by its design. It must also prove to be energy-efficient. On the

Buildings

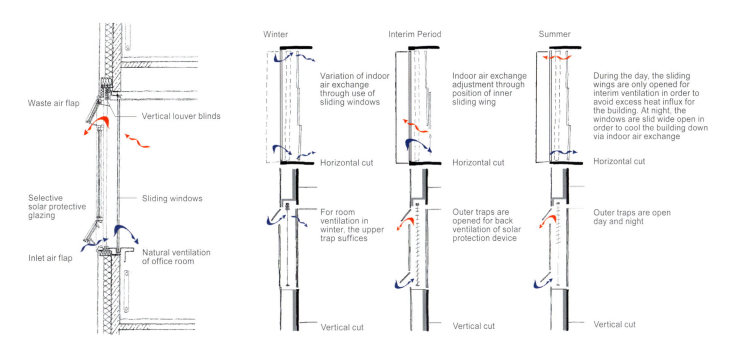

Fig. C1.32 Façade and Ventilation Concepts for the Kaiserhof Office Towers

other hand, the building must be capable of being sold or rented out and, therefore, design is certainly also a consideration.

Figure C1.33 shows another design option for solar protection. The outside shutters consist of individual aluminium ribs and when, they are up, allow for generous self-shading on the Southern side during the height of summer. As the sun gradually goes down, the shutters automatically come down. Spacing and slant of the ribs is defined in advance through simulation techniques and according to energy and daylight yield as well as orientation.

Solar Protection with Daylighting
One of the most effective means of solar protection – which also meets all requirements regarding energy and daylight yield, visibility and flexibility – are vertical louver blinds. If the standard version is only minimally changed, a highly wind-resistant, transparent and daylighting form of solar protection can be achieved. A good example for this are the perforated, concave lamellae versions that offer very good daylighting and view to the outside.

Another version of vertical louver blinds bend the lamellae in the upper quarter of the standard version at a different angle to those below. This achieves a cost-effective and well-functioning form of daylighting.

An even better form of daylighting can be achieved through a combination of a daylighting system in the upper façade region and vertical louver blinds for the rest of the façade area *(Figure C1.24)*. In doing this, however, one needs to make sure that the light control element also offers sufficient glare protection in summer.

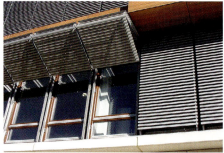
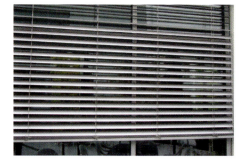

Fig. C1.33 Folding shutters for the Campeon office building in Munich. Architects: Maier Neuberger Projekte GmbH

Fig. C1.34 Vertical blinds with simple daylight function

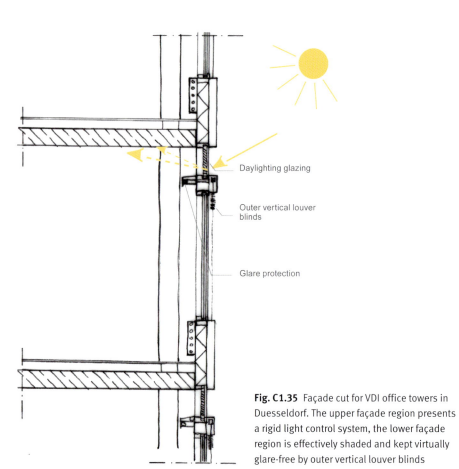

Fig. C1.35 Façade cut for VDI office towers in Duesseldorf. The upper façade region presents a rigid light control system, the lower façade region is effectively shaded and kept virtually glare-free by outer vertical louver blinds

Glare Protection

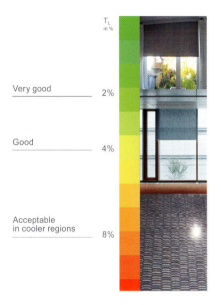

Fig. C1.36 Parameters for light transmission rate T for glare protection devices, without outer solar protection. Light transmission rate essentially defines luminance distribution in the window area and, thus, also thermal comfort

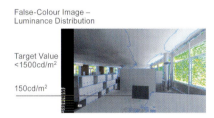

Fig. C1.37 Luminance check through daylight simulation. The target value for luminance distribution at the workstation far field of about 1500 cd/m² is not reached due to outer solar protection with light control

For rooms with computer workstations, there must be adequate glare protection in order to limit near and far field luminance. This prevents contrasts between monitor and field of vision from becoming too prominent. In this, all glare sources need to be considered: sunlight hitting the work pane and its immediate vicinity, visible section of the sky, luminance of glare protection device and also large luminance differences brought about through glare protection design in form of holes or slits (opening factor). Light transmission rate of the glare protection, together with the opening factor, then defines the expected luminance for the room. *Figure C1.36* shows target values for glare protection light transmission rates, for achieving thermal comfort at computer workstations. We assume that the glare protection is located behind heat-insulated glazing and that no outer solar protection is present.

If the glare protection presents low light transmission, then it prevents contrasts from becoming too high but, as a rule, it will heavily restrict not only daylight and window usage but also the psychologically viable vision contact to the outside. In order to avoid this, there are two possible solutions, in principle:

First, you can use existing outer solar protection for glare protection also, so that interior glare protection only needs to be minimally activated. A prerequisite is that the solar protection device allows for sufficient daylight to pass through. Not all types are suitable. Further, local wind factors need to be verified, in order to determine how often the solar protection device needs to be pulled up for safety reasons. Luminance distribution, as *Figure C1.37* has shown, can be calculated, quite precisely, in advance via daylight simulation.

Secondly, the glare protection device's direction of movement can be inversed, from bottom to top. Then, depending on building structure and furniture, sufficient glare protection can be achieved while daylight still enters the room in the upper façade region. An example for this can be found in chapter D: Dockland project.

If the glare protection is used for purposes other than work at the monitor, it may be designed in a more transparent manner. This goes, for instance, for glass halls that host functions.

Daylight Utilization

Whether sufficient daylight is available can be, firstly, determined by the obstructions present and, secondly, by façade design. Obstruction-caused shading happens from neighbouring buildings or from the building concerned. In building design, it is essential to keep the need for sufficient daylight presence in occupied areas in mind, as a factor to be absolutely considered. Some pointers for the adequate distance to obstruction can be found in *figure C1.38*. They show that, if courtyards are too narrow or protrusions too prominent, a daylight potential loss of between 30 and 50% can very rapidly result. For glass roof atria, the glass roof results in 30 to 40% less daylight yield, even with single glazing. Aside from the decrease caused by the glazing itself, there is also a higher pollution level on the horizontal plain. *Figure C1.41* gives guidance values for the influence of glass roofs on interior daylight presence. In this, light transmission and pollution rates for the glazing are considered, as are influences exerted by mutual shading.

For the design of façades of occupied rooms, the most important factors for daylight yield are window area, drop height and light transmission characteristics of glazing and solar protection system. Since daylight is required for most utilizations somewhere above the table plane, glazing in the lower façade region only has minimum influence on elevating room brightness. A window area ratio of 60 to 70% to inner façade and to the room itself allows for optimum daylight utilization inside the room, provided that the glazing in the façade has been correctly placed. The best possible effect can be achieved when drop height can be reduced to a minimum *(Figure C1.40)*. Daylight coming in through the upper façade region then reaches into maximum room depth without reflecting off ceiling, floor or interior walls. If daylight ratio is decreased through greater drop height, this can only be compensated by better reflective surfaces of room envelope surfaces (especially the floor). In most cases, this is not even possible since, as a rule, ceilings are usually designed to be very bright and thus a significantly higher reflection rate cannot be achieved. Flooring, and its colour, is usually defined by different criteria, such as hygienic and cleaning considerations, which means that only very few variations in design are possible.

Light transmission characteristics of the glazing, and also the solar protection device, both have a direct influence

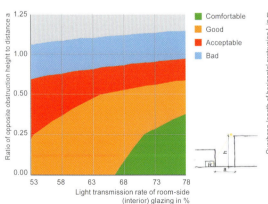

Fig. C1.38 Daylight level inside the room: influence of opposite obstruction and light transmission rate of glazing.

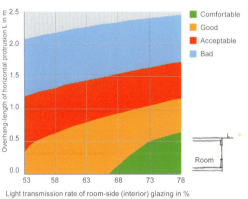

Fig. C1.39 Daylight level inside the room: influence of a horizontal protrusion and light transmission rate of glazing. Boundary conditions: Reflectance, floor: 20%, waste: 50%, ceiling: 70%, outside façade: 20%, room floor-to-ceiling height: 3 m, drop height: 0.2 m

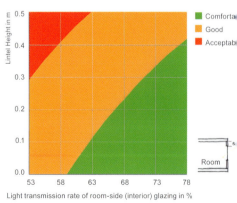

Fig. C1.40 Daylight level inside the room: influence of lintel height and light transmission rate of glazing. Boundary conditions: Reflectance, floor: 20%, waste: 50%, ceiling: 70%, outside façade: 20%, room floor-to-ceiling height: 3 m.

Buildings

on natural brightness levels inside the room. For instance, a solar protective layer always decreases light transmission rate. Neutral layers have a spectral effect, which means that they allow the largest possible proportion of the sun's light spectre to pass through while the other parts, like UV and long-wave IR radiation are reflected or absorbed. The afore-mentioned figures show the influence of light transmission rate on daylight availability. Tinted glass windows without spectral effect are not considered since they are not suitable for Green Buildings in Europe.

While light transmission presents evenly for glazing, it can become variable for solar protection systems. This usually applies to daylighting systems. The easiest way that daylighting can be achieved is with vertical blinds. In the so-called cut-off position, diffused sunlight can get into the rooms without causing overheating there. If the upper ribs are arranged horizontally and the lower ones vertically, a high proportion of daylight can reach deep into the room from the upper façade region. Getting even deeper for excess room depth (above 5 m), however, is then only possible through the use of highly reflective outer ribs and light guiding ceilings. Use of these types of systems results in a high level of visual comfort since equable brightness is achieved even in rooms that are only lit from one side. Daylight tracking by standard ribs, depending on sunlight, can have a comparative effect for many sky conditions found throughout the year. Solar protective system quality (regarding daylight transmission and control) is compared to that of standard vertical blinds (without daylighting and automatically operated). Standard vertical blinds received the classification »satisfactory«; energy-efficient and comfortable systems always offer at least a small daylighting function. Aside from the daylighting function, very efficient systems can be controlled via the hangings. While this depends on shading and the solar protection present, it also guarantees maximum daylight exploitation for the rooms.

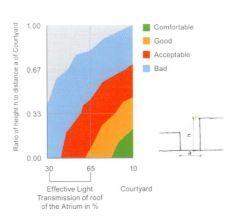

Fig. C1.41 Impact of surrounding obstruction and roof effective light transmission on daylight level inside a room. The rate of effective light transmission of the glass roof of the atrium can be determined at the product of glass roof proportion, soiling factor and light transmission of roof glazing. Boundary conditions: Reflection rate floor, wall, ceiling, outer façade, height clearance, drop height, light transmission office glazing

Fig. C1.42 Classification of solar protective systems in regard to the level of existing daylighting

Noise Protection

Fig. C1.43 Close-up of the Neudorf Gate façade in Germany. Architects: Rasbach Architekten, Oberhausen

The primary task when planning for sound insulation is of sound-insulating design for self-contained building components. This goes for the building envelope (sound-proofing from the outside) and the inner walls and ceilings (sound-proofing from the inside). Under Green Building stipulations for energy-efficient construction, the components must be capable of handling several functions at once: façades, for instance, must function in a sound-absorbing manner at frequented roads, even when the rooms are to be ventilated via casements.

Double-skin façade In Germany, in the 90ties, many buildings were constructed with a double-skin façade – despite the fact that double-skin façades were not required, under technical or energy considerations, for all the buildings. Over the past few years, there has been an increasing trend toward the consideration of life cycle costs and indoor comfort, so that double-skin façades are nowadays only being built when it actually makes sense to do so. For new buildings, double-skin façades really only offer two advantages: decrease of wind influence on solar protection devices and window ventilation; lowering the level of sound penetration. *Figure C1.45* shows sound insulation improvements, depending on the opening proportion of outside glazing. On account of the opening ratio of at least 7.5 to 10% of façade area, which is required for back ventilation, decreases are possible of between 4 and 7 dB for any closed windows lying behind, but up to 10 dB for a tilted window in the same position. In order to ascertain a good to acceptable interior sound level of 50 to 55 dB (A), it makes sense to set the application areas for double-skin façades at mean outdoor noise levels of 65 to 75 dB (A). Naturally, the course of outdoor noise level throughout the day needs to be measured precisely since, for instance, in case of frequent and high noise peaks, these cannot be sufficiently absorbed by the façade. The above-mentioned values merely serve for orientation purposes regarding a preliminary check for the requirement and sensibility of the proposed undertaking.

Sound insulation and window ventilation – no overheating When conceptualising the façade of the Neudorf gate in Duisburg, a different approach was taken. Via constructional means, the target was a noise reduction level of at least 5 dB. Since double-skin façades frequently present physically caused excess temperatures, these had to be avoided. The solution was found in a façade construction with two separate structural components: the larger façade area is a classical double-skin façade with back-ventilated solar protection in the interspace, yet without

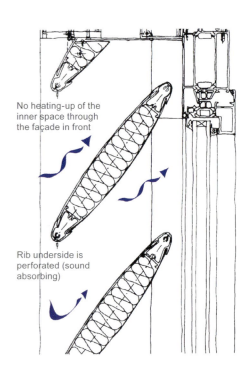

Fig. C1.44 Façade detail: individual rib

Buildings

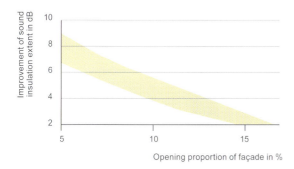

Fig. C1.45 Impact of sound insulation for double-skin façade as depending on opening proportion and absorption degree in the façade corridor

Fig. C1.46 Virtual image of the renovated Berliner Allee office building, Duesseldorf/Germany. Architects: Bartels und Graffenberger Architekten, Duesseldorf

opening wings into the room. Between these areas, and dependent on room flexibility, there is a cyclical arrangement of sound absorption ribs, behind which the opening wings are located. The ribs are perforated in the lower section, and smooth on the upper in order to allow for rainwater to pass off. They are arranged vertically overlapping, in order to guarantee protection from the sun year-round (Figure C1.44). Airborne noise insulation measurements have shown that, irrespective of window opening size, there is always a sound reduction of 6 dB. This presents a distinct advantage to the occupant: the windows can be operated as usual, whether tilted for ongoing ventilation or completely opened for interim ventilation with a noticeable wind influence factor.

Sound Insulation and Window Ventilation – the Hybrid Façade The Berliner Allee office building in Duesseldorf is an existing building from the 50ties and is located at a heavily frequented road (Figure C1.46). It was the desire of the client to develop a renovation concept that would have all the advantages of a double-skin façade while, as much as possible, avoiding its disadvantages. Jointly with the architect and the client, a hybrid façade was developed, the structure of which was strictly oriented on the centre-to-centre grid of the existing building. By only equipping every other façade axis with impact glass, even the tiniest office space always has two different window ventilation options. In the vicinity of the impact glass, a solar protection device is located in the façade interspace, which is ventilated via an inlet air slot. Part of the waste air is guided outside through a slot in the upper façade region. However, the largest proportion of waste air dissipates naturally through a vent stack close to the struts (Figure C1.47). This arrangement offers the following advantages:

• In case of traditional window ventilation with an outer solar protection device, the occupant can take advantage of the option for interim ventilation, offering direct outside air contact without the risk of overly hot inlet air.

• When ventilating via a window that has an additional impact glass, the occupant may actually ventilate his rooms for the greatest part of the year in a totally sound-insulated manner. Thanks to the vent stack integration in strut vicinity, opening surfaces of the outer façade skin can be decreased in size, which elevates sound insulation while maintaining the same high ventilation standard.

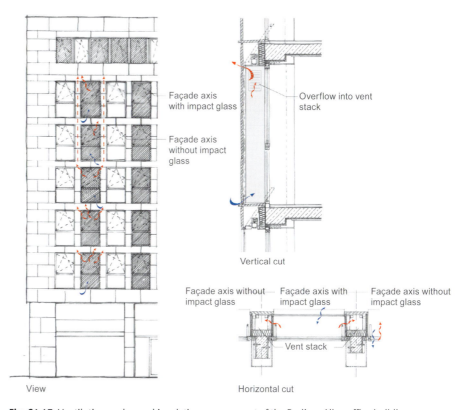

Fig. C1.47 Ventilation and sound insulation arrangement of the Berliner Allee office building (view, vertical and horizontal cut of façade)

Façade Construction Quality Management

Façade design has changed enormously over the last centuries. Today's façades for energy-efficient buildings are designed in a manner that unite creative considerations with an optimal framework for indoor comfort. In this, a whole list of factors needs to be brought together into one functioning unit, the aim of which is to keep requirements for technological systems as small as possible through the implementation of constructional measures:
- Heat and sound insulation. Solar and glare protection
- Daylighting
- Natural ventilation and airtightness

In view of the building life cycle, however, other considerations need to be solved also:
- Rain and windtightness
- Cleaning concept
- Fire protection strategy
- Functional reliability

The façade is one of the most important components of a building and for this reason one needs to be careful to adapt façade design right from the start to indoor climate and utilization requirements. As far as energy considerations go, this can be done by means of a thermal building simulation, a current simulation or laboratory tests. During the further course of planning, the façade then needs to be detailed up to a scale of 1:1. And, to test the creative effect (i.e. how does it look?), a sample façade is frequently done for larger projects. This is the best way to judge the impression that a building makes. Other than for building technology, individual façade components can be neither measured nor changed or optimised once the building has been completed and is in operation. For this reason, it is necessary to verify all their important characteristics in laboratory tests prior to the production and erection of the façade. This includes testing for:
- Impact resistance
- Air tightness per element
- Ability to withstand climatic changes
- Stability considerations for loose components
- Total energy transmittance for glazing with solar protection

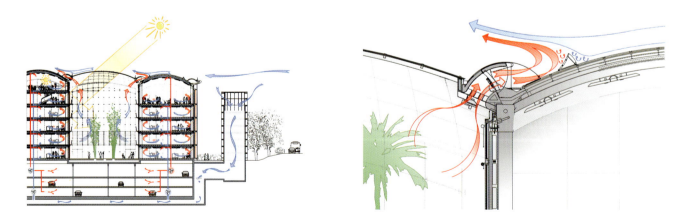

Fig. C1.48 Natural ventilation concept for atria in the Lufthansa Aviation Centre/Frankfurt in Germany. Architects: Ingenhoven Architekten, Duesseldorf

Buildings

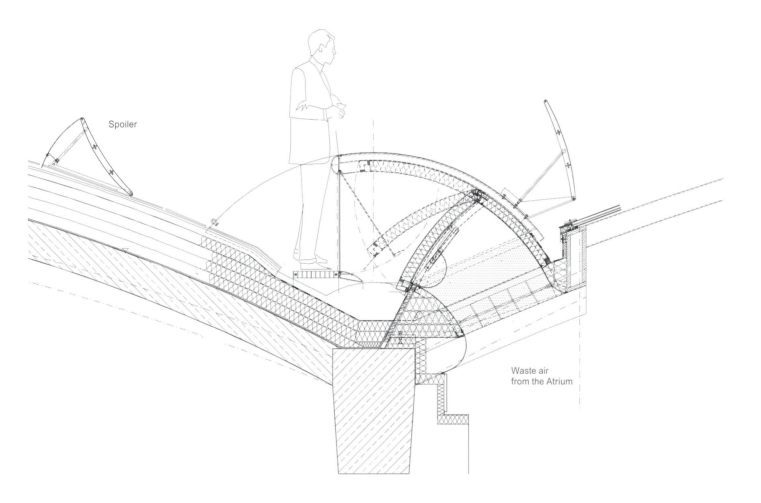

Fig. C1.49 Constructional detail view of waste air flap for natural de-heating in the Lufthansa Aviation Centre/ Frankfurt. The waste air flap was especially developed for this project. In advance of being installed, it was aerodynamically optimised for perfusion through water channel model experiments. Optimisation stages are depicted in images 1 through 4. It can be seen that, through the use of a flow pipe, ventilation is characterised by less turbulence and thus becomes more energy-efficient. For the roof construction, this was achieved by using a spoiler at 2 m distance to the roof opening. It makes sure that the flow can escape in an aerodynamically advantageous manner, thus achieving greater ventilation efficiency than for conventional roof vents.

Building Materials and Furnishings

Building materials emissions play a decisive role for health and well-being of the occupants, whether they are aware of their influences or not. As a rule, the materials used should be free of smells and the following upper limits for environmentally friendly buildings should be adhered to:

- Total emission rate, volatile organic compounds (VOC): less than 0.2 mg/m²h
- Emissions, formaldehyde: less than 0.05 mg/m²h
- Emissions, ammonia: less than 0.03 mg/m²h
- Emissions, cancer-causing agents (IARC): less than 0.005 mg/m²h

Since a building, once completed, only offers very few options of changing indoor air composition (one can merely increase air exchange rates through window ventilation), it is therefore important to use low-emission or emission-free materials from the outset. This, however, is easier said than done: on one hand, many suppliers are unaware of the emission qualities or the toxicological properties of the agents that they deliver. On the other hand, even the best ecological measures can achieve nothing if undeclared auxiliary agents are used during mounting and installation (synthetic resin diluter, primers) or if, during end-cleaning, cleanings agents are used that then counteract and in no time render null and void all the previously so carefully implemented measures.

Only a few years ago, it was mainly walls paints and carpet adhesives that emitted most of the harmful substances. Meanwhile, there are a number of solvent-free and low-emission products for this materials group on the market, so that there barely needs to be any impact on indoor air anymore. Our main focus, instead, needs to be on those materials that are frequently considered much less:

- Metal coatings, e.g. iron oxide varnish and special effect finish for rails, door frames etc
- Primers for foil bonding and re-jointing
- Close contact glue for carpet rims and small floor covering parts
- Covering varnish for damaged power-coated components
- Glue for mounting of insulation materials: systems engineering and fire protection

The list could go on since every single constructional undertaking always comes with a number of surprises as far as unexpected auxiliary building materials go. This makes it all the more important to record as early as possible all those materials and auxiliary materials than can be expected to be used for any and all of the finishing trades. Prior to them being made available on the market, they need to be fully declared by the supplier and equipped with safety certificates. Only then should they be released. Of equal importance is a monitoring of building site activity to make sure that only those products that were declared and released are really being used. Otherwise, there is always the danger of the entrepreneur using some of his own warehouse supplies. A good guideline can be found in the prime contractor handbook titled »Building Ecology«.

There are also **primary-energy considerations** to be taken into account for determining sustainability of a given construction project. For this, we need to take the entire building life cycle but also materials life cycle into account when selecting building materials and deciding on manner of construction. An excellent example for the wide-area application of wood as a renewable building material can be found in the NRW (North-Rhine Westphalia) state representation building in Berlin (Figure C1.51). When selecting the materi-

Fig. C1.50 Excerpt from a D&S Advanced Building Technologies handbook for prime contractors titled »Building Ecology«. Here: Requirements for coatings and paints

Buildings

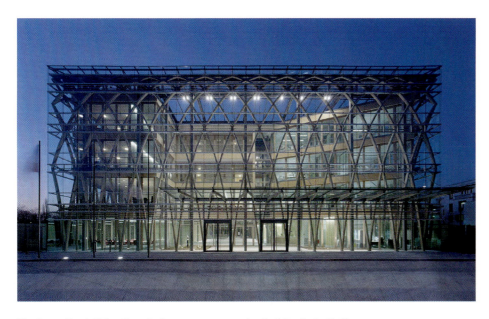
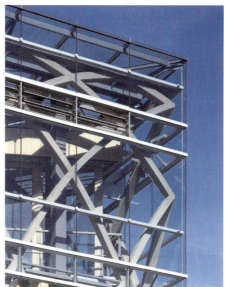

Fig. C1.51 North-Rhine Westphalia state representation building in Berlin/Germany.
Architects: Petzinka Pink Technologische Architektur®, Duesseldorf

als to be used, interactions between materials characteristics and the other energy flows need to be considered also. For instance, if local wood is used as supporting structure, a huge amount of energy for concrete or steel may be saved, true. However, since heat storage in wood is less than for concrete, more energy needs to be expended for cooling purposes each year. When looking at the entire building life cycle from an energy point of view, this results in a negative effect. One option for adjusting wood heat storage capacity to the level of concrete can be found in *figure C1.52*. For wood support construction, gypsum plasterboard plates with PCM parts are used as an underlay. PCM (phase change material) is a novel building material that stores heat by changing its state of aggregation. A layered ceiling made of pure PCM, for instance, of 1 to 1.5 cm thickness, achieves equal heat storage capacity as about 20 cm of reinforced concrete. In this manner, an effective primary-energy savings amount of 3 to 5% can be achieved over the entire life cycle of the building.

Other than for the building envelope, which is exposed to heavy climatic influences, one may primarily fall back on the use of renewable raw materials for interior finishes. Local wood, for instance, can be used for numerous slabs and construction materials. Further, you can use renewable raw materials to replace numerous mineral-oil containing substances and fibrous insulants. Even though insulants made of wood fibre, sheep's wool, hemp or flax are not widely spread throughout the market yet – most likely also on account of the high prices – there are sheer limitless opportunities to use natural and/or renewable materials for sound and heat insulation as well as for indoor acoustics. Let's just think of the ceiling pad for acoustic ceilings, or the impact-noise insulation under the floor screed.

Rising crude oil prices have increasingly rendered the replacement of mineral oils for building materials and coatings more attractive. Synthetic resin coatings and bitumen membranes are already successful on the market, where mineral oil has been replaced with vegetable oil. If – as is usually the case – technical equivalence is given to conventional products, using building materials that are based on renewable raw materials should be a given for Green Buildings.

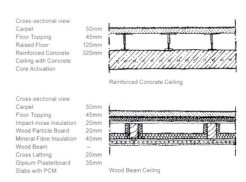

Fig. C1.52 Comparison of ceiling construction approaches for either wood or concrete versions, and for similar quality thermal storage capacities and sound insulation.

Indoor Acoustics

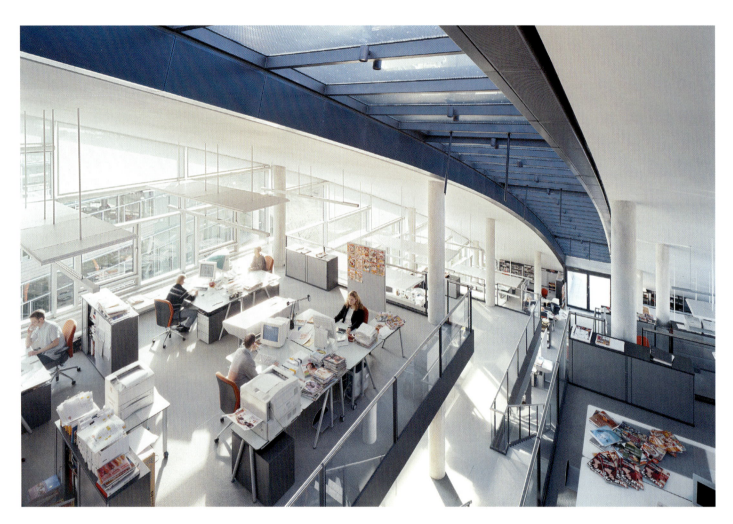

Fig. C1.53 Interior view of the Burda Media Park. Architects: Ingenhoven Architekten, Duesseldorf

Contemporary indoor acoustics design is characterised by its many facets and its adaptability for fitting into an overall design concept. However, the best acoustic concepts can often be undermined by other, energy-sensible measures. Since neglecting acoustic requirements can significantly impact overall comfort levels, integrated solutions must be found that include all the comfort parameters for achieving optimum room utilization and energy targets.

For a good indoor acoustic effect, absorbing elements are required inside the room, the area sizes and absorption capacities of which are oriented on prospective use. *Figure C1.55* shows recommended absorption area per user zone, in respect to main area, according to various stipulations and own experiences. By adhering to these values, good to acceptable indoor acoustic conditions can be achieved.

In the higher frequency range from about 800Hz, the presence of a carpet usually already makes a sufficient con-

Buildings

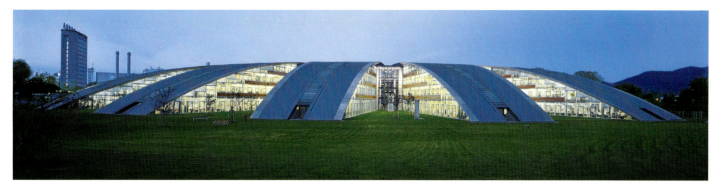

Fig. C1.54 The Burda Media Park in Offenburg, Germany. Architects: Ingenhoven Architekten, Duesseldorf

tribution toward sound absorption. In the same frequency range, sound control plaster, for instance, would also be of help yet using both things together does not result in an additional advantage. A problem, rather, are medium and low frequencies. In order to cater to them, acoustics boards need to be set at 5 to 10 cm deep. For larger rooms with less wall area, where the massive ceiling spaces are used for improving thermal storage capacity in the rooms, it is quite difficult to guarantee indoor acoustic comfort. Solutions are found by exploiting opportunities offered by sound-absorbing equipment like furniture. Roll container and sideboards with perforated side walls, for instance, wardrobes and cupboards with perforated doors or, quite plainly, open shelves with ring-binders all have sound absorbing characteristics and thus offer the desired comfort. Without exploiting these potentials, however, the development of an optimal, integrated concept is impossible. Today as in future, it is very rare to find an energy-efficient building where room furnishings do not serve at least a dual function.

Naturally, acoustic effect is also subject to where and how, precisely, the sound-absorbing objects have been positioned inside the room by the occupants. Depending on the specific requirements and how complex the room geometry is, either simple or complex methods must be used for calculation and design. Reception halls and lobbies, for instance, often will be used for functions, too. However, speech intelligibility is very heavily dependent on the positions of both speaker and audience. With a 3-D simulation model, the parameters for speech intelligibility for every point of the room can be determined, evaluated and even made audible. These types of simulations make sense either when there are different utilizations for different acoustic requirements for the same room, or when architectural design – as is often the case – has a significant influence on sound distribution inside the room *(Figure C1.56)*. For the latter case, especially, alternative materials and furnishing options can be investigated early on and evaluated in respect to expected speech intelligibility and indoor sound. The effort for precise calculation of sound distribution is minimal when compared with the possibly very significant loss of acoustic comfort that could result if, for instance, a speaker cannot be heard at every place in the auditorium or if music enjoyment in a concert hall is hampered by bothersome echo occurrence. Loudspeaker announcement quality can also be determined with those types of acoustic simulations, which is important, for instance, in case of emergency or evacuations when one needs to make sure that what is being said over the speakers is actually understood by everyone in the room, even if the room is large.

A high thermal storage capacity is very important for energy-efficient

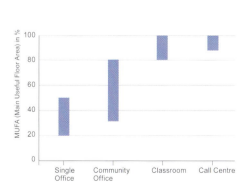

Fig. C1.55 Parameters itemising the required acoustically effective absorption area for different utilizations

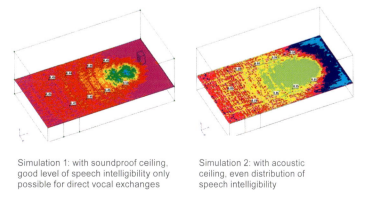

Simulation 1: with soundproof ceiling, good level of speech intelligibility only possible for direct vocal exchanges

Simulation 2: with acoustic ceiling, even distribution of speech intelligibility

Fig. C1.56 Acoustic simulation results: lecture hall. The image on the left shows quality readings for a concrete ceiling, on the right for sound-absorbing ceiling design

Fig. C1.57 Examples for acoustically effective furniture: table screen (left), sideboard with perforated door (middle), Door with micro drilling (right)

buildings. It leads to a balanced indoor climate and also reduces cooling energy demand. Since, for most cases, massive ceilings are used for this – on account of their storage capacity – different areas need to be found for implementation of indoor acoustics measures. Just imagine if we were to cover the massive ceilings with absorptive materials. Thermal storage capacity for the room would be lost, to a large extent at least. This problem applies especially for densely occupied rooms with simultaneous high concentration requirements. Typical uses are community and open-plan offices *(Figure C1.58)*. The available elements, aside from the ceiling, are shown in the examples to follow. *Figure C1.54*, for instance, depicts the Burda Medienpark (Burda Editions Media Park). The rooms are equipped with a thermo-active storage ceiling and are very high. The pendulum lamps are used, in combination with acoustic panels, as absorbers. This results in a very good indoor acoustic effect. Readings, subsequently taken at the company, were able to confirm the predictions made. The voluminous rooms, spanning four levels, present reverberation readings of 0.6 to 1s. This corresponds to the requirements for meeting and office rooms.

Furniture is an excellent source of acoustic attenuation. In conjunction with carpet use, good reverberation times can be achieved provided that the furniture is selected carefully. Even a small table screen can result in acoustic attenuation right at the source, presenting an absorption surface of 1 to 1.5 m^2 for the medium and high frequency ranges. And a sideboard with perforated door, for instance, when freestanding and with the back against a wall, can offer absorption areas of 2.5 to 3 m^2. Nearly every vertical furniture surface can serve as an acoustic absorber if subjected to surface treatments like slits and micro drilling *(Figure C1.57)*. Readings prove that, by choosing furniture carefully under sound insulation considerations, almost anything can be achieved as far as acoustic comfort goes.

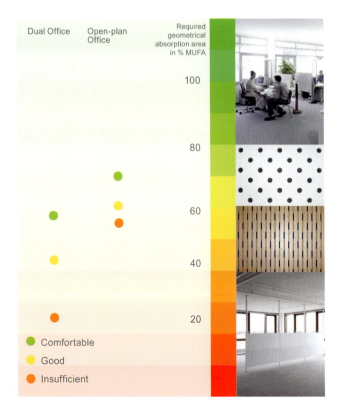

Fig. C1.58 Required absorption area for acoustic comfort in office rooms

Smart Materials

Smart Materials or intelligent materials are one of the prime considerations in the development of construction or integral approaches for resource-conserving buildings. The target here is to improve or completely develop new the characteristics of the materials in view of their energetic and adaptive qualities. In the sections to follow, we will look at some examples of products that are either on the market already or just about to hit it.

PCM (Phase Change Materials) are paraffins or salt hydrates that are capable of changing their condition from a certain temperature. These materials, for instance, change from solids into fluids when they are heated and the critical value has been reached. This means that they act like a heat storage body that can be loaded up from a certain temperature onward (see Figure C1.59). The critical value can be set according to material composition, which makes their application manifold. By adding PCM to gypsum plasterboard sheets, plaster or light ceilings, and depending on PCM proportion, a layer of 1 to 6 cm can achieve the same thermal characteristics inside the building as a concrete ceiling that is 20 cm thick. This means that, even for lightweight construction, light ceilings can achieve large thermal storage capacity. Figure C1.60 depicts the result of a building simulation. Inside a room with a light ceiling, operative temperature is higher by 3 °C than inside a room with a reinforced concrete ceiling and also inside a room with a light ceiling with PCM.

Vacuum Façades The building envelope offers a huge potential for the further development of energy-efficient construction if the following can be achieved: to completely uncouple it from the outdoor climate and thus achieve an inner surface façade temperature that remains at comfort level year round. There are several products for vacuum insulation that have

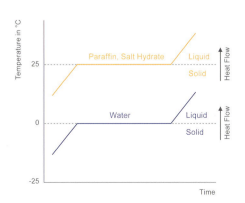

Fig. C1.59 Simple depiction of PCM functioning

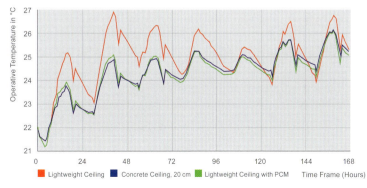

Fig. C1.60 Course of operative room temperature for different ceiling constructions (from a building simulation)

Fig. C1.61 The coat of a polar bear collects sunrays and then acts as a transparent insulation material to keep the heat inside the body. Dolphins are capable of swimming to rapidly with minimum energy demand because the micro-structure of their skins reduces friction to a minimum

been on the market for quite some time and these are being used primarily for special applications or for renovation works. Aside from the good heat insulation characteristics, it is also of advantage that they do not require a lot of space: a vacuum insulation that is 1 cm thick, for instance, can substitute 7 cm of mineral fibre insulation. It is also for glazing that vacuum insulants are pushing into the European market these days. Insulation values for vacuum insulation glazing are better by 35 % than for triple glazing with argon filling. Having said that, there is also the fact that vacuum glazing is more than 25 mm thinner and considerably lighter. A decisive disadvantage, however, and one of the reasons why it is not being as widely used are the costs, which are much higher than for conventional products.

Mineral coatings Selective coatings are standard nowadays for neutral solar protective glass in Europe. The aim here is to allow the sun's radiation frequencies, which generate visible light, to pass through. The other frequencies that do not contribute to light generation – but merely possess heat-generating characteristics – are prevented from passing. This function can be applied also to hangings serving for sun protection but, there, not as a filter for radiation transmission but for reflectance. If these kinds of layers are applied to aluminium ribs then the rib position can be arranged so that better visibility results. This is due to the fact that, even when the ribs are opened wider, less solar heat hits the room and this, in turn, means more effective sun protection.

Low-E Characteristics Every body or object emits heat via convection or radiation. If radiation emission to the inside is reduced by means of low-E coating, the surface is perceived as being cooler. These layers are especially suitable for the roofs of halls and industrial buildings that heat up to a great extent when sunlight hits them and that pass on the heat to the occupied space below. Through the coating of glass or membranes, a construction approach to lowering operative temperature in the occupied areas can be achieved – without the need for additional mechanical cooling.

Glass with self-cleaning properties
For glass with self-cleaning properties, surface behaviour when compared to conventional glass is different in such a manner that dirt can only stick to the surface with great difficulty and is usually for the most part washed off by the rain. This prevents dirt from becoming ingrained and facilitates cleaning. The manufacturers aim to significantly reduce cost expenditure for cleaning of the façades. There are three different ways to make glass with self-cleaning properties.

Fig. C1.62 Vacuum glazing

Fig. C1.63 Solar protection with selective reflectance layer. Creation by Warema Renkhoff GmbH

Fig. C1.64 Simply depiction of functioning for a solar protective device with reflectance coating

Fluorine or silicone based coating with hydrophobic surface behaviour
The process, often referred to as »Nano Technology«, refers to coating different kinds of surfaces with a fluorine-silicone based material. A second, new surface is added to the existing one, which is mostly smooth. The fluorine-silicone based material sticks to the base and has a water and dirt resistant effect. The nano coatings stick to the surface as happens, for instance, with paints. This means that they can be applied to many different types of surface but, owing to aggressive environmental influence, they only have a limited life span.

Titanium Dioxide This pyrolite glass coating is dually active and combines two characteristics in order to achieve its self-cleaning effect. Coating the outside with titanium dioxide results in decreasing surface tension (hydrophilic) and therefore prevents drop formation. The water spreads across the surface, as a thin aquatic film, and then absorbs the dirt as it runs off. These self-cleaning properties are reinforced through a photocatalytic process *(Figure C1.65)*. UV absorption by the titanium dioxide layer generates oxygen. In the process, organic dirt caking dissolves and less dirt can stick to the surface.

Silicon-chemical compounds with hydrophobic surface behaviour
Exclusively suited to glass, silicon atoms (a glass-typical substance) are used as a coating that can be applied to either newly manufactured or existing glass. By means of a photo-process, under application of cold light, the silicon is chemically bonded with the glass and sealed. The surface structure of the glass remains unchanged and manufacturers state that the new seal, which is water and dirt resistant, has an extremely long life span.

Bionic materials and surfaces Over the last few years, bionics has established itself as an independent field of science. Learning from nature has now become a guideline for all industry branches. In construction, it is mainly roof support structure designers that profit by discovering new approaches to their design. For instance, they examine in detail such arrays as tree leaves or the wings of butterflies. Nature offers countless treasures for the application to energy-efficient systems that, when adapted to façades, present novel and innovative concepts. There are, for instance, already plans for developing breathing building envelopes on the basis of amphibian skin microstructure. These skins would be able to adapt to changing climatic conditions without sustaining any loss of energy.

Fig. C1.65 Self-cleaning glass coating with silicon-chemical compounds that allow for water to drip off easily

Fig. C1.66 Micro-view of the skin of a shark, which could serve as an inspiration for novel and energy-efficient façade systems

Natural Resources

An important target of Green Building construction is to use as many natural resources as possible. To what extent this really can be done is very heavily dependent on climatic conditions and precise intended use. For central European climates, the following rules can be considered as valid for the most passive use possible of natural resources:

Rule 1: The higher that thermal requirements are, the higher also are heat and solar insulation requirements.

Thermal comfort requirements, as a rule, are expressed in terms of minimum room temperature in winter and maximum room temperature in summer. For office utilization, for instance, minimum winter room temperatures range between 20 to 22°C, and ca. 25 to 27°C are the maximum room temperatures desired in summer. Room temperature, in this case, is considered to be the combination of surface temperature of interior walls and air temperature. This means that in winter, there is also an indirect requirement for high surface temperatures, something that can be fulfilled only with very good heat insulation. In a similar way it means that with the demand for comfortable room temperature in summer, there is also a demand for minimum surface temperatures. This in turn can only be achieved, via efficient solar protection.

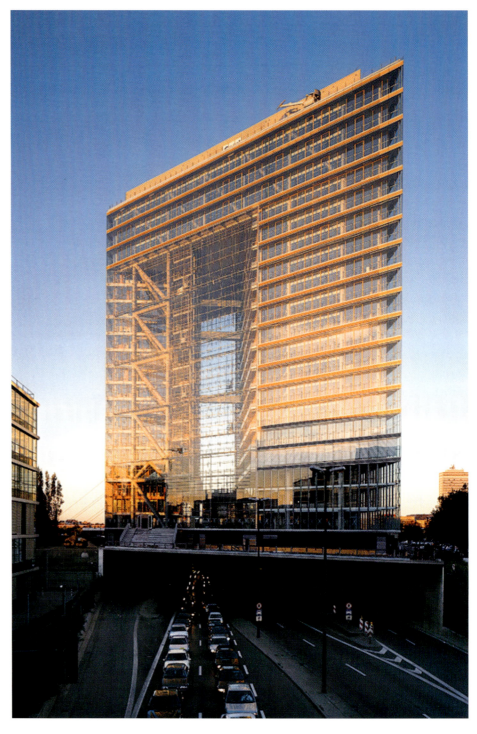

Fig. C1.67 Duesseldorf City Gate. Architects: Petzinka Pink Technologische Architektur®, Duesseldorf

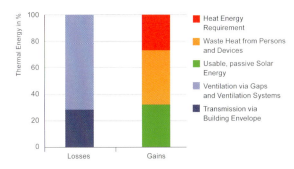

Fig. C1.69 Heat balance of a typical residential building (passive house)

Rule 2: Exploitation of passive solar gains.

The easiest manner of minimizing heat energy requirements through constructional means is by using solar heat. This can be done most efficiently for residential buildings since each residential building usually has a warm area (living room) and a cooler area (bedroom). If zoning is done correctly, and also building orientation, then southern oriented glazing is capable of capturing a lot of solar heat. If construction is then done in a massive type manner, storage of this heat is favoured and the building may fall back on it during overcast days. For other utilizations, passive solar energy use may also be exploited. Hotels, hospitals and care homes, for instance, are very similar to residential buildings when it comes to heat requirements. In offices and educational institutions, it is usually the work at the monitor that prevents extensive usage of solar gains and these buildings are often »loaded up« with sun over the weekend. Frequently, an attempt is made not to apply the solar gains directly to the occupied rooms but instead to adjacent buffer rooms like atria or double skin façades that can be closed. *Figure C1.68* shows an example of a closable double-skin façade, taken from the office construction sector and depicting the Duesseldorf city gate. Measurements taken at the façade have shown that a 20% heat insulation was achieved; this corresponds to an approximate primary energy requirement portion for room conditioning of about 5%. The closable façade of the Duesseldorf city gate, however, also has some other characteristics that allow for a total absence of radiators: static load removal across two façade levels during high wind speeds plus elevation of inner surface temperatures. For passive houses with residential application, solar energy contributes a much larger amount to overall building energy requirement since heat can be more efficiently used for the above-mentioned reasons. Depending on orientation, the proportion is 30% in respect to covering heat loss. When this is applied to primary energy requirement for room conditioning, the corresponding proportion is 20%. This high rate clearly shows that, if solar gains were not exploited, the small heating energy requirement of 15 kWh/m²a for passive houses in central European regions would not be possible *(Figure C1.69)*.

Rule 3: Using building structure as thermal storage.

Thermal storage capacity of a building significantly influences indoor climate and energy requirement. Extreme examples, for instance, are container buildings made of light materials or old castles and fortresses with thick walls. While, for light buildings, indoor temperatures fluctuate almost simultaneously with outdoor temperatures,

Fig. C1.68 View of double-skin Façade of Duesseldorf City Gate

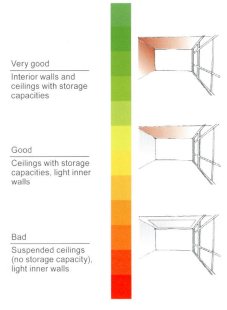

Fig. C1.70 Layout of wall and ceiling arrangement in respect to storage capacity for occupied rooms

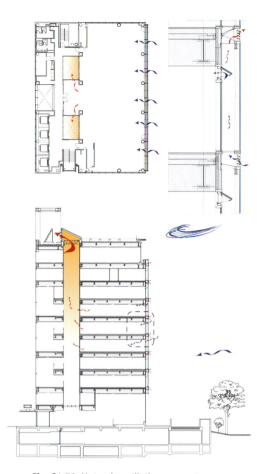

Fig. C1.71 Natural ventilation concept for the Sekisui Building, layout and cross-section

Fig. C1.73 Sekisui office towers in Tokyo/Japan. Architects: Kajama-Design, Tokio

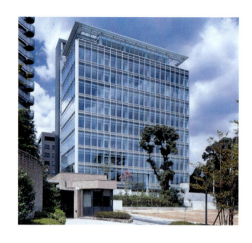

Fig. C1.72 Natural ventilation concept, cross-section

thermal effects for massive buildings (caused by outdoor climate) are often only noticed much later or not at all. Massive buildings, however, have the advantage of being able to smooth out room temperatures because room heat does not only heat up the air of the room itself but also the building mass. Indoor temperatures therefore rise less quickly than for light buildings. That effect, however, also has some disadvantages: if, for instance, for room heating, there must be outside energy influx then it takes much longer for the room to actually heat up. This is due to the fact that building mass needs to be heated up as well. For climates prevailing in Northern and Central Europe, storage capacity of a given building may be used very effectively for either passive room cooling or for lowering cooling energy requirement. Night temperatures are usually low enough during the summer to allow for them to be used as a natural energy potential that guides heat to the outside if it has been stored in the building mass during the day. This means that, on the hot day to follow, there is a new cool mass present that, again, may absorb the new room heat of that day. In order to achieve a noticeable effect, however, the building must have massive components. In *Figure C1.70*, values for storage capacity of rooms are itemized. This clearly shows that, at the very least, ceiling storage capacity must be maintained if the room is to maintain a mentionable inertia of room temperature fluctuation levels. Further, we need to consider that massive components only need to have storage capacity up to 10 to 15 cm depth because, as a rule, during the course of the day it is not possible to activate a larger thermal mass.

Rule 4: Exploitation of natural ventilation potential.

Natural outdoor air potential for ventilation are enormous in the central European regions. If used correctly, then mechanical ventilation can be foregone for more than 70% of the year without restricting comfort levels. Depending on conception, utilization behaviour and comfort level, it may even be possible to ventilate naturally throughout the entire year. Since outdoor temperatures are frequently low during the summer, they also present a high potential for reducing cooling energy requirement. Cooling, however, becomes difficult during the hot summer periods when, even in central Europe, night temperatures do not drop below 22 °C.

In order to turn natural forces into usable powers, concepts must remain adaptable to changing outdoor air conditions in respect to temperature, wind velocity and wind direction. Today's buildings solve this problem either via mechanical control of ventilation elements (opening width can be regulated according to prevailing outdoor conditions) or through manual operation of different, adjustable ventilation openings in the façade.

Not only in Europe, but also in Asia, natural ventilation potential is an important consideration in building design. In Japan, for instance, the climate may be more humid in summer than it is in Europe. However, during the interim period, there is absolutely a potential of between 25 to 40% for natural ventilation and heating. *Figure C1.73* shows the Sekisui House in Tokyo. Previously, that building had the usual exhaust air façade, which did not allow for natural ventilation. Now, a naturally ventilated double-skin façade was designed. This allows for a solar protection device to be positioned in front of the thermal shell, leading to thermal relief for the rooms. Depending on local climate, natural ventilation should be used either as night ventilation or during the interim period. Outside air can enter via mechanically operated ventilation

Buildings

Fig. C1.74 Interior view of the double-skin façade of the Sekisui Building

flaps, which are actuated in a natural manner: in the middle of the building, there are two large shafts that suction off the air via the roof. In the roof region of the waste air opening, there is a constant suction effect caused by wind current. The resulting pressure difference from the wind forces, superimposed by the chimney effect, results in air current through the building. In order to ensure that each level receives an equal amount of air, the overflow openings leading from the office area to the shafts must be arranged at different sizes, depending on level and height effect. Flow balancing of the opening, as experts call it, is calculated by means of simulation technology.

A further example for an effective natural ventilation concept can be found in the Playmobil Funpark *(Figure C1.77)*. This is a completely glazed hall, meaning that heat and cooling loads must be analysed very carefully. Usual calculation procedures do not suffice for these types of buildings when it comes to defining optimum indoor climate. The following are important criteria, in this case, for determining both dimensions and arrangement of heating and cooling elements inside the room: cool air drop at façades and the roof, ventilation loss via joints during high wind speeds, local operative temperature in occupied zones and thermal buoyancy. Such detailed analyses require simulation calculations for thermal-dynamic

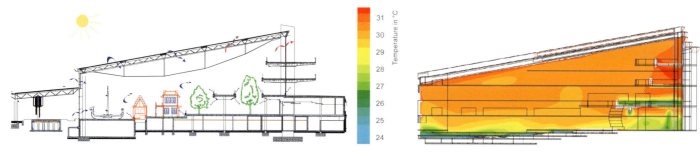

Fig. C1.75 Ventilation arrangement during summer (cross-section)

Fig. C1.76 3-D current simulation. Temperature and air velocity distribution for winter operation conditions

behaviour of a building in relation to system technology and natural ventilation concepts.

As part of the preliminary draft, different glazing variations were analysed. The goal was to obtain an optimum combination of minimum cooling load, minimum cool air drop, minimum heat load and investment and operating expenditures that are justifiable. The best results were obtained with a combination of solar protective dual glazing in the façade and triple glazing for the roof, also with a solar protective layer. Natural ventilation openings are arranged throughout the façade, for one in order to ensure a good mixing of indoor and outdoor air and, secondly, to allow reaction to different weather conditions. For instance, a light cross draught may be perceived as comfortable by someone sitting indoors, if outside temperatures are moderate at around 20 to 25 °C. The same type of draught, when wind speeds are higher or outdoor temperatures lower, may be perceived as uncomfortable and, hence, needs to be removed. In direct occupied areas, outside air supply happens via basic ventilation with shear velocity and heat recovery effect. The resulting thermal stratification in the hall is maintained at a stable level by means of targeted ventilation via the ventilation flaps. Additionally, building storage capacity is increased through activation of all massive ceiling areas via water-filled pipe coils.

The recreational park has been in use since the end of 2005. Building service installations are only employed when natural potentials are no longer capable of meeting the entire demand. For instance, ventilation systems only become operational when outside air influx needs to be increased for the hall on account of visitor numbers inside. The main portion of cooling load, with over 60 % however, is still handled by natural ventilation via the façade flaps.

Fig. C1.77 Playmobile Indoor Recreational Park at Zirndorf/Germany.
Architects: Architekturbüro Jörg Spengler, Nuremberg

Buildings

Innovative Tools

State-of-the-art design and planning tools are EDP programs that allow for a very detailed calculation of physical processes of buildings. As a rule, we distinguish between conventional calculation programs, developed on the basis of simplified calculation procedures (norms and standards), and more complex simulation programs. These calculation programs are generally easy to use but, in return, they only offer simple results. They serve for defining maximum and minimum air temperature settings or indoor heating and/or cooling load, often on the basis of very simplified mathematical models. This does not suffice for reliable information regarding thermal indoor comfort, the operating behaviour of a given building under real-life and variable conditions or for defining energy efficiency already in the early planning stage. Yet, it is in the early planning stage, precisely, where concepts are worked out and thus the path toward the expected level of sustainability is set. Modern simulation methods may not have completely replaced the simple calculation programs of the past but they have overtaken them for the concept phase on account of their higher validity for the entire planning process. For evaluation and optimisation of a building and its envelope, various simulation programs must be utilized since not all the required results can be obtained with one method only.

The most widely used simulation method is for calculating thermal behaviour (thermal building simulation), which defines thermal comfort as mean value for a given room. The calculation principle is based on establishing a balance for the entire energy flux in a given room and defining indoor air and surface temperatures from this *(Figure C1.78 – C1.80)*. Then, the detailed implications for thermal room behaviour and room energy requirement – as they result from different glass coatings and façade constructions, from light versus massive building materials, from the various user interferences (window open/closed, light on/off) or from local climate fluctuation – can be shown. Aside from determining comfort level, it is also possible to determine very realistically energy requirement for heating and cooling. Evaluating electricity requirement for artificial lighting, on the other hand, can only be determined in conjunction with an additional daylight simulation test. Since the dynamics of natural energy potentials – like solar radiation, natural ventilation, wind influence, earth heat and/or cooling – are all taken into account for this procedure, the method is the first step toward the conception of an energy-efficient building. Adapting the building concept to user requirements, optimising façade design in view of local climatic conditions, and exploiting natural energy potentials all result in an indoor climate concept that provides with high – or at the very least acceptable – indoor comfort with low building energy requirement. By means of the

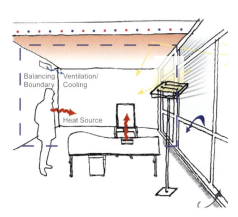

Fig. C1.78 Balancing principle for a building simulation program

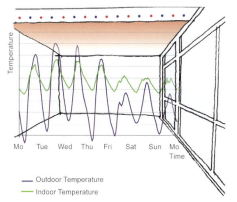

Fig. C1.79 Example for results obtained from a thermal behaviour simulation for a room (temperature course)

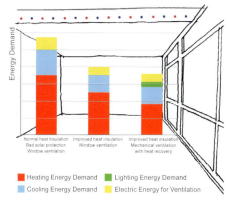

Fig. C1.80 Example for results obtained from a thermal behaviour simulation for a room (temperature frequency)

Fig. C1.81 Balancing principle for a CFD simulation program

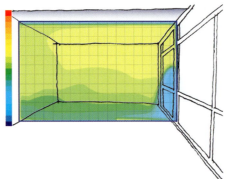

Fig. C1.82 Example for a flow simulation (temperature flow)

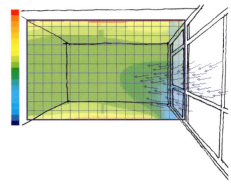

Fig. C1.83 Example for results obtained from a flow simulation (air velocity and flow direction)

annual simulation, we can show how the room temperature and also heat and cooling performance behave – in terms of their frequency of occurrence, over the course of the year. This allows for optimum overall conception for the building. Further, important insights can be gained about the building's operating behaviour: when does it need to be heated? When is cooling required? What heat and cooling loads result during the interim period? These conclusions cannot be reached via a simple calculation procedure. Once building, envelope and indoor climate have been adjusted to each other in an optimum and also energy-efficient manner, the second step on the road toward developing a Green Building is the conception of energy supply systems. This is done with the assistance of building and system simulation programs.

Thermal comfort may have different levels at different parts of the room. For instance, operative temperature in direct vicinity to hot or cool surfaces may differ by several Kelvin from mean room temperature. While mean indoor air and operative temperatures may be determined in a time-dependent manner via thermal simulation programs, current simulations can assist in local evaluation of indoor climate at certain times *(Figure C1.81–83)*. Current simulations, also known as CFD simulations (Computational Fluid Dynamics) subdivide the room into lots of little room volumes. Depending on simulation target and room size, up to 4 million such volumes may be needed. For each little volume, a balance is made up for energy and matter currents, dependent on the respective boundary conditions. The result shows distribution of temperature, air velocity and substance currents (e.g. carbon dioxide). Due to their enormous calculation capacity and duration, these programs can fre-

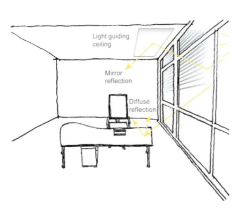

Fig. C1.84 Balancing principle for a daylight simulation program

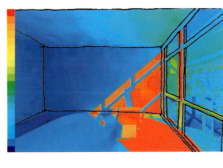

Fig. C1.85 Example for results obtained from daylight simulation

Buildings

Fig. C1.86 Visualisation of a room with the assistance of a daylight simulation program

Fig. C1.87 Photograph of a room in the D&S Advanced Building Technologies building OWP 11 in Stuttgart/Germany

quently only be applied for one setting or a few time intervals but not for determining dynamic processes over the course of several weeks or months.

Aside from pure daylight simulation for interior rooms, daylight programs may also be used for determining, in terms of quantity, general shading of façades through adjacent obstructions or solar protection devices. In comparison to contemporary CAD programs, which only allow for one visualisation with shadow design, this method allows for calculating shading proportion and solar energy flows.

With the assistance of daylight simulation programs *(Figures C1.84 and C1.85)*, several factors surrounding the utilization of natural light may be determined. We distinguish between three different sky models for this calculation: overcast sky, clear sky with sun and clear sky without sun. These programs determine brightness levels at given points in the room and also luminance density for interior surfaces, for different sky conditions. This, in turn, allows for exploitation of optimisation potential in respect to arrangement and size of glass surfaces or photometric characteristics of building materials such as light transmission and light reflectance. The data obtained may also be used for a photorealistic visualisation that can be valid for the decision making process *(Figures C1.86 and C1.87)*.

C2

Building Services Engineering

Benefits Delivery

An essential interface for Green Buildings is that between indoor climate technology and façade. It is a decisive factor for thermal comfort, occupant satisfaction and, to a large extent, also for the energy efficiency of a given building. Thus, utmost care must be taken in respect to the correct approach to this particular interface.

We start the conception from the base of user demands from his or her immediate environment. Contrary to prevailing opinion, these are quite clearly expressed in terms of immediate vicinity surface temperatures, air temperature, air velocity, illuminance level and luminance density etc. The planning engineer, therefore, as a first step uses balancing in order to verify thermal comfort requirements and lighting requirements in terms of prevailing climate at the building site and characteristics of the planned façade.

For residential and office buildings in central Europe, he or she will find out that the heat balancing in winter cannot be closed. This means that the natural, passive energy and heat gains through the sun and interior heat sources through utilization do not suffice to meet user requirements for thermal comfort. This deficiency, in turn, allows for defining the characteristics of the heating system in order to eventually meet thermal comfort requirements. Through variations in the building envelope, the required functions of the heating system may be optimised for certain values. This not only applies in respect to required heat load for meeting specified room temperature levels. The influence of local surface temperatures on thermal comfort may also be measured. It is then up to the planning engineer to decide whether a surface temperature that is too low may be prevented through an increased heat insulation standard or through a targeted heating system.

This method may be applied to any and all areas of indoor climate technology, heating, cooling, ventilation and lighting. For this, user requirements must be clearly defined throughout the year, which allows for concrete definition of required system characteristics. The specific characteristic of a given systems technology to hand over heat, cold, air and light in such a manner that indoor temperature, air velocity, illuminance level and luminance density meet user requirements in terms of time and location, is known as **benefits delivery**.

Not only for heating, but for cooling also, thermal comfort requirements are expressed in terms of surface and air temperatures and also air velocity. The heat balance for residential and office buildings in Central Europe shows that, on days with high cooling load and many interior heat sources, air and surface temperature requirements frequently cannot be met. The resulting heat excess leads to overheating of the rooms. Together with the planning team, the planning engineer needs to analyse whether increased air and surface temperatures can be avoided through improved summer heat protection or through an effective room cooling system. Further, for the areas of ventilation and lighting, system characteristics can be worked out on the basis of the existing requirements.

The resulting and defined characteristics requirements for heating, cooling, ventilation and lighting become a kind of »specification manual« for the room climate systems to be designed. Comfort deficits actually lead to greater energy demand during final operation. As a rule, the user is not willing to accept comfort deficits. Rather, he or she will attempt to reinstate a comfortable indoor climate by adjusting system technology usage levels.

Concept and Evaluation of Indoor Climate Control Systems

For evaluation of an indoor climate control system for office areas, local consideration of work place comfort is to be recommended. People engaging in mainly sedentary tasks over long periods of time suffer much more when comfort deficits ensue and this means that they react to them much more sensitively, for instance to draught and cool air drop, than people who are constantly in motion. Therefore, comfort level consideration needs to be expanded to include operative temperature. As can be seen in *Figure C2.1*, thermal comfort for a given room must be evaluated separately for both room halves. A half room, here, is defined as a space that the occupant senses to the front and back or to the right and left. Thermal comfort only ensues when locally impacting comfort deficits can be balanced in the half rooms and the temperature difference between surface temperatures of the two half rooms is not too great.

For local comfort considerations, it would be advisable to consider and treat separately comfort deficits caused by convective heat sources – for instance cool air drop – from those caused by radiation-based heat sources for example emission to cold surfaces. Of course, it is also possible to discharge convective heat sources in a radiative manner but this can usually only be done at the cost of increased energy demand. *Figure C2.2* shows effective heat sources in an office setting.

An important boundary condition for evaluating comfort is the heat insulation level of the outer façade, since surface temperatures on the façade interior depend on it.

As *Figure C2.6* shows, a façade U-value of, for instance, 1.4 W/m²K and/or 1.0 W/m²K results in temperatures for inner façade surfaces that are 6 and/or 4 K lower. On account of the inner façade temperature, indoor air cools down at the façade area, a cool air drop results and thermal comfort is affected in the occupied zone. *Figure C2.7* shows that cool air drop, in case of temperature that is lower 6 K, leads to a maximum air velocity of ca. 0.42 m/s. However, for occupied zones, only air velocities of 0.15 to 0.2 m/s a re permitted. At 4 K sub-temperatures, cold airdrop still results in an air velocity of 0.35 m/s.

When looking at comfort deficits, it is not necessarily air velocity in the immediate faced region that is of importance but, rather, air velocity at about 1 m distance from the façade, since this is where most people's work stations usually commence. Often, the immediate façade vicinity is to be kept free in any event, in order to allow for operation of pivoted windows at openable façades. *Figure C2.8* shows that air velocity for cold airdrop, at 1 m distance to outer façade, is ca 0.2 m/s for a U-value of 1.0 W/m²K and ca 0.25 m/s for a U-value of 1.4 W/m²K.

This shows that, for a U-value of 1.0

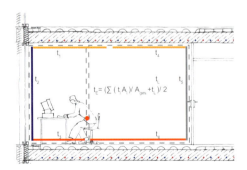

Fig. C2.1 Operative temperature in an office room at half room view

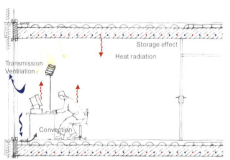

Fig. C2.2 Convective and radiative heat sources in an office room

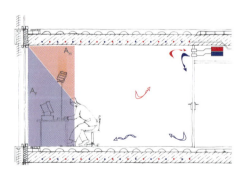

Fig. C2.3 Influence of surface temperature on heat sensation of a person

Building Services Engineering

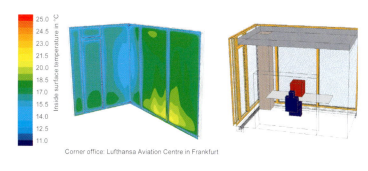

Fig. C 2.4 Airflow simulation for a corner office in a new building (Lufthansa Aviation Centre in Frankfurt/Germany)

Fig. C 2.5 Lufthansa Aviation Centre in Frankfurt. Architects: Ingenhoven Architekten, Duesseldorf

W/m²K, air velocities on account of cold air drop in the occupied region, remain below the maximum permitted value of 0.2 m/s. For faces with a U-value of 1.4 W/m²K, in absence of additional heating, there will be uncomfortably high air velocities in the occupied areas.

Aside from convective comfort deficits, we must now also look at the radiative ones. If there are small temperature differences between the interior surface areas we can simplify our consideration to assume linear relationships for heat radiation.

As *Figure C2.3* shows, a person sitting at a workstation emits heat toward the cold façade area. In order to obtain comfort, the resulting heat loss needs to be balanced by a warm area that is effective in the same half room. If, as described above, we use the simplistic view of linear relationships, radiation balance is given when the product of sub-temperature of cold surface and effective surface and the product of excess temperature of heating surface and effective heat surface is the same for a given half room. On the basis of this equation, we can now calculate distance L, of workstation to façade, which must be adhered to in order to meet comfort requirements. Minimum distance to façade with thermal activation, at a U-value of 1.0 W/m²K is ca 1.7 m. For a façade with a U-value of 1.4 W/m²K it is ca 2.6 m.

Figure C2.4 shows obtainable inner surface temperatures at the Lufthansa building in Frankfurt/Germany. Façades connecting to the atrium, as well as façades to the outside, achieve high inner surface temperatures on account of their good heat insulation level (double and/or triple glazing) and thermally activated ceiling.

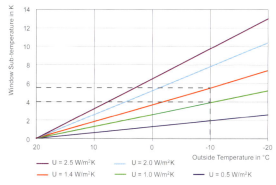

Fig. C 2.6 Window sub-temperature as depending on outside temperature

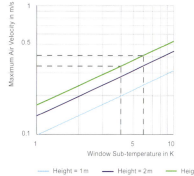

Fig. C 2.7 Air velocity and cold airdrop for window areas Window Sub-temperature in K

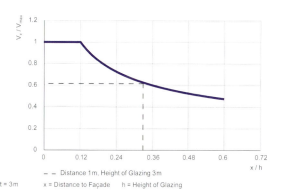

Fig. C 2.8 Air Velocity as depending on room depth

Fig. C 2.9 Office Building of the VHV group in Hannover/Germany. Architects: BKSP Architekten, Hannover

Heating

Benefits delivery for heating systems is an essential area when it comes to future energy savings. In Central Europe and most industrialized nations, heating systems are required for almost all buildings on account of the outdoor climate. Shortcomings in heat delivery to the users often can be felt later on through higher energy demand during operation.

On account of heat insulation, which by now has become very effective, the focus for heating of buildings is no longer on available heat performance. This will always be present in a sufficient manner so long as the heating system has been correctly arranged. More than anything, it has now become a matter of demand-based supply of heat. Room heating systems need to make sure that heat is delivered according to utilization requirements in respect to location and time. For instance, care should be taken that both interior heat sources and passive solar energy usage contribute as large an amount as possible to heating the rooms. In order to achieve this, today's room heating systems need to react quickly and present as little inertia as possible, including room control systems as well.

Further, care needs to be taken that the heating systems can be operated at low temperatures. On one hand, this has a positive effect on control capability and, on the other, energy demand for distribution can be greatly reduced on account of lower heat emission of the pipelines. Further, lower heating temperatures are generally perceived as being very comfortable.

Aside from local specifications regarding their thermal environment, users also present time-related demands in respect to room conditions. Probably the most widely known of these is temperature drop at night, which requires lower room temperature during the night. While night temperature setback or turnoff for office buildings is usually desired for energy conservation reasons, comfort considerations are often behind the same action in a residential setting, e.g. lower room temperatures in the bedroom. Aside from the setback itself, reheating is also an important aspect to be considered since, at the start of utilization time, this is actually required to re-establish comfortable room settings.

The VHV group's office building in Hannover/Germany constitutes an excellent example for requirement-oriented benefits delivery. The façade consists of triple glazing with exterior solar protection device and a highly insulated panel with a U-value of 0.7 W/m²K. Room heating consists of thermally activated ceiling for base load, and of edge trim activated elements as heating ceilings with thermostat for peak load (Figure C2.10). Flow temperature for the thermally activated ceiling, in heating cases, is a maximum of 28°C and for edge trim activated elements a maximum of 35°C. The combination of base and peak load system guarantees for requirement-oriented benefits delivery. The inert, thermally activated ceiling is controlled in a manner that results in ceiling surface temperature being a max of 2 to 3 K above room air temperature. Via the room control system, edge trim elements are regulated in an unsteady manner. This allows them to use brief heat sources for heating purposes and thus avoid room overheating. Further, the room control system allows each user or user group in a large-capacity room the option of individual control and, hence, of setting one's own feel-well temperature levels.

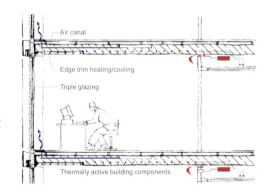

Fig. C 2.10 Office Building of the VHV Hannover, by BKSP architects, room climate cross-section with edge trim activation element.

Cooling

Benefits delivery for room cooling system, as a rule, is very similar to that of heating systems. The main difference is that we now have reverse heat flow. When arranging room cooling systems, we must therefore also consider energy balance for the room as well as local surface temperatures based on utilization requirements. The essential energy gains here are solar radiation and radiation from interior heat sources like people, lighting or machinery. Since cooling has a high energy demand, cooling demand should be reduced as much as possible through constructional means. This leaves mechanical application at a minimum.

On account of the good insulation levels that have risen steadily over the past few years, buildings emit very little heat during the low temperature periods at night. Interior heat sources, hence, can very quickly lead to overheating for office buildings in Central Europe, meaning that even at outdoor temperatures of 26 °C upward, mechanical cooling is already required. Reducing these types of heat sources and optimising façades toward as low a heat intake as possible while, at the same time, exploiting maximum daylight utilization options, are among the essential targets for future developments and for Green Buildings in general.

Meanwhile, cooling systems are already under consideration for residential settings since, on account of their high quality insulation, they barely emit heat anymore at night when cool outdoor temperatures prevail. This is counterproductive when it comes to Green Buildings and, on account of low night temperatures in Central Europe, is also not required. Residential buildings, even today, can be designed in a manner that means they do not require cooling expenditure.

Cooling demand depends on solar radiation, size and transparency level of the façade and interior heat sources. For other climatic regions, e.g. in desert or subtropical settings, outdoor conditions may be so far removed from those on the inside that cooling requirement depends on outdoor air conditioning.

Cooling happens either via cool surfaces inside the room or via cooled air. Due to the lower heat capacity of air in comparison to water, energy demand for cooling by means of air is greater than with water. For Green Buildings, hence, we need to take care that, as a first step, the »cooling« and »ventilation« functions are considered independently of each other.

Cooling surfaces are to be arranged in a manner that allows them to absorb excess heat radiation as efficiently as possible. Ideally, cooling areas should be situated at the room ceiling since the head presents the highest surface temperature and thus the highest heat emission. Head heat is absorbed by the cooling surface at the ceiling, something that occupants always experience as being very comfortable indeed. The floor in the immediate façade vicinity presents another option for the arrangement of cooling surfaces. Solar radiation coming in through the façade can be directly absorbed here and then removed via the cooled floor prior to heat reaching the room again. This principle was applied successfully at the Bochum Century Hall, as *Figure C2.11* shows. There is considerable solar influx on account of the glass roof and this is successfully discharged via the cooled floor.

Aside from direct heat discharge via the floor or comfortable heat discharge through the ceiling, energy efficiency may be optimised via the size of heat-conducting surfaces, analogous to the heating system. The larger heat conducting surface size, the more closely operating temperature may be to room temperature. We speak of a high temperature cooling system in this case whereas, for office settings, temperatures of ca 18 to 20 °C are sufficient. Especially for cooling, outdoor climate may also be used as a resource-conserving concept. For moderate, Central European climates, night air temperatures usually stay below 18 °C. This means that this particular cooling potential may be used via a day-night storage arrangement. In this case, we speak of thermally activated building components (TAB). Via storage mass of the components, night cooling stores a certain cooling potential that then becomes available for cooling during the day.

Ventilation

Since heating and cooling functions according to the same principles, it makes sense to use the same surfaces for both heating and cooling purposes. This results in long operating times for the systems and, therefore, in a very economical approach. Especially to be considered, here, is the control technology, since room regulators and regulating valves must close in summer when temperatures drop too low and open in winter when they get too high. They also need to be able to do this for different regulating parameters. For heating and cooling surfaces with a large storage capacity, regulation is not to be recommended on account of their inherent inertia because changing target temperature settings would take too long if it is based on controlled variable considerations. These types of systems – like, for instance, thermally activated ceilings – are to be controlled, not regulated. The controls must be arranged in such a manner that surface temperature does not deviate by more than 2 to 3 K from room temperature. This is the only way to avoid overheating or under-cooling of the rooms.

Ventilation of buildings refers to the air exchange of indoor air with outdoor air whereas, depending on utilization requirements, the outdoor air – prior to entering the room – is treated: filtered, heated, cooled, humidified, dehumidified or cleaned. With the incoming air, user-dependent substance loads that present bad smells, harmful substances, CO_2, and the like, is to be deviated to the outside. Substance loads originate from various material sources, which must be analysed in a utilization-oriented manner. Canteens and eating halls, for instance, provide substance sources through the foods consumed there. In case of industrial operations, the production machines also constitute material sources that emit, depending on the process, smelly substances or even harmful ones. In office settings, it is humans that act as substance sources through their perspiration. Then, there are also computers and furniture, which both emit various substances. Via ventilation, an attempt is made to dilute this substance load inside the room and then to dissipate it so that the air quality in the room becomes both hygienically impeccable and health-supportive.

Ventilation is also used for dissipating heat sources, meaning for cooling. For this, cooler outside air streams into the room and warmer room air streams outside in turn. The temperature difference between outside air and room air, as well as the airflow, influence cooling load.

Just like for heating and cooling, ventilation also requires the creation of an energy and mass balance sheet. Here, it is shown what types of materials or substances are being emitted inside a given room and how much outside air needs to be brought in to ascertain dissipation of the substance loads. The required ventilation load must be covered through sufficient ventilation.

Fig. C 2.11 Cross-section of the Bochum Century Hall. Architects: Petzinka Pink Technologische Architektur®, Duesseldorf

Building Services Engineering

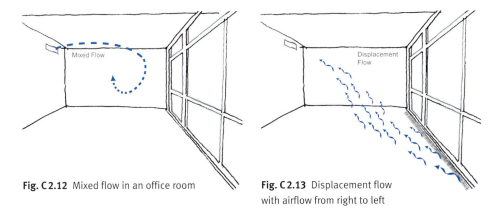

Fig. C 2.12 Mixed flow in an office room

Fig. C 2.13 Displacement flow with airflow from right to left

The easiest manner of ventilating is that of natural ventilation via windows that can be opened. If this is done, outside air enters the room either through the open window or the façade element. Depending on window size, window type, temperature difference between outside and room air and façade pressure conditions, either more or less outside air streams into the room and room air to the outside. *Figures C2.14 and C2.15* show relative airflow rate dependent on window type and also obtainable outside air exchange dependent on inside and outside temperature differences.

In case of natural ventilation, this airflow can only be regulated with difficulty, since conditions are constantly changing. Further, low outside temperatures can quickly result in draught conditions in façade vicinity. From an ecological point of view, a natural ventilation concept may make sense on account of the power savings for mechanical ventilation. However, in case of high outside air exchange rates and low outside air temperatures, one needs to consider that huge airflow rates during natural ventilation will not be able to enter the room without draught. Further, in case of extreme outside temperatures in winter, as well as in summer, there is considerable energy loss because heat recovery is not possible in case of natural ventilation. Hence, for these time periods, mechanical ventilation with efficient heat recovery is the method of choice.

Hence, for Green Buildings, we need to precisely evaluate whether heat recovery potential is larger than electricity demand for mechanical ventilation. In that case, it needs to strive for a combination of natural ventilation in the interim periods and mechanical ventilation in extreme periods during winter and summer. We speak of a hybrid ventilation concept in this case.

For HVAC systems, during benefits transfer in the room, the following criteria need to be considered:
• Air flow inside the room

• Air transport between outside air entry into the building and inlet air entry into the room and
• Air treatment procedure for heating, cooling, humidifying, dehumidifying, filtering and cleaning

With the concept of **air flow routeing** inside the room, the course is set for an energy-efficient and effective ventilation of the room. For air flow routeing inside a room, we basically distinguish between three different airflow forms:
• Mixed flow,
• Displacement flow and
• Stratified flow

In mixed flow, inlet air is guided into the room inductively via rifled air passages, slit air passages or nozzle air passages *(Figure C2.12)*. Via the induction, inlet air mingles quickly with room air, resulting in almost complete mingling of room air. Hence, with this airflow form, room air conditions are almost identical anywhere in the room.

In the case of displacement flow, inlet air is guided into the room in such a

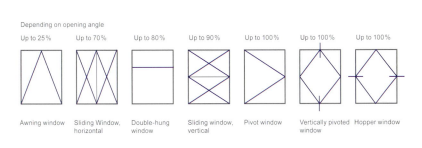

Fig. C 2.14 Relative air flow rate depending on window type

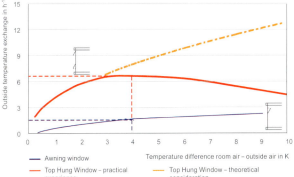

Fig. C 2.15 Outside air exchange depending on temperature difference between indoor and outside air

Fig. C 2.16 Standard Hall of the Stuttgart State Fair in Germany. Architects: Wulf & Partner, Stuttgart

manner as to displace airflows caused by substance sources or by heat sources. This principle is applied, for instance, in clean rooms during the manufacture of silicon plates. In most cases, inlet air is guided in through the sides in order to target dirt particles in the air and displace them via a kind of plug-flow *(Figure C2.13)*.

With stratified flow, inlet air is guided into the room in a manner that uses natural uplift caused by heat sources to achieve a stable air layer in the occupied area. Inlet air is usually guided either directly into the occupied area or into its immediate vicinity. To avoid draught, inlet air here has very low velocity of around 0.2 to 0.4 m/s.

A distinct advantage of this form of airflow is that both heat sources and substance sources dissipate from the occupied zone through their own uplift. Hence, this form of airflow is especially suitable for rooms where room height overall is larger than height of occupied zone. Ventilation demand can be considerably decreased through this, since only the occupied area and not the entire room needs to be targeted, for instance in the case of trade fair halls, lecture theatres, airport terminals, general halls etc. Since inlet air speeds are low, this type of airflow leads to a comfortable room climate also in office rooms. In office rooms, however, occupied zones extend almost over the entire room size.

This means that energy-related advantages, when compared to mixed flow, are not quite as prominent as is the case for high rooms.

Real-Life Example: State Fair Stuttgart
An essential requirement for benefits transfer in trade fair halls is to create a satisfactory room climate for trade fair visitors and exhibitors while also providing limitless flexibility and supply certainty. Usually – for this approach – trade fair halls are heated, cooled and ventilated through the ceiling via rifled air passages according to the mixed flow principle. On account of hall height, expenditure is very high when it comes to guiding the conditioned air from the

Building Services Engineering

Fig. C 2.17 Stratified airflow simulation in standard hall at the Stuttgart State Fair. Colour field diagram for air temperature inside the hall.

Fig. C 2.18 Interior view of a standard hall at the Stuttgart State Fair

ceiling into the occupied zone in a draught-poor manner. The state trade fair, thus, has opted for a different path and relies on stratified flow. In the cooling event, which prevails for trade fair use on account of the huge amount of inside heat sources, inlet air is stratified into the occupied zone. To this end, there are two stratified air inlets each in the region of the entrance gates. These are supplied – via short air transport passages – by the ventilation centres in the supply duct below. This innovative ventilation approach, which has never been used before in trade fair halls of that size, was developed with the assistance of simulation calculations and was then optimised further during model experiments at a scale of 1:1. Here, the essential problems to be solved were, firstly, whether it would be possible to apply this ventilation approach also to trade fair halls 70m wide and, secondly, whether air velocities would remain within the comfortable range.

Compared to conditions at similar modern trade fair settings, the required inlet airflow was decreased by 30% with this ventilation approach. When applied to the entire trade fair grounds, this means that ventilation systems with a total air volume of 1 million m^3/h were suddenly no longer required – and yet there is a higher comfort level in the occupied zone than at comparable fair halls that are being ventilated by the mixed air principle. Further, the optimisation allows for the economical use of heat recovery systems presenting heat recovery rates of more than 80% – on account of the high waste air temperatures.

By applying the stratification ventilation principle for the sustainable optimisation process, complete with heat recovery and central arrangement with ice storage, overall heat and cooling systems were reduced by 40% in comparison to other fairs. Aside from being economical, there are also ecological benefits. Each year, for instance, there are 1130 fewer tons of CO_2. This corresponds to the approximate annual harmful substance emission rate of 220 residential one party homes.

A second, important consideration for an energy-efficient arrangement of benefits transfer for ventilation is the **air transport** between outside air entry into the building and inlet air entry into the room. If this path is looked upon not merely as air distribution but truly as a transport path that requires energy demand, and for which there is also air loss through leakage, we can see that the required effort ought to be kept as low as possible. Hence, during design, we need to take care that outside air entry into the building happens as close as possible to the rooms that are to be supplied with inlet air. The simplest solution here would be window ventilation, meaning natural ventilation, since it allows for air to stream directly into the room. However, if there is a need for somehow treating the outside air, we need a system technology that is to be arranged in either a central, semi-central or decentralized manner.

In case of a central arrangement, there is usually the largest amount of effort expended on air transport – since conditioned inlet air generally must be transported to the various rooms through a complex air duct system. Since the room furthest removed ge-

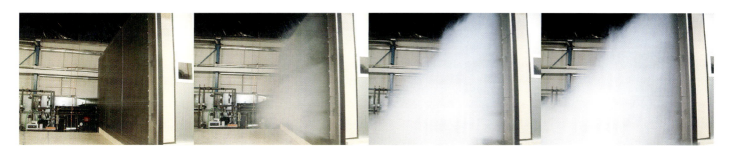

Fig. C 2.19 Airflow experiment at 1:1 scale at a fair hall at the Killesberg in Stuttgart

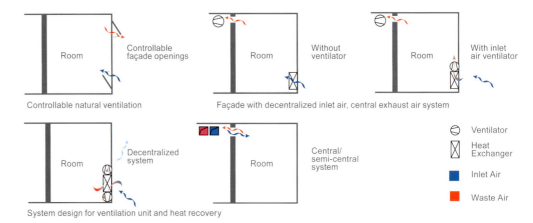

Fig. C 2.20 Overview of various ventilation designs

nerally defines the maximum pressure level required, this pressure then needs to be throttled for all inlet air admissions. This means that energy demand is comparatively high. On account of the central arrangement, the ventilation system must be in operation whenever even only a single room needs ventilation. For the central solution, it would require a huge system effort to achieve either room-based inlet air conditioning or individual turn-off. In case of Green Buildings, therefore, a separation of the regions to be supplied by mechanical ventilation is generally required. This means that office areas in close façade vicinity, which are ventilated via windows, can be disconnected from mechanical ventilation during the interim periods in spring and autumn. Ventilation demand may then be restricted to both the extreme periods and those areas that must absolutely be ventilated mechanically on account of building-or utilization considerations. A huge advantage for this arrangement is that there is only one system for which maintenance, inspection and operation requires very little effort.

The alternative to central ventilation can be found in so-called room ventilation units: decentralized ventilation. During decentralized ventilation, each room, each axis or every second axis is equipped with a decentralized ventilation system. Herewith, the ventilation systems may be equipped with various functions. Contrary to central ventilation, air transport can be reduced to a minimum here since outside air is suctioned directly in the room and treated there. The decentralized arrangement means that each user may decide individually whether he or she wishes to be supplied with conditioned air or not. On account of the long interim periods for Central European climate regions, there are also long periods of time during which the decentralized ventilation elements actually would not need to be operated. Further, due to shorter transport times, pressure loss for decentralized devices is much less than for central systems. This, in turn, means that energy demand is reduced considerably. Both these aspects, taken together, lead to an energy-savings potential of ca 20 to 30% when compared to central ventilation arrangements. A disadvantage for decentralized devices, however, is their much higher need for maintenance and inspection. Therefore, decentralized ventilation is only economical for today's construction undertakings and at current energy prices when construction volume-based savings obtained through shorter transport passages may be offset to benefit the creation of new office or useful space creation. For instance, in the case of high buildings with low storey heights, several storeys may be handled at once (for same building height) due to there being no need for air duct installation areas. The easiest manner of decentralized ventilation is an outside air perfusion element without ventilator or further air treatment characteristics. Waste air is suctioned either directly from the room or, via overflow, at the hallway-separation wall in the hallway. Through opening or closing of the element, each user can individually decide whether he wishes to be supplied with outside air. This concept, in a way, is the first evolutionary stage toward window ventilation. It is very easy to handle and very economical. However, the user cannot influence incoming air temperature, which always corresponds to outside temperature. Further, no heat recovery is possible during window ventilation. The ventilation elements are either integrated into the raised floor or the façade. *Figure C2.20* shows the different available ventilation options.

Depending on indoor climate demands, these elements can be complemented with air treatment characteristics, to heat, cool or humidify (etc.) the outside air. In case of fluctuating pressure conditions at the façade, e.g. in case of skyscrapers without a double-skin façade, it may also be necessary to integrate an inlet air ventilator to guarantee sufficient air inflow. The more complex the system becomes, however, the more costs for such a system increase also. A decisive disadvantage, for a design including decentralized inlet air elements and central exhaust air dissipation, is an increased heat recovery demand that cannot be handled in an economically viable manner.

Building Services Engineering

While waste air volume flow can be cooled down via a heat exchanger, waste air temperature level is not that high and, therefore, distribution effort immense. Alternatively, waste airflow can be cooled down with a heat pump in order to achieve a higher temperature level for the in-feed. However, high heat exchange costs do not allow for economically viable handling of this option, even for rising energy prices. These types of arrangements, hence, are not to be recommended for Green Buildings.

Decentralized ventilation concepts for Green Buildings, hence, must offer the option of heat recovery through a decentralized ventilation element, which means that – aside from inlet air – waste air is also handled by this element. Solutions of this kind require the highest integration level of HVAC into the façade, and that already at a very early stage of planning. An advantage of this arrangement, however, is a highly efficient heat recovery approach, coupled with individual user operation where the user can turn the ventilation element on or off according to requirement. For Green Buildings, therefore, this is to be highly recommended. A disadvantage is found in the costs, which are still very high on account of more complex system requirements. Further, these are always individualized solutions, which must be adapted to respective building or façade type and thus can only be manufactured in lower numbers.

The third of these criteria during benefits transfer can be found in actual **air treatment** in the ventilation device itself. Depending on requirements, the outside air needs to be heated, cooled, humidified, dehumidified, filtered or cleaned. For the various climate-system procedures, care needs to be taken that demands placed on inlet air are met with as little energy demand as possible. Here, too, demand-oriented regulation or control is a must.

 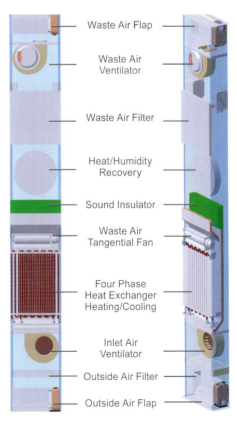

Fig. C 2.21 Decentralized ventilation element with inlet and waste air heat-recovery, at a width of about 33 cm. Project: Nycomed in Constance

Fig. C2.22 Union of decentralized power plants to form one virtual power plant

Energy Generation

All buildings must be supplied with electricity and, depending on local climate conditions and comfort requirements, also with heat and cooling. Mostly, heat is generated in the building itself through combustion of fossil fuels like oil or gas. Electricity is usually supplied by an outside source and is often also used for cooling generation. Growing environmental conscience, liberation from the energy market, rising energy prices and attractive subvention measures have now led to other energy generation forms being tried and/or developed. Here, two groups have crystallized where primary energy is being exploited much more efficiently than contemporary arrangements.

In the first group, quality electrical power is being home-generated while waste heat is used for heating the building in winter and cooling it in summer. These systems are known as trigeneration. They allow for reaching utilization factors usually only found in modern power plants. Further, they present the advantage that energy is being generated on location and therefore only minimal distribution expenditure is required. If, instead of fossil energy sources, biomass or biogas is used, energy generation becomes nearly CO_2 neutral.

The second group uses regenerative energy sources like the sun, wind or earth heat for energy generation. On account of the fluctuating energy supply and rather small energy density, these types of energy sources are not capable of replacing conventional energy generation completely, especially when it comes to power supply. Generation variability is also the reason why the electricity thus generated is usually fed into the public supply network, which then serves as virtual storage.

Virtual Power Plant

With the increased spread of small, decentralized power plants for energy supply of buildings, the concept of a virtual power plant becomes tangible. It describes an interlinking of all decentralized power plants into one union, which is then administered jointly from a central control room. Through coordinated in-feed of electricity, e.g. from wind turbines, trigeneration stations, photovoltaics and biogas plants, peak electricity demand can be met. Base load is still covered via the central large-scale power plants. Although large energy suppliers do not yet consider this decentralized option to be a valid alternative for covering their own peak load demand, the smaller municipal energy suppliers already apply this principle very successfully. In Coburg, for instance, emergency power units from private buildings are emergency-operated in a remote manner by the public energy provider whenever electricity peaks happen in public supply networks. The building owners are doubly rewarded for making available their power:

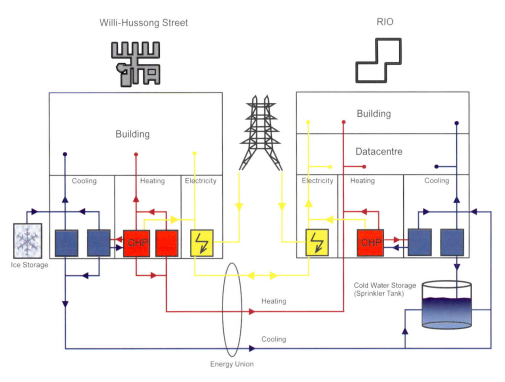

Fig. C2.23 Schematic diagram of the energy union between Willi-Hussong Street and the RIO logistics centre of HUK Coburg

Trigeneration or Trigen Systems (CCHP)

for one, running times are offset against the required monthly safety trial runs. Secondly, for the supply. From an energy consideration, also, this is very efficient because best demand values can be obtained for all the systems.

The HUK-Coburg insurance company supplies an exceptional example for a virtual power plant with decentralized trigeneration systems. In order to ascertain energy-efficient operation, the logistics centre and the other buildings present are lumped together to become one coherent unit *(Figure C2.23)*. Involving favourable storage techniques as well, optimum trigeneration operation is guaranteed. This is an important component, among others, in the strive for moving the energy obtaining process out of the expensive and inefficient peak load times and onto favourable weak load times. The core in this is the sprinkler tank, which is required for fire safety reasons. It is being adapted into a cold-water storage unit with a cooling load of 900 kW. Simulations assist in optimising both its shape and loading and unloading techniques.

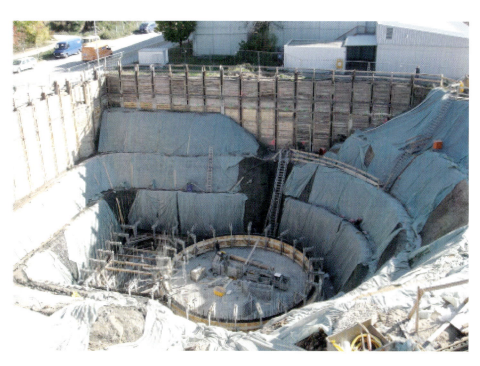

Fig. C 2.24 HUK Coburg – Construction of 1100 m^3 sized sprinkler/cold water storage

The effort required for installation and operation of a trigeneration system is both large and pricey. For this reason, this kind of technology is primarily used for buildings with high-energy consumption like data centres or regional heat networks. In order to operate such a system in an economically viable manner, long operating times are required. This can only happen when there is year-round heat and electricity consumption. Applications that have heat demand year-round, like, for instance, public pools are predestined for such concepts. In other cases, where no heat energy is required in summer, the resulting waste heat during electricity generation may be used for cooling generation. At the core of such a trigen system is an engine that actuates the generator for electricity creation. The lower performance classes, between 10 and 1 000 kW, often use a combustion engine. Since combustion engine and power generator form one unit, this type of system is also known as a CHP (combined heat and power unit). The technology is tried and tested, the aggregate easy to regulate. Electric efficiency factors of 35 to 40 % and total efficiency factors of 80 to 85 % can be obtained. For large systems above 1 000 kW, gas

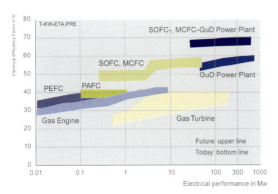

Fig. C2.25 Application areas of trigeneration systems and their electrical efficiency factors

turbines are utilized and these have a total efficiency factor of up to 85 %. In order to increase electrical efficiency even further the gas turbines can be combined with a steam turbine. This results in electric efficiency factors of around 58 % and total efficiency factors of nearly 90 %. For operation of these so-called gas and steam cogeneration plants, liquid or gaseous combustibles like natural gas, biogas or heating oil are used *(Figure C2.26)*. In order to achieve high efficiency factors also for smaller size systems, recent years have seen the development of micro-gas turbines for performance classes below 100 kW. The advantages of a micro-gas turbine are its simple, compact and robust construction and also its good speed control with high partial load efficiency factor while at the same time presenting low nitrogen emission.

Fuel Cell

A fuel cell also generates heat and electricity simultaneously. In contrast to a gas and steam cogeneration plant, the combustion engine in this case is replaced by a fuel cell where chemical energy is directly converted into electric energy. An advantage of this conversion is the high total efficiency factor of up to 65 %. Unlike in the case of mechanical systems, it is not subject to a limiting factor – the Carnot factor. This factor defines what theoretical proportion of the incoming heat can be converted into mechanical work. This results in small fuel cells presenting efficiency factors of a size that is usually only typical for large combination power plants.

The technological development of fuel cells concentrates on five different fuel cell types with different characteristics *(Table C2.1)*.
The following electrolytes are employed nowadays:
- Solid Oxide Fuel Cells
- Molten Carbonate Fuel Cells
- Alkaline Fuel Cells
- Phosphoric Acid Fuel Cells
- Polymer Electrolyte Fuel Cells

During the electro-chemical conversion process, almost no harmful substances result. Small amounts are created while heating the reformer. The reaction water that results during the procedure can be entered into the sewage system without problem. Heavy metals are emitted neither with the wastewater nor with the air.

The first fuel cell that ever hit the market was called PAFC. Its technological market maturity was achieved by serialisation and then confirmed in pilot facilities. The PC25C by ONSI, with the PAFC electrolyte, supplies 200 kW of electricity and 220 kW of heat. It converts 40 % of energy supplied by natural gas into electricity and 45 % into useful heat. Temperature may be decoupled in a low

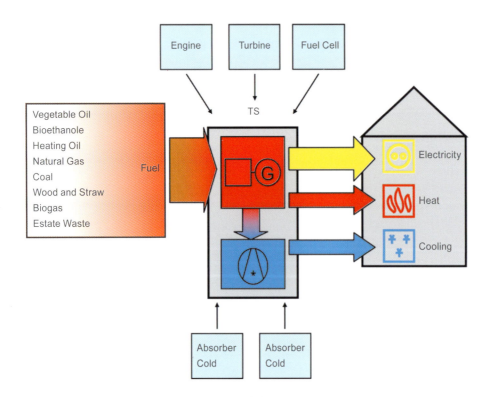

Fig. C2.26 Schematic layout of trigeneration system (TS)

temperature range of 70/35 °C and a high temperature range of 115/95 °C. The fuel cell CHPU may be regulated with a setting between 0 and 100%, whereas an operational setting between 50 and 100% is sensible. However, investment costs are still very high, at an average lifetime of 70 000 operating hours.

Fuel cells with PEFC technology are considered to have a great future in the automotive sector and also for home energy supply. Currently, fuel cell heating systems, with performance data of 4.6 kW for electric energy and 6 kW for thermal energy, are being developed. These are custom-made, virtually, for the requirements of detached houses and residential blocks in Northern and Central Europe. High temperature fuel cells (SOFC and MCFC) are especially suitable for static power generation and also for coupled static electricity and heat generation with high performance readings. Owing to high system temperatures, these contemporary gaseous fuels and gaseous liquid or even solid combustibles (hydrocarbons) can reform with the waste heat of the fuel cells, meaning they can separate hydrogen. Further, high temperature heat may be usefully applied in industrial processes of all kinds (for instance as process steam). This may then also be used for downstream turbine aggregates, for the purpose of further electricity generation – leading to an even further increase of electric efficiency factors for fuel cell power plants.

FC Type	Electrolyte	Temperature Range (Cell in °C)	Gaseous Fuel (primary)	Electrical Efficiency Factor	Manufacturer	Output (MW)
Alkaline (AFC)	30% KOH	60 – 90	pure H_2	60		
Polymer Electrolyte Membrane (PEMFC)	PEM Nafione®	0 – 80	H_2, Methane, Methanol	60 (H_2) 40 (CH_4)	BGS Siemens	0.25 0.12
Direct Methanol (DMFC)	PEM Nafione®	60 – 130	Methanol	40		
Phosphoric Acid (PAFC)	conc. H_3PO_4	120 – 220	Methane, H_2	40	Toshiba ONSI	11 0.2
Molten Carbonate (PMCFC)	Li_2CO_3/ $_2CO^3$	650	Methane Coal Gas Biogas Biomass Gas	40 – 65 60	ERC MTU	2 0.28
Solid Oxid (SOFC)	$Zr(Y)O_2$	800 – 1000	Methane Coal Gas, H_2 Biogas Biomass Gas	50 – 65	Westinghouse Sulzer Hexis	0.1 0.001

Tab. C2.1 Comparative table of the different fuel cell types

Solar Energy

Fig. C 2.27 Glass-covered flat collectors and foil collectors for heating of drinking water

Fig. C 2.28 Photovoltaic-collectors for electricity generation

Worldwide, solar energy comes in many forms. In plants and biomass, for instance, this type of energy is chemically stored and may be regained through different procedures, such as combustion. Air currents and wind energy also result from sunlight warming the surface of the earth. Solar energy can be used directly via solar collectors for heat or electricity generation. Thermal solar collectors, in essence, consist of an absorber and a heat insulated shell, the front of which is transparent. Through using highly efficient materials like vacuum insulation, a gas filling or selective absorbers, the collectors can be adapted to the most varying requirements. At the low temperature range, below 50 °C, their utilization includes pool heating; at medium temperature range (50 to 100 °C), there is drinking water heating and room heating and, for the high temperature range above 100 °C, the application is a process heater for industry. At the low temperature range, inexpensive and uncovered absorbers are generally used. At the medium temperature range, the absorbers are usually selective and covered with a glass plate. For reduction of heat loss at the high temperature range, vacuum pipe collectors or double covers are used.

With photovoltaic collectors, sunlight is not converted into heat but into electricity. For this, silicium is used on mono and poly crystalline and also in amorphous form. Mainly, it is the mono and poly crystalline forms that are being used for solar cells. It is cut from crystal blocks and presents a high efficiency factor of around 14 to 18 %. Development, however, is now heading in the direction of amorphous silicium that, through vapour depositing on a base, can be made in a cost-effective and material-conserving manner. The efficiency factor is somewhere between 5 and 7 %. Without state grants, however, the use of photovoltaic systems is not economical in view of current energy prices and thus restricted to niche applications like areas for which no power supply network is available. In Germany, therefore, the renewable energy law (EEG in German) regulates in-feed compensation. This results in amortization times of between 15 and 18 years. The energy backflow, meaning the time the cells require to generate as much energy as was expended for their manufacture, lies between two and six years.

Solar Energy as Actuator for Cooling Generation

Solar cooling energy has continuously developed over the last few years. The incentive of this particular system is in the fact that times for cooling requirement also correspond with those times where the highest amount of solar radiation is available. For solar energy to heat conversion, three procedures, in essence, are available:

- Absorption
- Adsorption and
- Desiccant cooling systems

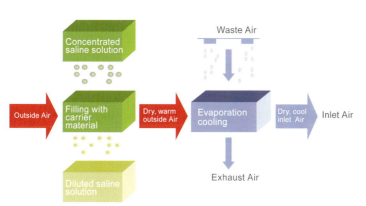

Fig. C 2.29 Schematic depiction of air treatment procedure in a desiccant cooling system

Absorption

Absorption cooling systems have been in operation for years and especially cut a niche for themselves at the low temperature range to -60 °C. At these types of low temperatures, ammoniac is used as a cooling agent. At normal temperature levels above 5 °C in the climate system, water and lithium bromide is used. Since, during the absorption process, some 140 % heat is used for conversion into 100 % cold, the heat – from an energetic point of view – should come from either waste heat procedures or regenerative energy sources. For actuation of the absorption process, heat in form of steam or hot water may be used at 80 to 180 °C. This temperature level applies more during combustion processes than for solar collectors. The highly efficient trigeneration system used to be reserved for large-scale plants from a cooling performance of 300 kW onward. In the course of decentralization of energy supply, however, small absorption facilities between 4.5 and 35 kW are currently in development.

Adsorption Systems

An adsorption system functions according to the same principle as an absorption cooling system. Only, instead of a liquid solvent, a solid adsorption agent, e.g. silica gel, is used. Since this procedure is a discontinuous and therefore more complex one, these types of systems are more costly. Their advantage lies in low temperature levels during heat inlet, between 50 and 90 °C, which allows for efficient integration of solar collectors.

Desiccant Cooling System

Desiccant cooling systems work with low operating temperatures of 50 to 90 °C. Outside air is dehumidified and cooled. We distinguish between solid and liquid sorption agents. Solid agents can be found in DEC systems (desiccative evaporate cooling), which employ a rotating sorption wheel to dehumidify the air and then, through heat influx (waste heat, solar heat), regenerate it once more. In systems with liquid sorption agents, contrary to what happens with rotating sorption wheels, the dehumidifying and cooling processes are separate from each other. Hot, humid outside air is initially conducted, inside the absorption unit, past packing sprinkled with saline-solution. There, it releases water to the saline. The dehumidified air is subsequently cooled via a heat exchanger and then goes on into the building as inlet air. Inside the heat exchanger, the suctioned waste air is sprinkled with water. The evaporated water lowers waste air temperature to such a degree that it is capable of absorbing heat from the dehumidified inlet air and afterward giving it off again as exhaust air. Initially, the diluted saline solution gives off to thermal fluid – via heat exchanger – the heat that was released during water absorption. The thermal fluid is also cooled via the central unit and closes the water cycle once more. Part of the re-cooled, diluted saline is de-watered once more in a regenerator with inlet heat, which closes the saline cycle via a buffer storage device. Inlet air may consist either of waste air from the CHPs or of solar generated heat.

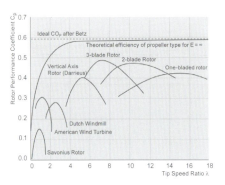

Fig. C 2.30 Application areas for different forms of wind turbines. For optimum performance exploitation of a wind turbine, tip speed ratio λ is important. This specifies the ratio of blade tip speed to wind speed. The rotor performance coefficient defines efficiency of a wind turbine.

Wind Energy

Air currents that cause wind are, in essence, pressure-balancing currents in the atmosphere. These air currents may be used for electricity generation with the assistance of wind turbines. From the 12th century onwards, wind power has been used to drive windmills. Technological advances and decreasing energy prices had led to wind power not being developed any further. Only after the energy crises, from 1975 onwards, wind power started to gain significance once more. Its real rise, however, did not start until 2000, when the renewable energy law came into effect here in Germany and as a result, there was a high compensation for electricity fed into the grid. Wind energy may be handled via wind turbines that work either on the resistance or buoyancy principle. Turning of the resistance wheels happens through air resistance to the rotor blades. They have low rotation speed and large blade area. Often, they are used for driving water pumps and have a power coefficient of around 20%. Buoyancy wheels, on the other hand, use pressure and suction forces at the wing profile. Owing to the aerodynamic shape of the wings and their low resistance level, they achieve high power co-efficients of 40 to 50%. Wind turbines are suitable for electricity generation. For an economical application, wind velocities of between 4 and 5 m/s are required. Regions with sufficient average wind for this can be found at the North Sea and Baltic Sea coasts and in the low mountain ranges. Since regions with plenty of wind are limited and the public does not like seeing wind turbines, wind turbine operators are increasingly heading out to sea, where the wind is not only constant but also strong. According to a current Greenpeace evaluation, wind power generation may be increased over the next ten years by 10 to 15%.

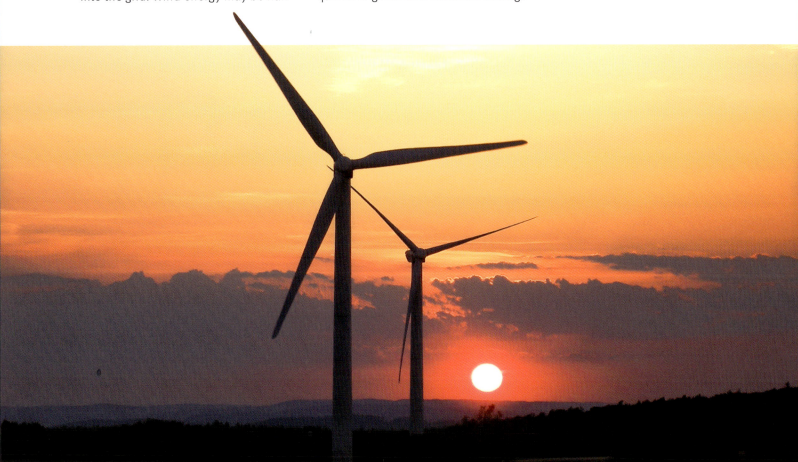

Fig. C2.31 Drilling pile during construction of a building. By layering the pile with pipelines, an energy pile for heating and cooling may be created.

Geothermics

Heat and storage mass from the earth may be exploited via the following systems:
- Ground plate with inlay heat conducting pipes (geothermal collector)
- Energy piles (thermally activated drilling piles)
- Geothermal probes
- Ground water with suction and injection well

An advantage of geothermal usage is the available earth and ground water temperature, which – in Northern and Central Europe – ranges between 10 and 15 °C. This may be used for cooling a building via heat exchanger – provided that the building envelope and the room climate system are arranged for it. For heating, a heat pump is involved to bring temperature up to a higher level.

Ground Plate with Inlay Heat Exchange Pipe

Activation of the geothermal collector is only possible to a limited extent on account of the small size contact area and low heat transmission capacity. If the collector is submerged in ground water, its heat transmission capacity is elevated. Hence, it is best to use this approach when the ratio of ground area to storey area of a given building is relatively large.

Energy Piles

It is cheaper to thermally activate the auger piles required for construction of the building. An essential requirement here is that they must be at least 12 m long, since for shorter piles the effort required for hydraulic connection is too high when compared to final benefit. During conception, one needs to keep in mind that the earth in winter must not cool down to freezing limit in pile vicinity. Otherwise, the wall friction of the piles is weakened and their load capacity lost. *(Fig.C2.31)*

Geothermal Probes

For a geothermal probe system, a heat transmission system is drilled all the way down into the earth, between 30 to 300 m. Two u-pipes per drilling hole serve as heat transmitters. If one of the two pipes should get subsequently damaged, it may be taken out of operation. The second pipe can still meet ca 60 to 70 % of the original earth probe performance capacity. As a rule, earth probes are set at a depth of 100 m since, for deeper drills, you generally require special mining permits and cooling becomes more complex on account of the higher earth temperatures.

Ground Water Utilization

The most economical of all these approaches is direct usage of ground water. For this, the ground water is extracted via a selection well and then returned to the earth via an injection well. With a heat transmitter, heat is extracted from the ground water for heating purposes and/or for cooling, heat from the building is inserted into the earth. This system requires a special permit from the water law authority. If the groundwater turns out to be contaminated it needs to be filtered and cleaned prior being returned. The required measures can become very complex and decrease the economical aspects of the system. If there is sufficient ground water that is not contaminated, the cost-efficiency only depends on drilling costs for the suction and injection well.

During planning and concept development for geothermal systems, it is important to find thermal balance throughout the year for the earth, since otherwise the soil cannot regenerate anymore and, over time, will either cool down or heat up. Ideally, the earth is used for heating in winter and cooling in summer. Ground water currents may also be used in a supportive function for soil regeneration.

Biomass

Fig. C 2.32 Wood Pellets

Biomass, by far, is the most significant renewable energy source worldwide. 44% of it apply to solid remnants from straw and wood, and about 50% to wet remnants from energy plants, slurry and dung. The generation of heat and electricity from solid remnants usually takes place in combustion plants. Wet remnants are used in biogas production.

For small to medium-size buildings, with a heat load of up to 1 MW, fire wood or heating pellet based central heating is on offer. Heating pellet-based has a distinct advantage in that the heating material can be automatically supplied and the heat input regulated. Another advantage is that wood pellet quality is regulated via DIN norm. This means that combustion happens under stable conditions. Wood chips furnaces, on the other hand, are usually employed by large CHPs since wood shavings require twice as much storage area as wood pellets but, in return, are much more cost-effective. In contrast to wood pellets, wood shavings contain different water content and different quality levels. This is why combustion procedures are often irregular and difficult to control.

Biogas

In Germany, the proportion of natural gas of total primary energy use is around 22%. It consists mainly of a hydrocarbon called methane, which results naturally from the decay of ancient-time biomass in an air vacuum. This process may be recreated in a decomposition container where biomass corrodes under conditions of total air tightness. This biogas consists about 60% of methane, and for further energetic usage must be largely dehumidified and de-sulphured. Usage of biogas is CO_2 neutral since only the same amount of carbon dioxide is released during combustion that was initially absorbed by the plants during their growth.

Biogas is often used in CHPs since the engines there are not sensitive to fluctuating gas composition. Application in fuel cell plants or for gas turbines has already been tried out in pilot plants. Two different processes are available for biogas generation.

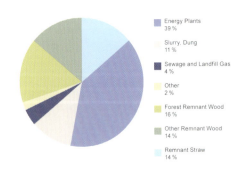

Fig. C 2.33 Worldwide biomass usage distribution

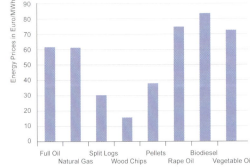

Fig. C 2.34 Full Price of different regenerative energy sources

Building Services Engineering

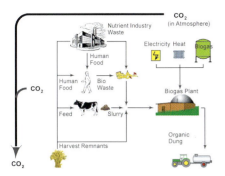

Fig. C2.35 CO_2 cycle for biogas utilization

Fig. C2.36 Average biogas yield for various remnants

During what is known as wet fermentation, wet and/or liquid remnants are processed. This procedure is usually applied, because dry fermentation is still in its early stages. Hence, especially suitable as biomass, are remnants like slurry, organic waste, and bio waste or silage corn. Waste products from the nutrition industry, like ensue during fruit and vegetable processing, slaughter or eating, can also be used. For hygiene reasons, these are heated for about an hour at above 70 °C. *Figure C2.36* shows average biogas yield as stemming from different biological remnants.

Since biogas usage is both economical and sustainable on account of its excellent remnant exploitation, biogas has been fed into the natural gas network here in Germany since 2006. In Jameln/Wendland, the first biogas station was opened. Sweden covers 51 % of its total gas requirement with biogas already. In Italy, assistance measures are already being prepared to lower CO_2 emission levels. Here, too, biogas usage plays a decisive role. In Tuscany, a tourist project is currently underway that involves several hotels, is supposed to improve infrastructure and support agriculture. Energy supply is via a biogas power plant. This is especially interesting since the only other alternative would be expensive liquid gas. This concept is supported by solar-powered cooling systems and wind energy usage. For storage of fluctuating wind energy, in this case, the power network cannot be used since the hotel facility is not connected to public power supply. For this reason, the wind electricity generated is being used to pump water for irrigation to a higher situated reservoir. In case of electricity requirement on wind-free days, the height difference of the water is then used to generate power via wind turbines. With this overall energy concept, emission of harmful gases can be reduced by 85 % in comparison to conventional energy supply means.

Fig. C2.37 Sunflower cultivation for regenerative energy production

C3

Commissioning

Sustainable Building Procedure Requirements

Nowadays, during the planning and construction process, computer-based simulation programs are used during the concept phase. Usually, only the simplest of procedures are applied during commissioning of a building and its technological systems, as well as for verification procedures to verify quality levels promised during planning. Typically, there are only visual controls during site tours and functional controls for select operation points of the systems. For buildings with low heat insulation requirements and absence of innovative building technology equipment, this approach may well be sufficient. For energy-efficient buildings, however, novel technology systems are frequently employed for the very first time and they have a higher requirement for supervision since there is very little experience to fall back on when it comes to their construction and operation.

Further, the technological and constructional systems employed are so attuned to each other that any shortages of design in one can have great impact on the others. An example for this is building density: if construction design does not make allowances for radiators in front of the façade, then high building envelope density is very important for room comfort in winter. For buildings with radiators, constructional shortcomings can usually be compensated more easily by raising operating temperatures of the heaters. Energy use may increase that way but thermal room comfort remains intact. For buildings with panel heating, this measure is not possible anymore since there is not a lot of leeway for surface temperatures that are both comfortable and healthy. Further, economical aspects of Green Buildings are very much dependent on expected low energy costs. Therefore, an important construction goal must be adherence to concept and planning specifications for component quality and energy benchmark. For achieving these goals, we nowadays have available tried measuring techniques and computer-based procedures that must be a fixture of the planning and construction process. Green Buildings are only economical if they live up to their promises during operation. An essential step in this is a detailed commissioning and then furnishing proof during operation. Further, it is important to find out about any changes that result from the planning process in order to be able to correctly define optimum target values for long-term operational optimisation.

Blower Door Test – Proof of Air-Tightness

For heat insulation and for building fabric, air-tightness of a building is of utmost importance. Untightness leads to uncontrolled air exchange and increased heat loss. Especially in areas with lots of wind and in exposed situations, this results in ventilation heat loss that could constitute up to 10% of total heat consumption.

A much greater problem happens in case of untight component joints. Humid air comes in through the cracks and condenses inside the components. This can lead to humidity damage and favours mould growth. In the façades, untight areas lead to the inflow of cold air that sinks down and causes draught. For this reason, air tightness is a factor especially for low-energy buildings that usually do not have a radiator near the façade. This goes especially for light buildings with hollow profiles that allow cold air to come in. Further, untightness favours sound transmission via the walls.

The buildings' and its components' air tightness is determined via a so-called blower door test. This procedure was originally developed for apartments but it is also suitable for measuring tightness in larger buildings. The technique is simple: in a specified section of the building, air is either suctioned out or blown in with the assistance of a fan. The relation of measured pressure difference to volume current generated is used to determine the quality of the envelope area under consideration since untight façades present less pressure difference and thus allow for more air to come in. Often, the fan is positioned in front of the door and air volume flow is measured in terms of how much of it is needed to generate a pressure difference of 50 PA. From this, the value n_{50} is determined. This value may not exceed $3\,h^{-1}$ for rooms with window ventilation and, in case of mechanical ventilation, must not be above $1.5\,h^{-1}$. Measurements should be conducted for both excess and low pressure in order to identify leakages in joints, for instance in airtight layers. Locating air leaks may be done with a flow meter, usually a hot-wire anemometer, or with vapour. During the cold seasons, a thermographic scan, executed at low pressure, is also suitable. Cold air coming in through the leaks cools down the building components, which can then be located via infrared imaging.

The measurements can also be undertaken in existing buildings. For new buildings, the best time is when the façade has been closed and insulated, but with the unfinished floor, not yet covered. The most common leakage points are joints between windows/façades and floor/walls. Further, air passages within the structural design are frequently disregarded during the planning stages.

Often, the level of air tightness decreases only a few months after the building has been occupied, which usually happens when foil adhesion and sealant jointing was either unprofessionally handled or applied under conditions of excess material tension. Thus, it is advisable to conduct a new air tightness test for critical areas prior to the expiry of the guarantee period. Only then can energy quality of a building envelope be ascertained.

Fig. C 3.1 Blower door, built into an ordinary door. Infiltration level reading did not show any leakage at window joints at a wooden façade.

Fig. C 3.2 Infiltration reading shows an untight crack at the upper edge of the glass joint.

Thermography – Proof of Thermal Insulation and Evidence of Active Systems

Over the last few years, thermography has become a multifunctional tool for construction applications. For new buildings, it often serves as a control tool for the building envelope and for heating and cooling systems. During revitalizations, the images allow for swift analysis of building envelope quality levels and for location of hidden heating ducts.

A high quality building envelope, with respect to heat insulation, is a prerequisite for lower heating energy consumption and, hence, for energy efficiency. There should also be as few thermal bridges as possible. The construction management conducts visual controls to this end. However, this cannot determine whether the specified quality levels and values that were previously measured in the laboratory are actually obtained for the various assembly groups after completion. With an infrared camera, images of surface temperature course can be obtained. »Backward calculations« are then applied to determine the level of insulation quality and also the number of thermal bridges present. Weak points, which can be identified with a thermographic camera, can often lead either to unwanted energy loss or to below freezing temperatures in the building interior. Hence, through early use of this technology, financial and constructional damage can be prevented in time. The new buildings of the LBBW in Stuttgart/Germany had their façades subjected – after completion – to random air tightness tests and also to a full-scale thermographic imaging. These types of controls were part of the encompassing inspections and of the commissioning procedure. In this case, a high energy quality of the building was proven (Figure C3.3).

In a supportive function, thermography may also be applied during Blower-Door tests. This applies especially in cases when the inlet air passage via the façade cannot be absolutely traced during the blower-door test. Infrared images clearly show air leakage for windows, doors and glass façades, which means that also the air tightness levels of small façade areas may be precisely evaluated.

Panel heating and cooling systems have low operating temperatures for heating and high ones for cooling. This means that manual function control becomes impossible. Further, it is not only sheer surface temperature but also an even perfusion level that is of importance for optimum operation conditions. Infrared images allow for swift identification of correct surface activation with the correct homogenous temperature distribution level (Figure C3.4). For new and existing buildings, thermography offers the opportunity of wide-area façade imaging that, in turn, allows for analysis of heat insulation levels and leakages and for implementation, on that basis, of energy-preserving measures. To this end, simulation calculation results are compared to those obtained from thermographic imaging and then adjusted accordingly. This allows for practice-oriented, concrete conclusions to be drawn for energy consumption and energy cost savings.

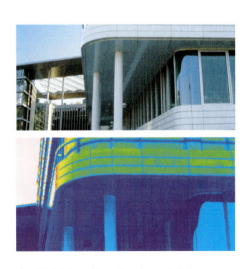

Fig. C3.3 Infrared imaging shows that the supports penetration of an overhanging ceiling does not cause thermal bridges

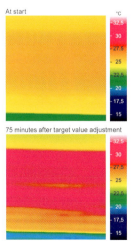

Fig. C3.4 Thanks to infrared technology, load conditions of thermally activated components can be determined via surface temperatures

Proof of Indoor Comfort

Room temperatures are an important indicator of thermal comfort. We distinguish here between air temperature and operative room temperature. Generally, air temperature can be measured with conventional room temperature sensors, provided that they are sufficiently ventilated and are not placed at unfavourable locations inside the room. Positioning near interior heat generators (computers) or in sunny areas happens more often than one would think, but an accurate measurement of air temperatures is not possible that way. Hence, we recommend taking great care of this particular detail since correct temperature measurements are very valuable for operation and correct settings of target values have a major impact on energy consumption.

Operative room temperature is measured with the assistance of a so-called bulb globe. *Figure C3.5* shows a test set-up to this end. The sensor exchanges heat with all surrounding envelope areas and with the air temperature, meaning that it can accurately depict human sensation. Comparison with values calculated during the planning stage thus becomes possible and is of enormous importance for each individual project. Calculations from planning, finally, have an impact on sales or rental contracts for the building and often become important decision criteria for implementation of a given concept. Bulb globe measurements frequently show that, in rooms with outside solar protective devices and a high storage capacity, operative room temperatures are close to mean room temperatures. In those cases, calibrated measuring sensors may also be used for evaluation of operative room temperature. Further, when comparing target and actual values, it is important that boundary conditions during operation essentially match those from planning so that wrong conclusions can be avoided. This especially applies to usage and equipment of the rooms. *Figure C3.6* shows predicted room temperatures and measuring data over three years, for the energy-efficient OWP 11 office building. You can see that they are very close.

Fig. C3.5 Operative room temperature is measured with a bulb globe

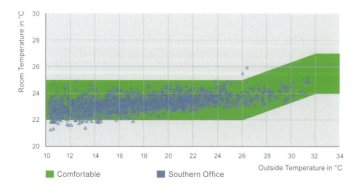
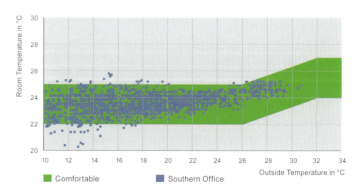

Fig. C3.6 Comparison of calculated room temperatures via building simulation (left) with actual measured values during operation (right). They are very close, even with concurrent use of the southern office (OWP 11 office building).

Fig. C 3.7 Measuring air quality after building takeover

Air Quality

In essence, air quality depends on four different factors: outside air quality, type and size of natural or mechanical ventilation, person occupancy rate and materials emission inside the room. The amount of harmful substances in the room air, especially, has an impact on human health and well being if those people spend their time inside closed rooms (offices or flats). Building material emissions and also possible pollution from ventilation units both occur very frequently and are responsible for hampering productivity levels and health of employees, leading to sick-leaves and allergies.

Contemporary service providers rely on performance capacity of the individual, which means that many employers have been sensitised toward providing as healthy an environment as possible for their staff. To this end, it becomes essential – during planning and construction of buildings – to focus on keeping harmful substance load, from furnishings, building or extension materials, to a minimum. Special attention needs to be paid here to volatile hydrocarbon compounds (VOC), aldehyde and fibre particles. From the post-war period to today, there is quite substantial »negative heritage« from the past, be it in residential buildings, office buildings, school buildings or any other type of buildings. Nowadays, the buildings must be refurbished with what often constitutes enormous effort. As an example, we only need look at the many PCB or asbestos refurbishments that negatively impact handling of existing building substance and costs as well.

In case of the LBBW new building in Stuttgart/Germany, great care was placed on correct usage of low-emission and/or emission-free materials and of composite materials. Early on, comprehensive planning stipulations were created and their implementation controlled during development and subsequent execution of construction approach. Positive results were obtained from air quality readings taken after completion of the first extensions. Ecologically doubtful emissions stayed at a minimum for the room air, hardly any higher than for outside air. At full occupancy, the Zirndorf/Germany Playmobil Funpark holds 2000 visitors. Its concept provides for natural window ventilation for the purposes of ventilation and cooling alike. If the window vents prove unable to supply the hall with sufficient fresh air without hampering thermal indoor comfort, a mechanical base ventilation function is added. The base ventilation is designed as layer ventilation, coming from below. This optimises both fresh air inflow in close people vicinity, and harmful substance removal, with very little energy demand. Monitoring during operation shows that maximum CO_2 concentration levels of 950 ppm are reached in the occupied zones. Only four to five hours after opening time, it becomes necessary to activate the ventilation system. During that time, energy requirement can be kept to a minimum.

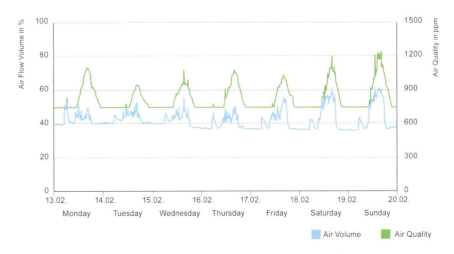

Fig. C 3.8 Weekly course of measured air quality and air flow volume of the ventilation system. Room temperature is one of the criteria used for airflow volume determination.

Noise Protection

Fig. C 3.9 Sound Measurement in the interim façade space and outside for a double-skin façade

The quality of a working environment is influenced primarily by the level of noise interference the user is subjected to. Ability to concentrate depends, to a great part, on the level of distractions through noise interference and on the content of conversation fragments that reach the ear. Since man cannot close his ears to sound, it is important especially for working environments where heavy mental work is performed that acoustic disturbance factors are kept to a minimum. These can stem from building engineering systems, from adjacent room use or from outside noise.

It makes sense, therefore, to evaluate acoustic conditions at the site as soon as possible. In order to work out further constructional steps, we recommend sound level measurements to be conducted at several, adjacent and specially constructed model rooms. This allows for measuring not only sound insulation levels of office and hallway dividing walls but also the amount of sound insulation against outside noise.

Acoustic conditions in a given work zone are to be considered as a coherent unit, especially in the case of double-skin façades that are supposed to provide noticeable reduction of outside noise influx even with natural ventilation happening via the windows. Since, in the case of double-skin façades, outside noise may constitute a lower proportion of the overall indoor noise level, it may then apply that acoustic influences from adjacent rooms are subjectively perceived as more harmful. At the site, sound insulation quality should be clarified early on. Any performance defects can soon result in sound insulation reduction levels of 5 dB and more. Open joints, especially, as they occur at many interfaces, are destined for weakening sound insulation.

Despite the available simulation methods, precise calculation of sound reduction for double-skin façades is still not always possible.

Therefore, it is important to have a model façade element tested for sound insulation merits at the shell construction stage already. This provides the client with an early confirmation of outside noise reduction.

Countless measurements taken by the authors point to the fact that, for double skin façades, reduction levels of between 3 to 10 dB can be obtained. The different results, in essence, are due to different sizes of interim façade spacing and also due to size and arrangement of inlet and waste air openings. Precisely what degree of sound reduction may be obtained with a readily installed double-skin façade is closely connected with the required level of protection against overheating of the façade interim space, since this, in turn, defines ventilation cross-section size.

Daylight Performance and Nonglaring

The amount of daylight reaching the room is determined primarily by the quality of the façade. The interior design and here, especially, the choice of colours, also furniture and mobile wall arrangement, workstation alignment and positioning of daylight sensors also play a decisive role when it comes to reducing electricity requirements for lighting. Further, the solar protective device's automation needs to be set in such a manner as to allow optimum operation with respect to daylight and heat yield. In this, great emphasis is to be placed on occupant satisfaction. If automatic control of the solar protection device is not accepted by the user and, for this reason, he always counteracts it, then an optimum result cannot be obtained. During revitalisation of the main building of the ZVK Wiesbaden in Germany, occupant behaviour was taken into account for solar protection control layout. Initially, luminance camera pictures were taken of the outside perforated vertical louver blinds. They served to provide a scientific evaluation of glare occurrence for different rib positions. Further, rib position impact on interior brightness was measured. Simultaneously, the users were asked about their favourite rib positions and about utilization of the inside vertical solar protection device. Only by involving the user, the control concept of the solar protection device could be adjusted in such a manner as to guarantee optimum daylight usage during operation.

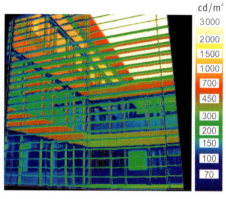
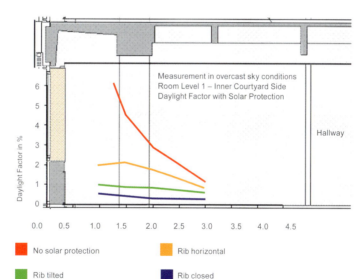

Fig. C3.10 Measurement of illuminance and illumination for different rib positions (outside solar protection) and of the Vertiso (inside glare protection)

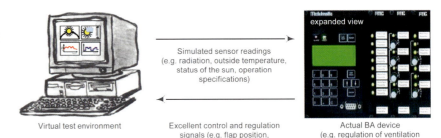

Fig. C 3.11 Emulation principle as a new quality standard procedure for construction practice

Emulation = (in this case for control system analysis in automated construction) evaluates a real BA component in a virtual test environment under realistic and reproducible boundary conditions.

Emulation

An essential factor for Green Building design is the creation of concepts that allow for later operation to be handled in an energy and cost effective manner. The available concept-based and technological means for this are manifold. They range from an intelligent, effective outside solar protection device – that also allows for both outside and self-shading factors – to natural ventilation concepts through targeted opening and closing of vents, all the way to innovative, regenerative and energy-conserving heating, cooling and lighting concepts.

What most concepts have in common is that they need to be designed transitionally and to be sustainable and also be implemented in the same manner. The expert planner, for instance, when designing natural ventilation of the atria, needs to consider the ideas of the architect in respect to façade and façade flaps and, further, technical requirements for smoke extraction and fire protection. At the same time, it must be ascertained that all the part systems are compatible with each other and, above all, are permissible. Due to sector blending between ventilation, façade, smoke extraction and fire protection, an overriding control concept must be available for control and regulation purposes and this control system cannot be applicable, as used to be done in the past, to one sector only. Similar considerations apply to the controls and regulators, which concern the overall energy concept. Here, too, trans-sector knowledge is of the essence. For Green Buildings, the basic parameters for control and regulation concepts are worked out and specified during the planning stage. They must be developed anew for each building. Although, through usage of simulation computers, »virtual operation experience« can be gained in the planning phase already, these prototype-based solutions are, naturally, also a source of errors.

For regulating and control parameters, software is used increasingly but based on standard solutions, it must be adapted for each individual project. In practical construction, these parameters are often not available since, during process measuring and control technology planning, operation is usually only described in written form and then supplemented with data point lists. Hence, as part of the energy concept, programming of the parameters for regulation and control is left up to the executing firm. As a rule, however, the entire discussion from the planning stage about the coherency of the energy concept and energy-saving operation is only passed on in a rudimentary manner. Further, the programmers of the control and regulation system are very rarely energy experts who would be able to really understand the thermal, dynamic and energetic processes inside the building. Additionally, measuring and control programming usually happens way too late in the construction process, often during the hectic completion phase. We all know the results! Nearly every building, when it is actually put into operation, shows up with defects in the process measuring and control technology. Dealing with them is usually done on the back of the building occupants and there is considerable time and cost expense involved for everyone. Green Buildings are especially affected since, often, concepts are implemented that are novel, have never been used in that manner before and hence can rely on very little experience from the past.

An added difficulty is found in the fact that a full and encompassing commissioning, quality control and inspection of the finished regulation and control system is only possible with great difficulty. This also goes for inspection of the control and automation units for a solar protection device under all the critical operating conditions. One reason for this is the outside climate, which cannot be influenced during commissioning. Further, the parameters for these devices can only be controlled with great difficulty from »outside«, meaning without having had the benefit of getting an inside look at the actual programming.

Commissioning

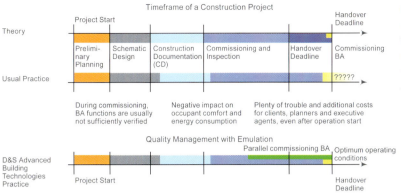

Fig. C 3.12 Theory, construction practice and carving new paths with emulation for quality management in the area of regulation and control technology (BA = Building Automation)

A practical example

No sooner is a building operational than there is a series of complaints about the solar protection system. Complaints range from workstation glare to too much obscurity to finding out that the blinds seem to constantly run up and down in an incomprehensible manner. And this is despite such systems being meant to increase occupant comfort! Unfortunately, it has nowadays almost become the rule that solar protection devices do not work or do not work as intended when a building becomes operational. Often, the systems are then adjusted well into the operation period of the building. Aside from dissatisfaction and anger from the side of the client, these shortcomings can cause considerable costs for the planning and execution team participants. The client, too, loses income, for instance through rent reductions. The profit of everyone involved is decreased by these latter-stage adjustments, perhaps even eaten up completely.

Similar things apply to quality assurance for components relevant to the overall energy concept. Since these are strongly influenced by the specific usage and the prevailing outside climate, many of the functions cannot be sufficiently tested prior to use. To avoid these kinds of problems, new paths need to be carved out.

Emulation is a step toward the right direction. This procedure allows for regulation and control algorithms, e. g. of solar protection devices or energy concepts, to be inspected prior to being put into operation, sometimes even prior to installation – irrespective of the status of works at the building site. During the emulation process, control and regulation devices are integrated into a virtual test setting. The test setting – which, in essence, consists of a computer, readers and loggers and, if need be, a link-up to a Bus system, e. g. LON – tricks the relevant control into thinking that it is inside the real building. The computer simulates normal office operation as well as choosing critical operating conditions. Scenarios that are handled here are especially boundary conditions of the outside climate, like status of the sun, solar radiation, outside temperature, wind speed, auto and outside shading, changing cloud conditions and different usages. This results in any shortcomings of the regulation and control component being able to be recognized and dealt with prior to installation in the building and being put into operation. This is especially important for Green Buildings, since commissioning here requires the greatest care.

With emulation, the quality of a building also improves, which constitutes an advantage for everyone involved. Clients, users and tenants are provided with a functional building right from the start. The architect and the planners of the building services equipment can test the regulation and control functions of the systems under various boundary conditions and thus obtain certainty that the building and its systems are functional not only under the boundary conditions that prevail during commissioning. Thus, emulation assists everyone involved: to reach the desired quality standard and also to minimise fee payments and costs.

Fig. C 3.13 Emulator set-up as a virtual test environment for realistic regulation and control components

C 4

Monitoring and Energy Management

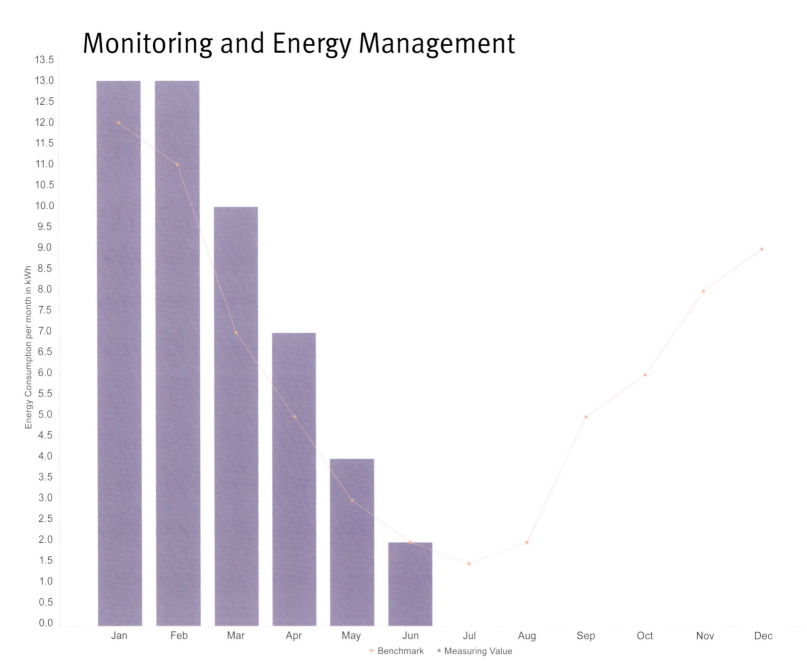

Monitoring and Energy Management

Green Buildings stand out through their minimal total building energy requirement and their optimised system technology with lowest energy demand. Here, the systems are so attuned to each other that faulty operation parameters can lead to inefficient operation and therefore to higher energy demand. Unfortunately, it frequently happens that the energy benefits defined during the planning stage later cannot hold up during operation. One can even go as far as saying that the inspection of energy benefits during operation is only rarely undertaken. In most cases, neither owners nor operators have any idea of just how much energy is required by their building to »stay alive«, ascertain indoor comfort, and whether planning phase promises are actually being kept. Interestingly enough, when it comes to cars, we usually know these kinds of figures down to the comma and point, not only for our own, even for our neighbours' vehicles! It is almost a matter of public interest to show just how economical one's own vehicle is despite its size.

Altogether it can be said that building operation, on account of missing or insufficient instrumentation, is oriented more towards satisfied occupants/tenants of the building than towards low energy consumption. This cannot be considered a fault per se, merely as being not encompassing enough. It would be desirable to have a strategic energy management in place, with the long-term goal of achieving occupant/tenant satisfaction with the lowest possible energy and cost expenditure. Unfortunately, this is only done in the rarest of cases. Usually, one restricts oneself to controlling monthly or annual energy costs for plausibility or by comparing it to the previous month's or year's bill.

Unfortunately, this drawback can be traced back to standard, insufficient instrumentation of the systems and the tools available. Instrumentation is not so much oriented towards analysis and optimisation of energy consumption but, rather, merely on the functioning capacity of individual components. Tools for targeted analysis and interpretation are usually not very user-friendly and, therefore, are not or only rarely used.

Whether a given building or system may be operated in an energy-efficient manner or whether increased consumption in comparison to the last billing period could be resolved through a different application, climate or other influencing factors, is something that – in most cases – can only be determined with immense effort or not at all. If you keep in mind that, in Germany for example, over 40% of total energy consumption is used on heating, cooling, ventilating and lighting of buildings, it is difficult to comprehend why so few methods and tools are actually available for this area.

Aside from the unavailable tools or insufficient measuring technology equipment, there is another reason for not using all potential factors during ope-

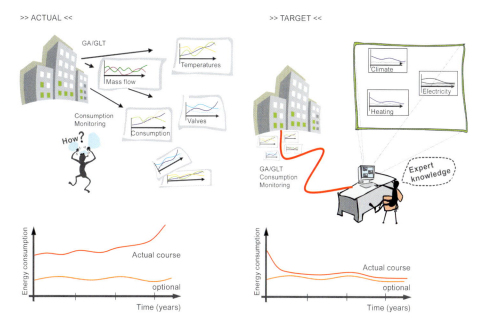

Fig. C 4.1 Current situation for optimizing operations in comparison with future automated operation optimization methods

ration that had been envisioned in the planning stage for lowering energy demand: knowledge from planning is often lost because years can elapse between planning, construction and final operation, and the names of those involved change. *Figure C4.1* depicts the current situation for operation optimisation, in comparison with a newly developed solution.

While most buildings record operating parameters, these are – as a rule – not interpreted in a manner that would allow us to find out whether the building is being operated at optimum level. In most cases, we still restrict ourselves to comparing actual energy consumption to the previous billing period's energy consumption. This means that available potentials are not fully exploited.

Green Buildings, therefore, require a different approach: simulation models that were created and applied during the planning phase depict thermal behaviour of the building and are, per se, a kind of reference for the analysis of actual, measured energy consumption of the building. Simulation models can show, parallel to operation, theoretically obtainable energy demand. By comparing registered energy consumption to calculated energy demand (measured under the same boundary conditions: equal climate and comparable utilization), we can draw conclusions about the energy-saving potential during operation.

Targeted, strategic operation and energy management requires the expansion of system engineering instrumentation to a point that would register and then log energy flow, indoor temperature, system parameters etc. at the smallest, most discreet time intervals possible. In that case, we speak of a data logger concept. If this is done smartly, additional costs can be contained and the amount of energy costs saved through efficient energy management exceeds by far the expense of a detailed data logger system.

A data logger concept is arranged in such a manner as to measure and analyse energy balance as cohesively as possible. Care must be taken that measuring precision and error tolerance is adapted to the metered values. For instance, when measuring the temperature of thermally activated components, higher recording precision (on account of the temperature difference of ca 2 K between flow and return) is required than for radiator heating with a flow-return temperature difference of 20 °C. Additionally, the test points must be installed at the correct locations. Wrong locale can soon result in recording deviations of up to 30 %. Aside from knowing about energy technology, measurement engineering knowledge is also required.

Comparison of actual recorded data with what was calculated can also be fine-tuned even further to include – apart from energy demand and energy consumption – operating parameters and system engineering conditional

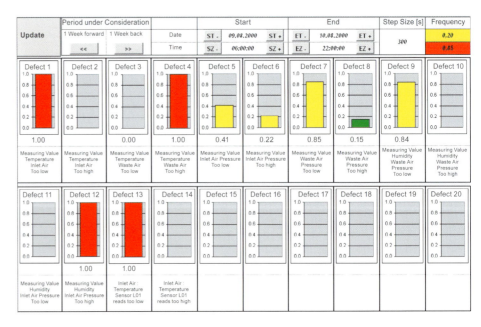

Fig. C 4.2 Energy monitoring system with Building optimisation and fault detection functions

Monitoring and Energy Management

values for measurement, determination and comparison. This allows for earlier recognition of operating behaviour changes – caused, for instance, by pollution of system components. This means that inefficiency and operating malfunctions can be handled in a preventative manner.

Analysis of the enormous amount of data, however, is not merely done by looking at the readings. Therefore, comparison of recorded values and calculated values is automated. We speak of so-called energy monitoring systems with Building optimisation and fault detection functions. *Figure C4.2* shows such a system. The signalling layout is meant to show the operator which system regions are still running in the »green zone«, meaning at optimum. Systems with yellow identification have already reached an inefficient operating stage that may yet increase. Here, detailed analysis is required. Areas marked red require urgent improvement of system parameters in order to avoid inefficiency, operating defects and increased energy costs.

The tools shown there can also assist in creating a strategic operation and energy management set-up. Targeted analysis and interpretation of operating data, then, allows for energy-efficient operation.

Project Example: Proof of Overall Energy Efficiency

Proof of overall energy efficiency can be obtained at the earliest one year after operation started. For energy balance, essential influencing factors like climate, utilization and system operation should also be shown since any energy benchmark from planning is only applicable to the defined parameters there as the target value. For this reason, a transparent proof furnishing procedure is very complicated, especially if there are strong differences between operation boundary conditions and those from planning. In this case it would be possible to adjust any index according to operating conditions. This requires a so-called »robust simulation model«, which logs interchanges between climate, utilization and building and system operation. Frequently, systems like this already exist in the planning stage, making multi-use of them possible.

With the OWP 11 building serving as an example, *Figure C4.3* depicts such an approach: heating energy demand calculated during planning, for the OWP 11 building, is 37 kWh/m^2a. Readings for the first year of operation are 50% higher. Through a step-by-step adjustment of operating parameters in the simulation model, the higher heating energy consumption could be traced. It turned out that the heat sources specified in planning had not yet been reached during operation since not all office zones were completely filled with workstations yet. The »missing« interior heat sources resulted in higher heating energy consumption.

With a robust simulation model that is adjusted to building operation, the potential of possible energy-savings measures can be easily calculated.

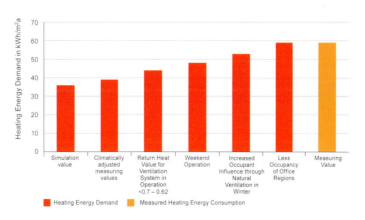

Fig. C4.3 Analysis, via simulation, of Heating Energy Consumption for the OWP 11 building.

A closer Look – Green Buildings in Detail

D

D1

Dockland Building in Hamburg

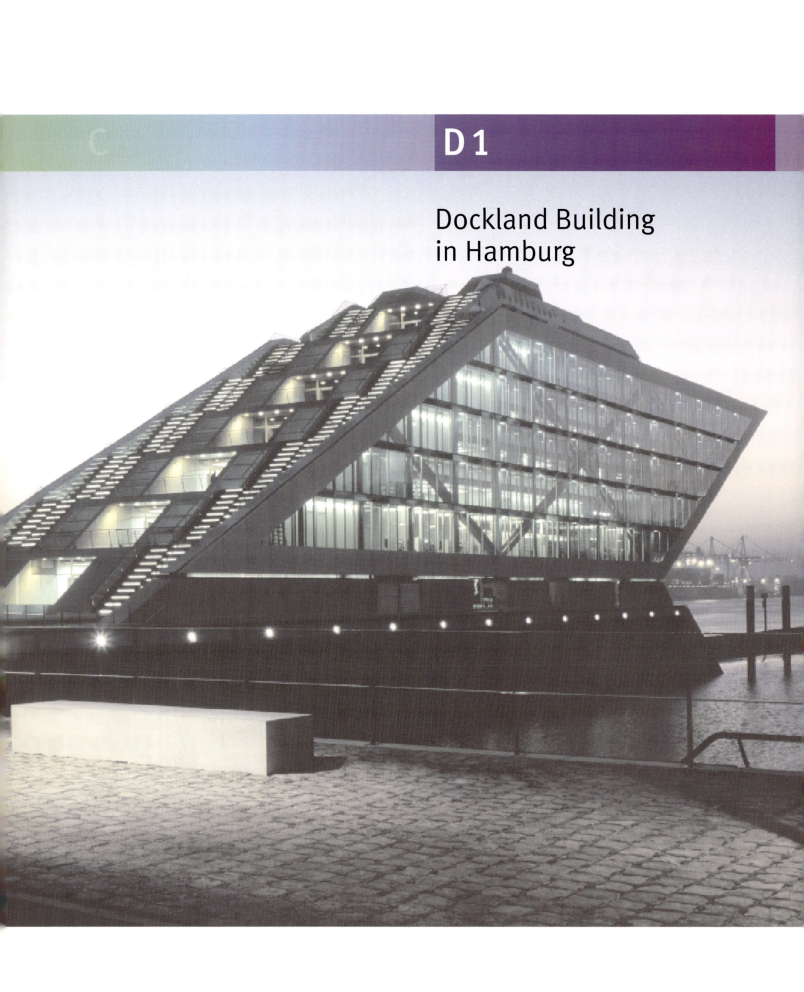

Interview with the Architect Hadi Teherani of BRT Architects, Hamburg

1. What, in your opinion, are the defining criteria for successful buildings?

The defining architectural quality features are the room, the volume, the view, a dynamic process of interactions and relationships. Technological achievements may give wings to a new room concept but they cannot initiate it. Convincing architecture is sensuousness taking form, its culture, morale, identity. Buildings that provide identity ask for clearly defined, vivid architecture presenting functional advantages but, especially, with emotional radiance.

2. What is the role of sustainability in your building designs?

The beauty of a building rests on its logic and efficiency, not on its décor and timeliness. An architect must be capable of finding integrated solutions. Clever clients avoid spending too much money. Smart ones know that is much more dangerous to invest too little. If you pay too much, you may lose part of the money. But if you invest too little, you stand to lose everything because the investment does not fulfil its long-term purpose. The overall success of a property can only be determined by looking at its total life cycle.

3. What are the goals of BRT, Bother Richter Teherani Architects, when it comes to Green Buildings? What are your visions there?

One of our essential goals is to reduce operating costs to a minimum.

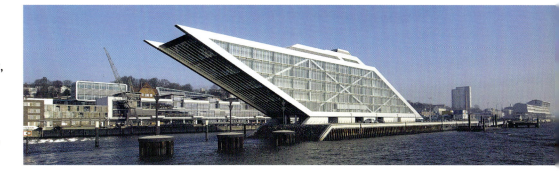

Fig. D1.1 Dockland Office Building, Hamburg/Germany

Without intelligent solutions when it comes to handling energy matters, there is very little economic leeway for architecture. Long-term energy costs of a building, compared to the often-discussed construction costs, are much more dynamic when it comes to saving potential. Looking after the longings of people while still not going beyond their economic scope means that the architect, if he manages this difficult undertaking, becomes virtually irreplaceable. This is the reason for my working under the guideline: it is not enough to solve individual problems presented by the construction or the city; all problems need to be addressed at the same time.

4. How did your cooperation with D&S Advanced Building Technologies come about? What are the essential pillars of your many years of working together?

We naturally use state-of-the-art technology for our buildings, but under both economical and ecological considerations. This means, for many cases, to finally use little technology. Whenever sensible, we rely on low-tech instead of high-tech and, instead, access nature's more effective solutions. Foregoing an air-conditioning system, for instance, or an electrically powered ventilation unit, generally leads to an increase of work and life quality. We can indeed learn from the past, return to regional construction considerations and climatic conditions and then use this in an economically and ecologically viable manner. BRT's technological minimalism does not mean that we ignore technology but, rather, that the engineer's ambition ought to be directed towards minimizing the energy consumption of a building while optimising its functions through a combination of intelligence and experience. The aim must be to achieve increased occupancy quality for the buildings through innovative concepts while, at the same time, conserving resources.

This broad horizon type of approach

can be found, in comparative form, at D&S Advanced Building Technologies. So we do not even have to have discussions about different approaches.

5. What are the characteristics a planning team needs to have in order to create sophisticated and sustainable buildings?

Even twelve years ago, when we first used the cooling ceiling during the extension of the Sparkasse bank building in Kiel/Germany, we realized how important it is to push right up to the limits of the possible while challenging industry and being innovative in one's approach. We simply need to work on finding alternatives for, in the not-too-distant future, energy is going to be so scarce or heavily taxed that we have no time to lose in developing new solutions. However, the user must also be interested in these mechanisms and must be supportive of them. Technology becomes wrong the moment it stresses the user and means for him not relief but, instead, greater time and cost expenditure. Technology must adapt to human needs, not vice versa.

6. How did the idea for the Dockland building design come about?

This particular international metropolis owes its internationalism and uniqueness to the urbane power of water. As Helmut Schmidt so fittingly put it, Hamburg is a splendid synthesis of the Atlantic and the Alster river. If this is so, then there must be an architectural equivalent. We are not looking to recreate history but, rather, to tell new and fascinating stories with contemporary means. It is the only way the history of the city can continue to be told. The special feature of this building, with its own mooring, was to incorporate its distant neighbour. This is the ferry terminal of William Alsop from the 90ties, the dynamic of which was unfortunately tamed after the competition. This was done via a steamer motif with widely overhanging bow tip, to create a distinct city gate and the waterside with a freely accessible viewing platform. An ideal location for watching boat traffic of the harbour and ferry port.

7. What were your goals for this design?

According to my understanding, architecture should assist in establishing identity, yes, it may even create emotions. A factual approach should not be mixed up with sterility. Any enterprise that redefines itself from a constructional point of view only stands to gain, to the outside as well as internally, if it positions itself in an architecturally distinct and unique manner. Anyone wishing to employ highly motivated and qualified staff in future must not only be able to create employment, regardless of how and where, but also needs to establish a working culture that unites collectivism and individuality.

8. What are some of the extraordinary qualities this building has to offer – to client and tenants?

The location of a given company or government agency is a clearly defined statement to the outside. Its effect by far transcends the location of the building itself. Much more significant, however, is the character of the building that radiates to the inside. Our goal, which we work on very intensively, consists of finding the highest possible organisational and spacious individuality of the individual workstations in conjunction with a specific and communicative interpretation of building design. This is to be done without affecting the structural order of the city. In this special situation in the water you even get the feeling that, with this special building, you are really in motion.

Interview with Christian Fleck, Client, Robert Vogel GmbH & Co. KG

1. What, in your opinion, are the defining criteria for successful buildings?
Location, aspiration and its implementation, good architecture, economical operation, occupant identification with the building, as little technology as possible – as much as necessary, low associated costs, easy operation, minimal energy use, conservation of resources, good marketing options also in future, longevity.

2. What does living inside a building mean to you? What factors are essentially decisive as to whether you feel comfortable or not?
Location, environment, rooms, architecture, view, insight, harmonic proportions, heat, cooling, uncomplicated handling, understanding.

3. What is the role of sustainability, of life-cycle consideration, in your building stipulations?
We develop, build and operate our buildings. For this reason, life-cycle consideration plays a decisive role for us. Aside from a huge, also ethical (toward future generations) responsibility, sustainability is based on clear economical considerations, too. In future, responsible handling of resources (especially of renewable ones) with respect to associated costs, is going to become extremely important. High associated costs also mean a low basic rent. Further, companies with a good image will continue to have clear market advantages. The asset holder, therefore, will always be more concerned with quality than the »simple« investor.

4. You experience the entire process, from design to operation. Where do you see the greatest improvement potential: in the process itself, in finding ideas, planning implementation, constructional execution or operating behaviour?
Small teams, trust. In the finding process, some other aspects need to come into consideration also, like easy handling, user relation, low operating costs, sustainable handling of resources and the environment.

Personally, I believe that the planning processes are frequently hampered through too many people being involved in both the planning and the building process. There are simply too many experts for everything, project supervisors, special surveyors, consultants etc. who only unnecessarily delay everything and money is wasted that then needs to be recovered again during the actual execution phase. Here, savings are then made and this has a negative impact on quality. Naturally, the projects are becoming more sophisticated but often the decision-makers (also on the client's site) do not grow with the project.

I also feel that the construction process itself is not yet very progressive – we plan and plan and then put out a call for the bid and only then the other companies get involved – when, really, industry and other firms should be involved much sooner in order to achieve synergies for everyone.

Especially during the initial design stages, planning should have a higher status (like, for instance, sometimes happens in boat building), which would allow for basics and concepts to be clarified and scrutinized in more detail. The first two HOAI stages (HOAI = official scale of fees for services of architects and engineers) – basic evaluation and preliminary planning – are often merely touched upon.

5. What are the characteristics a planning team needs to have in order to create sophisticated and sustainable buildings?
Expert knowledge, experience, dedication, passion, personal involvement – weren't these the words of D&S Advanced Building Technologies? – staying power to clarify everything over and over again, fun, a sense of responsibility.

The planners should not only be capable of acting inside their own range but also to look beyond the horizon.

6. What are some of the extraordinary qualities this building has to offer – to client and tenants?
Unique location, exceptional architecture, premium quality, maximum flexibility, state-of-the-art technology; everything a modern and innovative building needs in order to hold its own on the market for at least the next 20 years. It is one of the new symbols of Hamburg.

Highly transparent and yet sustainable

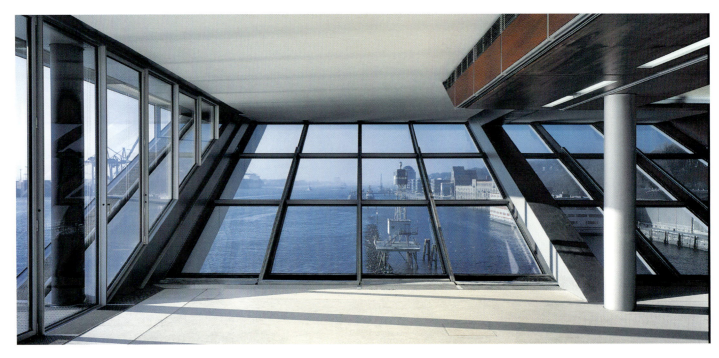

Fig. D1.2 View from the tilted façade onto the river Elbe

Since 2007, there is a new building in the fishing harbour of Hamburg. It is exceptional and formally brings up connotations of a cruise ship. Robert Vogel GmbH & Co. is the client. The building was designed by BRT Bothe Richter Teherani Architects of Hamburg. In approaching this project, the client right from the start placed emphasis on sustainable solutions with low life-cycle costs since he was to keep ownership of the building after its completion and operate it. At the same time, flexible solutions were desired in order to allow tailor-made solutions for renting out the units. It goes without saying that such a building needs to offer a maximum level of thermal comfort that leaves nothing to be desired and yet can be achieved in an energy-efficient manner.

These targets could only be met via integrated solutions. Hence, jointly with the architects, D&S Advanced Building Technologies worked out a system-planning approach across the trades, starting from building and façade to indoor climate engineering and building services equipment all the way to facility management for the opera-tion to follow. The results were integrated completely into the execution planning. For this, the integrative planning process was supported by modern planning tools (thermal building behaviour simulations, daylight engineering analyses) to allow for very early analysis of obtainable thermal comfort levels and envisioned operating costs.

The building is designed as an office building and was erected on a wharf facility *(see Figure D1.1)*. On account of its ship-like silhouette, the impression results of the building being a cruise liner moored length-wise at the wharf. The »bow« overhangs by ca 40 m across the Elbe river, the »stern« and the roof are publicly accessible via the staircase. The »ship« was not allowed to interrupt the clear view from the nearby »Alton Balcon« and so the building envelope had to be designed as transparently

Dockland Building in Hamburg

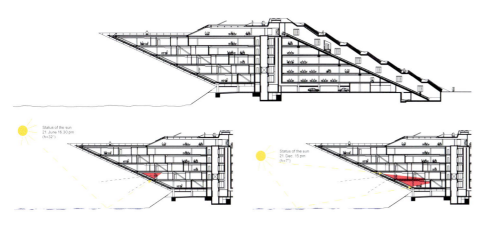

Fig. D1.3 Cross-section of the Dockland Building

Fig. D1.4 Radiation course for different times of day and different seasons for the tilted western façade

as possible. For this reason, an indoor climate and façade concept had to be developed that provided for energy-efficient operation under the conditions of high building envelope transparency and premium comfort requirement.

For generous glazing of office buildings, an optimum level of winter and summer heat insulation is imperative. Further, the building needs to be capable of being ventilated for as long a time period as possible via opening wings. On account of the prevailing windy conditions a double-skin façade was designed, which offers the advantage of an exterior solar protection device even at high wind speeds. Through this, cooling load in office rooms – at maximum façade transparency – can be nearly halved in comparison to an inside solar protection and this means that thermal comfort is greatly increased. In addition, the support structure was integrated into the double-skin façade, which means that it is afforded protection from

the extreme climatic conditions at the site. The outer façade skin consists of room-high and anti-collapse, line-wise arranged laminated safety glass and is permanently ventilated. The inside glazing, which is also at room-height, contains additional, simple, narrow and room-high pivot windows that allow for low-draught natural ventilation. The transposed inlet and exhaust air openings in the outer façade are flush with the upper edge of the finished floor level and the lower ceiling edge. In order to assure winter heat insulation, an economically viable dual heat insulation glazing was installed.

This façade was able to set the scene for energy-efficient indoor climate engineering at excellent thermal and visual comfort level and with simultaneous high building transparency. The low cooling loads can be optimally dissipated via energy-efficient systems like component activation. Component activation, on account of the large heat trans-

mitting areas, takes place at »high« cooling temperatures of above 18 °C. Building and ceiling mass is used to pass off – to the cooler outside air – during the night the heat that was absorbed over the course of the day – without much hassle, via a heat exchanger. This means that, for a large part of the year, no mechanical cooling is required.

Component activation in winter is used as base load heating, which means that – via agreeable surface temperatures – an optimum comfort level can be achieved. For this, component surface temperature is kept close to indoor temperature, which results in a certain amount of self-regulation effect being able to be used. On account of the different utilizations of the individual rooms, however, this self-regulation effect does not suffice by itself, which means that – complementary to component activation – individual room regulation for heating is always required as

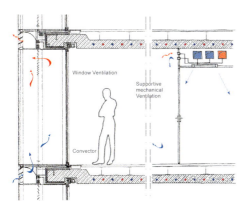

Fig. D1.5 Cross-section of the office and the double-skin façade

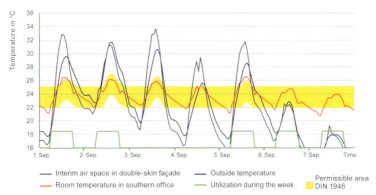

Fig. D1.6 Week's course of operative indoor temperature, determined with the aid of a simulation-based calculation during preliminary planning

Fig. D1.7 Cross-section of the western façade. The solar protection device runs from bottom up.

Fig. D1.8 Recooling unit as »ship funnel«

well. For the Dockland building, room temperatures can be controlled via lower floor panel convectors. On account of their exclusively convective heat emission, they compensate for cold air drop in the direct façade vicinity. Therefore, even during the heating period with low operating temperatures, an optimum comfort level is achieved with component activation. Due to the different possibilities for erecting dividing walls, room temperature is controlled via mobile »room thermostats« that are positioned at the individual workstations for user-specific control.

The supportive, mechanical ventilation is only required during the extreme winter and summer periods. In the interim period, the windows can excellently be used for room ventilation since the double-skin façade avoids rain inlet and relieves wind turbulence. That way, a comfortable inside temperature can be achieved year round for the office rooms – this was also the case during the lengthy heat wave in June 2006.

On the tilted west side, facing the water, a single-leaf façade was used since solar radiation calculations had shown that – during the hot summer months – no direct sunlight would be hitting the inside of the rooms due to the tilted arrangement of the façade. Rather, care must be taken to avoid direct glare in winter through a low sun and reflex glare in summer through mirror effects from the Elbe river. To this end, the interior solar protection device is run up bottom to top, resulting in freedom from glare and sufficient daylight for visual comfort *(Figure D1.2)*. Running the solar protection top down would very frequently have resulted in obscuring the entire façade and, through this, also the office rooms. Since there were only limited engineering areas available for further cooling arrangements, the required water tank for the sprinkler system is also used as a cold water storage facility. It can be filled at night and provides an additional cooling reservoir for lowering room temperatures. With this, an energy-efficient solution for cooling generation had been found *(Figure D1.9)*.

In closing, I wish to share with you a nice detail on the topic of integrated solutions. The recooling plants, which are responsible for free night cooling during component activation and also for recooling of the chiller, were able to be arranged – in accordance with the architect – in such a manner as to make them look like ship funnels from a distance.

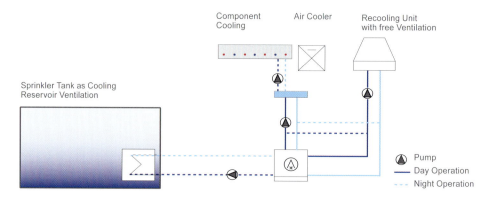

Fig. D1.9 Cooling concept for the Dockland building: The recooling units are used for direct cooling purposes, the sprinkler tank as a cooling reservoir

Dockland Building in Hamburg

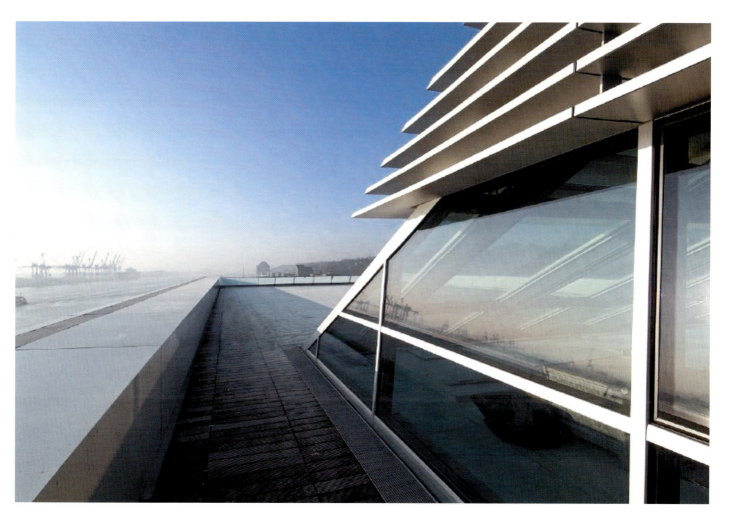

Fig. D1.10 View from the Dockland building roof

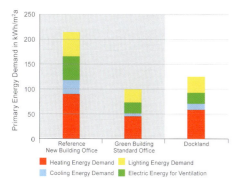

Fig. D1.11 Primary energy balance for room conditioning

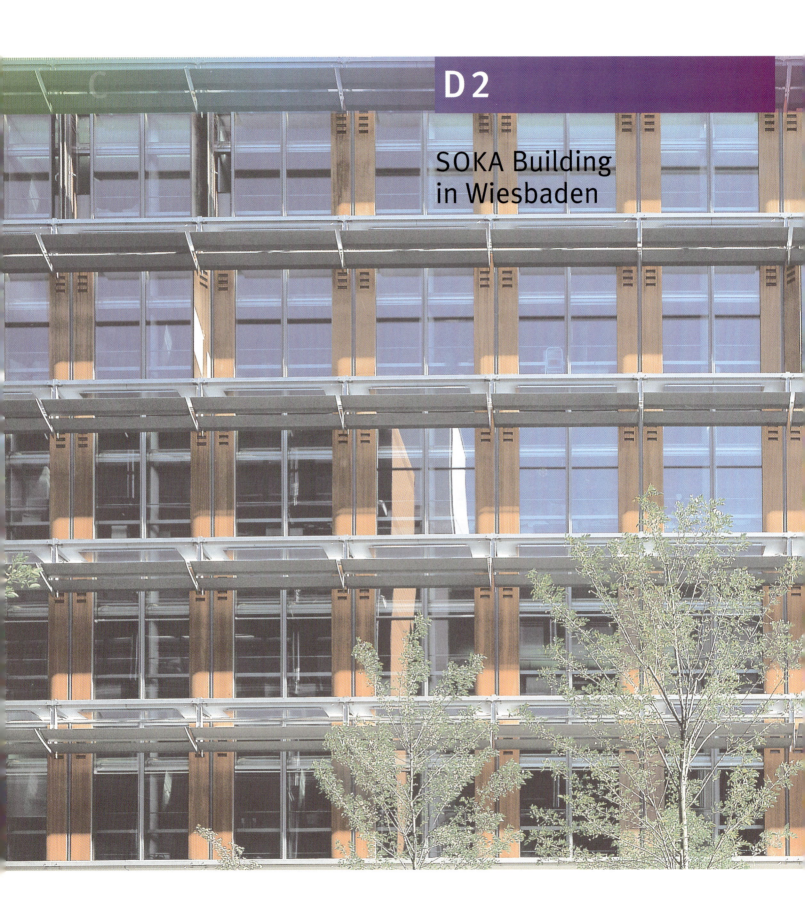

D 2

SOKA Building in Wiesbaden

Excerpts from the Book titled »SOKA Building« by Prof. Thomas Herzog and Hanns Jörg Schrade of Herzog und Partner, Munich

Fig. D2.1 Layout of the entire complex

New approach. When it comes to achieving the aforementioned changes in the energy household during operation of a building, everything that is of relevance to this, referring to individual cases, must be thought over once more. In this, local conditions (climate, culture, environment, topology, legal issues, geothermic conditions etc.) play a decisive role. Climate data with extreme and average values need to be at hand in order to recognize both utilization options and risks. As far as correct conditioning from a thermal point of view is concerned, the building needs to be viewed at a thermo-dynamic overall concept, and thought through as the same, by the architect as the main responsible entity. This is a matter of an essential necessity for reorientation and/or expansion of expert competencies. It is no longer enough to view buildings as mere volumes, however designed – whose envelope protects from environmental influences – with additionally implanted heating and cooling, possibly also ventilation – or air conditioning systems as energy-dependent and complicated additional systems that are to adapt to building shape and design: room shape, constructional-physical merits of the ceilings, walls and floors, shape and type of windows and so much more! Rather, it would be important, as soon as urban planning positions in relation to the environment have been clarified, to start focusing on the sheer volume of parameters that finally serve as decisive and interactive factors for indoor climate. Through varying physical characteristics – like heat conduction capacity, storage ability, absorption and reflection of radiation from the respective areas through colouring and surface roughness characteristics, control via multiple light reflectance, its concentration or diffusion and many other parameters – a successive and energetic overall optimum for the building construction may be obtained. At the very latest when we arrive at the point where the respective components or constructional sub-systems need to be designed from scratch, it becomes essential to involve »special experts«. Historically, the first of these was the engineer responsible for calculating the parameters surrounding the roof support structure. The latest addition to that group is the specialist engineer looking after the ever-expanding technology. As a result, wind channel experiments became essential for design processes. Further, calculations through building aerodynamics became an important factor for natural ventilation of components, as did experiments regarding inside airflow via novel ventilation systems in the façade. Additionally, the required certainty for planning decisions can only be obtained by making use of large-scale simulations or construction of 1:1 scale models from different materials. As already in process at numerous European institutes, they are subjected at the testing bay to experiments and load tests regarding functionality, visual effect, vibration danger under conditions of maximum wind stress and also hail resistance.

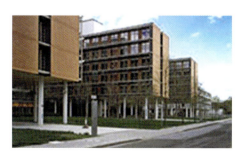

Fig. D2.2 ZVK office building, outside and interior views

Interview with Peter Kippenberg, Board Member of SOKA Construction

1. What, in your opinion, are the defining criteria for successful buildings?
Buildings are commodities that ought to meet user requirements and at the same time also be pleasant to look at. To me, lighting is important, and this includes both daylight and artificial lighting. Good room arrangement should be a given, with practical design and passages that are as short as possible. Further, office building should be easy and inexpensive to redesign, since a building's and even an administration's organization changes constantly, if not only due to technological advances. In the age of resource scarcity and rising energy prices, energy-conserving concepts are becoming increasingly more significant.

2. What does living inside a building mean to you? What factors are essentially decisive as to whether you feel comfortable or not?
As I already stated in reply to your first question, lighting is essential for me, a feeling of freedom and generosity. Even if conventional cubicle offices were put in, one should plan for glass areas between room and hallway, as is done in a combi-office situation, so that the individual feels less isolated at his workstation. Of importance are not only comfortable room temperatures in winter and summer but also a favourable radiation environment. This factor is not sufficiently considered. In the era of computer workstations, staff must be able to work in a glare free environment with low luminance contrast so that their eyes do not become too strained by the contrast between the dark computer screen and the bright room.

3. What is the role of sustainability, of life-cycle consideration, in your buiding stipulations?
We considered this right from the start in our planning. To give you an example: our architects wanted to implement the thermally active ceiling concept by ingraining water-conducting pipes in the slab. I vetoed this because the supportive structure of a building is the part that needs to last longest and nobody knows how long the synthetic hoses that are nowadays used for heating and cooling of components will last. I demanded that the water pipes be ingrained into the floor screed. This makes repairs that much easier. My prompt, at the time, initiated some scientific investigations in which D&S Advanced Building Technologies played a decisive role and from which, I believe, they gained some additional knowledge as well.

Sustainability has made an impact in other areas as well. For instance, one of my stipulations said that the building must be usable for any different office types that work on the same ceiling height, like cellular offices, combi offices or open space offices. This makes it possible to flexibly adapt office rooms to the organisation forms of the future.

A further advantage can be found in the fact that the entire power supply (high and low voltage, IT-cables) was moved into the façade so that, by shifting the mobile dividing walls, the newly created rooms could be interconnected virtually by computer without the need to lay anew the electrical wiring. Virtually, we handle the rooms via the window raster, which makes it easy to recombine areas for lighting according to different room organisation modes.

4. You experience the entire process, from design to operation. Where do you see the greatest improvement potential: in the process, in finding ideas, planning implementation, constructional execution or operating behaviour?
The most important thing, in my experience as client of several large projects, is that – as client – you need to know precisely what you want prior to issuing the planning order. For instance, before entering the architectural competition, and also before involving the project control division of Drees & Sommer – with whom we were very satisfied, incidentally – I had asked a professor specializing in utilization planning to compile a basic survey that outlines what possibilities for building there are. On our part, we clarified what office organisation we wanted for our building, what auxiliary utilizations we required and what prerequisites needed to be in place for making the building available to be rented out. It also needed to

be clear as to what sizes we could subdivide areas into that could be rented out separately. This meant that we had to determine possible demand. The second most important factor is a sensible overall planning approach. I am against starting construction with incomplete planning, as is often the case today. It is the only way to avoid costly amendments at a later stage. The constructional execution, and quality, is also very important. Control of the building after handover should not be left to chance or solely to the dedication of the staff. Often, clear definitions for comfort criteria are lacking, meaning how hot or cold it should be in summer or winter, how is the solar protective device going to be »worked«. Here, you can save a lot of money if you go about it the correct way. The largest leverage for a successful project happens right at the start, when the client himself needs to clarify what precisely he wants and what type of house he gives the order for building.

5. What are the characteristics a planning team needs to have in order to create sophisticated and sustainable buildings?

This question is not easy to answer in general terms. Naturally, you require intelligent people when it comes to complex buildings. Naturally, the different expert divisions need to be represented within a given team. It also seems important to me that such an inhomogenous team includes creative people, even if this sometimes entails chaos. Further, it is important that there are so-called organizers, who are capable of ordering these ideas and creating concepts. Finally, detailers need to be present also; they are the ones to provide individual quality assurance.

6. What are some of the extraordinary qualities this building has to offer – to client and tenants?

Our tenants and staff always assess our building in a very positive manner. Air quality is highly pleasant and hygienic, owing to the innovative air conditioning concept with component heating and cooling and fresh air supply without contemporary air conditioning system. Even on hot Wiesbaden summer days, temperatures remain at a comfortable level. The building is not draughty and lighting conditions are excellent. Finally, our building is beautiful and neither seems narrow nor compressed, although occupied zones constitute less than 20% of the overall area. Overall, even in entrance and development areas, the house presents with a lavish impression. Finally, construction costs were comparatively inexpensive at 1 540 €/m² useful space area plus V.A.T. when compared to other buildings of similar quality. With increasing operation it becomes evident that energy consumption is lower than initially provided for during the planning stage.

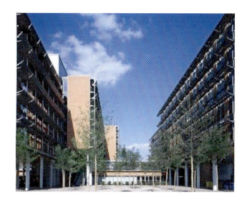

Fig. D2.3 View between the two new building sectors

Robust and Energy-Efficient

The goal during planning of the four new building sections and the renovation of the main building was to achieve energy-efficiency, comfort and low investment and operating costs with as little building technical equipment as possible. The client had explicitly asked for an innovative approach. The design of the architect provided an excellent base for this undertaking.

The new building sectors consisted of a basement and ground floor as well as four to five upper floors. The ground floor serves for the development of the sections. Further, there are special utilizations like conference rooms, restaurant and kitchen on that floor. The basement contains storage and control rooms and also the central computer system for the SOKA Bau. The upper floors are exclusively used for office purposes. At 13 m, the sections have a highly efficient depth for good natural ventilation and lighting of useful spaces. The core characteristics for energy-efficient construction in this building are as follows:

• Intelligent and decentralized ventilation façade, integrated, without fans. During winter, closable ventilation slits are available for controlled ventilation. On account of their spacing and size, they provide hygienic basic air exchange inside the room in a natural manner. In summer, the pivot windows may be opened to the outside for natural window ventilation.

• Highly insulated façade, with triple glazing and highly insulated façade profiles. On account of high surface temperatures above 15 °C, there is no need for an additional radiator. There is merely a »mini-heating element«, which is integrated in the ventilation façade.

• Low temperature heating and high temperature cooling in form of regulated, floor screed integrated water filled pipes.

• In the mid-nineties, the new building was one of the first buildings with large-space arrangement of thermally active components.

• Effective and daylighting solar protection device, developed jointly by the architects and the Bartenbach firm. For all orientations, active measures for conducting natural daylight and sunlight into the depths of the room have been provided for. This assures even distribution of the light right into the depths of the room.

• Energy supply with trigeneration and free night cooling for thermo active slabs. Trigeneration or combined heat and electricity generation describes the coupling of a combustion engine to a generator for generating heat and cooling. Natural gas is the fuel of choice. The building employs two CHPs that, in case of power failure, serve as emergency power supply also. A large part of the self-generated electricity is used for the building itself. Excess electricity is fed back into the power company's supply network. The heat thus generated is used for heating the building and also, via an absorption chiller, for cooling supply. If the heating requirement of the building exceeds generated heat yield, the missing part is supplemented via the existing public heat supply. Likewise, excess heat can be fed back into the local district heating network. The existing building has been integrated into the overall energy concept. Renovation of the main building encompassed the complete building envelope and building services engineering. This, compared to the previous year, resulted in a heating energy requirement reduction of 65%.

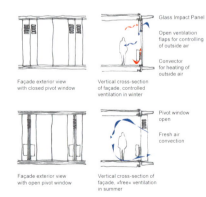

Fig. D2.4 Natural ventilation of the offices

Optimizing Operations – Total Energy Balance for 2005: Heat, Cooling and Electricity

For operation optimisation and energy management after takeover of the building, the client received the support of the Biberach University of Applied Sciences and of D&S Advanced Building Technologies. The 2005 results for the essential building sectors significantly confirm the predictions obtained from the comprehensive simulation during planning. In relation to heated Gross Floor Area (GFA) of the new building of 56000 m², the characteristic value of consumption for useful heat is at 39 kWh per m²GFA_e per year. This corresponds to an annual consumption of just about 4 l heating oil per m². When applied to gross floor area (without garage), the new building of the SOKA BAU thus constitutes a »4-liter house«.

Useful heat consumed by the new building stems to approximately even parts of respectively 40% from the public heat supply network of the city of Wiesbaden and the two CHP units in the building. The remaining ca. 20% come from waste heat of the absorption chiller and thus constitute some kind of heat recycling. On account of the low operating temperature for the thermally active ceilings – of max. 27°C for heating – especially, it becomes possible to use part of the waste heat from the absorption chillers for heating purposes. In 2005, the thermally active ceilings received about 60% of their heat from this »waste energy« source. During the heating period, they provided ca. 60% of total heat required, the remaining 40% came from the mini-radiators inside the façade, which serve for outside air cooling.

Useful cooling consumption for the new building, less the computer room, was at 18 kWh per m²GFA_e per annum. This value lies within the Green Building benchmark for cooled office buildings in Germany. Two thirds of this is generated without the use of energy-intensive chillers, merely through cooling towers (free cooling operation). Further operating optimisation is possible in future.

One third of the overall property electricity is generated from inside the building, via environmentally friendly trigeneration via the two CHP units. The new building, in 2005, consumed 110 kWh/(m²GFA_e) on account of its electricity-intensive utilizations (computer centre, print-shop). One third of this electricity consumption can be accounted for by special consumers like the computer centre, kitchen, print shop, ramp heater and underground car park. Without these special utilizations, the characteristic value of energy consumption for the building reduces to 75 kWh per m²GFA_e per annum.

The project was awarded 1st premium prize of the 2006 Architecture and Technology Award.

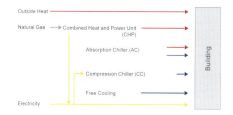

Fig. D2.5 Block diagram for energy supply of total property area

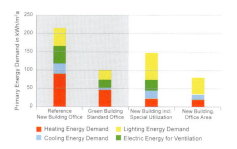

Fig. D2.6 Primary Energy Balance for room conditioning systems of the new building

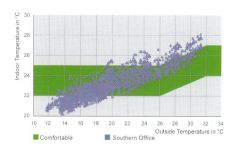

Fig. D2.7 Comparison of achieved indoor temperatures/ simulated values from planning

D 3

KSK Tuebingen

Interview with Prof. Fritz Auer of Auer+Weber+Associates, Architects

1. What, in your opinion, are the defining criteria for successful buildings?
We interpret success according to whether the building is acceptable to client and occupants. Quite a lot is needed to achieve this.

We must look at all the demands on a building, including costs. These, incidentally, should always be considered in relation to success, not isolated. What can the building provide for this kind of money? The appropriateness of the means, therefore, is very important to us.

2. What is the role of sustainability in your building designs?
We believe that buildings should not only be spectacular but also substantial. Their usage we consider to be one of the most important criteria in this. I feel that buildings, and this means also their architecture, stand for a certain continuity in our culture because they are long living.

But among other factors, the fundamental prerequisite for this is their purely substance-based shelf life. This means, no cheap, expendable materials but materials whose initial purchase costs may be higher but which present a better quality and thus are more durable. For me, it is important that buildings age in a dignified manner without rotting.

3. What are the goals of the firm of Auer + Weber + Associates when it comes to Green Buildings? What are your visions there?

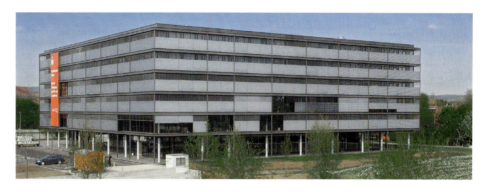

Fig. D3.1 Administration building of the Tuebingen regional bank

From an economical operation and energy point of view, the use of natural energy resources should be a priority.

Another point is the employment of organic materials that contribute to comfort but are also effective from a technological viewpoint. We also need to unite the various aspects, like urban planning, architecture and sustainability, which are all interrelated.

4. What does your cooperation with D&S Advanced Building Technologies look like? What are the essential pillars of your many years of working together?
Once upon a time, there was a tiny technical hand-drawn sketch by Mr Lutz, which we received as a proposition for problem solving. This mirrored the expertise of D&S Advanced Building Technologies. For us, D&S Advanced Building Technologies became an essential component that provides concrete solutions. It is very important to us that the expert involved lives within his or her time, is able to look beyond the horizon and is willing to carve new paths together with us.

5. What are the characteristics a planning team needs to have in order to create sophisticated and sustainable buildings?
True openness must prevail from both, or let's say several, sides. All those involved in planning must have a common goal. This means that different interest areas must be integrated into the whole.

Each expert involved should be granted a certain freedom in terms of development and there should be no subjecting to orders by one side, even if it turns out to be the side of the architect. The ideal case scenario would be openness and cooperation of all experts involved in finding new solutions. Only then can we find new solutions not only from the engineering but also from an aesthetic point of view.

6. How did the idea for the building design come about?

The building functions as the corner pillar for the Mühlbach quarter region. In this part of town, we find institutions of various kinds, which are all in spatial relationship with each other. This is why the design of the Kreissparkasse Bank Headquarters was not allowed to base itself on any types of fronts or lengths. The square base plan does not provide direction to the entire region but stands on its own. This results in a united cubicle, which then integrates itself into its surroundings in a freer, lighter manner through its lifted ground floor. It also guarantees the permeability of outdoor areas and thus establishes a spatial relationship with the other institutions. Another aspect was the outer skin design of the building, which was to be glazed at full building height without any economical drawbacks resulting and without hampering thermal comfort inside. This was achieved thanks to premium glazing with a shading device, and also through a ceiling cooling approach.

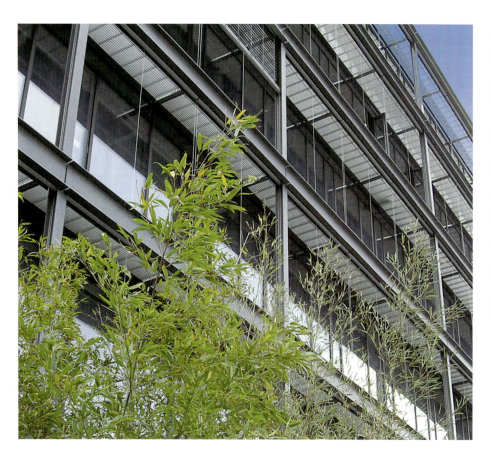

Fig. D3.2 The triple glazing for the building was designed especially and the frame elements were premium heat insulated

Fig. D3.3 Interior view with super heat insulated façade

Transparently Ecological

In April 2006, the Tuebingen regional bank moved into its new administration building called »Sparkassen-Carre«. The new building allowed the bank to expand on its capacities and to operate more efficiently. Aside from the economical aspect, the building concept was meant to be a model for ecological and progressive construction. From this idea, the architect office of Auer + Weber + Associates came up with a clear design representation of a timeless and economical construction approach. Through optimised, construction-based heat insulation and a sustainable energy concept, the ecological aspect is highlighted. Via 150 auger piles, which were required for the foundations of the building, earth heat is accessed for heating and cooling purposes. The piles are efficiently integrated into a room climate concept with low temperature heating and high temperature cooling function.

Constructional heat insulation is provided via specially developed and highly efficient triple glazing plus a super heat insulated façade. It was a challenge for the façade and climate engineers of D&S Advanced Building Technologies to design efficient heat insulating frame elements that also met the design requirements of the architects. So far, super heat insulating frame constructions, had been very wide and were, therefore, not suitable for this type of filigree construction. Working together with the passive house institute in Darmstadt, it became possible to increase the heat transfer coefficient of a narrow 58 mm frame construction by 50% and to decrease the heat loss coefficient U_f from 1.6 to 0.9 W/m²K.

This kind of efficiently heat insulating façade construction forms the base for an innovative indoor climate concept. The rooms are heated and cooled via thermally active ceilings; an additional edge trim temperature control element allows for individual regulation. This, in turn, is the base for greatest possible thermal comfort since surface temperatures of floor and ceiling were matched to climatic conditions. In addition, the edge trim temperature control elements, further, are layered with sound insulating material and thus improve indoor acoustics – a dual purpose that further increases the economical viability of the concept. Façade heating areas could be foregone on account of the excellent heat insulation since inner surface temperatures are always above 18 °C. Ventilation is arranged for hygienic air exchange in order to save electric energy for this particular air transport. The floor source air inlets are arranged in front of the pivot windows and further minimise cold airdrop as a result of leaky joints at the windows. Stratified ventilation allows for impulse-free air influx into the room, which excludes decrease of comfort through high air velocities. The comfort level was proven with an airflow simulation.

For the conference room, also, a room climate concept was designed that integrated into the overall ecological picture. Through use of a stratified ventilation concept, smell and heat stress of the air in the occupied zone is greatly improved in comparison to conventional concepts. In a low-impulse manner, the air comes in through the source air out-

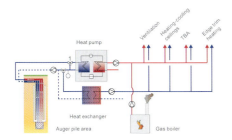

Fig. D3.4 Heating and cooling scheme with geothermal application

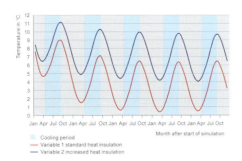

Fig. D3.5 Soil temperature course over several years

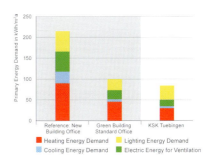

Fig. D3.6 Primary energy balance of systems for room conditioning

Fig. D3.7 Conference Room

lets in the walls and evenly distributes across the occupied zone. The smell and heat loaded air, on the other hand, rises past the people and is suctioned out in the ceiling region. Intrusion depths of 15 m are easily reached with one-sided ventilation. The level of required air current can be arranged, just like in the office zones, according to hygienic air exchange and is some 30% less than for conventional systems.

This means that energy demand and investment costs are both decreased. Arrangement of the ventilation concept and proof of air quality was achieved via airflow simulation.

The geothermal usage concept was designed with the assistance of a system simulation procedure. For this, thermal building behaviour was investigated together with soil heat withdrawal in winter and heat introduction in summer.

The system simulation shows that geothermal usage with 150 energy piles, in connection with a heat pump, covers in excess of 70% of the energy demand of the building. Cooling energy demand

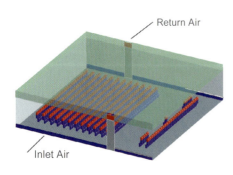

Fig. D3.8 Airflow simulation

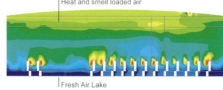

Fig. D3.9 Room climate concept with component activation, edge trim element and source air inlets in façade vicinity

can even be almost completely covered without the heat pump. The only requirement is for the auger pile region to be sufficiently flushed with ground water. If this is not the case, the soil cools down more slowly. For this reason, during planning, an even energy balance over the entire year ought to be achieved, which means that only that amount of heat may be withdrawn from the earth that is being reintroduced again in summer. This concept leads to a prognosis of primary energy requirement reduction for room conditioning systems by around 68%. CO_2 emissions decrease by around 177t per annum in comparison to a conventional solution with gas boiler and chiller.

Fig. D3.10 View of the façade, shaded and sunny side

Fig. D3.11 Ventilation ducts for the offices. Distribution occurs inside the concrete ceiling.

D 4

LBBW Stuttgart

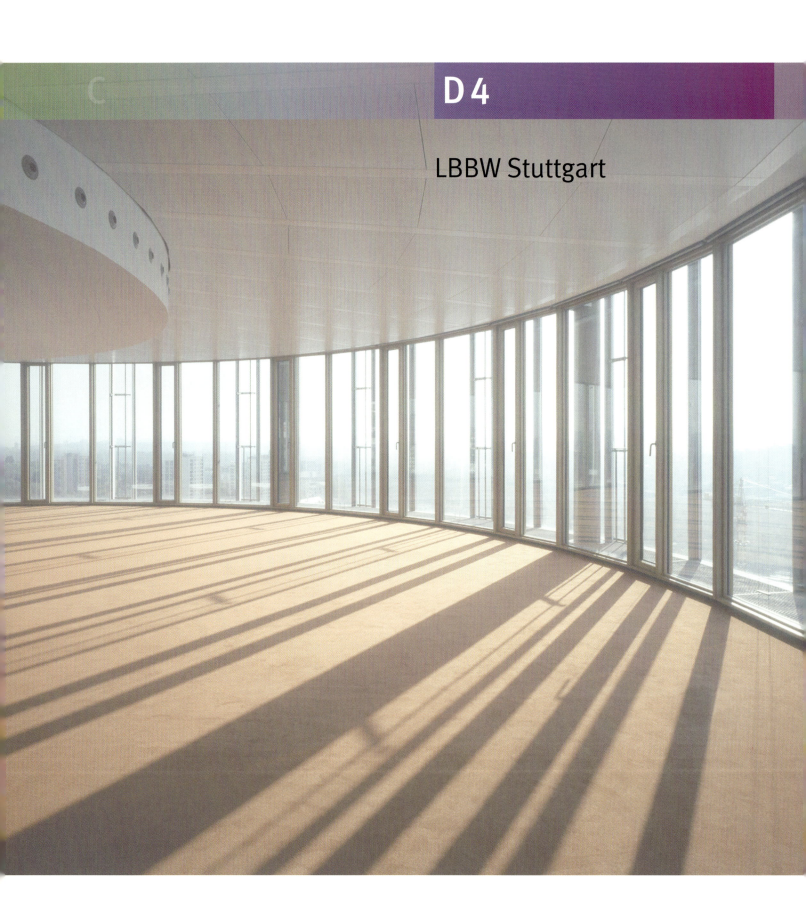

Interview with the Architect Wolfram Wöhr of W. Wöhr – Jörg Mieslinger Architects, Munich, Stuttgart

1. What, in your opinion, are the defining criteria for successful buildings?
I believe that successful buildings distinguish themselves by their sustainability in regard to their aesthetic appearance but also their technological features. Modern buildings, therefore, should always have a relationship with the inventory and react to their environment. Then they guarantee optimum usage.

2. What is the role of sustainability in your building designs?
There are many different aspects that work together in order to help a building become part of an integrated whole: we need to look at its technological, functional, urban-planning and aesthetic arrangement. The growing world population and the increase in urban settlements with simultaneous decline of rural areas is a challenge to designers. They need to create places worth living in for the generations to come.

3. What are the goals of Wöhr and Mieslinger Architects when it comes to Green Buildings? What are your visions there?
A futuristic topic that increasingly keeps occupying our minds – aside from constant progression of modern building technologies and their aesthetic appearance – is how can we resuscitate existing building stock? With several of our projects, we have already undertaken building refurbishments that contribute towards an ecologically sensible, sustainable use of the building stock.

4. How did your cooperation with D&S Advanced Building Technologies come about? What are the essential pillars of your many years of working together?
Our cooperation with D&S Advanced Building Technologies is characterized by openness and excellent teamwork. A high level of expert knowledge always results in successful execution of a given project.

5. What are the characteristics a planning team needs to have in order to create sophisticated and sustainable buildings?
A successful planning team must have both expert knowledge and creativity as well as, to a high degree, team spirit and the ability to communicate.

6. How did the idea for the LBBW building design come about?
Initially, there were a lot of urban planning factors to keep in mind. We were facing a special situation here, which was the connecting of the new building to the existing LBBW buildings on the site of Stuttgart 21. This gave rise to the idea of a space-creating city extension. It was important to me to set a solid mark that would define and distinguish the place.

7. What were your goals for this design?
With Stuttgart 21, I wanted to create a new, lively and vivacious part of town to exist as a functioning component of the inner city. For this reason, the historical building stipulations in Stuttgart, perimeter block development, were an important guideline for the new building. The materials used, also, were supposed to adapt to old traditions and form one solid unit with those already present. In the next step, I looked at optimisation of working space quality via organisation and interior make-up of the buildings. Another topic that is always close to my heart is the accessibility of a building from the outside.

8. What are some of the extraordinary qualities this building has to offer – to client and tenants?
A building speaks its very own language and this language fulfils representative as well as identification-related requirements. An excellent working place quality level is mirrored in this particular building's architecture. The layout is flexibly variable, which means that a swift reaction to changing requirements becomes possible and, for each new utilization, an optimum working environment can be created once more.

Interview with the Client Fred Gaugler, BWImmobilien GmbH

1. What, in your opinion, are the defining criteria for successful buildings?

The first is a high degree of flexibility. For this reason, there should be as few user-specific fixtures in the areas to be rented out. The second of the criteria is an economical layout. Correct building depth contributes towards economical operation, especially in the case of open office configuration. The third aspect is usage quality. With today's dense occupancy rates, cooling of the useful areas is a must. Its quality level should not be subject to economisation.

2. What does living inside a building mean to you? What factors are essentially decisive as to whether you feel comfortable or not?

Well-chosen colours on all visible surfaces, for instance, are an important factor. I am looking for warm wood tones and manageable room size. These measures serve to create a sense of comfort, which, here in Germany, we call »Gemütlichkeit«. Another important factor is the chance for occupants to socialize with each other. Nothing is more important than the tea kitchen or the copy room, regardless of how small they might be. For an open office configuration, on the other hand, you need meeting areas where you can socialize and discuss topics that may go beyond the immediate work subjects as well. In other words, during planning one needs to ask the occupants what their expectations of the rooms are, in terms of their character.

3. What is the role of sustainability, of life cycle consideration, in your building stipulations?

This aspect, indeed, is as important as the initial investment for the building itself since you really have to live with both factors. The decision on the initial investment is usually a matter of a few minutes. However, once operating costs get out of hand, the damage is considerable. For this reason, each building we handle should be considered from a life-cycle aspect also and we wish to improve in this area with each building we erect. During planning, and later also during operation, we test each system and component for its sustainability. Further, we determine whether it is causing or saving costs. Therefore, this discussion is no longer limited to initial investment only.

4. You experience the entire process, from design to operation. Where do you see the greatest improvement potential: in the process, in finding ideas, planning implementation, constructional execution or operating behaviour?

All of the above. Just like D&S Advanced Building Technologies does for its project support, we also need to be aware early on that it is during the initial planning phase where you need to make the correct decisions. During the actual building stage, it is very important for someone on the client's side to look after quality control. When it comes to operating costs, we do two things: first, as already mentioned, there are sustainable decisions during planning. Then, we strive to lower energy costs even further during operation and we do this by forming a so-called operations team which has certain savings targets and also goes out to seek advice during the initial phase.

5. What are the characteristics a planning team needs to have in order to create sophisticated and sustainable buildings?

Above all, it needs to be creative and persistent in following its goals. Aside from their architecture and investment costs, the energy consumption of buildings nowadays is a big factor.

6. What are some of the extraordinary qualities the LBBW building has to offer – to client and tenants?

This building complex is located at the entrance to the City of Stuttgart and impresses through its prominent Highrise design. I like both its overall appearance and also its interior design, which not only pleases us as clients but also the occupants. Further, I think the ecological approach to operating the building is remarkable. One should not forget that Green Building as a term is synonymous for buildings that not only strive to be aesthetically pleasing but also take into account the energy aspect and hence, satisfy their owners and occupants.

High and Efficient

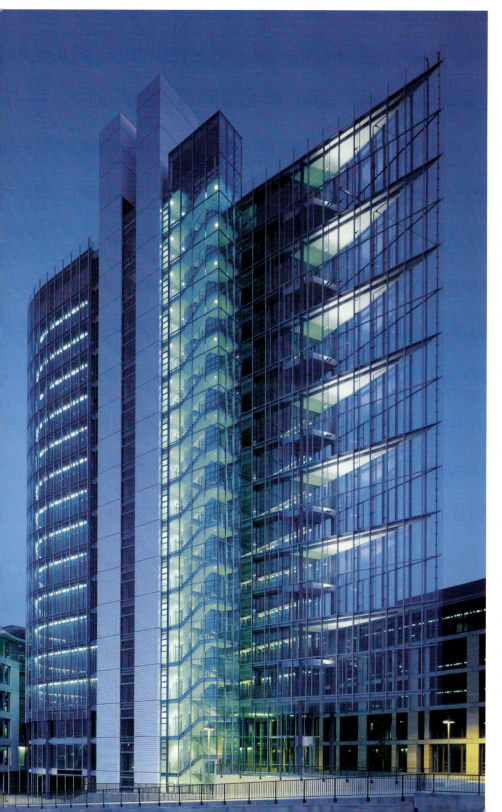

The new buildings of the Landesbank Baden-Württemberg (State Bank of BW) launched the urban planning developments for the Stuttgart 21 project. Some 2000 staff work in an area of ca. 58 888 m², in the direct vicinity of the existing LBBW building. An important goal here was to stay below the annual energy requirement of the EnEV public supply company and at the same time meet the sustainability requirements of the City of Stuttgart's so-called »Energy Seal of Approval« during planning, building and later also operation. The idea behind the seal is to motivate a volume of energy preservation that goes beyond the legally specified amount. In case of an architecture presenting openly transparent work areas consisting of large glass surfaces and only few compact building components, this is a challenging task indeed.

The Energy Quality Seal consists of two parts, the »Energy Quality Seal for Building Planning and Construction« and the »Energy Quality Seal for Building Operation«. The benefit for the participants is both on an idealistic and economical level. Idealistically, it is due to being an active and sensible contribution towards the protection of the environment and its resources. It is also economical since the implementation and fulfilment of criteria specified by the Energy Quality Seal results in active quality control for planning, construction and operation of a given building and also in decreasing operation costs.

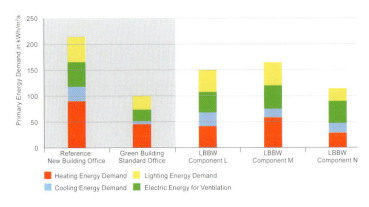

Fig. D4.1 Primary Energy Demand for the LBBW new buildings for room conditioning

The Quality Seal looks at the building envelope, heating, ventilation, cooling and lighting from a sustainable perspective.

Building on a comprehensive analysis of utilization and requirements of comfort, a demand-oriented indoor climate and energy concept was worked out taking into consideration aspects of building physics and façade. With the assistance of simulation calculations, it was already in the early planning stage that achievable levels of thermal comfort and the resulting energy demand were analysed and incorporated in the decision making process. The simulation models were arranged in such a manner as to be applicable not only for planning but also during subsequent building operation, for a comprehensible (strategic) operation optimisation since monitoring energy demand is one of the aspects of the Energy Quality Seal.

With the assistance of a variant study that took into account heat insulation concepts and system engineering, economical and energy ecological aspects could be defined. The heat insulation concept with the best expenditure-utilization ratio for this building – with an insulation reading (WLG 040) of 14 cm – lies in the non-transparent façade and – with 20 cm – on the roof. The windows are equipped with double heat insulated glazing and have a window surface ratio of around 70%. The studies clearly show that the requirements of the Quality Seal, if we are to stay within acceptable and economical means, can only be achieved by additional use of outside heat. Using ecologically more favourable applications like a CHP or a bio mass boiler, would constitute an alternative but are impossible due to the existing urban planning contract.

The overall concept, which was finally implemented, specifies the abovementioned heat insulation concept for the L and M flat buildings, with radiators and cooling ceilings. Since the high-rise has been completely glazed, triple glazing with heat insulation and a double-skin façade is used. An advantage of this specific heat insulation concept lies in the fact that the cooling ceiling can be used also as a heating ceiling and that no radiator is required for the façade.

Comfort in the rooms was defined via numerical airflow simulation. In the façade vicinity region at up to 1 m distance, there are only a few comfort deficits from cold airdrop at the room size pivot windows. In the region of the working space, however, comfort requirements were completely met.

The flat buildings are equipped with an outside solar protection device. One advantage of a double skin façade in a high-rise is an effective solar protection in the interim façade space that remains stable even during high wind velocities and therefore, especially in summer, provides optimum protection. The upper ribs are arranged horizontally and support daylight illumination. Control is per room and/or façade and takes into account shading from adjacent buildings.

Air exchange in the office rooms is hygienic and, on account of the open space setting, arranged dually. Air distribution has been designed in such a manner as to allow for exclusion of office areas with windows that can be opened in the interim period. Even in a high-rise, the rooms can be naturally ventilated for 70% of the time due to the double-skin concept.

The overall concept further includes a thermal solar power system with a collector surface of 350 m² that is being used for heating of air and drinking water. Rainwater is used for outdoor irrigation. The annual energy yield of the solar power system is around 135 MWh/a

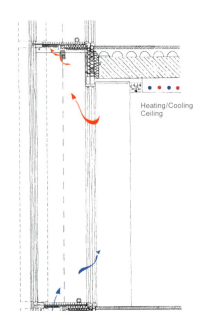

Fig. D4.2 Façade design of the LBBW high-rise

LBBW Stuttgart

	Installed Capacity [W/m²]		Energy Requirement [kWh/m²a]	
	boundary value	target value	boundary value	target value
Community Office 500 lx	15	11	22	13
Hallway 100 lx	4.5	3.5	4.5	1.5

Stock Evaluation

	Installed Capacity [W/m²]	Energy Consumption [kWh/m²a]
Community Office	11.3	17.0
Interior Trafficked Areas	5.0	4.0
Hallways	4.4	3.5

Tab. D4.1 Summary of Quality Seal requirements for lighting, and readings

and can be included in meeting overall primary energy demand.

Diverse new tools were developed to meet the Quality Seal's requirements for construction and operation. The façade, once completed, was subjected to random testing for density and also to a complete infrared thermography. These controls were part of the encompassing inspection and commissioning procedure.

The simulation models from planning can be used for inspection of ICA functions prior to installation of the DDC devices. This allows for early identification of malfunctions, which prevents later trouble, increased energy consumption or uncomfortable room conditions during later operation. These simulation models are used as a referential base for the subsequent operation optimisation. The simulation models create a kind of ideal operation situation. Comparing actual with ideal operation, optimisation potentials can be worked out that were previously impossible with the usual systems. For the Energy Quality Seal, the tools are currently applied in order to define actual energy consumption and the resulting level of energy efficiency. *Table D4.1* shows quality seal requirements for lighting, and results of the readings. Annual energy demand calculation was handled via simulation, and validated through the readings. Measuring heating, cooling and electricity consumption was handled according to the same system.

Primary energy consumption lies somewhere between the demand of the reference building and the target value of the Green Building Standard Office. The high-rise, with its improved heat insulation, presents the lowest primary energy consumption level and remains about 20% above the target value. The results for the first two years of operation are satisfactory but also point towards a further optimisation potential that is meant to be realised over the next operation years through operational energy management.

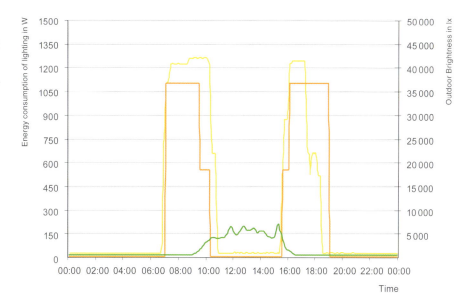

Fig. D4.3 Electricity consumption for lighting for a communal office

D 5

The Art Museum in Stuttgart

Interview with the Architects
Prof. Rainer Hascher and Prof. Sebastian Jehle

1. What, in your opinion, are the defining criteria for successful buildings?
We believe that they depend on the relevant utilization and task at hand. A laboratory building must perform differently to a museum and, on the other hand, a museum by the motorway is different in its design to one in an established city setting. Renovation of a protected 19th Century building with a massive natural stone façade cannot be subjected to the same energy standards as a new building etc. Essential criteria for a successful building and its erection, on account of the complexity of building requirements, are to be defined from scratch at the beginning of each planning process and are to be specifically adapted to the respective task.

2. What is the role of sustainability in your building designs?
Construction and operation of buildings constitute, as a rule, stress for the environment since there are no ecological procedures per se, but only more or less environmentally damaging procedures and materials. For each level of operation assembly and disposal, energy flow is generally required, resulting in environmental stress from transport movements, and toxic substances result for man and nature. For this reason, debates surrounding architectural design will in future no longer be possible without also including the sustainability component. The term »sustainable development« does not merely touch on ecological considerations; rather, there are also economical, societal and cultural values. These should be integrated into the planning concept in a manner that results in innovative buildings.

3. What are the goals of Hascher Jehle Architects when it comes to Green Buildings? What are your visions there?
The relationship of inside to outside, for our daily habits, has achieved the same significance as was previously the case for separating a building from nature through the use of innovative technologies and materials. This integrates a building more intensely into its environment. There are softer transitions in the envelope region – light, for instance, can be guided, filtered, dimmed, diffused and reflected and energy flow becomes more controllable. The psychological gain resulting from a transparent envelope, seeing and experiencing the change of night and day, of wind and weather, of summer and winter, became an important component for open and eventful architecture during the 20th century. It will also continue to be of great importance for 21st Century architecture. With this in mind, we aim to optimise viable energy concepts not solely for their own sake, at the expense of room quality and quality of life, but rather to develop innovative and premium quality user concepts for day-to-day requirements that open up new paths of energy supply. In the best case scenario, there is a sustainable development of architecturally defined living spaces that do not solely depend on such tangible elements as walls, ceilings and floors (all of which initially define the room) but also on more abstract and yet very clear dimensions like light, temperature, air exchange, smell and acoustics.

4. How did your cooperation with D&S Advanced Building Technologies come about? What are the essential pillars of your many years of working together?
By chance, we came together some 14 years ago, during the planning stage for the national terminal of the BS airport and, back then already, were engaged together in developing energy-preserving concepts for buildings. We know and trust each other.

5. What are the characteristics a planning team needs to have in order to create sophisticated and sustainable buildings?
To obtain innovative and quality results for a given task, a carfully matched team should be put together that consists of specialist engineers and scientists, technical advisors, construction supervisors and also of cost and project managers. Such a team, in its entirety, presents an encompassing quality profile. We see ourselves as head of such a team, which develops tailor-made solutions for the task at hand. Within a holistic overall concept, partial tasks

Fig. D5.1 The new Art Museum in Stuttgart

are executed by specialists during planning. This happens in a simultaneous manner. They are then synchronised by the architect, as coordinator and »creative head« of the team, and integrated into the comprehensive planning process. This simultaneous and holistic approach, through its ongoing cooperation with the expert planners, results in synergy effects. Innovative, comprehensive solutions are the result – at a premium quality level that would not even be thinkable with contemporary planning methods. The rigid planning process is replaced by a series of parallel and interactive design procedures – this gives rise to new architectural concepts and ideas.

6. How did the idea for the Art Museum design come about?

There is a subterraneous motorway intersection, which runs under the small castle park. This goes back to 1969, has five tunnels, and for the most part, had been out of operation for years and had only been used by the local Stuttgart sprayer and skater scene.

One characteristic feature of our concept was the integration of this subterranean structure. The diagonal tunnels were used for covering 4/5 of the exhibition space. We did not wish to destroy the existing substance but rather were interested in systematically running it through the entire building. The cube, through this, gets a slight imperfection and this creates a very special tension in some of the rooms. We believe that modern times came up with a perfectionist approach that eventually backfired: the approach was egocentric and based on wishing to find the perfect geometric solution to everything. Yet an old city like Rome, for instance, touches us so deeply precisely because we can still feel the air of what once was, even if it has been covered by new buildings several times over. Through its special setting, the lower exhibition area has a unique character of its own.

7. What were your goals for this design?

We are not merely looking for a public building to occupy a given space but we were looking to create a space – interior as well as exterior – that would serve as a location of communication to the citizens and visitors of Stuttgart. The museum and its adjacent space become an active part of downtown and public life. While the rooms housing the permanent exhibition are entirely inside, the cube with the changing exhibition is arranged in such a way that the exhibition rooms are still indoors but extend to the outside around the envelope. This interim space functions like a shopping window for art, with a very special external effect for the museum and the city itself. The glass cube's transparency is an integrated design component.

The façade has different effects, depending on day or night. During the day, it presents as an elegantly restrained building through its minimal supportive steel structure, the horizontal stripes and its set back basement. At night, however, perception turns to the reverse: the outer glass envelope dissolves, the stone cube lights up in its natural colours and establishes a direct relationship with the adjacent royal building.

8. What are some of the extraordinary qualities this building has to offer – to client and tenants?

We want to leave it up to the client to answer this question. Aside from client satisfaction, we also place emphasis on public acceptance of the museum – the people of Stuttgart seem to like the building because they voted for it to receive the »Prize of the Public« during a competition run by a local newspaper, the Stuttgarter Zeitung.

Crystal Clear

The new Stuttgart Art Museum mainly consists of the gallery rooms in the basement. The visible glass cube, however, makes a prominent mark. It primarily covers the entrance areas and also one roof area with special utilizations like restaurant and conference area *(Fig. D5.1)*. The actual exhibition area in the above-ground glass cube is arranged in a centralized manner surrounded by an access corridor that is divided by a concrete structure wall covered with natural stone. Through the glass façade, visitors get a splendid view of the Stuttgart city center. In the evening hours, the lit façade attracts people to the »Schlossplatz« that has become a central meeting hub for the city ever since it was completed in spring 2005. A glass roof with highly selective solar protective glazing closes the building on top. The roof area is used as a function setting and also as a restaurant. The target, during planning, consisted of obtaining year-round comfort for the glass cube and the exhibition spaces – by applying energy-preserving concepts that were easy on resources as well.

Deciding on the best indoor climate concept for the Stuttgart Art Museum constituted an exceptional challenge as far as the cooperation between architects, expert planners and climate consultants were concerned. Through application of innovative simulation tools, the climate concept was developed during the planning until it was an a stage to be implemented. In the roof area, multifunctional lamella are used that were especially developed for this purpose. They serve for heating and cooling as well as functioning as a so-lar and sound protective sail.

Concept for Natural Ventilation and Cooling for the access Corridor

The access corridor is about 2 m wide and includes the glass cube in all areas. Through it, visitors get to the public roof areas and also to the exhibition rooms of the museum. It was one of the aims of this design to guarantee a clear view from the access corridors into the city, year-round. For this reason, the glazing has been equipped with both a solar protective layer and also with additional imprint in order to reduce solar radiation influx as much as possible. The imprinted parts of the glass façade correspond to energetic studies while the arrangement of the imprinted fields had been left up to the architect. He selected them according to outer design and translucency from the interior.

The primary idea behind the room climate concept for the access corridor

Fig. D5.2 Natural stone wall in the access corridor

Fig. D5.3 Water-filled pipe coils serve for thermal activation of the natural stone wall

was to exploit natural ventilation potential and to decrease peak indoor temperatures through activation of the massive, heat storing components. It becomes clear that a fully glazed corridor with low depth can be conditioned without too much energy demand provided that indoor climate in summer does not have to be as comfortable there as it is in the exhibition areas. Hence, the indoor climate for the Art Museum works according to a cascade concept, at least on hot summer days: when entering the accessory hallway, the air there is perceived as being cooler than on the outside. The climate in the exhibition areas is very comfortable, then, since it needs to be kept at a constant level year-round on account of the art works there. The access corridor is ventilated via near-invisible ventilation flaps in the floor region of the first storey. The natural stonewall is thermally activated via water-filled pipes. In winter, they serve for base heating and in summer for peak load cooling *(Figures D5.2 and D5.3)*. Together with the glass coatings, this results in the effect that summer temperatures in the accessory corridor are perceived as being more comfortable than outside. The simulation procedures used helped in determining what temperature conditions occurred how often. For the largest part, natural ventilation and the cool natural stonewall suffice to meet requirements. Should the hot weather stretches last longer then it is possible to use some of the museum's mechanical ventilation for the access corridor also. From an energy consideration this is only tolerable if it happens for a brief time of the year – just like predicted during simulation.

Natural Ventilation and Acoustics Concept for the Roof Area

To prevent overheating and also to save cooling energy, louvers were installed in the glass roof. They also work as smoke extractors in case of fire. The louvers are opened depending on weather conditions and indoor temperature. Via the louvers on the Southwest façade and/or the staircase on the Northwest façade, inlet air gets into the building. There are further ventilation openings between the staircase and the events room in the roof level. By using the uplift height of about 20 m, the air can rise easily and this leads to good distribution levels inside the room. This type of natural ventilation also results in free cooling of the roof level and it is automated. In case of very high outside temperatures, ventilation louvers are closed and mechanical ventilation is activated. This avoids heating up of the room beyond comfort limits during hot summer days. Additionally, the louvers are used for night cooling.

There is a problem, for low rooms with glass roofs especially, with a lack of thermal and room acoustic functions. The museum's conference room, for instance, which is located under the glass roof, needs to provide the following: free view of the sky, low echo and good thermal comfort levels. Also, use of passive solar yield via the glass roof is meant to decrease heating energy demand in winter. The design of an effective solar protective device and

Fig. D5.4 The glass roof presents with an arrangements of multifunctional lamella with reflectance function toward the top.

The Art Museum in Stuttgart

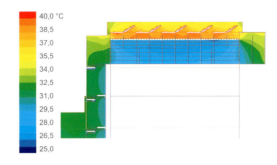

Fig. D5.5 Roof level temperature distribution, determined via thermal building and airflow simulation

natural ventilation, on the other hand, are both meant to minimise cooling energy demand in summer. As a first step, the roof glazing was equipped so much with imprints and solar protective coatings that an optimum combination of transparency and solar protection was achieved. The second step was to develop a lamella that could be rotated and presented a dual function of being absorptive-cooling and also, toward the warm glass roof, heat-insulating. On top, the lamella have a well-reflecting surface and were equipped with a heat-insulting layer *(see Figure D5.4)*. In this way, the radiation absorbed by the ribs is passed on to the top and does not increase cooling load of the useful spaces. The resulting heat then finds its outlet via the open ventilation flaps in the roof. Further, on the underside, the ribs are equipped with water-filled heating/cooling registers and thus serve as a heating and cooling ceiling in one. The central social area for guests can be temperature-adjusted to comfort level from below via the floor heating/cooling function as well as from above through the multi-functional lamella. Additionally, the lamella are coated with sound-insulating material that contributes towards dampening sound reflectance and thus also background noise interference and echo. This, in turn, is very important for lecture and concert situations.

Temperature distribution for the roof level was calculated in advance with the assistance of thermal building and CFD-simulations. It was proven that, despite the high temperatures under the roof, thermal comfort remained at an acceptable level underneath the lamella *(Figure D5.5)*. Only in extreme cases, in summer, mechanical ventilation needs to be employed for improving indoor climate readings. The operation outcome for 2005 confirms the predictions obtained from the simulations.

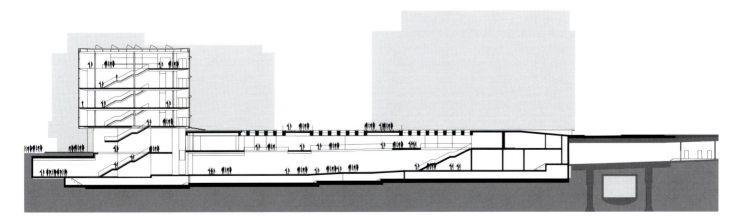

Fig. D5.6 Cross-section of the Art Museum

D6

breeam
'Excellent'

New building:
European Investment Bank (EIB) in Luxembourg

European Investment Bank in Luxembourg

Interview with Christoph Ingenhoven of Ingenhoven Architects

1. What, in your opinion, are the defining criteria for successful buildings?
A successful building should make people happy who live and work there. It should render their lives easier and happier. Naturally, building cannot be a substitute for life per se and we cannot bring about the well-being of a person through a building but we can, at least, make it possible in a supportive function.

2. What is the role of sustainability in your building designs?
Sustainability plays a decisive role for our building design. We have a clear idea according to which ideas and criteria these kinds of buildings are to be designed. We also strive to reduce energy requirement in whatever possible manner. Aside from energy savings we also develop concepts for user-friendliness. One example would be the simple idea of opening a window. This may sound easy but we know how difficult it can eventually be for many buildings to achieve ventilation and activation in this manner. The possibility of opening windows and doors to influence room temperatures, possibly also solar protection, is also connected with the sustainability of a building. Buildings, one must envision, can only be successful when they are »humane«, which means when human beings do not lose their right to think and read-through technological systems with perfect control mechanisms.

3. What are the goals of Ingenhoven Architects when it comes to Green Buildings? What are your visions there?
Once you have subscribed to the idea of sustainable buildings or Green Building design, in my opinion, this means nothing else but the need to think of yourself as a kind of spearhead for making a certain type of avant-garde architecture possible. By avant-garde, I do not mean in terms of shape or outer form but, rather, in terms of conserving resources. In the energy sector, for instance, we would desire for buildings to present at least an even, better still, a positive CO_2 balance. Another target might be that one uses an energy-efficient building operation and building planning for one thing to use very, very little energy for erection and operation of the building in the first place. Further, that the tiny bit of energy we do require is generated via alternative, renewable energy sources like sun, wind, earth heat etc. With the possibly resulting excess for a given building, one would then help the not so energy-efficient installations obtain a more even balance. Yet, there are also other means of compensation, for instance when looking at a high-rise project in downtown. It should be possible, really, to reinstate the square meters that are being used up for building on one hand, by erecting atria, gardens, roof gardens and the like, perhaps even on or over several floors. This would return to the people what they have lost and these could be cultivated in such a manner as to disturb the microclimate as little as possible. Or we could work with intelligent roof materials that avoid, for instance, the occurrence of heat islands, collect rainwater via non-contaminated roof material and then, in a filtered form, return it to the soil via the gardens, if possible on or very close to the original source.

4. How did your cooperation with D&S Advanced Building Technologies come about? What are the essential pillars of your many years of working together? What are the characteristics a planning team needs to have in order to create sophisticated and sustainable buildings?
We had been looking for reliable partners for a very long time. Eventually, we got to a point where it was no longer possible to handle our self-defined targets – taking a very innovative approach to ecological architecture and possibly also to continue advancing in this area – with our usual consultants and engineer firms. We always try to surround ourselves with the very best and then to establish long-term relationships. I feel that it is part of our work to subscribe to this type of team spirit. Then came a time when we realized that we had to reorient ourselves in the sector of domestic engineering and that this included a comprehensive responsibility for building comfort. It has now been more than 15 years but this was how our initial contact with D&S Advanced Building

Fig. D6.1 Detailed view, photograph of modelo

Fig. D6.2 Visualisation of the atrium

Technologies came about. We started out with building physics then went on to process engineering and process construction. Finally, our cooperation also included the areas of domestic engineering and establishing energy concepts because nothing is really possible without engaging in this type of comprehensive approach that includes and unites the areas of building physics, façade, domestic engineering systems for controls and energy concepts. We continue to be very interested in this integrative concept and it must be said that D&S Advanced Building Technologies has delivered increasingly year after year. If my observation is correct, the D&S Advanced Building Technologies team has been built up over the years to become – in my opinion – a highly competent consultants' team, which is very comfortable for the architect.

5. How did the idea for the European Investment Bank building design come about? What were your goals for this design?
We looked at the urban planning concept of the so-called »Zitadelle« for the »Kirchbergplateau«. It stems from a Spaniard and envisions concentration of the envisioned buildings. Our building for the European Investment Bank, for instance, is the extension of an existing building by Denys Ladsun from the 1970ties. Ladsun was a famous British architect who had designed a very beautiful, exceptional building that only partially meets today's requirements. This building had to be extended. The old and the new building were situated at the edge of the so-called »Kirchbergplateau« with a view of the old town of Luxembourg.

The ecological concept included a tube-shaped shell that encloses the building as a kind of glazed skin and offers as small a surface as possible for cooling and heat exchange. Inside this shell, there is a meandering interior building producing large surfaces between the inside and outside. It is kind of inserted there. For people working in this building, this is significant, as often – in view of energy conservation, window ventilation, daylight utilization etc. – buildings can only sensibly be erected up to a certain depth. We, however, with this approach, were able to position winter gardens inside that shell, running all the way down to the valley. Towards the street, we are able to arrange for atria. The difference here is that the atria facing the street are temperature-controlled and the winter gardens running down to the valley are not. This is because we assigned utilizations to the atria facing the road and this is not possible without setting minimum temperature control. The back parts of the building also have their utilizations like, for instance, break areas, outdoor areas and athletic areas. These, however, do not constitute a problem if they get a bit cooler in winter and a bit hotter in summer. Through applying this concept, we were able to create a buffer zone between inside and outside. It allows us to largely control heat loss in winter, even eliminate it. Of course, it is also necessary to control solar radiation influx and to minimise it. This is done through an exterior cooling design with solar protective devices and shading units as well as through the building orientation itself. With this project, we are one big step closer to the target of a CO_2 balanced building.

European Investment Bank in Luxembourg

Sustainably Comfortable

As first prize winners of an international competition, Ingenhoven architects was entrusted with the general planning for the new building of the European Investment Bank (EIB). The new building's site is located in the European quarter, on the »Kirchbergplateau« in Luxembourg, in the direct vicinity of the existing EIB building dating back to 1980. EIB, in this case, is both client and occupant of the new building. D&S Advanced Building Technologies supported the architects in their challenging planning task and provided services in the areas of façade planning, indoor climate concepts, control concepts (building automation), façade flaps, building aerodynamics, building physics, thermal building simulation, and airflow simulation. Implementation of an overall ecological concept – by taking into account international Green Building Standards like the »Building Research Establishment's Environmental Assessment Method (BREEAM)« – was the overall and joint target of the planners in this case.

The architect's design in this case specifies a cylindrical glass shell that spans seven different building blocks arranged in meander-form. This results in large atria between the building blocks, which can be used on the south side as temperate areas and on the northern side act as unheated, thermal buffer zones. The glass shell makes sure of a compact building shape and allows for passive solar energy usage in winter. In summer, the atria are naturally ventilated through openings in the glass shell and thus unwanted solar yield is discharged. The above-ground sections of the building blocks are used as offices and provide room for more than 750 office workstations. Further, there are training and conference areas, restaurants and cafeterias and a multi-storey underground car park in the building. Gross floor area (GFA) is about 70 000 m². Construction commenced in 2004 and the building was completed in 2008.

Façade Technology
The four essential construction pillars of the façade consist of the arch-shaped glass roof and the rope façade of the atria as well as the single-leaf office façade facing the atrium and the double-skin façade to the outside. In the EIB building, adaptive solar protection devices were systematically arranged along the office façades. The atrium façades are equally transparent year-round. This assures a good level of daylight supply to the offices and, provided there is satisfactory summer and winter heat insulation, it allows for individualized control of window ventilation, solar and glare protection devices.

The arch-shaped glass roof forms the essential component of the climatic shell of the atria and is arranged as a thermal insulation aluminium structure with two-pane insulation glazing – in the northern atrium as heat insulation glazing, and in the horizontal sectors of the southern façade as neutral solar protective glazing. In part segments,

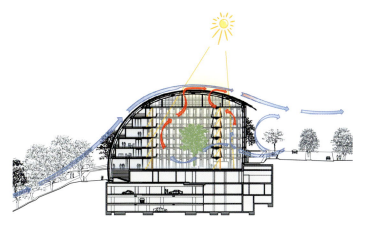

Fig. D6.3 Atrium in summer

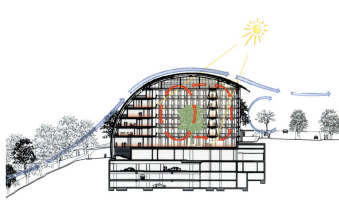

Fig. D6.4 Atrium in winter

Fig. D6.5 EIB building in Luxembourg. Model view from above.

the solar protective function is further supported by a light-redirection mirror raster in the interim pane space. About 30% of the triangular glass elements function as electrically controlled flaps – a special construction for this building.

The glass roof's support consists of a primary steel roof support, partially made up of arched steel supports and partially of the already-mentioned aluminium profiles. On the secondary support, the triangular glass panes are affixed with aluminium clamps and sealed with silicon joints.

The vertical façade of the southern atrium presents as a roof façade. The panes of the heat insulation glazing are affixed to the vertical ropes via cast aluminium clamping plates and are sealed with silicon profiles and/or elastic silicon. Connectivity of the mobile rope façade to the stationary block façades is via slick joints with specially designed brush seals.

The single-skin office façade facing the atrium is designed as a fully unitised wood frame façade with outside textile solar protection device; the outer façade of the office blocks is double-skinned. This aluminium façade, minimised from a construction and static point of view, is equipped with laminated safety glass glazing. The solar protection device is found inside the permanently ventilated dual façade interim space where it is wind-protected. The rope-guided, electrically driven vertical louver blind device is centrally controlled. The occupant may overrule the automated control function at any time.

Climate Concept

The arrangement of the office blocks and the atria, as well as the quality of the glass shell's heat insulation, results in air temperatures that rarely drop below 5 °C in the unheated atria in winter. For the adjacent office blocks, this even results in just about halving transmission heat loss. In combination with the highly efficient rotary heat exchangers of the ventilation units, we have a clearly reduced heating energy requirement for the offices. All the offices are equipped with an external solar protection device. Depending on the type of façade, it is either situated in the interim double-skin façade space or in the atrium and leads to effective shading. Optimisation of the building envelope, with the target of minimising outside influences for both heating and cooling situations, constitutes an essential step on the road towards a sustainable building guideline.

Due to the very efficient insulation of the building envelope, only component cooling and mechanical ventilation is used for the office rooms in the building blocks. Mechanical ventilation, here, supplies the hygienically required air volume. Further, the offices are equipped with opening wings for natural ventilation. The occupants can individually operate these. For regular office usage, this concept already provides a good level of thermal comfort.

For individual room condition regulation, floor induction equipment was arranged along the façade. This is applied according to requirement and, since it can be regulated in a swift manner, it allows for effective occupant influence on room climate as well as for demand-matched expansion of cooling options for rooms with increased cooling load. Overall, we have a flexible element for room conditioning available here and it offers a high degree of thermal comfort. The upper critical value for summer indoor temperature is at 25 °C.

Fig. D6.6 Room climate concept sketch

When developing a concept, solutions are also considered where the atrium is used as either an inlet or waste air atrium. In the case of the EIB building, the solution with central ventilation unit and highly efficient heat recovery function is the one that presents clear advantages as far as energy efficiency, economical viability and functionality are concerned.

Climate Concept for Atria

The large plenums in the new building of the EIB in Luxembourg present as two different types: atria oriented toward the south, which can be heated in winter, and unheated winter gardens that are oriented to the northern side.

Atria and winter gardens are naturally ventilated year round. In winter, this is done according to the interim ventilation principle. Within a few minutes, this leads to renewal of the air volume. In summer, the façade flaps are opened wide and permanently in order to discharge unwanted solar heat gain from the large, glazed areas. Opening width for natural ventilation is set, in summer as well as in winter, according to such factors as temperature in the atrium, environmental temperature and wind velocity.

The winter gardens function as thermal buffer zones and are neither actively heated nor cooled. Due to the low temperature level in winter and the resulting lower temperature differences for the atrium, no measures against cold

Fig. D6.7 Façade technology: Detailed view for description of functionality

airdrop were envisioned here.

Tempering of the southern atria is done via floor heating during the winter months. This is also used for cooling in summer. To counteract comfort influences trough cold airdrop along the vertical glass façade, inner pane temperature is increased via emitting surfaces arranged parallel to the façade. These are integrated into the footbridges that join the individual office blocks. They provide long-term heat radiation for the rope façade. At the same time, they are a heating element for the atrium that can be swiftly regulated. Due to the filigree rope façade construction, a standard solution with heated façade profiles, or convectors arranged at different heights, is not possible in this case. Further, the bottom of the façade is equipped with a horizontal deflection blade made of glass and there are also floor convectors along the façade. This comprehensive package, which was designed with the assistance of an airflow simulation on a 3D model of the atrium, significantly reduces negative comfort level influence through cold airdrop while leading to a comparatively high comfort level in the entrance hall region.

D 7

Nycomed, Constance

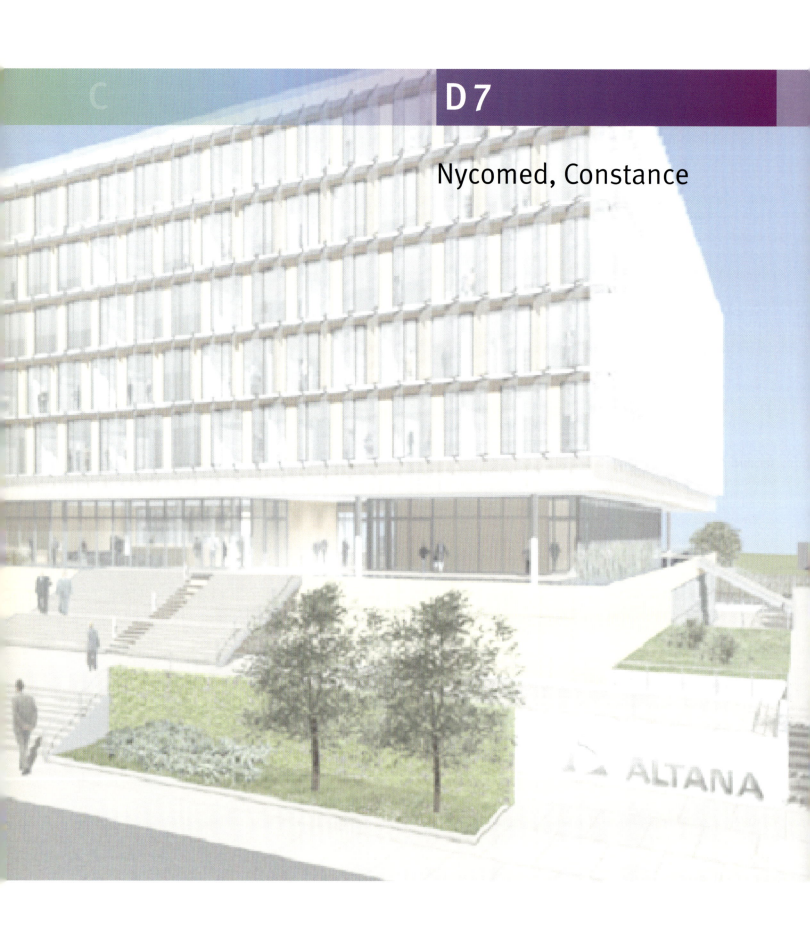

Interview with the Architect Th. Pink of Petzinka Pink Technol. Architecture®, Duesseldorf

1. What, in your opinion, are the defining criteria for successful buildings?
They were designed and built in a responsible manner.

2. What is the role of sustainability in your building designs?
The greatest one.

3. What are the goals of Petzinka Pink Technol. Architecture® when it comes to Green Buildings? What are your visions there?
To provide know-how.

4. How did your cooperation with D&S Advanced Building Technologies come about? What are the essential pillars of your many years of working together?
Mutual respect.

5. What are the characteristics a planning team needs to have in order to create sophisticated and sustainable buildings?
Passion, a progressive approach, social competency, the ability to be visionary.

6. What were your goals for this design?
To solve the building engineering task and to convey a perspective for the future.

7. What are some of the extraordinary qualities this building has to offer – to client and tenants?
A perspective for the future.

Interview with the Client Prof. Franz Maier of Nycomed

1. What, in your opinion, are the defining criteria for successful buildings?
I would like to point out, in answering this question, that it is primarily occupant satisfaction, enthusiasm and perhaps even a euphoric response that defines the success of a given building.

For this reason, it was very important to us to hold a variety of workshops and also engage in intensive occupant discussions during the preliminary planning phase in order to find out about the desires, suggestions and ideas of the employees. We also wanted to consider the fears and worries that these types of modern and transparent buildings can bring in their wake for any individual staff member.

Our target was to erect the »best possible office building« for the occupants, with a clearly defined ecological profile, a high degree of economic viability, flexibility, innovation and resource-minimising energy consumption (thermal component activation, triple glazing and pellet furnace). Further, the architecture was supposed to mirror the innovative drive of the enterprise and its core values.

2. What does living inside a building mean to you? What factors are essentially decisive as to whether you feel comfortable or not?
It means a feeling of safety while maintaining a certain degree of self-defined individuality. The comfort effect depends on several factors:

- Can I control windows and solar protection on my own?
- How individually designed are lighting, acoustics and view to the outside?
- Are colours and plants possible in the office zone?
- Is it possible to achieve comfortable indoor temperatures?
- Is there a large amount of daylight and a low degree of acoustic interference?
- Are there a sufficient number of social meeting points where I can socialize with my colleagues?
- Does the architecture allow for communal space but also for withdrawal space?
- Well-designed outdoor areas for usage during the breaks?

All these are components that influence, to a varying degree, the level of acceptance and comfort that a given staff member displays towards the building.

3. What is the role of sustainability, of life-cycle consideration, in your building stipulations?
When erecting any building, investment costs are initially in the forefront while usage or operating costs over the entire life cycle usually tend to be rather disregarded. However, they are actually more significant and must be involved in initial consideration because it only takes a few years before the sum total of maintenance costs reaches the level of initial investment costs.

By means of a life-cycle concept, we strive not only to optimise operating costs but also to achieve the highest possible synergy effect for all the trades. This is influenced by standardising individual components and systems. We are open to any sustainable innovations but, in case of doubt, will grant preference to tried and tested, long-lasting materials and systems.

4. You experience the entire process, from design to operation. Where do you see the greatest improvement potential: in the process itself, in finding ideas, planning implementation, constructional execution or operating behaviour?

The planning process for the individual trades needs to be integrated and co-ordinated much better still. Interfaces must be reduced both in volume and in terms of how complex they are. Neither are cross-trade planning, coordination and integration of the systems at an ideal level yet.

Planners need to be increasingly rewarded for their innovative ideas rather than for rigid contracts that are only oriented on construction costs. For the execution, a functioning quality control system at the site is essential. For this, it is necessary that all activities on site be handled with the assistance of a tried and tested, practice-oriented quality manual. The entire process must be closely monitored, from plans to materials being delivered, to installation and mounting, all the way to inspection. Correct and complete revision plans with qualified approval of services terminate this process. Another decisive factor is that quality of planning and construction needs to be applied and implemented in a consistent manner if we are to be spared subsequent lengthy lists of faults, enormous conflicts and even court proceedings.

When it comes to launching the building, we found out that modern simulation techniques may be of assistance but that actual building operation is required over the course of an entire annual decade in order to adjust room climate especially to a stable operating stage.

For limiting occupant conflicts and promoting tolerance we pass on this information to the respective employees during the launch phase and prior to the actual occupation of the building.

Prior to occupation, all buildings are introduced to the staff members by means of a very simply written »user manual« that is easy to understand and contains many illustrations.

5. What are the characteristics a planning team needs to have in order to create sophisticated and sustainable buildings?

The members of the planning team should always act as though they were in the process of planning and designing a building that they will subsequently occupy themselves. A higher degree of motivation and responsibility is barely imaginable, even if it only happens at virtual level. There must be a conscientious and active approach towards the ecological and economical responsibility for a building with an average life span of 50 years.

6. What will modern office concepts look like by 2050?

We have no way of telling because they may not be compatible with today's reality, even. Will they be highly mobile, flexible or emotional? Will colours, smells, music, art and similar elements be integrated into our working life that intermingles ever more with our private life? Will there even still be a division between work and recreation?

All the various options and alternatives, are food for thought to an innovative planning team and they provide a good base for building design of the future.

We need to maintain an increasingly optimistic and positive approach, true to the motto:

»In our world, the old and the new need to stick together until such a point that the new has proven to supersede the old.«

Efficient Integration

The new Nycomed building in Constance was to be situated on the site of the company, with a gross floor area of 18 000 m². Aside from typical office rooms, there is a conference room and a staff restaurant. Central meeting hub is the atrium. As an outside area easy to heat, it can actually be used year round. Integrating the building into the existing construction set-up already present, there are great opportunities to be gained but also challenges to be faced, for instance when it comes to energy supply of the building. From the start of the competition, the client placed emphasis on the building presenting a definite identity of its own in architectural terms but there were also to be premium quality energy-efficient and flexible concepts. The energy target, defined by the client and the general planner Petzinka Pink Technologische Architektur, at commencement of planning, was defined as a primary energy requirement of maximum 100 kWh/m² NFA (net floor area) for the systems used for room conditioning (heating, cooling, electricity for ventilation and lighting).

A module-based climate concept was designed for the office rooms, offering a good level of thermal room comfort matched to requirements. Base heating and cooling is via thermally activated floors and ceilings. On account of the triple glazing, super heat-insulated mullions and outer wall panels, comfort reasons do not require for an additional radiator to be placed in front of the windows since the surface temperature of the window, on the room side, does not drop below 16 to 18 °C. The panel also therefore contains the radiator, which can be expanded module by module in its performance capacity, to either meet higher demands or adjust to different room utilizations. It can function as a circulating air cooler or even as an outside air-handling unit with heat recovery. With this concept, a change of utilization for the rooms is possible at a later stage, anytime and with comparatively little effort.

The solar protection device for the office rooms consists of vertical glass lamella that can be rotated. They are 1.35 m wide and 3.5 m high. This form of solar protection has the advantage that a direct connection to the outside world exists at any time since the lamella are only parallel to the façade for a very brief period *(see Figure D7.1)*. In addition to the lateral transparency, the planning team worked out a number of solutions that would only allow for direct looking through the lamella with the solar protection function still intact. One variety was to equip the panes with a selective solar protective coating (low energy yield with high daylight yield through the sun's function) and additional imprint. This solution allows for sufficient solar protection, but direct visibility through the glass lamella is then restricted. The other variety was to insert, via lamination, different types of aluminium expanding metal between the two individual panes of the glass lamella *(Figure D7.2)*. As expanding metal, profiles were selected that had a slight inherent tilt to them and, therefore, provided a so-called »baseball cap effect« for solar protection. Since the expanding metal, at 1.5 mm, was not very thick, the »baseball cap« was only 0.8 mm deep. Since this type of solar protection device constitutes an

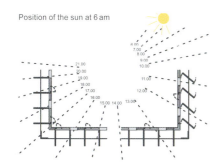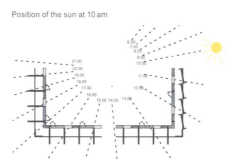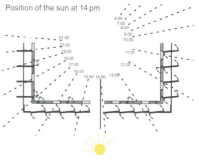

Fig. D7.1 Functioning of the glass lamella movement

entirely new invention it is necessary, as a first step, to test its structural make-up as well as its thermal effect. Suitable expanding grids were selected and compared with the target solar shading value of 0.1, for the solar protection device had to fit in with the room climate concept. In the end, the simulation results were able to show that only a very effective solar protection device is able to bring the basis room climate concept to the point of assuring sufficient thermal comfort. We needed to be absolutely sure about the selected expansion grids and so, in the laboratory, we set out to define both solar transmission and luminance distribution for different elevation angles of the sun. The results even went beyond the target values, with equally good view and avoidance from glare, from a solar elevation angle of 35°. From a construction point of view, also, we were able to master the challenges that presented themselves.

Figure D7.4 shows some of the technical details.

Energy supply was arranged in accordance with the existing buildings, which tap into regional heat supply. In the course of a building and system simulation for all outlets of the regional heating system (mainly the laboratories), the existing heat load profile for the regional heat distribution was defined. It turned out that, owing to the required heat performance for hot

Fig. D7.2 Glass rib with expansion metal

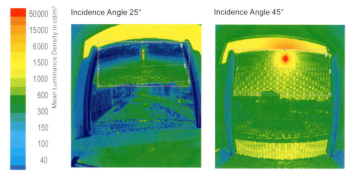

Fig. D7.3 Luminance density images for different angles of elevation

water and reheating for the ventilation units, there was a high heat load in summer also. Our calculations showed that a pellet boiler with a heat load of 1000 kW could be operated at full load for more than 7000 hours per year. When taking into account the lower energy prices of pellets in comparison to gas, a return on investment is possible within two years. At the same time, there is a saving of 1750 t of CO_2 emissions. This corresponds to the level of heating-related CO_2 emissions from 580 own homes. Cooling is achieved through chillers operating at elevated temperature (12/16 °C) and hybrid recoolers with water spray function. Since component cooling takes place at night only, over 70 % of chilled water can be gained by exploiting the cool night air. Overall, actual energy demand lies far beneath the target value defined during planning *(Figure D7.5)*. Excellent architecture and a high level of flexibility have resulted in a building that both occupants and facility management can feel good about.

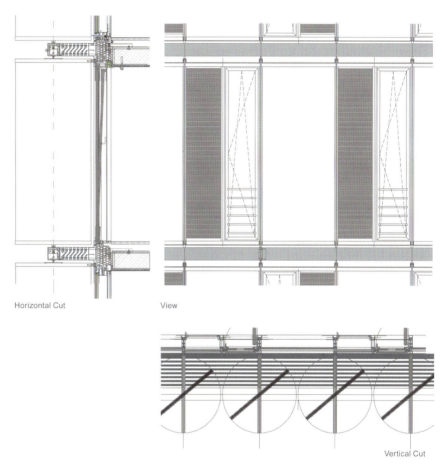

Fig. D7.4 View and cross-section of the office façade

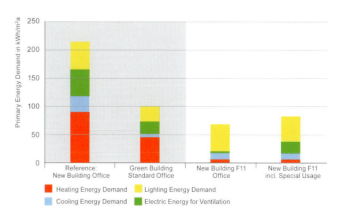

Fig. D7.5 Primary energy balance of the building for room conditioning systems for new Nycomed office building F11

D 8

DR Byen, Copenhagen

Interview with the Clients
Kai Toft & Marianne Fox of DR Byen

1. What, in your opinion, are the defining criteria for successful buildings?
The most important criteria include optimum organisation of the management, clearly defined strategies and excellent communication on all levels. This also goes for any subsequent procedures and decisions during the entire planning and construction process.

2. What does living inside a building mean to you? What factors are essentially decisive as to whether you feel comfortable or not?
To the Danmark Radio staff, room climate and floor plan of the building is of prime importance. We do not define a comfortable room climate merely on such physical factors as temperature, air quality, acoustics or lighting. We also consider architecture to be important, involving occupant interests as an integrative part of both planning and room design.

3. What is the role of sustainability, of life-cycle consideration, in your building stipulations?
We placed emphasis on a flexible design in order to be able to react to future technological and organisational advances in the multimedia field, which means that we could subsequently guarantee a long lifespan. Many building materials were selected according to life cycle considerations. During planning, our focus was on minimising resource consumption over the entire life cycle of the building. We were especially concerned with reducing energy consumption while at the same time looking for ecologically viable materials. Since Denmark Radio owns a huge property, we felt obliged to explore the use of novel technologies with ecological considerations and set an example for other Danish property owners and developers.

4. You experience the entire process, from design to operation. Where do you see the greatest improvement potential: in the process itself, in finding ideas, planning implementation, constructional execution or operating behaviour?
The main focus always needs to be on optimising operations because this is where environmental impact is at its greatest. However, it is during the initial stages of planning that the most pertinent improvements can be made since this is where we define the frame conditions for later design of the building. During engineering and in the construction phase, these stipulations must be consistently monitored at all costs. For actual operation, the ecological potential of the building needs to be exploited in full. This, also, requires constant verification.

5. What are the characteristics a planning team needs to have in order to create sophisticated and sustainable buildings?
The planning team needs to have solid ecological knowledge – in all areas of planning. It is just as important to then apply that knowledge through engaging in interdisciplinary teamwork. Ecological design is based on comprehensive considerations that require the vision, dedication and cooperation of everyone involved for implementing ecological goals.

6. What are some of the extraordinary qualities this building has to offer – to client and tenants?
As a large, semi-public enterprise in the public service sector, Denmark Radio considered it high priority to set an excellent example for the Danish construction industry. Byen's vision for Denmark Radio was that of a »flexible and open place of work and a vivacious atmosphere fostering creative teamwork«. In the end and thanks to the ecological focus, we were able to create a building with comparatively low operating costs for consumption of energy, water and other resources but also for waste management.

Interview with the Architect Stig Mikkelsen, Project Leader and Partner of Dissing + Weitling

1. What, in your opinion, are the defining criteria for successful buildings?

Successful buildings are based on concepts with a strong foundation and on clear ideas. These buildings should tell a story, of how they came about, and at the same time should impress with the clarity of their design. Over the course of the last few years, buildings have become increasingly more technical and complex. This brought new challenges to the field of design. In my opinion it is the kind of buildings that emerge from a deep technological and ecological understanding which points the road towards the future, specially if they also manage to consider complex requirements while at the same time presenting an easy and comprehensible architectural concept.

2. What is the role of sustainability in your building designs?

Designing an optimum work area can only be achieved on the basis of a deep base understanding of such considerations as room, materials, view, daylight, air quality and room acoustics and how they influence us humans. Aside from those parameters that can be measured and define room climate quality, an ecological design signals something to the occupant of the building. It says that, aside from the environment, the client, aside from the environment, is also concerned about the well-being of the people who use the offices in the end.

3. What are the goals of Dissing + Weitling, when it comes to Green Buildings? What are your visions there?

Our designs always strive for simplicity and try to tell an entire story, of the history of each individual project that we handle. If not an elementary, then at the very least a highly important role is taken over by the concept of sustainability when it comes to developing our designs. In the old days, buildings were rather traditionally designed or from only an artistic or interior design concept. Modern, complex buildings, on the other hand, are an entity of their own. They unite technological consideration, ecological requirements and architectural ideas.

Here at Dissing + Weitling, we architects consider ourselves to be a team with the goal of creating innovative and at the same time ecological designs. In the past, we have developed buildings with a so-called »organic strategy« and this is an area we will continue to focus on in future. True to our motto »from concept down to detail«, we favour designs that show the united aspects of ecology and sustainability in engineering also. This is how you get a building concept with a solid foundation.

4. What are the characteristics a planning team needs to have in order to create sophisticated and sustainable buildings?

A project that is true to ecological thought needs an ambitious client willing to go down that route. In order to reach new goals and also to rise to the challenge of sustainable build-

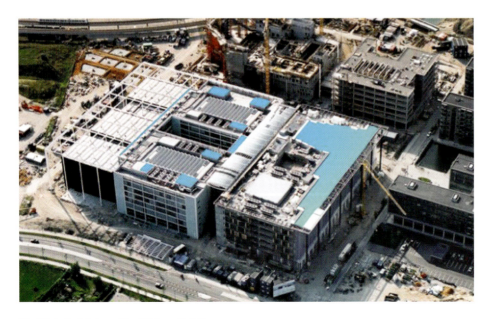

Fig. D8.1 Aerial view of the DR Byen Building

ings of the future, the design team must work together as one solid unit, not only for conception but also when it comes to all the details. As is usually also the case between architects and engineers, the individual team members need to have respect for each other. Current expert knowledge and the necessary experience when it comes to finding solutions to technical problems are both absolutely essential. Many so-called organic designs of the last few years show shortcomings because they come up with unsuitable technical solutions or they were not created with the necessary care. Unfortunately, this means that they damaged both the reputation of the clients and of organic or ecological designs in general. During the design stage, simulation of façades or other building elements continues to be an important means for finding the right solution. It offers the necessary added security, provided you can fall back on knowledge gained from past experience.

5. How did the idea for the Danmark Radio Segment 2 building design come about? What are some of the extraordinary qualities this building has to offer – to client and tenants?

The Danmark Radio Segment 2 project called for a special design with open work segments that allowed for interaction between the various staff members at the individual levels but also met the requirements of a big radio station. We were free to decide whether the rooms were to be ventilated naturally and whether we wanted to use PV panels. In our design, we exploited the unique location and hence the resulting orientation option of the building. The south façade serves to define the atrium that connects the four building segments with each other. For reasons of fire safety, it only has few openings. Therefore, the building is primarily lit via the north side. This offers a maximum of daylight with minimum heat gain. The Eastern and Western façades were designed double skin, allowing for natural ventilation with maximum daylight yield. A mobile solar protection device protects against the sun when it is low in the sky. The concept works with three different façade types: a combination of organically based balconies, a curtain wall made of glass, and a double skin façade. The North façade consists of large, simple glass sheets supported by struts arranged in front of them. The double skin façade allows for inlet air to reach the rooms via the interim façade space and adjustable ventilation ribs in the inner façade. The Northern façade, on the other hand, is equipped with vent holes in the lower region to allow for night cooling. The atrium's glass roof acts as a daylight filter and, here, the light level and heat gain are both controlled by the movable solar protection device. We are firmly convinced that the Danmark Radio project has allowed us to achieve a degree of integrated planning that sets new standards for quality and comfort.

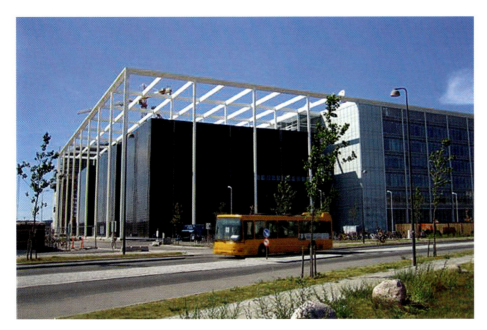

Fig. D8.2 View of the new Danmark Radio headquarters

Adjusted Climate Considerations

The new Danmark Radio headquarters in Copenhagen are arranged on an area of 125 000 m² GFA. The buildings cater to administration, studio production and can also be used as a concert hall. Thankfully, D&S Advanced Building Technologies was already able to function as advisor (for economical and ecological concepts) to the client during the creation of the tender dossier for architects and expert planners. For one thing, this resulted in a tender dossier that defined energy efficiency requirements for the buildings in much more detail than is usually the case. Parallel to the tender, D&S Advanced Building Technologies developed an overall energy concept, the essential elements of which were then applied at the building site:
• Use of natural stone aquifers of the underground base in Copenhagen as a cooling reservoir. In winter, the geothermal reservoir is charged via the cool surroundings. In summer, the groundwater reservoir is accessed for cooling the building *(Figure D8.4)*.
• Use of high temperature cooling systems for the buildings. Usually, cooling systems in Denmark are designed for low water temperatures of 6 and/or 12 °C. In order to use natural cooling energy from the soil, however, coldwater temperature needs to be as high as possible. Water temperatures for room cooling are between 14 and 20 °C, they are almost twice as high as usual.
• Minimising building cooling load through an efficient, wind resistant solar protection device while also obtaining high daylight yield through the double skin glass façades. Windy and yet sunny days are the norm in Copenhagen, which means that the solar protection device must be able to withstand any type of weather if cooling performance from inside the building is to be minimised and regenerative cooling energy usage from the earth is to be elevated. Further, it had to be possible to use natural ventilation at this site both during the day and at night (summer night's cooling), irrespective of the wind situation. For this, suitable façade systems and controllable ventilation flaps for the interior façade were developed.
• Exploitation of solar energy for electricity generation. This building complex presents the largest photovoltaic system in all of Denmark. It was the minimum aim, in this case, to cover all of the Aquifer Thermal Energy Storage (ATES) electricity requirements for drives and pumps entirely through solar energy.
• Use of rainwater for outside area irrigation and, partially, also for toilet flushing. The water reservoir functions as a natural rainwater preservation system and thus takes some load off the city's sewage works *(Figure D8.3)*.

It proved to be very advantageous to develop a comprehensive energy concept early on, which was then discussed with the client, the project management and the city authorities prior to selecting the planners. This also then led to a successful subsidy application process through Danmark Radio, COWI, D&S Advanced Building Technologies and Ecofys. The resulting group project »IT-Eco« is to set an example for room climate and energy supply solutions for Northern European buildings with high interior heat load. Three of four planned building sections were in operation by spring 2007, the Musical Hall followed one year later.

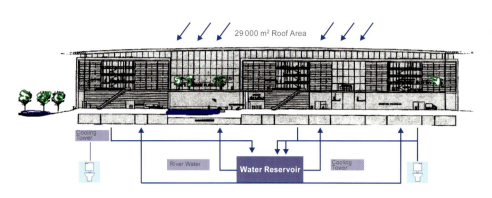

Fig. D8.3 Concept for rainwater storage. Aside from outdoor irrigation, the water is also utilized for toilet flushing in many sectors.

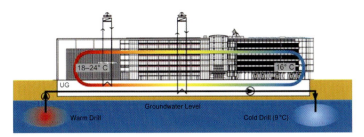
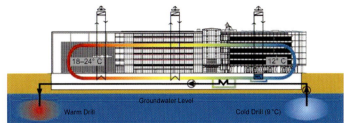

Fig. D8.4 Regenerative cooling principle for the project. In winter, the ATES is charged via the cool outside air, in summer this energy is available to the building for cooling.

Aquifer Thermal Energy Storage (ATES)-Concept

In Northern Germany and Southern Scandinavia, ATES systems are used as heat and cooling reservoirs at various depths. If used for heating, they are found in deeper regions from 1300 to 1900 m, for cooling they remain close to the surface at around 20 to 150 m deep, where additional groundwater is still available. What size of the aquifer reservoir is actually economical? This depends, to a large extent, on the cooling energy requirement of the buildings. For this reason, simulation tools are employed early on, in order to determine cooling requirements as accurately as possible over the course of the year. This was important, since the idea of natural cooling is not primarily based on the groundwater's low temperature but due to the low water flow speed, on a reservoir procedure. The ATES has two sides in this: a warmer and a cooler one. At the start of summer, the ATES should be full, meaning the cool side needs to be sufficiently cool so that the entire cooling volume can be passed on to the building. In winter, the ATES needs to be charged, which is achieved by cooling down water from the warm drill via the chilly outside air and then pumping it into the cooler side of the ATES.

First simulation results showed that, in Copenhagen, active cooling is already required between April and October for special utilizations. Theoretically, this means that half a year would be available for charging the ATES. However, this can only happen when outside air is sufficiently cool (< 5 °C) and hence suitable, meaning that available charging time reduces to about 4 months *(Figure D8.5)*. Detailed geothermal studies during the planning phase were conducted by COWI. Test drills showed that water yield corresponded to the assumptions made (ca. 30 m^3/h per drill), which means that eight hot and four cold wells were built, at a depth of 30 m in order to get down into the clay bed. With a now total cooling performance of 1 MW from the ATES, a large proportion of the buildings' cooling requirements can be met from natural sources.

Photovoltaics Integration

The different building parts are equipped with a photovoltaic system of 120 kWp (ca. 1200 m^2) total. The most beautiful integration idea can be found in the glass roof above the second segment. The shape, especially developed for this building, unites the aspects of design, solar protection and energy generation. Dissing and Weitling architects succeeded in preserving roof transparency and hence the view while, at the same time, integrating the solar cells *(Figure D8.6)*. For this innovative solution, they were awarded the 2006 Municipality of Copenhagen Solar Prize.

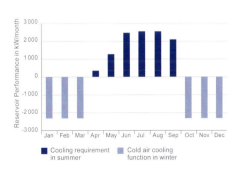

Fig. D8.5 Charge and discharge times of the Aquifer Thermal Energy Storage System

Fig. D8.6 A photovoltaic system was integrated into the glass roof.

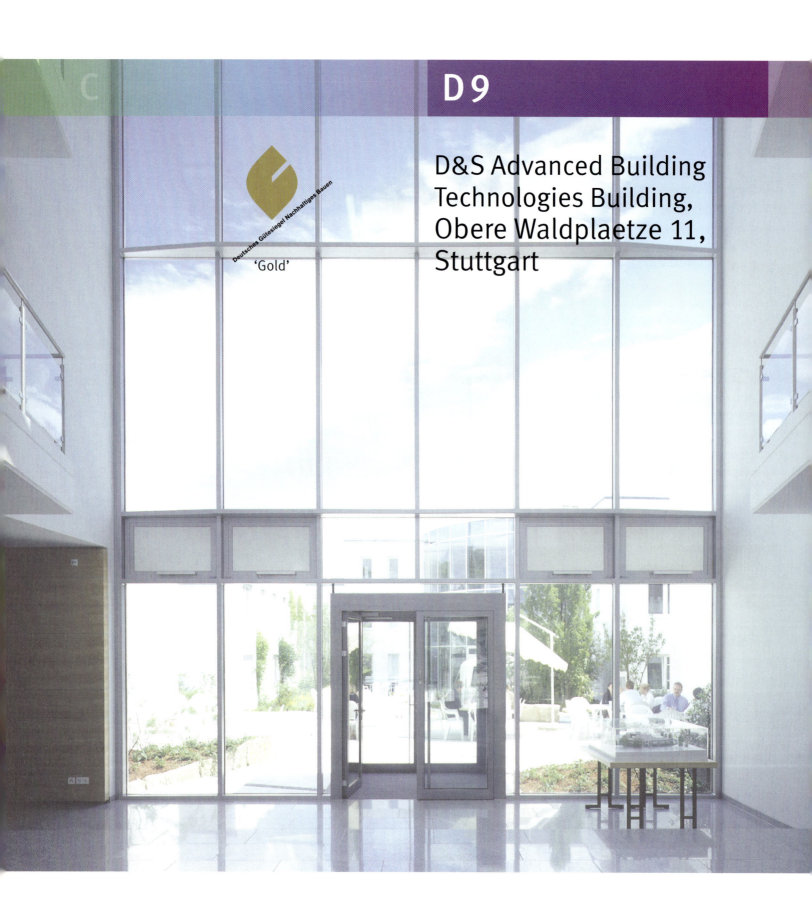

D 9

D&S Advanced Building Technologies Building, Obere Waldplaetze 11, Stuttgart

Deutsches Gütesiegel Nachhaltiges Bauen 'Gold'

Low-Energy Building Prototype

If you are looking for optimum thermal comfort at minimum energy demand, the building concept needs to be an integrated one. This can be seen very well by the example of the »Obere Waldplätze 11« office building of D&S Advanced Building Technologies in Stuttgart-Vaihingen, which went into operation in March 2002. The design of the heating and cooling systems for the building was matched to demand, based on the planned utilization and a corresponding winter and summer heat insulation as well as a façade technique that allows for minimised heating and cooling loads. On the basis of these boundary commitments, low temperature heating and high temperature cooling systems were designed, to guarantee optimum benefit transfer with heat and cooling performance according to demand. Further, the low excess temperatures foster the use of regenerative heat and cooling generation systems. For heating and cooling with low building energy requirement, a low energy demand for system engineering could be achieved also. In addition to the system functions of heating and cooling, ventilation also had to be developed in such a manner that minimum energy expenditure would still guide the hygienically required outside air flow to the work station, and without any restraints on comfort levels. If the prognoses during planning turn out to be true, then we have an office building here with lowest possible energy requirement and energy demand. The readings over the last years do indeed confirm the statements from planning – and very much so.

For this project, an integrated view was achieved through all those involved working together closely. It should be pointed out that, in the course of this cooperative project, the company handling the technical trades was already asked to become involved in the project after preliminary design was through. This was the only way of ensuring that the various building engineering-based new developments could be executed jointly with that company and then be integrated directly into the execution planning phase.

Basic Evaluation and Course of Action

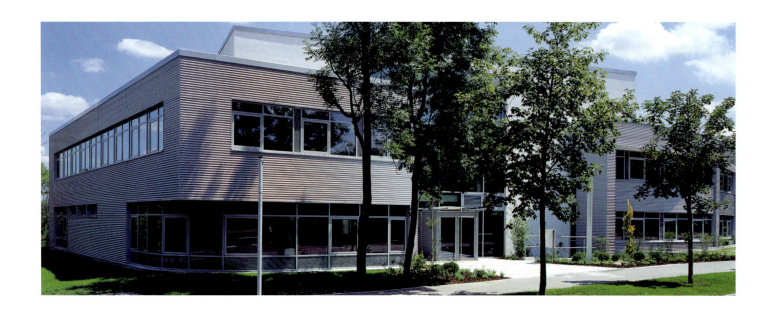

The base for an integrated approach lies in a solid basic evaluation where both client and occupant are involved in discussing specifications for the individual occupied areas. Aside from room temperatures, other considerations like local comfort requirements, for instance for work stations near the window, need to be considered as well. Visual comfort demands, air quality and acoustics round off the picture. Further, aside from room climate requirements, those concerning sanitary and electrical trades must also be reviewed.

The planning team analyses all these factors in regard to building physics whereas consequences for room climate engineering and heat and cooling supply are taken into account and evaluated also. Optimising this overall system – utilization, climate, building physics, façade, room climate system, and generating system – can be undertaken according to different evaluation criteria. In the forefront are mainly economic interests that are analysed in an integrated manner by means of life cycle considerations of several varieties.

Aside from utilization requirements, other boundary conditions can also influence concept planning and they can influence the economical framework of an overall concept. For this particular project, as part of an urban planning contract, there had to be a 30 % lower deviation of heat insulation, according to the heat insulation ordinance of 1995. This, certainly, became one of the decisive criteria in making a decision for not only meeting increased thermal insulation requirements but also to design a Green Building based on a low energy consumption idea. Insulating layer thickness and heat transfer coefficient of the building envelope are itemised in *table D9.1*.

Components	Heat Insulation Thickness in cm	U-Value in W/m²K
Wall Surface	16 / 18	0.21
Glazing	3-times	0.80
Roof	25	0.15
Underground Car Park Ceiling	15	0.23
Overhanging Ceilings	16	0.22

Tab. D9.1 Heat insulation standards for essential components of building envelope surface

Indoor Climate and Façade Concept

Optimisation of the building envelope in regard to lower heating and cooling loads, passive solar energy exploitation, primarily natural ventilation and its accordingly adapted room climate engineering concepts, as well as heat and cooling generation, were defined, analysed and optimised during the planning phase by means of coupled building and system simulations. With very good U-values and outside temperatures of -12 °C, subnormal temperatures for inner surfaces of the outside walls are at ca. 1 to 2 K and for the window and façade area at ca. 3 to 4 K. For workstations in window vicinity, this means that directed heat withdrawal through the cooler window surface lies below the operative level. In order to reduce solar load, façade areas were designed with a railing. Cool airdrop, which happens along the cooler window areas, also stays below the operative threshold at maximum air velocities of below 0.1 m/s and it is possible to do without radiators under the windows while not reducing thermal comfort levels.

To achieve optimum levels of thermal comfort we had to compensate heat emission within the same half room. This was achieved through so-called edge rim activation that functions at maximum flow temperatures of ca. 33 °C. Thermal component activation serves as the base load system and, on account of the large surfaces, it can be operated at minimal excess temperatures. The minimum outside airflow required for air hygiene is heated via a ventilation unit with heat recovery, and then subsequently guided into the room isothermally via newly developed slit air inlets in the floor. For optimum benefit transfer, the benefit transfer system's reaction speed also needs to be considered. Aside from swift regulation response, low operating temperatures are required as well as a low storage capacity of the room heating system to be regulated. Parallel to this, in the case of an integrated approach, cooling is also required and this must be considered. In this case, we desire storage capacity but must also strive for demand-oriented regulation of cooling performance to achieve optimum benefit transfer in combination with operating temperatures that are as high as possible. On the basis of these considerations, benefit transfer for heating and cooling was arranged as a combination system, consisting of a high-storage base load system in the form of concrete core activation and an edge rim element that is close to the surface, swift to react and has a low amount of storage mass. The surfaces, which are kept as large as possible, result in low excess temperatures for heating and low subnormal temperatures for cooling. *Figures D9.1* and *D9.2* show the systems described, for the office areas, as two photographs taken during the course of construction.

For heating and cooling, concrete core activation serves as the base load system while edge trim activation is individually controlled via individual room sensors, allowing for heating and cooling performance to be adjusted according to requirement. In the interim period, it is essentially only edge trim activation that is used for heating and cooling purposes. This means that, for both winter and the interim period, edge trim activation influences energy demand for benefit transfer. Room temperatures, as determined during

Fig. D9.1 Edge trim element as factory-assembled unit

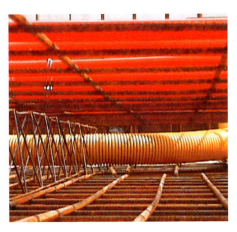

Fig. D9.2 Thermally active components and ventilation pipes, integrated into the concrete ceilings

Usage of Geothermal Energy for Heat and Cooling Generation

thermal building simulation, do not rise above 25 to 26 °C with outside temperatures of 32 °C. When looking at cooling performance daily profiles, you can see that concrete core activation is charged during the night hours. During the day, the cold generator is available for edge trim activation in the offices (CCA2), the cooling ceilings in the meeting rooms (CC) and for air-cooling. This concept allows for a significant reduction of maximum required heat and cooling generation.

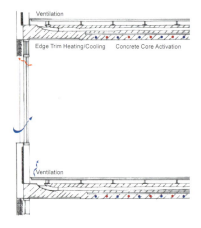

Fig. D9.3 Cross-section for room climate concept, office

Fig. D9.4 Workstation EMC measurement

For heat and cooling generation, we strive to use the same kind of systems engineering for cooling operation in summer as we do in winter for heating. The heating and cooling concept shown here allows for cooling generation without additional primary energy use. Operating cost savings thus achieved allow more room for investing elsewhere, for instance into innovative and energy-saving building services engineering. The state-of-the-art room climate system allows for achieving low operating temperatures of 33 °C max. This is an optimal basis for use of facilities in the area of regenerative heat or cooling generation like, for instance, geothermal energy.

In our latitude, the near surface soil – at a depth of between ca. 10 and ca. 100 m – presents an almost even temperature of 10 to 12 °C. Geological studies with a test drill on location have shown that heat conductivity of the subsurface – on account of varying amounts of ground water and up to a depth of 60 m with $\lambda = 3.8$ W/m²K – is indeed very favourable for using earth probes. The performance capacity of the soil was tested in advance via a so-called Thermal Response Test and a test probe. To this end, a constant flow of water is guided into the test probe, at constant flow temperature. Response function, meaning the difference between flow and return temperature, is then measured.

Due to the favourable geological conditions prevailing on-site, we decided for a system consisting of a monovalent, geothermally supported heat pump for heating and a heat exchange for direct cooling via the earth probe area. The individual components, including all the hydraulic changeovers, were gathered into a geothermal energy control unit and delivered to the site in prefabricated form. In comparison to the usual heat pump, conductivity of the heat exchanger was improved and hydraulic resistance greatly reduced.

For heating, any heat that can be gained from the soil is brought to operating temperature through use of the heat pump whereby the maximum operating temperature of 33 °C allows for a performance factor of ca. 4.5 (Generation of 4.5 parts of heat for one part of electricity). During cooling, heat withdrawn from the building is brought to the probe field via a heat exchanger. Aside from the advantage of cooling without the need for a chiller, returning heat to the soil in summer also presents the added advantage that the

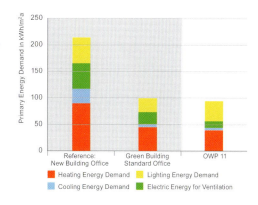

Fig. D9.5 Primary energy balance for the systems used for room conditioning

ground, cooled down in winter through heat withdrawal, can significantly regenerate. This allows us to avoid long-term soil temperature change in the probe field region. This, in turn, ought to be the aim of sustainable use of regenerative energy sources. For covering required heat load, a total of 18 earth probes (55 m depth each) were installed.

Building Construction
During the tender phase, especially for interior finish materials and auxiliary materials used (like binding agents) great emphasis was placed on emission that pollutes the air in the least possible manner. Low and energy-saving air exchange rates are only acceptable to the user when the indoor air is not additionally polluted through materials. Hence, during building construction, the materials used were inspected with the assistance of a previously created site manager handbook.

Monitoring and Optimising Operations
Monitoring and optimising of operations was handled by D&S Advanced Building Technologies in conjunction with Stuttgart University. Planning values were confirmed during operation. Measured primary energy consumption (compensating for degree days) for the systems used for room conditioning is only some 5 to 10 % above simulated requirement. During 1.5 years of monitoring operations, it was shown that the simulation model could also be very effectively applied to optimising operations by tracking changes in energy consumption, resulting especially from building utilization and outside climate. Aside from optimising thermal room comfort and energy efficiency, we also measured electromagnetic compliance (EMC) at the working place (DECT phone). Readings showed that we stayed far below the legally set critical values. However, prevention values and/or recommended critical values from other nations were partially not met. This shows that EMC monitoring, in the age of increasing usage of wireless connections, is of prime importance.

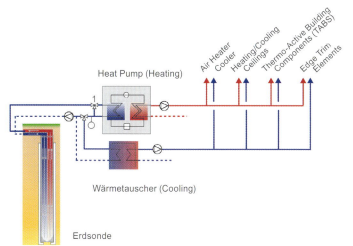

Fig. D9.6 Geothermal energy generation concept for heating and cooling

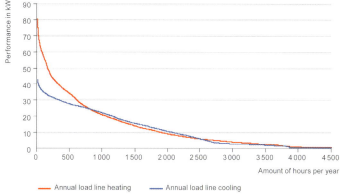

Fig. D9.7 Annual load graph for heating and cooling

Appendix

Glossary of Terms

Acoustic 40 f., 93 ff., 136, 163, 173, 176, 185, 191 f., 198
Acoustic Comfort 41
Acoustic Simulation 95
Activity Level 25 ff., 32, 35 f., 41
Air Exchange 33, 42 ff., 48, 57, 72, 83, 92, 114 f., 132, 158, 163 f., 170, 173, 201
Air Quality 12, 25 f., 42 ff., 48, 57 f., 74, 114, 135, 157, 164, 191 f., 198
Artificial Lighting 36 ff., 48, 58 f., 71, 80 f., 105, 156

Benefits Delivery 53, 109, 112 f.
Biogas 12, 52, 120 ff., 128 f.
Biomass 52, 120 ff., 128 f.
Bionic Materials 99
Blower Door Test 132 f.
BRE's Environmental Assessment Method (BREEAM) 15 ff., 181
Buffer Storage 125
Building Density 54, 74, 78, 131
Building Ecology 10 f., 92
Building Orientation 71, 101, 180
Building Shape 51, 67, 69, 71, 75, 155, 181
Building Simulation 90, 97, 105, 134, 142, 181, 200
Bulb Globe 134

CFD Simulation 106, 177
Climate Zone 47, 55 ff., 67, 74 ff.
Clothing 26 ff., 35, 49, 71
Cold Air Drop 29, 111, 152
Comfort Level 11, 20, 25 ff., 34 f., 41, 47 ff., 74, 94, 97, 102 ff., 110, 117, 150 ff., 163, 176 f., 183, 197 ff.
Comfort Temperature 35
Commissioning 65, 130 ff., 171
Cooling Ceiling 49, 148, 163, 170, 177, 200
Cooling Energy Demand 53, 56 f., 96, 105, 153, 159, 163 f., 170, 177, 189, 201
Cooling System 27, 61, 109, 113, 117, 124 f., 129, 133, 194, 197
CO_2 Concentration 43 f., 135
CO_2 Emission 12 ff., 53, 129, 165, 189
CO_2 Trade 13

Daylight 36 ff., 48, 56 ff., 68 ff., 80 ff., 105 ff., 113, 137, 150 ff., 156, 170, 180 f., 185 ff., 192 ff.
Daylight Autonomy 37, 58
Daylight Factor 37 ff., 137
Daylighting 38 f., 83 f., 87, 90, 158
Daylight Simulation 85, 105 ff.
Daylight Utilization 56, 86, 113, 180

Dockland Building, Hamburg 146 ff.
Double-skin Façade 88 f., 101 ff., 136, 151 f., 170, 181 f.
Drinking Water Heating 53 ff., 70, 124, 170
Draught 25, 34, 68, 104, 110, 115 ff., 132, 151, 157
Draught Risk 34
DR Byen, Copenhagen 190 ff.
D&S Advanced Building Technologies Building 49, 107, 139, 196 ff.

Electricity Demand 57 ff., 115, 120
Electromagnetic Compatibility 26, 45
Electromagnetic Radiation 45 f.
Emission Credits 13
Emissions 13 ff., 43 f., 53, 58, 92, 135, 165, 189
Emulation 138
Energy Benchmarks 51
Energy Management 7, 140 ff., 159, 171
Energy Pile 127, 164
European Investment Bank, Luxembourg 178 ff.

Façade Construction Quality Management 90
Façade Design 37, 86, 90, 105, 170
Field Intensity 46
Flat Collectors 124
Fuel Cell 122 f., 128

Geothermal Probe 21, 127
Geothermics 12, 69 f., 127
Glare Protection 48, 71, 78, 82 ff., 90, 137, 181
Glass, self-cleaning 98
Greenhouse Gas 13, 52 f.
Grey Water Use 63
Ground Water Utilization 127

Heat Emission 27, 34, 54, 112 f., 152, 199
Heat Energy Requirement 101
Heating Energy Demand 53 ff., 75, 78, 105, 143, 153, 159, 163, 170, 176, 189, 201
Heating Systems 112 f.
Heat Values 52, 143
HUK Coburg 120 f.
Hybrid Façade 89

Indoor Acoustics 41, 93 ff., 163
Indoor Climate 11, 26 ff., 42, 47, 53, 74, 81, 90, 96, 101 ff., 109 f., 118, 150 ff., 163, 170 ff., 181, 199
Indoor Humidity 25, 32 f., 53 ff.

Jahrhunderthalle 75 f.

Kreissparkasse (KSK) Tuebingen 160 ff.
Kyoto Protocol 13 f.

Layered Ventilation 25
LBBW Stuttgart 166 ff.
Leadership in Energy & Environmental Design (LEED) 15 ff., 69
Life Cycle 7, 11, 20 f., 51, 59 ff., 88 ff., 147, 149 f., 156, 168, 185 f., 191, 198
Life Cycle Engineering 7, 20 f.
Light Transmission 38, 85 ff., 107
Louver 31, 83 f., 137, 176, 182

Maximum Allowable Concentration (MAC) 44
Microclimate 32 ff., 179
Mobile Phone 46
Monitoring 65, 92, 135, 140 ff., 170, 201

Near Field Contrast 38 f.
Night Cooling 57, 113, 152, 158, 176, 193
Night Ventilation 57, 82, 102
Noise Level 26, 40 f., 48, 57, 88, 136
Noise Protection 40, 88, 136
Nycomed, Constance 184 ff.

Open-plan Office 96
Operational Optimisation 131
Operative Temperature 28, 30 ff., 81, 97 f., 103, 106, 110
Orientation 51, 60, 71, 81 ff., 88, 101, 155, 158, 180, 193
Overall Energy Efficiency 14, 143

Passive House 42, 54, 73, 101, 163
Performance Level 10 f., 25 ff., 43
Phase Change Materials (PCM) 93, 97
Photovoltaics 12, 52, 120, 195
Pollutant Concentration 44
Pollutants 42 f.
Power Generation 123, 126
Primary Energy Demand 53, 57 ff., 153, 159, 163, 170 f., 189, 201
Primary Energy Demand of Building Materials 60
Primary Energy Factor 53
Prof. P. O. Fanger 28

Radiation Asymmetry 29
Rain Water Use 63
Rape Oil 128
Reflection Characteristics 37
Regenerative Energy Resources 49 ff.

Requirement Minimisation 51
Residential Building 25, 51, 53 ff., 62, 68, 70, 101, 113, 135
Reverberation Time 40 f., 96

Shading System 51, 58, 68, 71, 80 ff., 107, 138 f., 162, 170, 180 ff., 188
Sick-Building-Syndrome 42
SOKA Building, Wiesbaden 154 ff.
Solar Energy 52, 60, 70 f., 81, 101, 107, 112, 124, 181, 194, 199
Solar Protection 37 f., 48 f., 57, 80 ff., 98 ff., 112, 137 ff., 151 f., 158, 170, 177 ff., 181 ff., 187 f., 193 ff.
Sound Absorption 40, 89, 95
Sound Measurement 136
Speech Transmission Index 41
Sunlight Factor 37, 59
Surface Temperature 26 ff., 74, 77, 100 f., 105, 109 ff., 131 ff., 151, 158, 163, 187

Temperature Gradient 74
The Art Museum, Stuttgart 170 ff.
Thermal Bridges 77 f., 133
Thermal Comfort 12, 25 ff., 40, 47 ff., 54 f., 74, 81 ff., 100 ff., 134, 150 f., 162, 170 ff., 182, 188, 197 ff.
Thermography 133, 171
Total Energy Permeability Grade 80
Trigeneration 53, 120 ff., 158 f.

Urban Development 69 ff.
User Acceptance 48
Utilization 100 ff., 107 ff., 112 ff., 118, 120 ff., 137, 142 f., 151, 155 f., 158 f., 167, 170 ff., 180, 187, 195 ff.

Vacuum Façade 97
Vacuum Insulation 60, 77 ff., 97 f., 124
Ventilation Element 102, 118 f.
Ventilation Flap 75, 104, 158, 176 f., 183, 194
Ventilation System 21, 34, 42 ff., 49, 54 ff., 101, 104, 117 f., 135, 138, 143, 155
Visual Comfort 12, 36 f., 41, 87, 152, 198
Volatile Organic Compounds (VOC) 42, 44, 92

Water Consumption 62 f.
Well-Being 26, 28, 32, 35, 40, 48, 71, 92, 179, 192
Wind Energy 52, 124, 126, 129
Window Ventilation 43, 47 ff., 58, 71, 88 f., 92, 105, 117 f., 132, 135, 151, 158, 180 f.
Wood 52 f., 60, 81, 92 f., 122, 128, 132, 168, 182
Wood Pellets 52, 128
Wood Shavings 52 f., 60, 128

Sources

Chapter A

Bauer, M., Schwarz, M.: Gütesiegel ›Energieeffizienz‹ für die Gebäudeplanung und den Betrieb, Deutsches Architektenblatt, 10/05

GEFMA 200, Kostenrechnung im Facility Management, Teil Nutzungskosten von Gebäuden und Dienstleistungen, State: July 2004, Deutscher Verband für Facility Management

BMVBW, Leitfaden Nachhaltiges Bauen, Bundesministerium für Verkehr-, Bau- und Wohnungswesen, First Reprint, State: January 2001, Berlin

International Energy Agency 2003 (IEA) – CO_2 Emissions from Fuel Combustion, 1971–2001, Paris 2003

Umweltbundesamt (Hrsg.), Deutsches Treibhausgasinventar 1990–2003, Nationaler Inventarbericht 2005

BP Statistical Review of World Energy, July 2005

IPCC Plenary XVIII, Climate Change 2001 Synthesis Report

Große wetterbedingte Naturkatastrophen 1950 bis 2002, GeoRisikoforschung, Münchner Rück, 2003

Evolution of the crude oil price, BP 2005

The Kyoto Protocol, to the United Nations Framework Convention on Climate Change which entered into force on 16th February 2005

Richtlinie 2004/101/EG des Europäischen Parlaments und des Rates vom 27.10.2004 zur Änderung der Richtlinie 2003/87/EG über ein System für den Handel mit Treibhausgasemissionszertifikaten in der Gemeinschaft im Sinne der projektbezogenen Mechanismen des Kyoto-Protokolls

VDI 2067: Wirtschaftlichkeit gebäudetechnischer Anlagen, September 2000

DIN 18960: Nutzungskosten im Hochbau, Berlin 1999

www.eurostat.com

www.gvst.de/site/steinkohle/herausforderung_klimaschutz.htm

www.env-it.de/umweltdaten/

www.umweltbundesamt.de

www.dehst.de

WWF, for a living planet: Living Planet Report 2008, www.panda.org/about_our_earth/all_publications/living_planet_report/, 2008

Leadership in Energy and Environmental Design (LEED), www.usgbc.org

BRE Environmental Assessment Method (BREEAM), www.breeam.org, State May 2009

BRE Manual: 2008 BREEAM Offices Assessor manual, August 2008

DGNB, www.dgnb.de, State May 2009

Mösle, P.; Bauer, M.; Hoinka, T.: Green Building Label. Green Building 01-02, Issue 1, p. 50-55, 2009

UNEP Sustainable Building and Construction Initiative, Information Note, available on the Internet: www.unepsbci.org/SBCI-News/PressRelease/, 2006

Chapter B1

Leitfaden Nachhaltiges Bauen, Richtwerte für Innenraumluft, Deutsches Bundesministerium für Verkehr, Bau und Wohnungswesen, Berlin, January 2001

Neufert, P.u. C., Neff, L., Franken, C.: Neufert Bauentwurfslehre. Braunschweig/Wiesbaden 2002, 37. Edition

Recknagel, H., Sprenger, E., Schramek, R.: Taschenbuch für Heizung und Klima 03/04, Munich 2003

von Kardorff, G., Schwarz, M.: Raumluftqualität und Baustoffauswahl, Baumeister, 09/1999

Mayer, E.: Tagesgang für thermisches Behaglichkeitsempfinden. Gesundheitsingenieur – gi 107, 1986, Issue 3, p. 173–176

Mayer, E.: Ist die bisherige Zuordnung von PMV und PPD noch richtig? KI Luft- und Kältetechnik 34, 1998, Issue 12, p. 575–577

CEN-Bericht CR1752: Auslegungskriterien für Innenräume. European Committee for Standardization, Central Office Brussels, December 1998

Witthauer, Horn, Bischof: Raumluftqualität: Belastung, Bewertung, Beeinflussung, Karlsruhe 1993

Bericht der Bundesregierung über die Forschungsergebnisse in Bezug auf Emissionsminderungsmöglichkeiten der gesamten Mobilfunktechnologie und in Bezug auf gesundheitliche Auswirkungen, Drucksache 15/4604, 27.12.2004

Deutschland, Elektrosmogverordnung (26. BImSchV)

Diss. F. Sick: Einfluss elementarer architektonischer Maßnahmen auf die Tageslichtqualität in Innenräumen, Fraunhofer IRB

Verlag, 2003

Verbundprojekt Licht in Büroräumen – Sonnenschutz, Abschlussbericht 2004, Universität Dortmund und Fachhochschule Aachen 2004

Voss, K., Löhnert, G., Herkel, S., Wagner, A., Wambsganß, M. (Hrsg.): Bürogebäude mit Zukunft, TÜV Verlag, 2005

Urteil mit enormer Tragweite – Im Büro gilt die 26 °C-Grenze, CCI-Print, Issue 7, 2003

DIN EN 13779: Lüftung von Nichtwohngebäuden – Allgemeine Grundlagen und Anforderungen an Lüftungs- und Klimaanlagen; Deutsche Fassung EN 13779: 2004

DIN EN ISO 13732/2: Ergonomics of the thermal environment – Methods for the assessment of human responses to contact with surfaces – Part 2: Human contact with surfaces at moderate temperature, March 2001

DIN EN ISO 13732/3: Ergonomie der thermischen Umgebung – Bewertungsmethoden für Reaktionen des Menschen bei Kontakt mit Oberflächen – Teil 3: Kalte Oberflächen, March 2005

DIN EN 15251 (Entwurf): Bewertungskriterien für den Innenraum einschließlich Temperatur, Raumluftqualität, Licht und Lärm, July 2005

DIN 1946: Teil 2 Raumlufttechnik, Berlin 1994

DIN 4109: Schallschutz im Hochbau, Berlin 1989

DIN 5034: Teil 1 Tageslicht in Innenräumen. Allg. Anforderungen, Berlin 1999

DIN 5034: Teil 2 Tageslicht in Innenräumen – Grundlagen, Berlin 1985

DIN 18041: Hörsamkeit in kleinen bis mittelgroßen Räumen, Berlin 2001

DIN EN 12646-1: Beleuchtung von Arbeitsstätten, Brussels 2002

DIN EN 12464-2: Beleuchtung von Arbeitsstätten, Berlin 2003

DIN EN 12665: Grundlegende Begriffe und Kriterien für die Festlegung von Anforderungen an die Beleuchtung, Berlin 2002

DIN EN ISO 7730: Analytische Bestimmung und Interpretation der thermischen Behaglichkeit durch Berechnung des PMV- und des PPO-Indexes und der lokalen thermischen Behaglichkeit. Berlin 2003

Arbeitsstättenrichtlinien (ASR 5) Lüftung

Arbeitsstättenrichtlinien (ASR 5) 6/1 u. 3 Raumtemperaturen

Arbeitsstättenrichtlinien (ASR 5) 7/1 Sichtverbindungen nach außen

Arbeitsstättenrichtlinien (ASR 5) 7/3 Künstliche Beleuchtung

VDI 3787/2 Umweltmeteorologie – Methoden zur human-biometeorologischen Bewertung von Klima und Lufthygiene für die Stadt- und Regionalplanung, January 1998

International Commission on Non-Ionizing Radiaton Protection (ICNIRP), www.icnirp.de

Chapter B2

Treiber, M.: IKE Stuttgart, interner Bericht

Wilkins, C., Hosni, M. H.: Heat Gain From Office Equipment. ASHRE Journal 2000

Ulm, Tobias: Primärenenergiebilanz für Bürogebäude, (Diplomarbeit), Universität Karlsruhe, 2003

Eyerer, P., Reinhardt, H.-W.: Ökologische Bilanzierung von Baustoffen und Gebäuden, Wege zu einer ganzheitlichen Bilanzierung, Basel 2000

Voss, K., Löhnert, G., Herkel, S., Wagner, A., Wambsganß, M. (Hrsg.): Bürogebäude mit Zukunft, TÜV Verlag, 2005

Testreferenzjahre für Deutschland für mittlere und extreme Klimaverhältnissse (TRY), Deutscher Wetterdienst, 2004, available on the Internet: www.dwd.de/TRY

Stromsparcheck für Gebäude – Ein Arbeitsdokument für Planer und Investoren, Seminardokumentation, IMPULS-Programm Hessen

Referentenentwurf: Verordnung über energiesparenden Wärmeschutz und energiesparende Anlagentechnik bei Gebäuden (Energieeinsparverordnung EnEV), November 2006

Directive 2002/91/EC on the Energy Performance of Buildings of 16. 12. 2002, Official Journal of the European Communities, 01/2003

Energie im Hochbau SIA 380/4, Schweizer Ingenieur- und Architektenverein, Zurich, 1995, available on the Internet: www.380-4.ch

GEMIS 4.14 (2002): Globales Emissionsmodell Integrierter Systeme, Ergebnistabellen, Öko-Institut Freiburg, www.oeko.de/service/gemis

Leitfaden Energie im Hochbau, Hessisches Ministerium Umwelt, Energie, Jugend, Familie und Gesundheit, Wiesbaden, Revised Version 2000

Produktkatalog Grauwassernutzung, Pontos GmbH, Carl-Zeiss-Str. 3, 77656 Offenburg

DIN 18599: Energetische Bewertung von Gebäuden – Berechnung des Nutz-, End- und Primärenergiebedarfs für Heizung, Kühlung, Lüftung, Trinkwarmwasser und Beleuchtung Teile 1 bis 10, February 2007

VDI 4600 Kumulierter Energieaufwand, June 1997

DIN 4701 Teil 10: Energetische Bewertung Heiz- und raumlufttechnischer Anlagen, Berlin 2001

VDI 3807: Energieverbrauchskennwerte für Gebäude, Sheet 1, 1994, Sheet 2, 1997, Berlin

www.blauer-engel.de

www.energielabel.de

http://epp.eurostat.ec.europa.eu

www.meteotest.ch

Chapter C1

Daniels, K.: Technologie des ökologischen Bauens. Grundlagen und Maßnahmen, Beispiele und Ideen. Basel/Boston/Berlin 1995

DIN 277: Grundflächen und Rauminhalte von Bauwerken im Hochbau, Berlin 2000

Behling, S. u. S.: Sol Power. Munich/Berlin/London/New York 1997

Oesterle, E., Lutz, M., Lieb, R.-D., Heusler, W.: Doppelschalige Fassaden. Ganzheitliche Planung. Konstruktion, Bauphysik, Aerophysik, Raumkonditionierung, Wirtschaftlichkeit. Munich 1999

Mösle, P.: Zwischen den Schalen. Die Auswirkungen der Gestaltung und Konzeption mehrschaliger Fassaden auf die Raumkonditionierung, db deutsche bauzeitung, 01/2001

Fischer, C., Einck, J.: Hochschalldämmende Fensterkonstruktionen, Intelligente Architektur, 7–9/2005

Bauer, M.: Alte Montagehalle für neuen Kunstgenuss, Liegenschaft aktuell, 06/2006

Lutz, M.: Sanierung von Fassaden und Gebäuden: Wenn der Denkmalschutz mitspielt, Liegenschaften aktuell, 01/2007

Stahl, W., Goetzberger, A., Voss K.: Das energieautarke Solarhaus – Mit der Sonne wohnen, Heidelberg 1997

EnEV: Verordungen über energiesparenden Wärmeschutz und energiesparende Anlagentechnik bei Gebäuden – Energiesparverordnung, 2004, www.enev-online.info

Hauser, G., Siegel, H.: Wärmebrückenatlas für den Mauerwerksbau, Wiesbaden/Berlin 1996

Zukunftsorientiertes Energiekonzept für das

Projekt Stuttgart 21, Planungsgebiet A1, Arbeitsgemeinschaft Stuttgart 21, Prof. Dr.-Ing. Eberhard Oesterle et altera, Fachzeitung Untersuchungen zur Umwelt, 11/1998

Evacuated Glazing – State of the Art and Potential, Dr. Weinläder, ZAE Bayern, Glastec 2006

Neue Baumaterialien der Zukunft, Behling Braun, Jahrbuch 2004

Schweizer Ingenieur- und Architektenverein (SIA) 180: Wärme- und Feuchteschutz im Hochbau, January 2000

DIN 4109: Schallschutz im Hochbau, November 1989

DIN 4108: Wärmeschutz im Hochbau Teil 1–3, August 1981, July 2001, July 2003

DIN EN 14501: Abschlüsse – Thermischer und visueller Komfort – Leistungsanforderungen und Klassifizierung, January 2006

DIN 18599/5: Energetische Bewertung von Gebäuden – Berechnung des Nutz-, End- und Primärenergiebedarfs für Heizung, Kühlung, Lüftung, Trinkwarmwasser und Beleuchtung, February 2007

DIN ISO 12207: Fenster und Türen – Luftdurchlässigkeit, Klassifizierung, June 2000

ISO 15099: Thermal performance of windows, doors and shading devices – Detailed calculations, November 2003

DIN EN 13363/1/2: Sonnenschutzeinrichtungen in Kombination mit Verglasungen – Berechnung der Solarstrahlung und des Lichttransmissionsgrades, January/April 2007

VDI 2569 Schallschutz und akustische Gestaltung im Büro, January 1990

www.ecoinvent.org

Chapter C2

Fischer, C.: Es ist fast alles machbar. Mobile Akustik als Zukunftsaufgabe im flexiblen Büro, Mensch & Büro, 06/2003

Bauer, M.: Flächenheizungen II. Baustein eines ganzheitlichen Konzeptes. Im Winter heizen, im Sommer kühlen. Deutsches Architektenblatt, 12/04

Schwarz, M.: Sonne, Erde, Luft: Das Konzept der NRW-Vertretung, HLH, No. 6/2004

Bauer, M.: Regenerative Energisyteme in der Gebäudetechnik – sorptionsgestützte Kühlung, industrieBAU, 05/2005

Bauer, M.: Das Raumklima und Energiekonzept der Landesmesse Stuttgart: Ener getische Spitzenleistung für variable Spitzenzeiten, industrieBau Spezial ENERGIE, 01/2007

Lutz, M., Schaal, G.: Dezentrale Raumluftkonditionierung. Gestaltungsfreiheit für die Architekten und hohe Flexibilität für die Nutzer, TAB, 12/2006

Schmidt, M., Treiber, M.: Entwicklung eines innovativen Gesamtkonzeptes mit energiesparender Raumklimatechnik für die regenerative Wärme- und Kälteerzeugung, gefördert durch die Deutsche Bundesstiftung Umwelt, Abschlussbericht, Universität Stuttgart, Lehrstuhl für Heiz- und Raumlufttechnik, July 2005

Oesterle, E., Mösle, P.: Träge und doch aktiv. Heizen und Kühlen mit Betonteilen, db deutsche bauzeitung, 04/2001

Recknagel, H., Sprenger, E. u. Schramek, E.: Taschenbuch für Heizung- + Klimatechnik, Oldenbourg Verlag 97/98

Schoofs, S. u. Lang J.: Kraft-Wärme-Kopplung mit Brennstoffzellen, Fachinformationszentrum Karlsruhe 2000

Schoofs, S. u. J. Lang: PEM-Brennstoffzellen, Fachinformationszentrum Karlsruhe 1998

Dehli, M.: Möglichkeiten der dezentralen Erzeugung von Strom und Wärme, FHT Esslingen 2005

Milles, U.: Windenergie, Fachinformationszentrum Karlsruhe 2003

Röben: Sorptionsgestützte Entfeuchtung mit verschiedenen wässrigen Salzlösungen. Dissertation am Institut für Angewandte Thermodynamik und Klimatechnik, Universität Essen, Aachen 1997

Gottschau, T. und Fuchs, O.: Biogas, Fachinformationszentrum Karlsruhe 2003

Levermann, E.-M. und Milles, U.: Biogas, Fachinformationszentrum Karlsruhe 2002

WAREMA Sonnenschutztechnik, Produktkatalog

ZAE Bayern: Bayerisches Zentrum für Angewandte Energieforschung e. V., Walther-Meißner-Str. 6, 85748 Garching near Munich

Arbeitskreis Schulinformation Energie: Lehrerinformation: Brennstoffzellen, Frankfurt/Main, August 1998

Infozentrale der Elektrizitätswirtschaft e. V.: Strombasiswissen: Brennstoffzellen, Frankfurt/Main, January 1999

BINE Informationsdienst, Basis Energie 3: Photovoltaik. Fachinformationszentrum Karlsruhe 2003

BINE Informationsdienst, Basis Energie 4: Thermische Nutzung der Solarenergie. Fachinformationszentrum Karlsruhe 2003

BINE Informationsdienst, Basis Energie 13: Holz-Energie aus Biomasse. Fachinformationszentrum Karlsruhe 2002

BINE Informationsdienst, Basis Energie 16: Biogas. Fachinformationszentrum Karlsruhe 2003

BINE Informationsdienst, Projektinfo 05/2000. Kraft-Wärme-Kopplung mit Brennstoffzellen. Fachinformationszentrum Karlsruhe 2000

VDI 6030: Auslegung von freien Raumheizflächen – Grundlagen und Auslegung von Raumheizkörpern. Berlin 2002

ASUE: Mikro-KWK Motoren, Turbinen und Brennstoffzellen, www.asue.de/2001

www.bine.info
www.zbt-duisburg.de
www.diebrennstoffzelle.de
www.energieberatung.ibs-hlk.de
www.cooretec.de
www.isi.fraunhofer.de
www.carmen-ev.de

Chapter C3 and C4

Mösle, P., Bauer, M.: Behagliche Temperaturen im Glashaus, Deutsches Architektenblatt, 05/2006

Grob, R., Bauer, M.: Emulation. Computergestützte Vorabinbetriebnahme von Regel- und Steuerungsanlagen, TAB, 10/2004

von Kardorff, G.: Ökomanagement am Potsdamer Platz. Kostendruck schließt den Umweltschutz nicht aus, leonardo-online, 03/1999

Chapter D

Herzog, Th (Hrsg.).: SOKA-Bau. Nutzung Effizienz Nachhaltigkeit, Munich 2006

Bauer, M., Mösle, P.: Raumklima- und Fassadenkonzept »Dockland« Hamburg, AIT, 10/2006

Oesterle, E.: Bürogebäude mit innovativem Energiekonzept – Heizen und Kühlen mit Erdwärme, EB Energieeffizientes Bauen, 01/2003

Bauer, M., Niewienda, A., Koch, H.P.: Alles Gute kommt von unten – Mit geringem Energiebedarf zu geringem Energieaufwand, HLH, 11/2001

Niewienda, A.: Entwicklung der Klimakonzepte für das Kunstmuseum Stuttgart, Bauphysik, Issue 2/2005

www.drbyen.dk

List of Authors

Michael Bauer
03.05.1966
Prof. Dr.-Ing. Maschinenwesen, Stuttgart University
Managing Director,
D&S Advanced Building Technologies

Peter Mösle
19.09.1969
Dipl.-Ing. Energietechnik, Stuttgart University
Member of Executive Board,
D&S Advanced Building Technologies

Michael Schwarz
21.02.1961
Dr.-Ing. Maschinenwesen, Stuttgart University
Team Manager Energy Management,
D&S Advanced Building Technologies

Ralf Buchholz
03.07.1968
Dipl.-Ing. (FH) Bauphysik, Stuttgart University
of Applied Sciences
Team Manager Building Physics,
D&S Advanced Building Technologies

Andreas Niewienda
19.08.1964
Dipl.-Physiker, Freiburg University
Consultant Energy Design/Management,
D&S Advanced Building Technologies

Michael Jurenka
12.11.1968
Dipl.-Ing. Maschinenwesen, Stuttgart University
Consultant Energy Design,
D&S Advanced Building Technologies

Ralf Wagner
15.05.1965
Dipl.-Ing. (FH) Elektrische Energietechnik
Consultant Building Services Engineering,
D&S Advanced Building Technologies

Herwig Barf
23.11.1963
Dipl.-Ing. Architekt
Team Manager Façade Technology,
D&S Advanced Building Technologies

Christian Fischer
02.04.1951
Dr.-Ing., "öbuv" Expert Surveyor,
Building Physics,
D&S Advanced Building Technologies

Hans-Peter Schelkle
30.06.1970
Dr.-Ing. Bauingenieurwesen, Stuttgart University
Consultant Facility Management,
D&S Advanced Building Technologies

Heinzpeter Kärner
30.07.1970
Dipl.-Kaufmann
Organisation and Coordination,
D&S Advanced Building Technologies

Ulrike Fischer
20.06.1964
Assistant to the Executive Board,
D&S Advanced Building Technologies

Ulrike Schweizer
24.08.1977
Dipl.-Betriebswirtin (FH)
Organisation and Coordination,
Drees & Sommer AG

Thank You

We would like to thank especially all those architects, clients and companies who made available to us their drawings and image material and who allowed us to interview them about their respective projects. They made a decisive contribution towards the contents of this book:

Bothe Richter Teherani, Hamburg
Robert Vogel GmbH & Co. KG, Hamburg
Herzog und Partner, Munich
Soka-Bau, Wiesbaden
Auer + Weber + Assoziierte, Stuttgart
Kreissparkasse Tuebingen
LBBW, Stuttgart
Wöhr Mieslinger Architekten, Stuttgart
Petzinka Pink Technologische Architektur®, Duesseldorf
Nycomed, Constance
Ingenhoven Architekten, Duesseldorf
Architekturbüro Hascher und Jehle, Berlin

COWI, Copenhagen
DR Byen, Copenhagen
Drees & Sommer, Stuttgart
Glaser FMB GmbH & Co. KG, Beverungen
va-Q-tec AG, Wuerzburg
Kajima Design, Tokyo
Institut für Industrieaerodynamik, Aachen
Gerber Architekten International, Dortmund
Maier Neuberger Architekten, Munich
Colt International GmbH, Eltingen
Rasbach Architekten, Oberhausen
MEAG, Munich
Bartels und Graffenberger Architekten, Duesseldorf
Steelcase Werndl AG, Rosenheim
Warema Renkhoff GmbH, Marktheidenfeld
Purratio AG, Neuhausen a.d. Fildern
Stefan Behling, Fosters + Partners, London
Prof.-Dr. Ing. Koenigsdorff, FH Biberach
Spengler Architekten, Nuremberg

Playmobil geobra Brandstätter GmbH & Co. KG, Zirndorf
VHV-Gruppe, Hannover
Architekten BKSP, Hannover
Professor Bernhard Winking Architekten, Hamburg
Architekten Wulff und Partner, Stuttgart
Projektgesellschaft Neue Messe GmbH & Co. KG, Stuttgart
Pontos GmbH, Offenburg
Dittrich-Planungs-GmbH, Wunsiedel

Further, we would like to thank our expert colleagues at D&S Advanced Building Technologies from the various teams:
Life Cycle Engineering
Energy Design and Management
Building Services Engineering
Façade Technology
Building Physics, Building Ecology
Facility Management

Image Material

All the drawings in this book were created especially. Photographs without credit are archive material of D&S Advanced Building Technologies.

Foreword
Dietmar Strauß, Besigheim p. 6

Chapter A
Jörg Hempel, Aachen p. 11 top
pixelio.de p. 8–9 and p. 12 bottom

Chapter B
Jörg Hempel, Aachen p. 30 bottom
pixelio.de p. 42 and p. 47

Chapter C
Architekten BKSP p. 112 top
Architekten Bartels and Graffenberger p. 87
artur / Tomas Riehle p. 100
BioKoN Saarbruecken p. 99 bottom right

Firma Colt International GmbH, Elchingen p. 84
Firma Warema Renkhoff GmbH p. 98 bottom right
Geobra Brandstätter GmbH & Co. KG, Zirndorf p. 104 bottom right
Gerber Architekten International GmbH, Fotograf: Hans-Jürgen Landes p. 80
Glaser FMB GmbH & Co. KG p. 98 bottom left
H. G. Esch, Hennef p. 66, p. 94, p. 95, p. 111 top right
Jörg Hempel, Aachen p. 64
Kajima Design, Tokyo p. 102 top right, p. 103
Mackevision Medien Design GmbH p. 116, p. 117
Martin Lutz p. 71
Petzinka Pink Technologisch Architektur® p. 75, p. 76, p. 114
pixelio.de p. 108, p. 126, p. 129, p. 131
Professor Werner Nachtigall p. 98
Taufik Kenan, Berlin, for Petzinka Pink Technologische Architektur® p. 93 top left and top right
wodtke GmbH p. 128

Chapter D
Hans-Georg Esch, Hennef p. 166–171
COWI Beratende Ingenieure p. 172–195
Herzog + Partner p. 154–159
Ingenhoven Architekten, Duesseldorf p. 181 and p. 182 bottom
ISE Freiburg p. 189 top
Jörg Hempel, Aachen for Robert Vogel GmbH & Co. KG, Hamburg p. 144–153
Model photos: Holger Khauf, Duesseldorf Photography: H. G. Esch, Hennef p. 178–183
Petzinka Pink Technologische Architektur® p. 184–189
Roland Halbe, Stuttgart p. 160–165 and p. 172–177

Cover
Hans-Georg Esch, Hennef Back, bottom left
Jörg Hempel for Robert Vogel GmbH & Co. KG, Hamburg Cover Image
Ingenhoven Architekten, Duesseldorf Back, top left
Taufik Kenan, Berlin, for Petzinka Pink Technologische Architektur® Back, top right